photo

This catalog was published in conjunction with the exhibition *Autophoto*,
presented at the Fondation Cartier pour l'art contemporain in Paris
from April 20 to September 24, 2017.

auto photo

Cars & Photography, 1900 to Now

FondationCartier
pour l'art contemporain

Éditions Xavier Barral

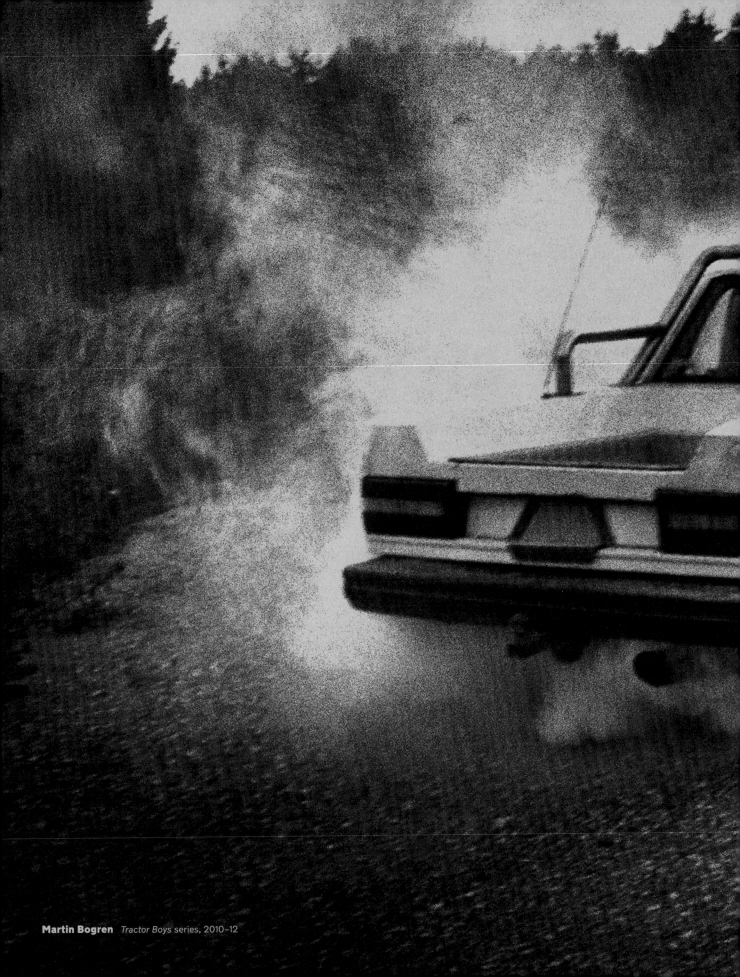

Martin Bogren *Tractor Boys series, 2010–12*

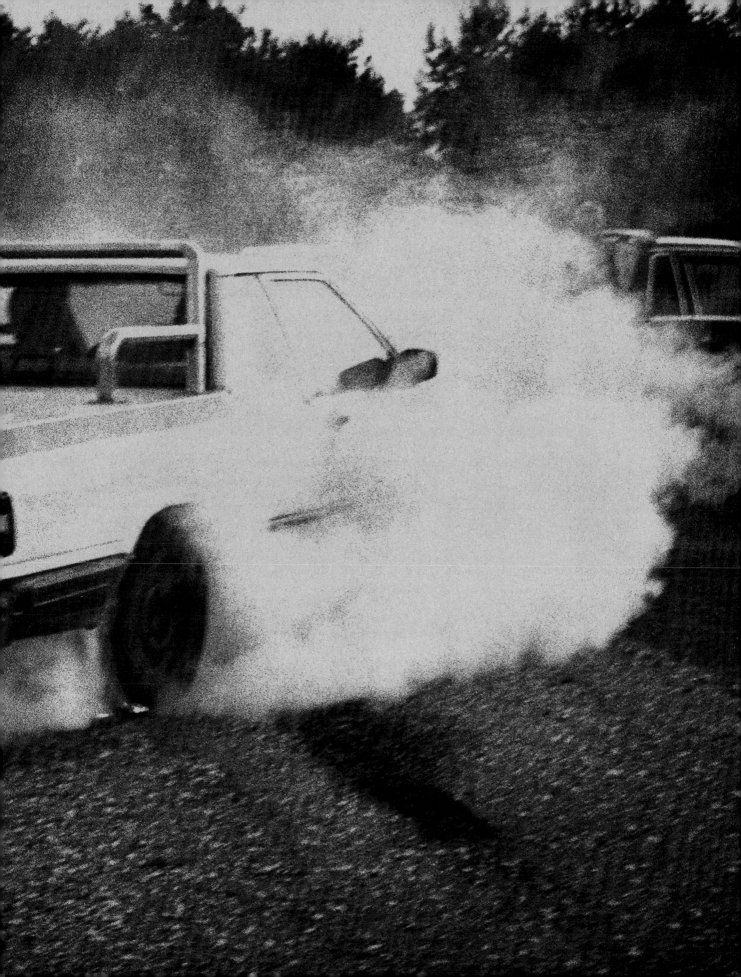

Autophoto

Xavier Barral and Philippe Séclier
Curators of the exhibition

A panorama framed by the rectangle of the windscreen. A long ribbon of asphalt stretching into the distance until it vanishes over the horizon. For more than a century, we have been able to travel the world by car and capture such an image from this "camera box" on wheels.

At the end of the nineteenth century, the automobile and photography—two instruments for shaping the landscape, two mechanisms of traction and attraction—paved the way for modern society by introducing new rituals and new velocities. While photography allows us to have and record multiple points of view, to "memorize" movement and to leave traces, the automobile enables us to move through space. Photography, which immobilizes, has benefited from the automobile, which provides mobility. And although cars and photography are both continually evolving, they have in fact taken parallel paths in order to increase their mastery over space and time. "Driving is a spectacular form of amnesia. Everything is to be discovered, everything to be obliterated," wrote Jean Baudrillard.[1]

But let us go back to the beginning. A little more than two hundred years ago, the brothers Nicéphore and Claude Niépce became interested in both the internal combustion engine and the phenomenon of light. The two inveterate inventors developed the Pyréolophore, the forerunner of the internal combustion engine, which was driven by heat-expanded air and fueled by a combination of coal, resin and oil. Patented in 1807, the Pyréolophore was mainly designed to propel boats.[2] Unfortunately, Claude's incessant research activities drove them deeper into debt and Nicéphore discontinued the engine projects to turn his efforts to heliography, a method for reproducing images that involved engraving and a *camera obscura*. Sometime around 1826, the world's first photographed image was born. Taken from the window of Niépce's house in Saint-Loup-de-Varennes in the Saone-et-Loire region and entitled *View from the Window at Le Gras*, it was obtained by coating a pewter plate with bitumen of Judea. Louis Daguerre, William Henry Fox Talbot, and Hippolyte Bayard would go on to perfect this new invention—officially dated 1839—through the use of different techniques (daguerreotype, calotype)

1. Jean Baudrillard, *America* (New York: Verso, 1988), p. 9.

2. See Paul Jay and Michel Frizot, *Nicéphore Niépce* (Paris: Centre national de la photographie, 1983).

and materials (silver plate, mat paper). Around 1880, Eadweard Muybridge and Étienne Jules Marey took on another challenge, the study of motion, and invented chronophotography, which enabled them to break down and capture the movements of a body or an animal in action. On the automotive side, experimental research on engines had continued throughout the century, but it was not until 1889 that a four-stroke engine was developed by Deutz AG.

A double revolution was thus underway. The automobile and photography progressed side by side during the twentieth century. Industrialization and mass production came along to make both widely accessible to the general public. The hippomobile gradually disappeared as the automobile took over. The latter was indeed all the more popular because, as urban planner Marc Desportes points out, it "obeys your every command, drives you anywhere you want, at any time of day or night. In that way, cars are similar to horses, but to horses that never tire and have the power of four, of eight of their kind … That is why they engender a feeling of action and freedom. That is why they differ from trains, which impose their routes and schedules and create a form of passivity in passengers, who, in spite of themselves, are forced to participate in a huge, inflexible, regimented machine."[3] This new kind of horsepower led to the first speed records being set: in Achères, France, where the 100 km/h mark was first crossed in 1899, then in Ostend, Belgium, where the 130 km/h barrier was broken in 1903, and in Daytona Beach, Florida, where 170 km/h was almost attained in 1905.

At first, due to their cost, cars were owned mainly by the well-to-do. The latter complained about the state of the roads, most of which were nothing more than dirt tracks that left much to be desired. Routes had to be organized for driving, networks had to established with roads that needed to be named and mapped. In 1900, the brothers André and Édouard Michelin began making topographical surveys in order to identify France's roads and evaluate their condition. Then, in the 1930s, they set out on a mission to photograph the world's major routes (p. 229). All over the planet, from Damascus to Buenos Aires to Santiago de Chile, from Timbuktu to Berlin to Prague, they found the same thing: roads everywhere were dangerous, unsuitable for driving, and lacking in any kind of convenience. They needed to be rebuilt, enlarged and made safe. Little by little, a web would be woven, and it would be expanded to cover all of the continents, even if it meant creating more and more traffic. Today, we have come a long way from the clouds of dust thrown up by a vehicle that announced the arrival of a more or less benevolent presence in the village. A long way, as well, from the tracks left by the "Croisière Noire" (28,000 kilometers across the Africa) and the "Croisière Jaune" (30,000 kilometers across Asia) organized by Citroën in 1924 and 1931, respectively (p. 238). Before routes were inundated with asphalt, obliterating the tire tracks left in the dirt, cars once drew a sort of Ariadne's thread reconnecting us to space and time.

3. Marc Desportes, *Paysages en mouvement. Transports et perception de l'espace, XVIII*-*XX*^e *siècle*, (Paris Gallimard, 2005), p. 237.

The rising popularity of the automobile, initiated in France by small firms such as Panhard & Levassor and De Dion-Bouton, took a decisive turn in 1910. Industrialization and the development of new manufacturing methods—in particular, the introduction of the assembly line—made it possible to meet both the growing demand and the aims of profitability. The principles of scientific management formulated by the American engineer Frederick Winslow Taylor were first put into practice in the United States by Henry Ford for his famous Model T. "Fordism" followed on the heels of "Taylorism" and would turn the city of Detroit, Michigan into the automotive capital of the world. A new economy was emerging, and photographers on both sides of the Atlantic were documenting the social history that accompanied it.

With the arrival of Kodak's light and easy-to-maneuver box camera in 1888, the Pocket Kodak in 1895 and, above all, the Kodak Brownie—which sold for a dollar—in 1900, the camera industry and the sensitive surface (negatives) market began to take off. Improvements in shutter speeds and instantaneity led to reduced exposure times, which finally made it possible to capture a subject in motion. In 1925, the first camera to use the 24 × 36 mm format, the famous Leica, was brought out by the German engineer Oskar Barnack. Major advances were also being made in the realm of color. At the beginning of the twentieth century, the first autochromes were able to reproduce reality as it appeared to the naked eye, and they were soon followed by other techniques in the 1920s and 1930s (Agfacolor, Kodachrome, Ektachrome, etc.). Although, at the time, black and white still predominated, color gave photographers a new medium for artistic expression.

By now roads had branched out into highways, into bypasses, with gas stations, parking lots, motels, drive-ins, and more. This initial conquest of space accelerated in the 1950s: the aim was to go ever faster, ever farther. Then the legendary road trip was born, and after the publication of Jack Kerouac's *On the Road* in 1957 and Robert Frank's *The Americans* in 1959, two iconic books of the Beat Generation, it became the thing to do. With the rise of consumer society in the 1960s, the automobile became a symbol of independence and freedom, as well as a status symbol, which caught the eye of many a photographer. "I think that cars today are almost the exact equivalent of the great Gothic cathedrals: I mean the supreme creation of an era, conceived with passion by unknown artists, and consumed in image if not in usage by a whole population which appropriates them as a purely magical object,"[4] was Roland Barthes's analysis. Each year millions of worshipers flocked to Paris, Frankfurt, Shanghai, Detroit, Geneva, Los Angeles, and Tokyo, for the high mass of the auto shows. There they discovered the latest innovations in traveling, positioning, and visions for the future in order to keep pushing back the frontiers of the open road.

4. Roland Barthes, "The New Citroën," in *Mythologies* (New York: Farrar, Straus, and Giroux, 1972), p. 88.

The intimate world of the home transposed into a mobile habitat is exposed to all kinds of eyes. It may even turn into a trap for its occupants: when unleashed on the road, the steel exoskeleton, becoming one with its passengers, may also become, without any warning, a devastating and at times deadly metallic shell. Left to rot in the landscape or rust in the scrap yard, this exoskeleton itself becomes perishable.

What cars have spawned above all in the last two decades, is an ever-expanding monster. Its arteries are becoming more and more clogged, and the pollution that this creates is now considered to be as much of a threat as reckless driving. Similarly, in the field of photography—a field that was to become more and more fertile with the advent of digital technology and the Internet—congestion has also reached a critical point. This type of expansion, across space and time, has been undergoing another kind of acceleration that is linked to hybrid technologies (gasoline-electricity, phone-cameras), connectivity, and social networks (carpooling, photo sharing). In addition, a new era is already on the horizon: that of the semi- or fully autonomous car loaded with algorithms, cameras, and sensors.

But before this new transformation allows us to finally let go of the steering wheel, let us pause. The different photographic series in the exhibition *Autophoto* show us how the automobile has, over the last century and through the eye of the camera, altered the landscape and, with its recurrent themes, forever changed our society and our way of seeing things.

Translated from the French by Jennifer Kaku

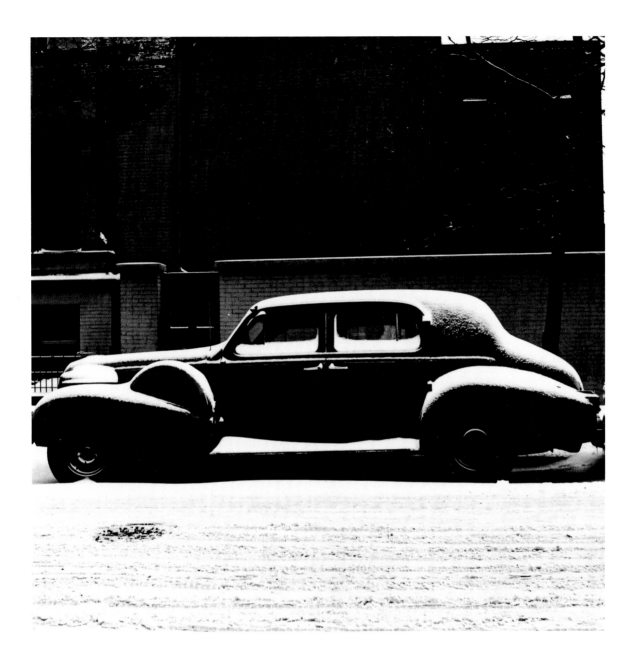

Yasuhiro Ishimoto *Chicago, Snow and Car*, 1948–52

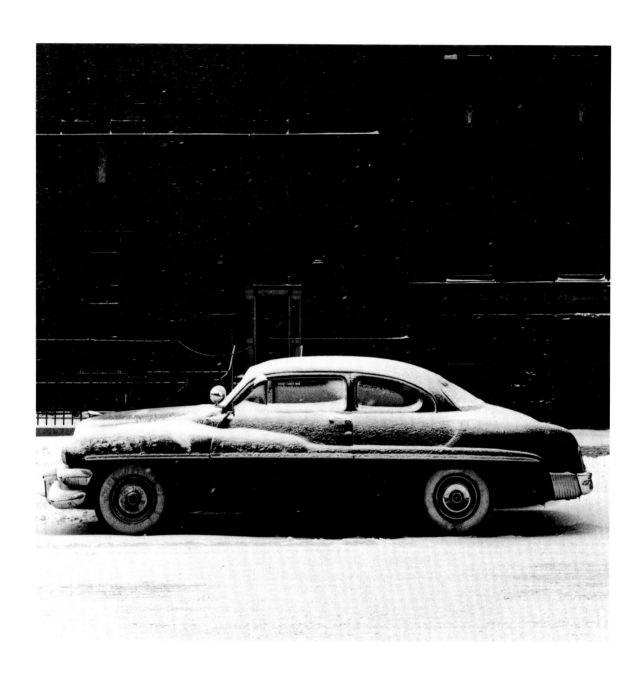

Yasuhiro Ishimoto *Chicago, Snow and Car, 1948–52*

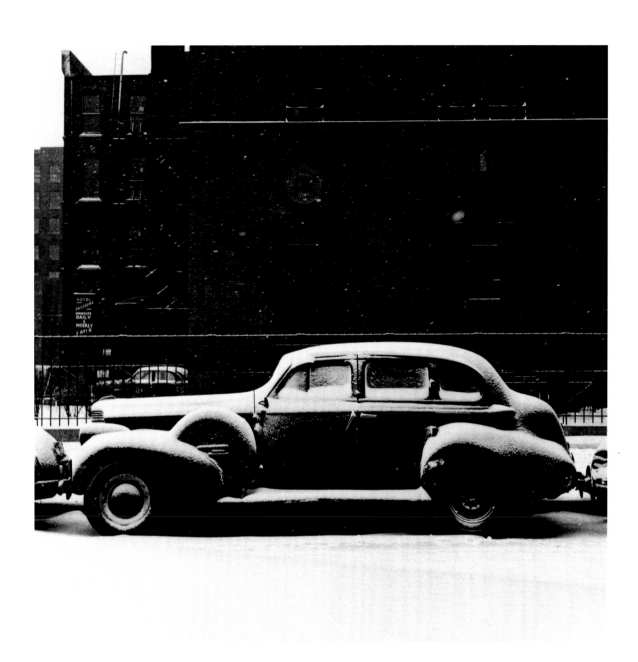

Yasuhiro Ishimoto *Chicago, Snow and Car*, 1948–52

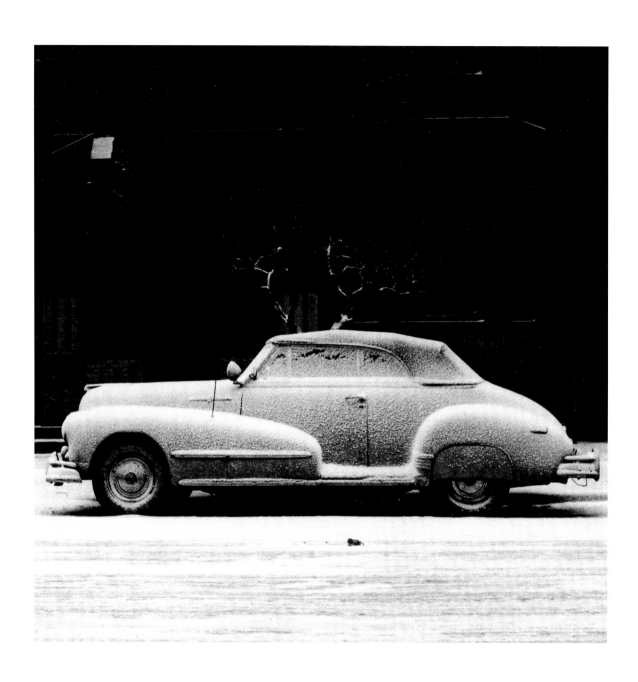

16 **Yasuhiro Ishimoto** *Chicago, Snow and Car*, 1948–52

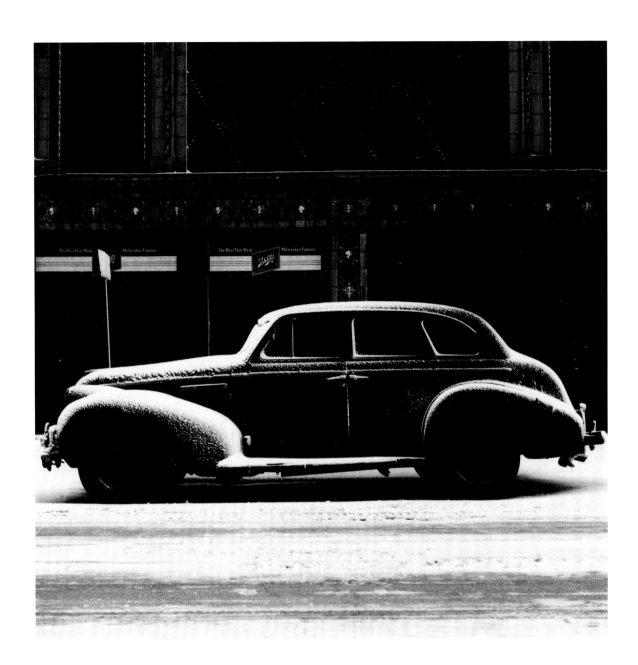

Yasuhiro Ishimoto *Chicago, Snow and Car*, 1948–52

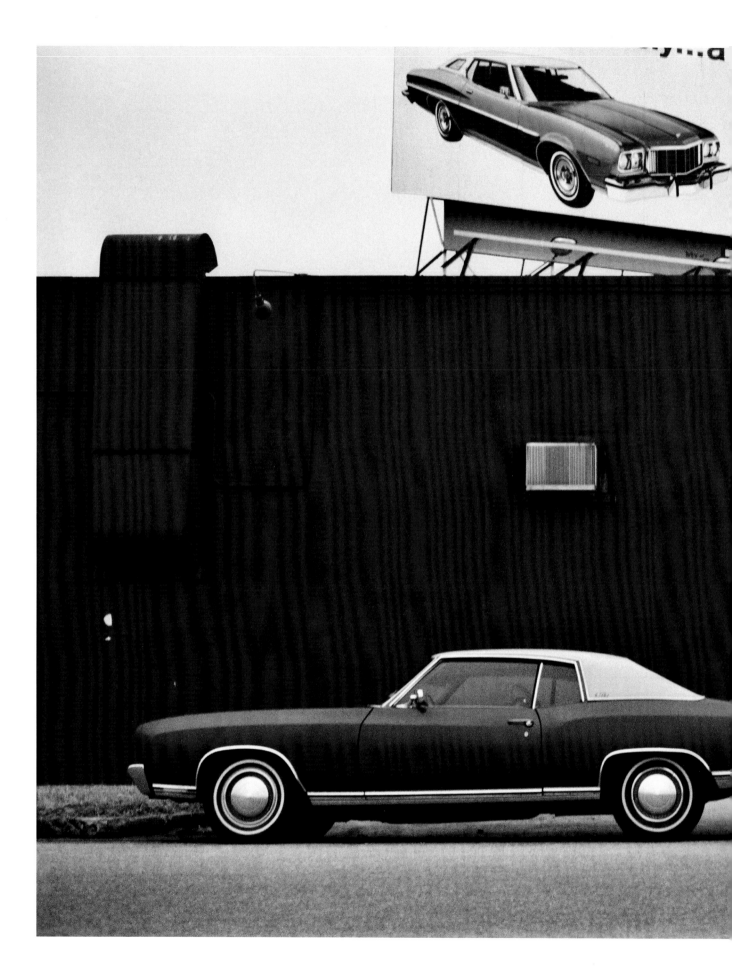

William Eggleston
Los Alamos series, c. 1974

"The cars came to be an about-face to bold garish color. It was a kind of 'I'm here' statement. Running in the other direction from the street photographer's decisive moment. A big tripod, a Leica, a 40-mm lens, Kodachrome film, and two years of wandering around. It was photography of the street itself. One car. One background. So simple. Night became its own color." **Langdon Clay**

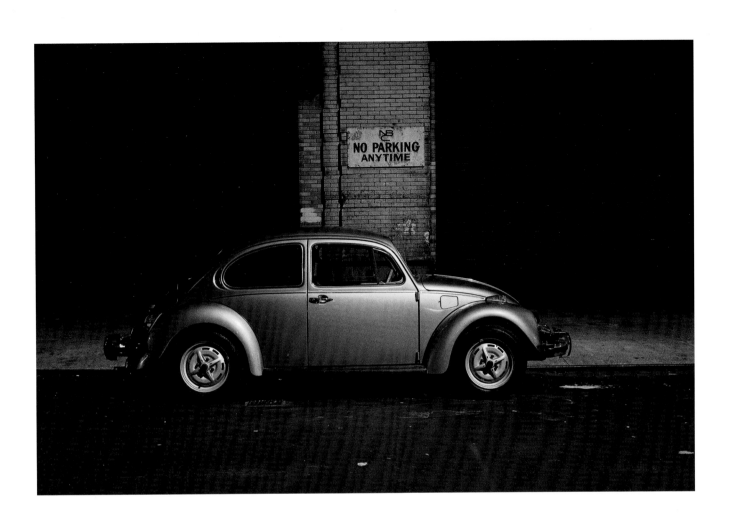

Langdon Clay *No Parking Car, Volkswagen Beetle (Bug), North of West Village. Cars – New York City* series, 1975

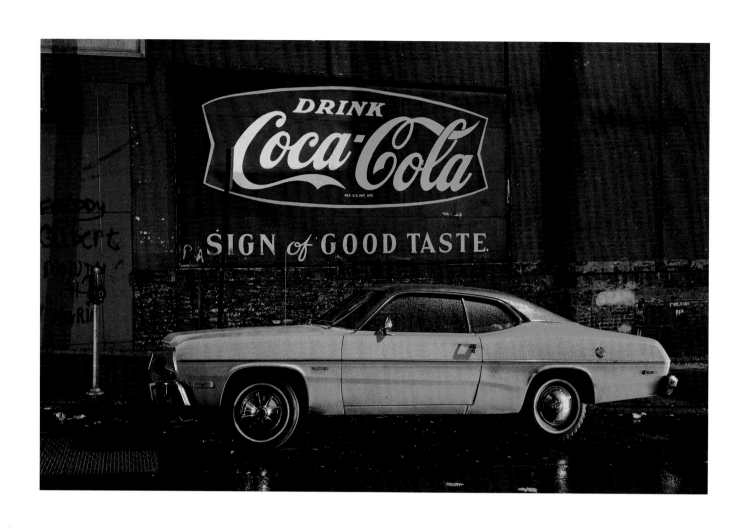

Langdon Clay *Sign of Good Taste Car, Plymouth Duster, Hoboken, NJ. Cars – New York City* series, 1975

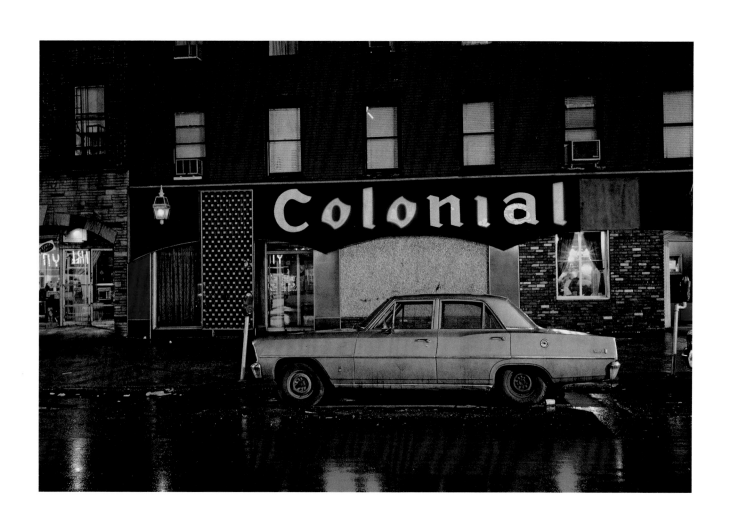

Langdon Clay *Colonial Car, Chevrolet Nova 230, Hoboken, NJ. Cars – New York City* series, 1975

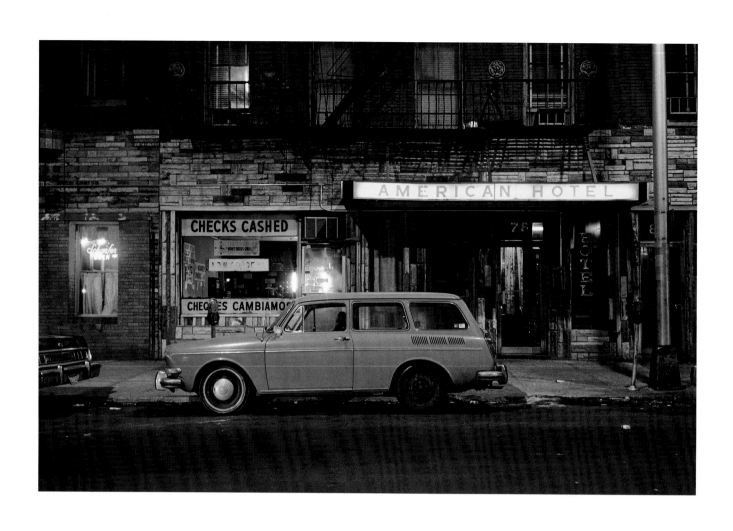

Langdon Clay *American Hotel Car, Volkswagen 1600 Squareback, Hoboken, NJ. Cars – New York City* series, 1974

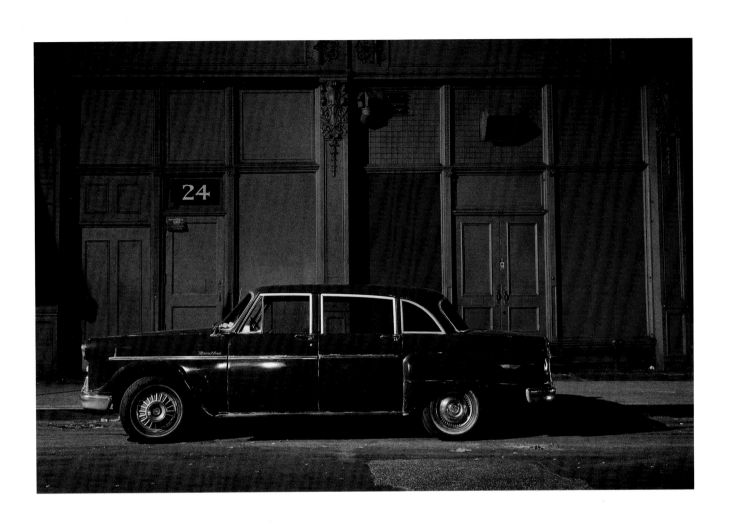

Langdon Clay *24 Checker Car, Checker Marathon, in the Twenties near 6th Avenue. Cars – New York City* series, 1975

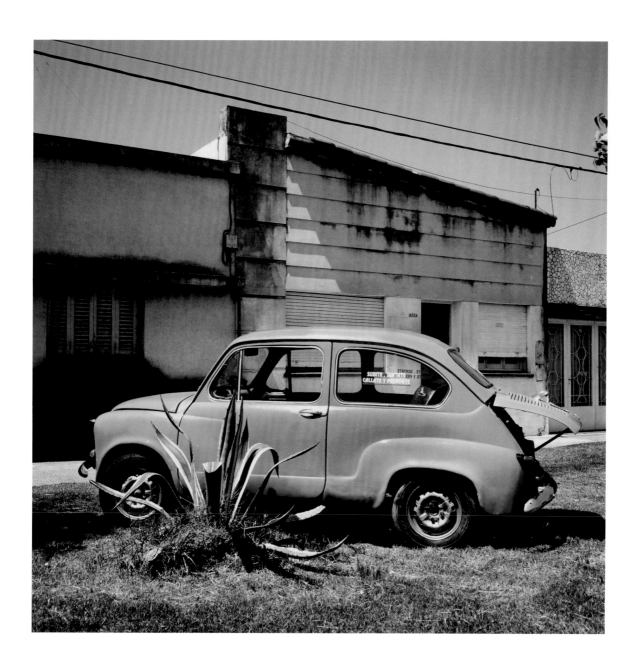

Marcos López *Tristes Trópicos* series, 2003–12

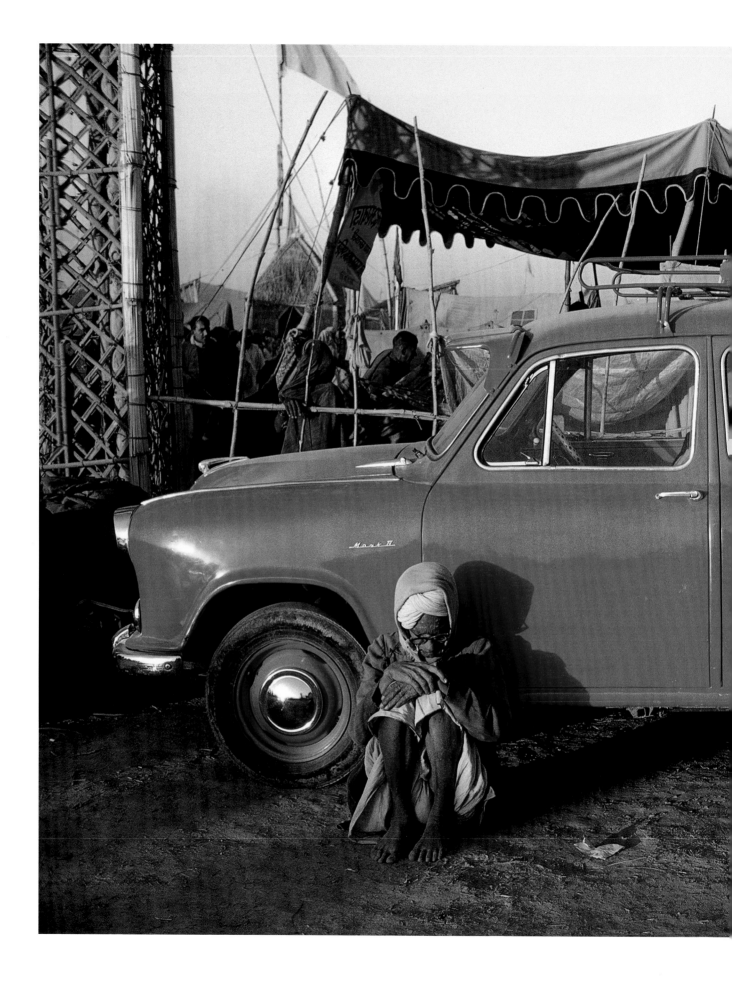

Raghubir Singh
Pilgrim and Ambassador Car,
Prayag, Uttar Pradesh, 1977

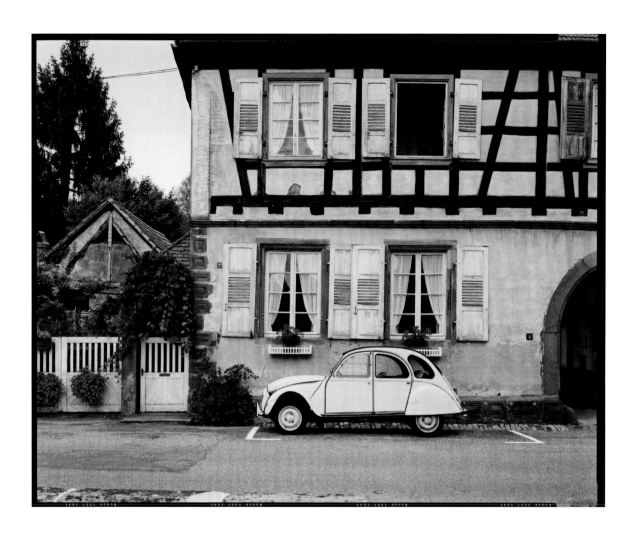

Raymond Depardon *Wissembourg, Bas-Rhin, France*, 2005

"On my bicycle tours, time and again, I saw passenger cars, buses, and trucks, which stood around. I think my first reaction was to look for the absent owners. Since I hardly ever saw anyone, I stayed alone with the situation, and a relationship to these vehicles began to develop, as I would not have expected it. The cars in the landscape had an impact on me, similar to the impact of actors on a stage, and since then I began to collect their wit and their tragedy." **Bernhard Fuchs**

Bernhard Fuchs *Roter Ford-Bus, bei Freistadt. AUTOS* series, 1994

Bernhard Fuchs *Grüner Fiat, Helfenberg. AUTOS series, 1996*

Bernhard Fuchs *Blauer Opel, Bad Leonfelden-Traberg. AUTOS* series, 1994

Bernhard Fuchs *Rotes kleines Auto, Helfenberg-Haslach. AUTOS series, 2003*

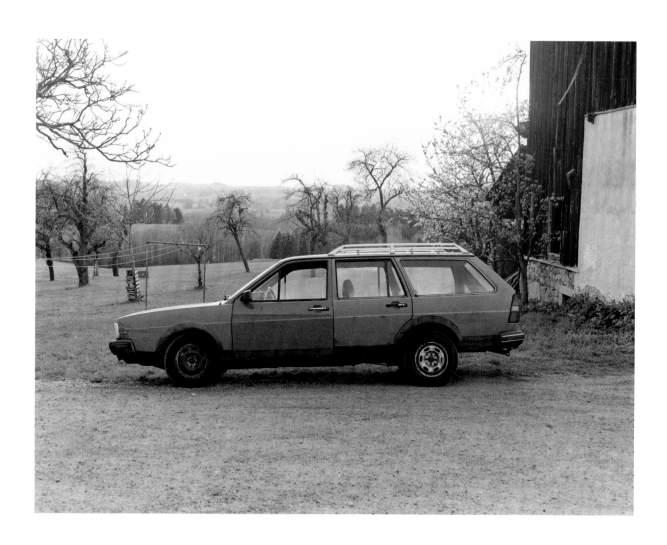

Bernhard Fuchs *Blauer Passat, Herzogsdorf. AUTOS* series, 2004

"What fascinates me about the act of researching and selecting photographs is to give an idea of series, of creating typologies of objects. The selection becomes a scientific catalog, and at the same time, this approach has this whole poetical minimalist dimension: even if the sixty 1963 models I have assembled are typical American cars of that year, they are all still different and unique in nature. These slight variations in the language of form create in me an exhilarating vertigo." **Luciano Rigolini**

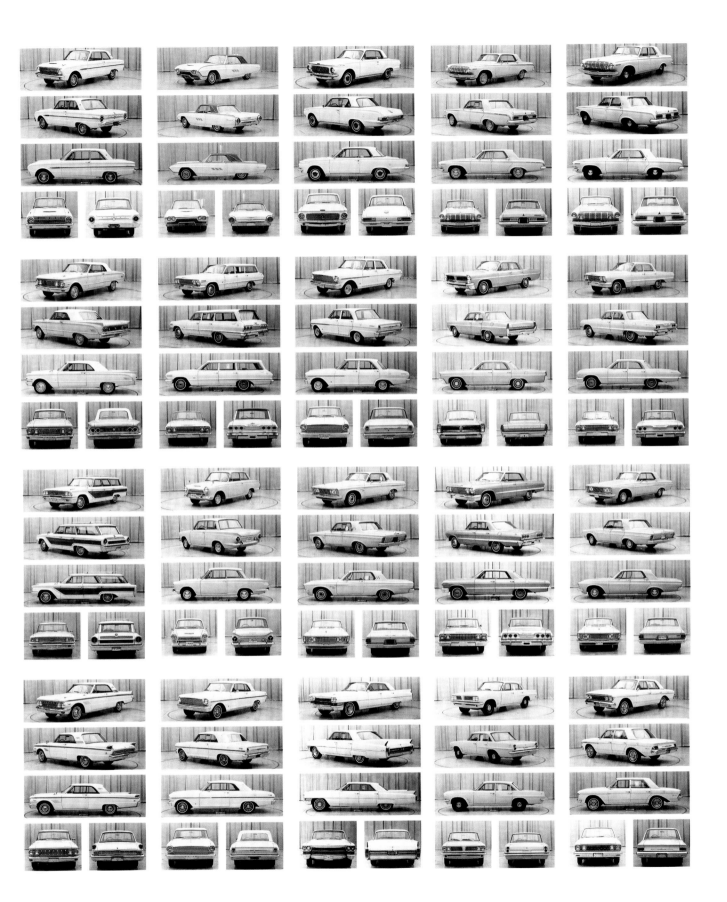

Luciano Rigolini *1963 American Cars, 2016*

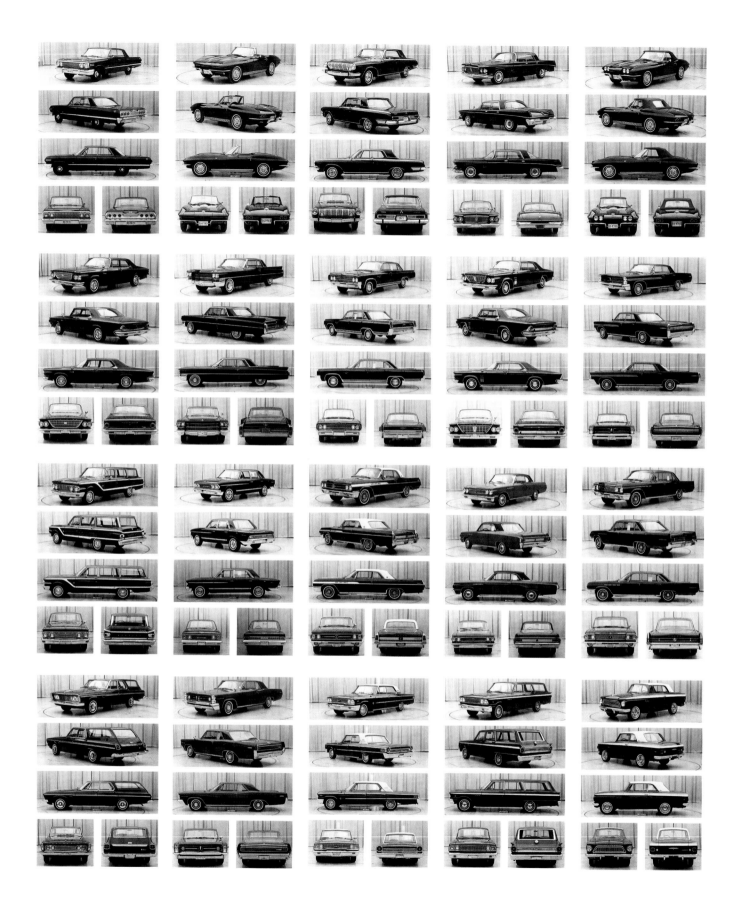

Luciano Rigolini *1963 American Cars*, 2016

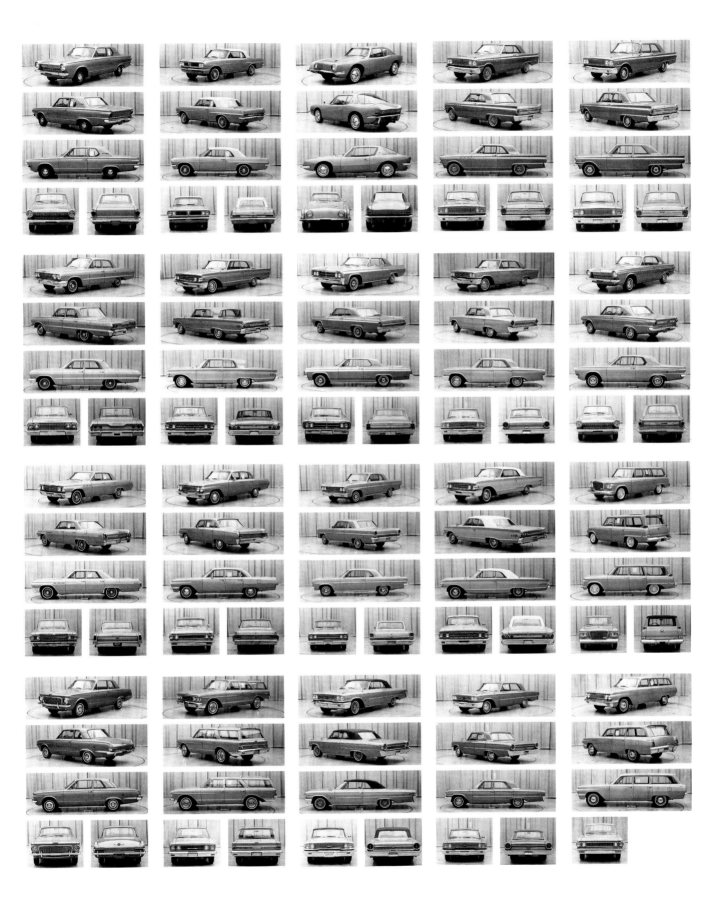

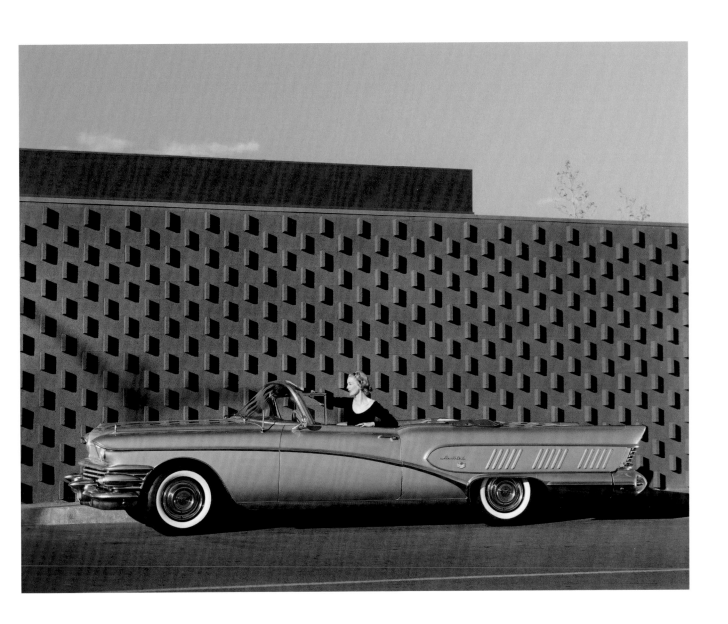

Luciano Rigolini *Tribute to Giorgio de Chirico*, 2017

"When I was looking at Walker Evans's photos from the 1930s, I saw the cars in his images as time bombs. The cars date the photos. I knew that by photographing a car I was leaving a trace behind, destined for those looking at the image twenty years later." **Stephen Shore**

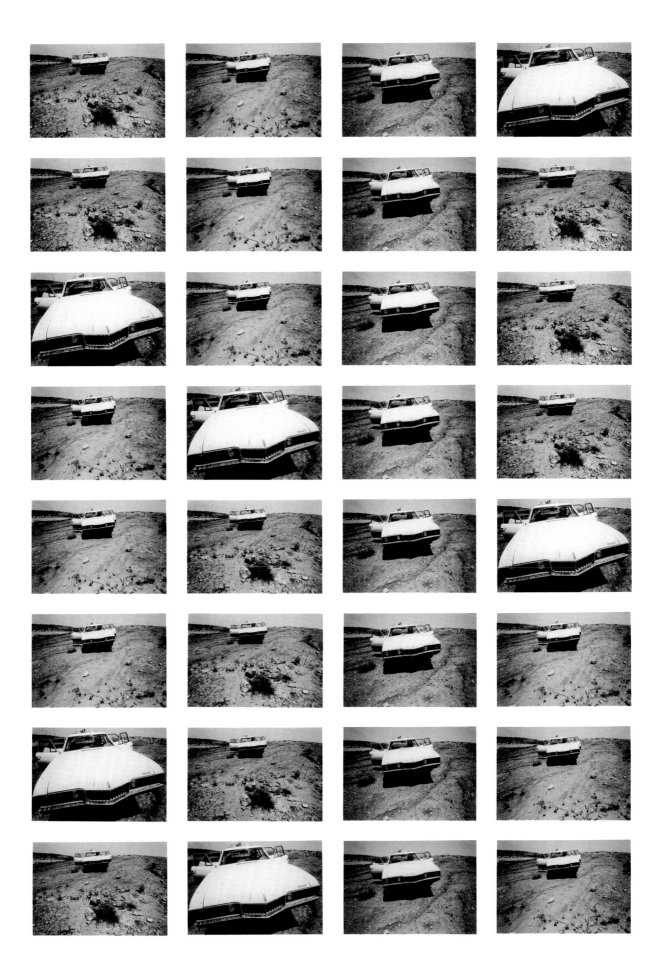

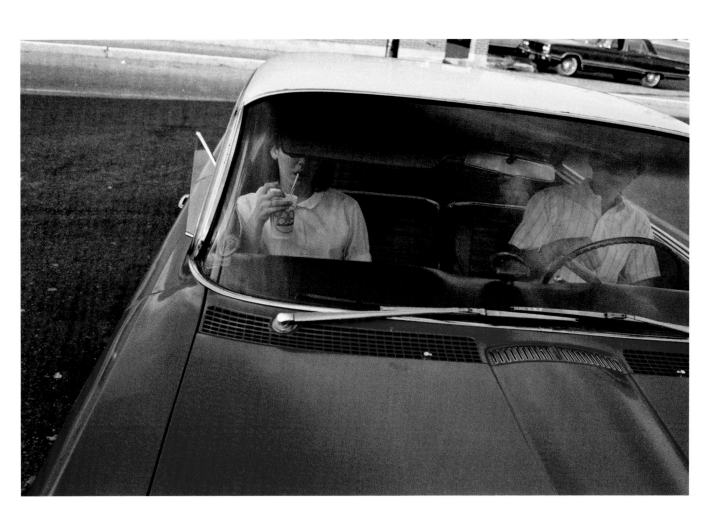

William Eggleston *Los Alamos* series, 1965–68

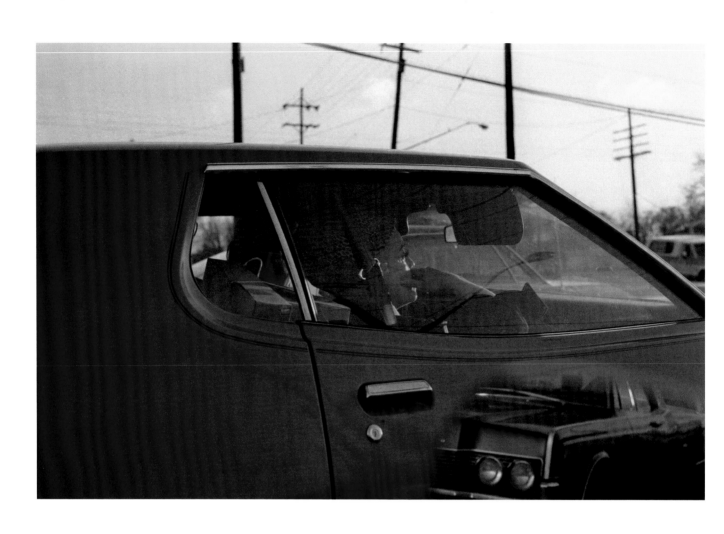

William Eggleston *Los Alamos* series, 1971–74

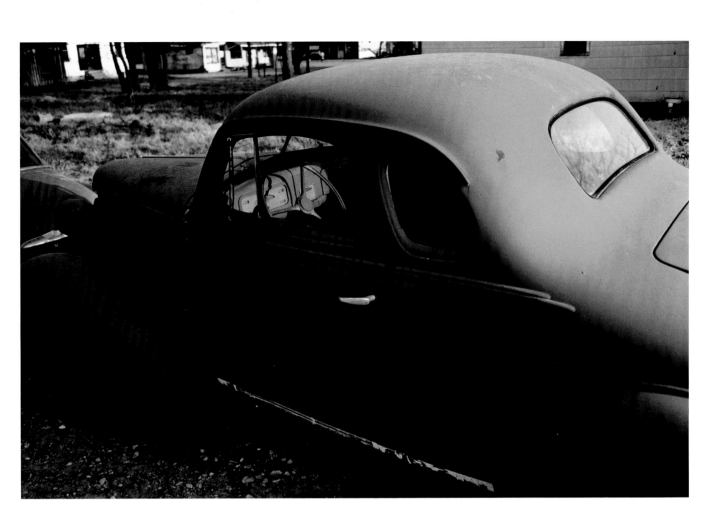

William Eggleston *Chromes* series, 1971–74

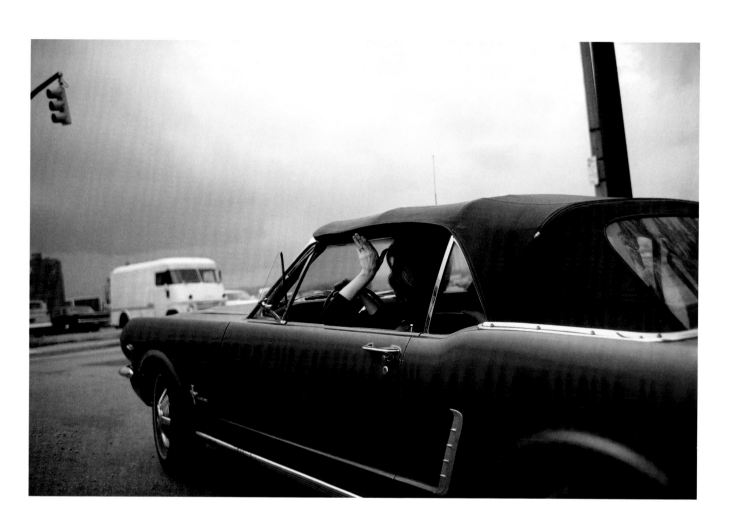

William Eggleston *Chromes series*, 1971–74

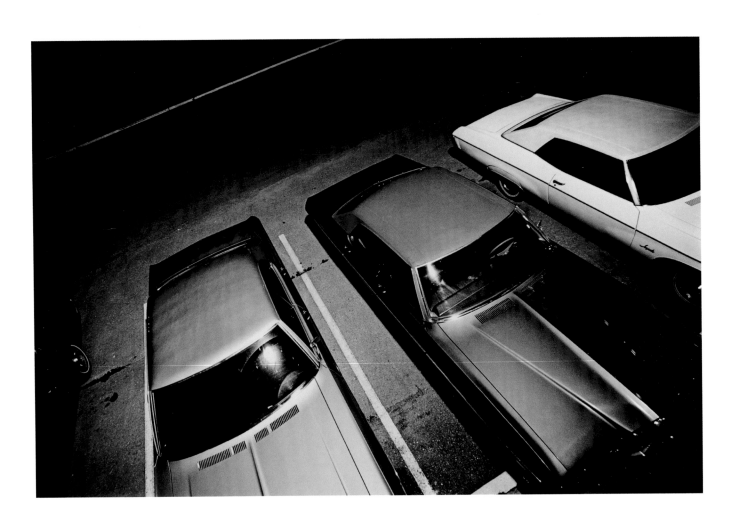

William Eggleston *Untitled*, c. 1970

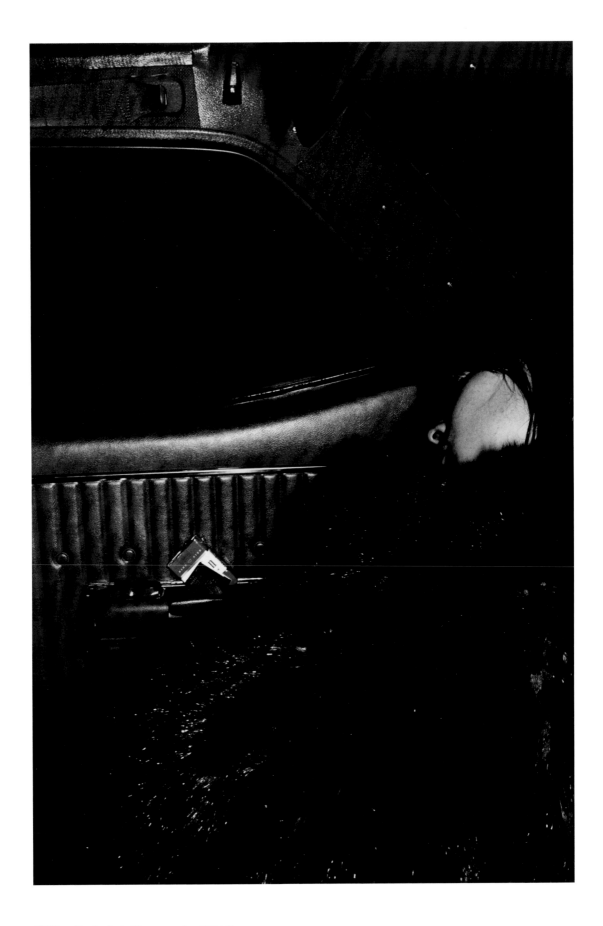

William Eggleston *Chromes* series, 1971–74

William Eggleston *Los Alamos* series, 1971–74

William Eggleston *Chromes* series, 1971–74

William Eggleston *Los Alamos* series, 1965–68

William Eggleston *Chromes* series, c. 1970

"They are vernacular photographs, collected over the years. Images taken between the years 1940 and 1980, which bear witness to the joys of everyday life. Seen together, they cannot help but embody successful upward mobility. They plunge us back into those years of prosperity, the postwar golden age when everything seemed possible." **Sylvie Meunier and Patrick Tournebœuf**

Eileen and gary

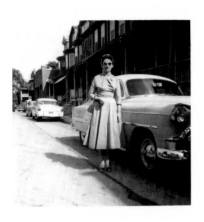 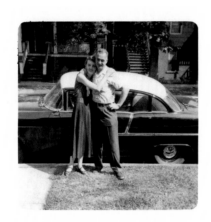 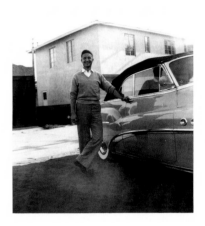

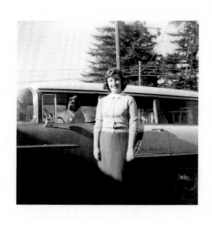 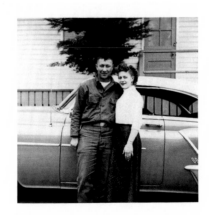 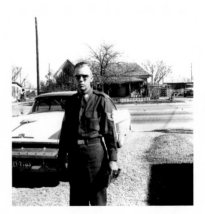

Sylvie Meunier and Patrick Tournebœuf *American Dream* series, 2017

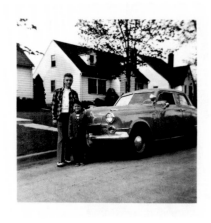
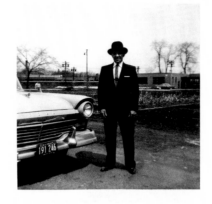
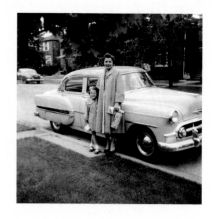
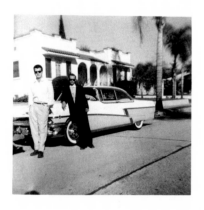
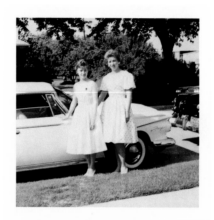
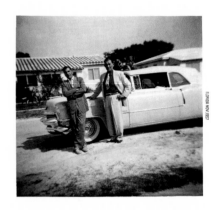
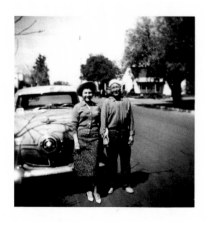
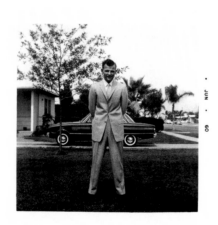
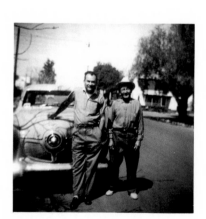

Sylvie Meunier and Patrick Tournebœuf *American Dream* series, 2017

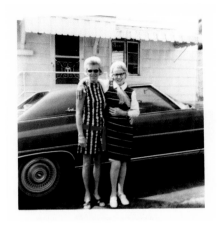 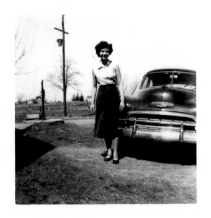 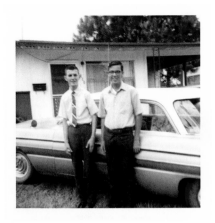

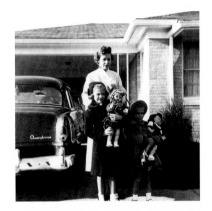 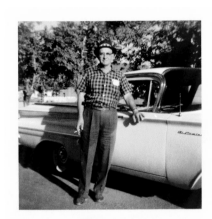 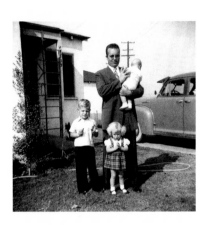

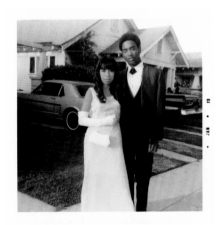 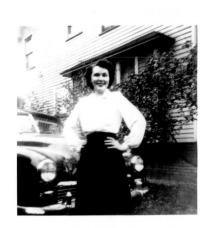 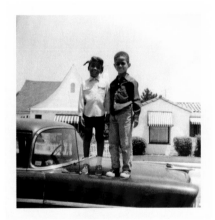

Jean Depara *Femme sur le capot d'une Cadillac Zéphyr*, 1970

64 **Malick Sidibé** *Une déesse sur DS*, 1974

Malick Sidibé *Taximan avec voiture*, 1970

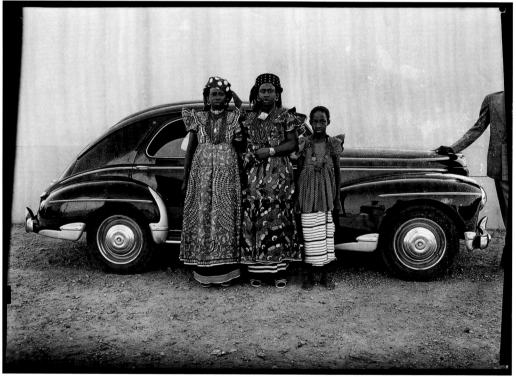

Seydou Keïta *Untitled*, 1952–55 — *Untitled*, 1952–55

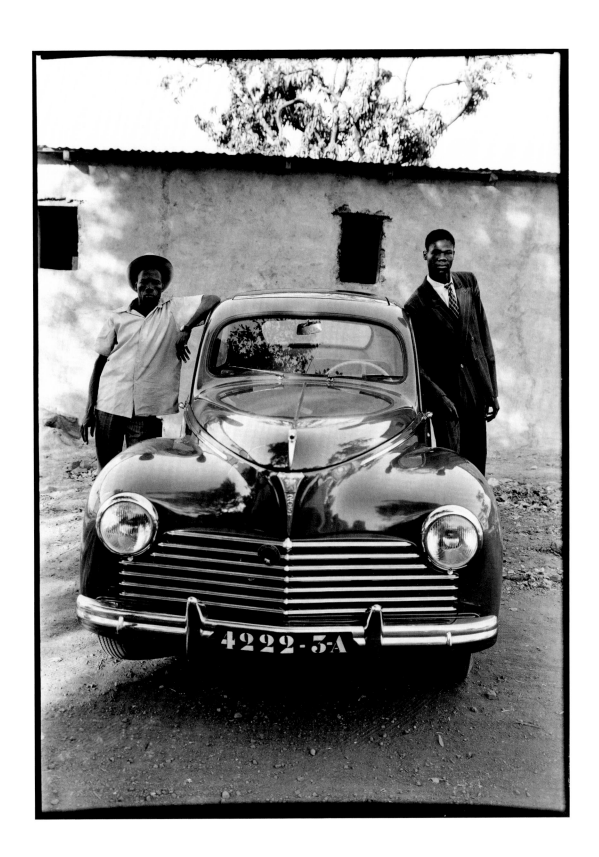

Seydou Keïta *Untitled*, 1952–55

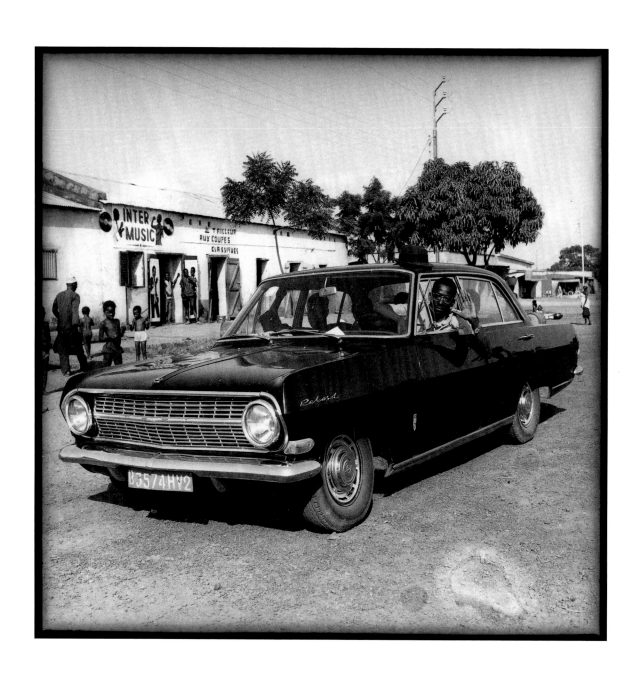

Sory Sanlé *La Balade en ville*, 1970–80

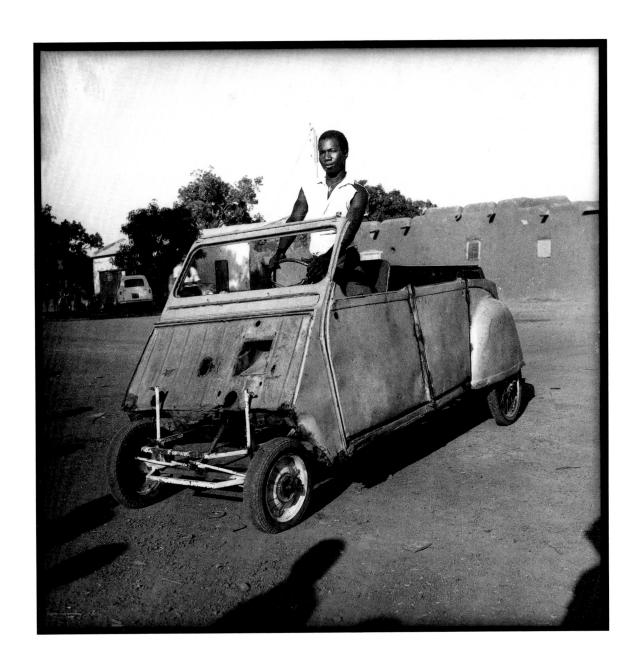

Sory Sanlé *« Deux Chevaux »* *bricolée,* 1970–80

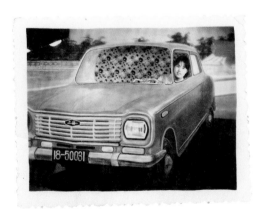

Studio portraits, China, c. 1950, collected by Thomas Sauvin

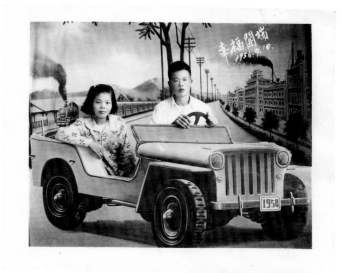

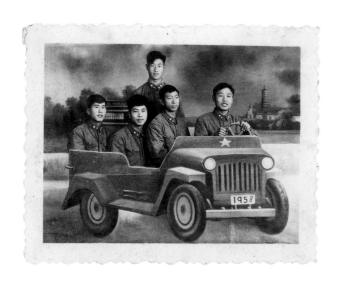

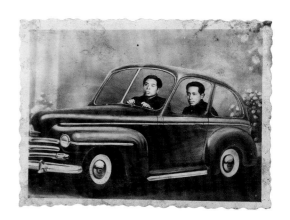

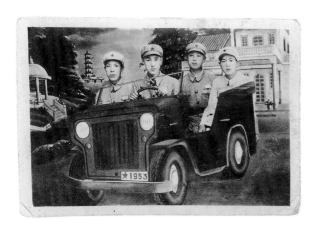

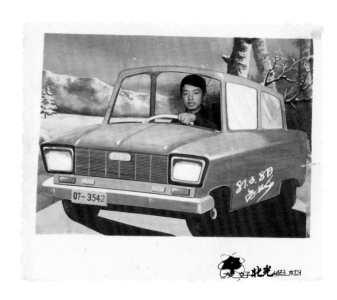

Studio portraits, China, c. 1950, collected by Thomas Sauvin

中華 美術攝影

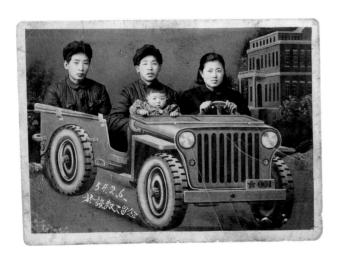

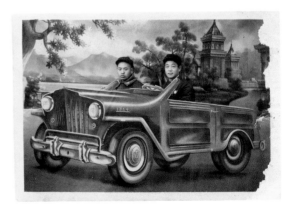

Edward Quinn *Françoise Sagan in a Jaguar XK120 at a dealer's showroom in Cannes*, 1954

Edward Quinn *Jane Fonda and Alain Delon in a Ferrari 250 GT SWB Spyder California, on the set of "Joy House," Antibes*, 1964

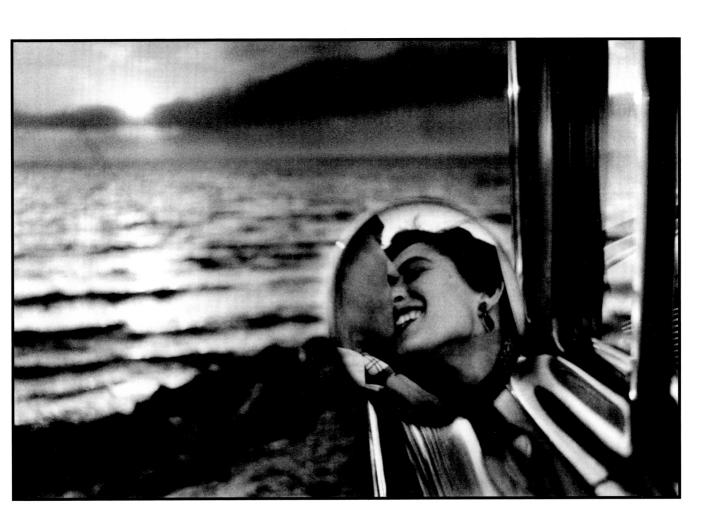

Elliott Erwitt *California, USA*, 1955

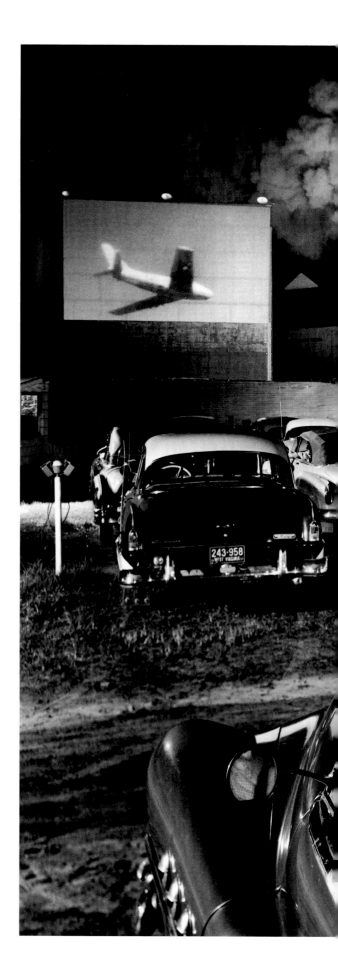

O. Winston Link *Hot Shot Eastbound*, 1956

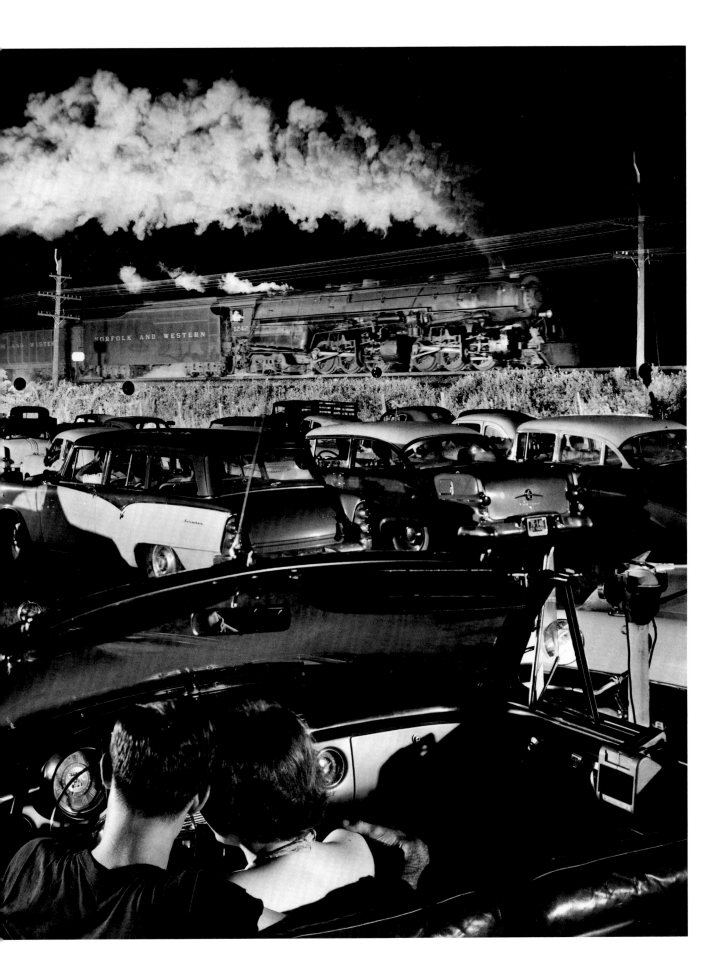

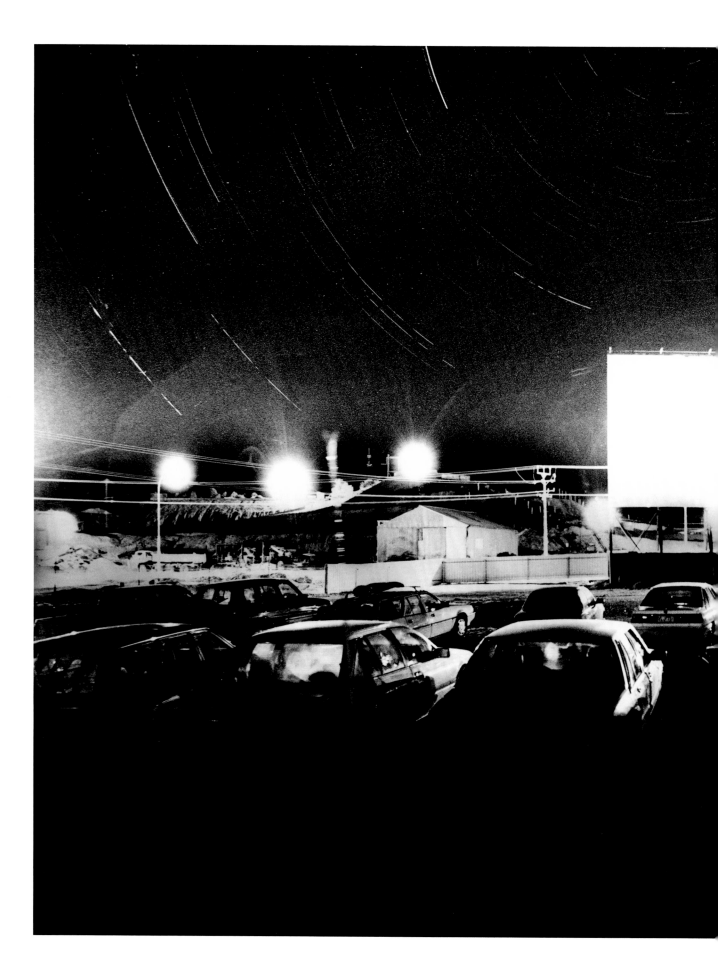

Trent Parke
Coober Pedy, South Australia, 2003

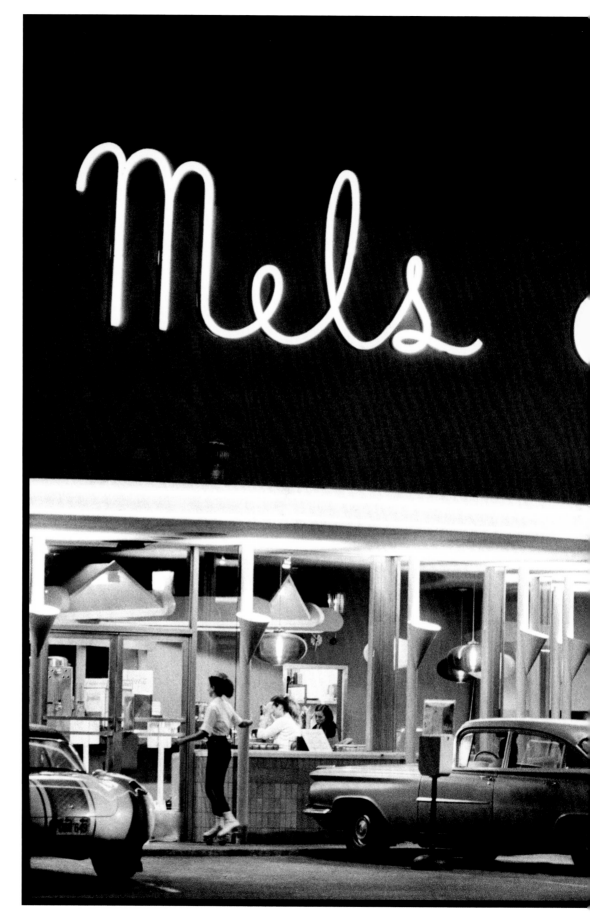

Dennis Stock
On the Set of "American Graffiti," Filmed in and Around the Bay Area, California, 1972

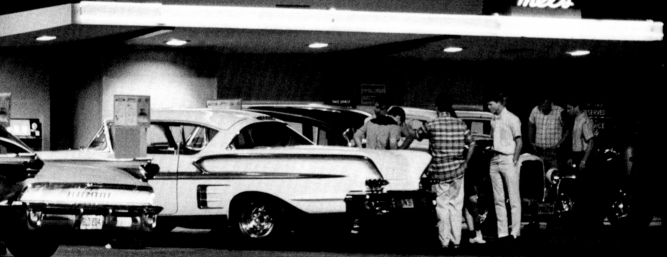

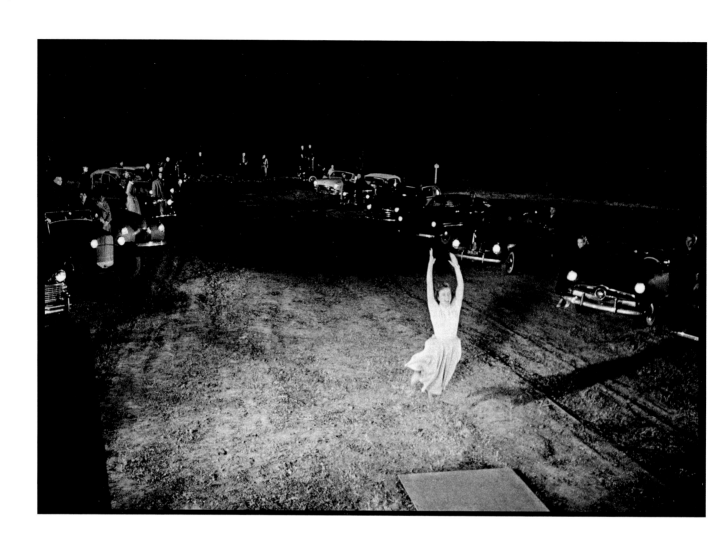

Dennis Stock *James Dean, the Race Car Scene in "Rebel Without a Cause," 1955*

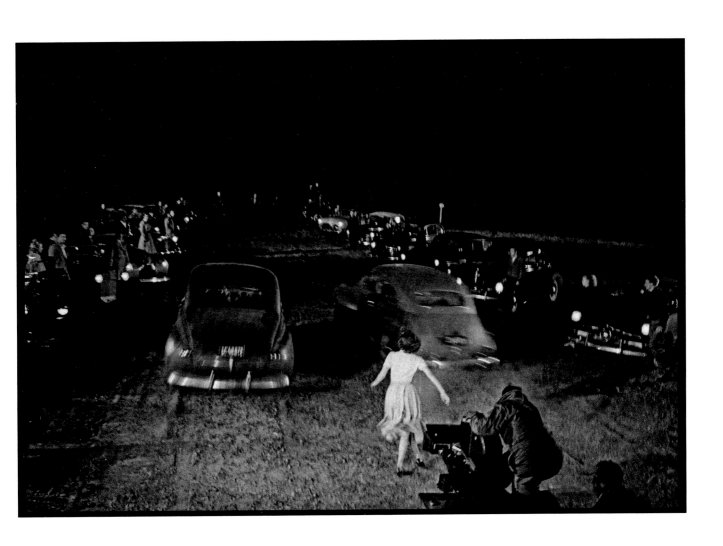

Dennis Stock *James Dean, the Race Car Scene in "Rebel Without a Cause,"* 1955

Dennis Stock *Montgomery Clift, Shooting of "The Misfits," Nevada*, 1960

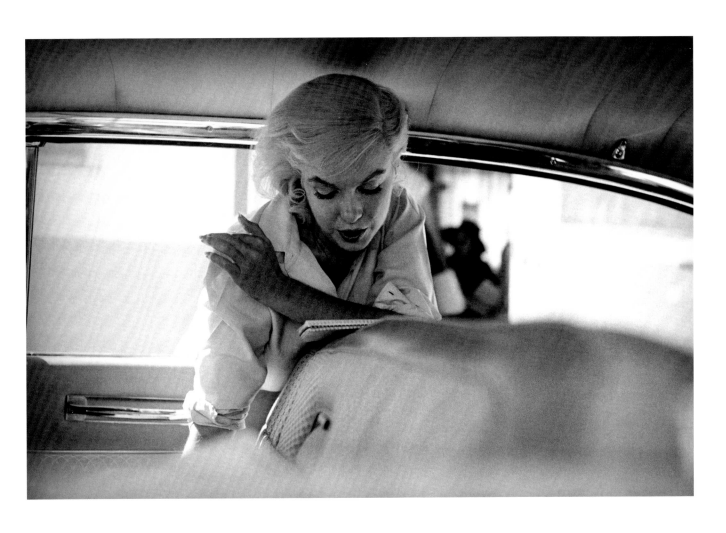

Eve Arnold *Marilyn Monroe in Her Car Studying Lines for "The Misfits," Nevada, 1960*

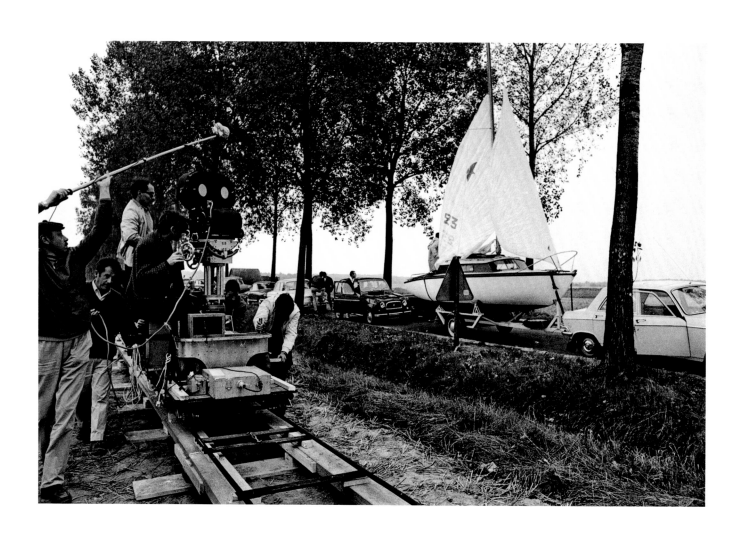

Gilles Caron *Jean-Luc Godard sur le tournage de son film « Week-end », 1967*

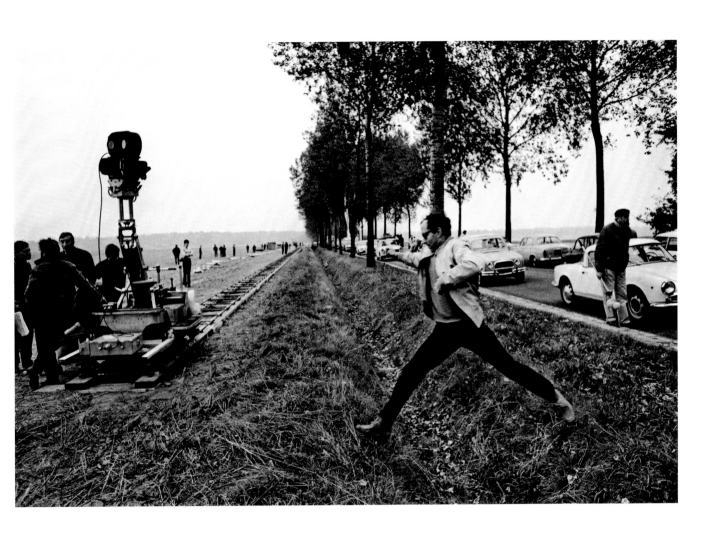

Gilles Caron *Jean-Luc Godard sur le tournage de son film « Week-end »*, 1967

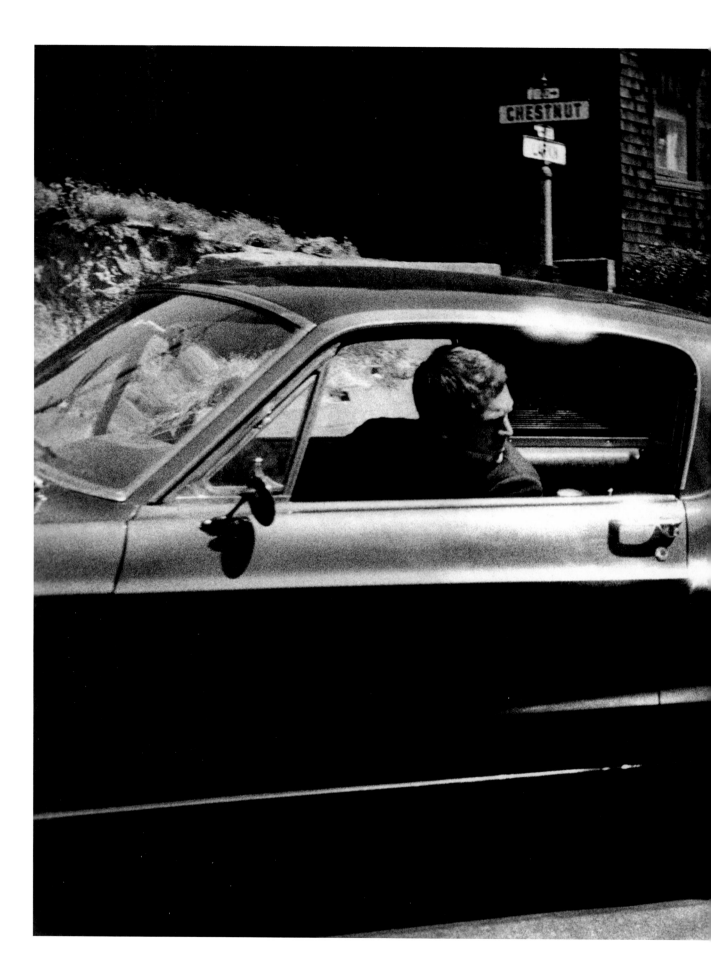

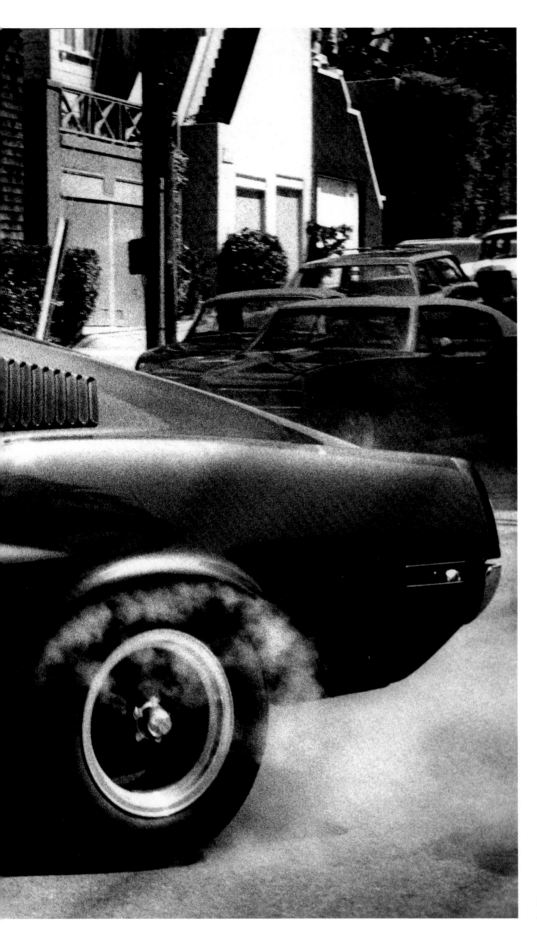

Barry Feinstein
Steve McQueen, "Bullitt," 1968

"I was inspired by the way a car can steal the show. Think of iconic car chases in films—it's often about spectacle, and has little to do with advancing a narrative. And that's the way I think of these cars, as dead-end technologies, but also as high-performance machines which, for their audience, sought to reflect the spirit and attitudes of their time." **Matthew Porter**

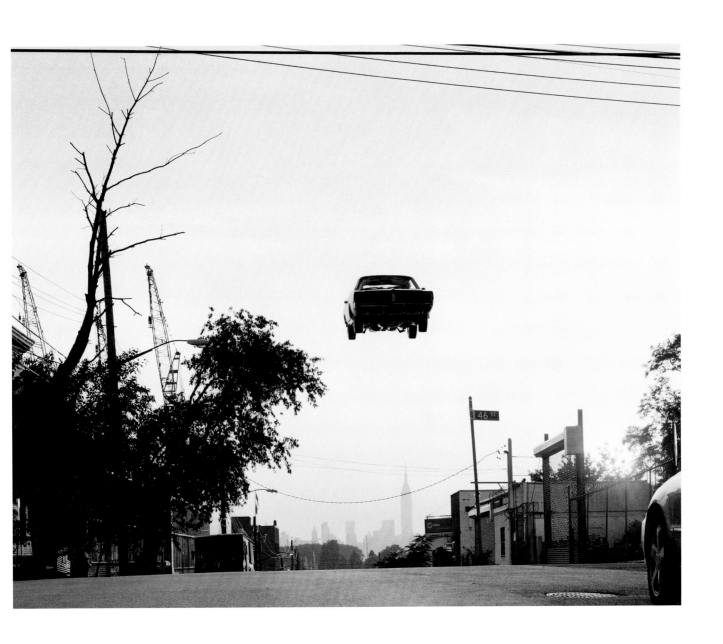

Matthew Porter *Borough Prime*, 2015

Photomobile Landscapes

Marc Desportes

The automobile profoundly transformed the twentieth century in terms of spatial, economic, and social organization. Film photography was the faithful witness of all of these changes. The car generated new photographic themes, such as road infrastructure, the automobile industry, the development of the suburbs, and weekend trips. Moreover, the car influenced photographers' approach to these themes and places, and subsequently their regard and sensibility, acquiring over time the role of a medium. This phenomenon began to emerge around 1900 on French roads—one of the cradles of the car—and in the hectic metropoles of the 1920s, from New York to Berlin.

Parallel Histories

Both the car and the modern camera made their appearance during the Second Industrial Revolution, a revolution not of steel and steam but of electricity and gasoline. Both underwent significant technical improvements during the 1890s. Combining a chassis and an independent engine, the car benefitted from numerous improvements before the outbreak of the First World War, particularly enhancements to its engine (combustion engine) and its various components (brakes, shock absorbers, etc.). The modern-day camera, on the other hand, saw improvements to the body, lens, shutter, photosensitive solutions, and film, which meant it was now possible to leave behind the cumbersome chamber models in favor of more lightweight varieties. In addition, the photographer no longer had to carry fragile glass plates, flasks of chemical solutions, and mixing bowls.[1]

Automobile advancements resulted in a drastic increase in speed. In France, from the mid-1890s onwards, the first real car races were held, and these were testing grounds for cars that were still in the experimental stages. For example, in the Paris–Rouen car race of 1894, cars traveled at 20 km/h. At the beginning of the 1900s, speeds of over 100 km/h were being reached. As for photography, another type of speed was sought: shutter speed, which relied on

Marc Desportes is urbanist.

1. For a history of photographic techniques, see for example the historic overviews by Naomi Rosenblum in *A World History of Photography* (New York: Abbeville Press, [1984] 2008).

the shutter's mechanization. In this respect, Jacques Henri Lartigue's famous photograph *Une Delage au Grand Prix de l'Automobile Club de France de 1912* (p. 312) demonstrates a convergence between the progress made in terms of speed—that of the car (traveling at 110 km/h) and the mechanized shutter (Lartigue used a focal-plane shutter with a shutter speed of 1/10 second).[2]

All this technical progress had a dramatic impact on a social and economic level. Applying Frederick Taylor's principles of scientific management, in 1913 Henry Ford introduced moving assembly lines in his automobile factories. The increase in productivity was enormous: in France in 1908, the production of vehicles was around 25,000; by 1913, it was 45,000, and in the United States, annual production by 1920 was over eight million. In large cities, cars gradually replaced horse-drawn carriages. In Paris for example, by as early as 1910 the number of cars on the roads overtook that of their precursors, and after the war the car became the dominant means of transportation. At the same time, the development of the rotogravure printing process allowed for the reproduction of thousands of copies of the same photograph in illustrated newspapers with a large circulation, a degree of reproduction never before achieved.

In addition to the mass dissemination resulting from industrial production, there also emerged an individualization of practices. There is an important distinction to be made between mass dissemination and multiplicity: the hundreds of automobiles produced in a mechanic's workshop, for example, contrasts with the handful of prints printed at high cost from a collodion negative.[3] As the reliability of cars increased, it was no longer necessary to travel with a driver. A parallel can be drawn between this growing individual mobility and the individualization of photography through the use of portable cameras. The camera, which had appeared in the early 1890s, became much more widespread after the First World War, due to technical improvements and the availability of easy-to-use, fixed-lens cameras on the market. The launch of the Leica in 1925 marked a watershed: for the first time, the public had access to a reliable camera with which they could focus, take a picture, and advance the film forward in daylight. This individualization of practices went hand-in-hand with the rise of leisure pursuits amongst a large public. The automobile industry with its mass production contributed to the emergence of a growing appreciation and range of leisure pursuits, of which millions of amateur photographs were taken.

The Traveling Driver-Photographer

One of the first uses of the car was for tourism. The new vehicle appeared as the ideal instrument for this outdoor pursuit. In 1900, the tire manufacturer Michelin published a guidebook for drivers, filled with advice about car maintenance, and listing the services available in the different regions of France.

2. As K. G. Pontus Hultén writes in the exhibition catalog *The Machine: As Seen at the End of the Mechanical Age*, presented at MoMA New York in 1968, this photograph made the speed of a car visible (New York: Museum of Modern Art, 1968).

3. The developing techniques of negatives in the 1850s allowed for several prints to be reproduced but did not yet allow for a profitable reproducibility of the positive print, as underlined by André Rouillé in his distinction between the positive and negative cycles in "L'Essor de la photographie (1851-1870)," in *Histoire de la photographie*, eds. Jean-Claude Lemagny and André Rouillé (Paris: Larousse, 1998).

In the following year's edition, Michelin listed "picturesque routes," asking readers to inform them of "interesting roads and dull roads." Driving through various places and regions on old roads, tourists rediscovered the countryside, having up until then traveled by train on railroads meeting technical and economic imperatives. "The charm of the automobile is to go everywhere, to stop when you want, leave when you like. There is a great sense of pleasure in visiting remote country villages, admiring picturesque sites, traveling at speed along all roads, and seeing the most varied of places," wrote a journalist in *La Vie automobile* in 1907. "The road, with its countless and varied incidents, the sensation of infinite space, and the magnificent landscapes make automobile tourism so pleasant," noted one of his colleagues.[4]

Country roads, unsuited to cars, had to undergo many improvements however. The mud, dust, bumps, subsidence (due to the weight of the vehicle), lack of tire traction, sharp bends, absence of warning signs, and road signals were corrected by resurfacing (using asphalt), straightening sharp bends, removing obstacles, and improving signalization.

The more picturesque roads offered drivers hills and slopes, curves and bends, a variety of vistas and landscapes, and unexpected panoramic views. However, it should be noted that the experience of country driving had its limitations: excessive speed and repeated breakdowns, a flat landscape and straight, tarred roads, and the experience became something else, no longer providing the pleasures so eagerly anticipated. On such roads, driving became simply a mechanical progression towards a continually receding horizon, punctuated by line after line of trees. Several photographs from the 1920s bear witness to such an experience, and allow the movement of the vehicle to be seen by creating a kind of blurriness, such as *1/100 de seconde à 70 km/h* by Anton Stankowski (1930). If the photograph was perfectly sharp, the movement ceased to be seen, as photographers from the nineteenth century had witnessed with their shots of moving trains that appear immobile.[5]

At the beginning of the twentieth century, the practice of automobile tourism converged with the practice of amateur photography. The amateur photographer now had at his or her disposal small fixed-lens cameras and manuals, such as the *Manuel du touriste photographe* by Léon Vidal, published in 1885.[6] In France, from the 1880s onwards, photography excursions were organized by the Société d'excursions des amateurs de photographie (SEAP).[7] According to Léon Auscher, one of the most active members of the Touring Club de France, the true tourist "sometimes stops his or her car with no other motive than to admire a beautiful landscape, to walk for a short spell in the shade of a forest, or to photograph an interesting landmark along the way."[8] Hence the numerous photographs taken by tourists at this time: portraits in situ,

4. For these quotations, I invite you to look at my work *Paysages en mouvement. Transports et perception de l'espace, XVIIIe-XXe siècle* (Paris: Gallimard, 2005), pp. 231 and 234.

5. See André Gunthert, "Esthétique de l'occasion. Naissance de la photographie instantanée comme genre," in *Études photographiques*, 9 (May 2001), p. 80.

6. Léon Vidal, *Manuel du touriste photographe* (Paris: Gauthier-Villars, 1885).

7. See *La République des amateurs. Les amateurs photographes autour de 1900 dans les collections de la Société française de photographie* (Paris: Jeu de Paume, 2011).

8. Léon Auscher, *Le Tourisme en automobile* (Paris: Dunod, 1904).

figures standing against the backdrop of panoramic vistas, and landscapes. But what landscapes were these? Undoubtedly, the gaze of driver-photographers on the natural setting had been influenced by painted landscapes. But their approach to a site was completely different to that of a painter. It was an easier approach that compromised the isolation of a place and the distance that protected its identity or authenticity. While photography reproduced tourist sites through an infinite number of images, the automobile increased the number of such sites by facilitating access to them. The result was a loss of the aura, to use the concept developed by Walter Benjamin. The landscape of the automobile relied on a certain immediacy with these places that the new vehicle allowed drivers to access so freely. The landscape became a dynamic, changing entity, born from the convergence of the site and the act of driving, a landscape woven from unexpected relationships between the driver of the car and those places whose aura would be irreparably tarnished.

Through its interposition in the discovery and perception of the landscape, the automobile appears as a medium: the windscreen frames the site traveled through in a continuous movement dictated by the road. It is perhaps in an effort to point out the originality of this new window open to the world that many photographers have included the frame of the windscreen and car doors in their compositions, making the automobile a kind of mobile *camera obscura*.

Photography and the New Urban Space
If driving in the countryside proved difficult, it was equally so in the city. The increased use of cars in the urban environment resulted in problems such as pollution, traffic jams, a lack of safety, and occasionally, mortal accidents. Solutions were found: the use of road signals, speed limits, the building of zebra crossings and pedestrian islands in the middle of roads, one-way streets, and traffic circles (the first was built in New York in 1905). Made possible through the widespread use of electricity, the first trials for electric traffic signals took place in Cleveland in 1914. After the First World War, these replaced the brightly colored and easily recognizable, manually operated signals in cities like New York, Paris, and Berlin. In order to facilitate the flow of traffic, interchanges were built, as for example in Paris during renovation work on the boulevards des Maréchaux in the 1930s. In 1935, a cloverleaf interchange —the forefather of today's complex multiple interchange—was constructed in the center of Stockholm.

The urban experience was inevitably marked by the proliferation of the automobile. One impact was speed: cars now drove at speeds that had never been reached before, all over the city, and not just on its main thoroughfares. The evolution of road signals also had a substantial impact. Their presence meant that everyone, drivers and pedestrians alike, were forced to pay attention at all

times, in all locations, transforming people's ordinary vision of the city. The interaction between drivers, policemen, and pedestrians were based on clear, simple gestures, devoid of all ambiguity. This experience of the city connected to the automobile seeped into the experience of the city in general: the mass of information, the necessity to remain alert at all times, the multiplicity of interactions and the ever-present risk of accidents resulted in a permanent feeling of tension, baptized "stress" by American psychologists in the 1920s. City dwellers had become fragile beings, and their sensibility, once based on continuity and regularity, was no longer appropriate.

The new changes reflected the modern aesthetic: smooth lines, continuous, mechanical. The uneven paving stones, the flickering light from gas lamps, and large squares plunged into darkness were now rare. Photographs of Paris by night taken by Brassaï in the early 1930s held a certain air of nostalgia (p. 136). Modern cinema, which began to develop from the 1920s onwards, taking advantage of the latest technical innovations such as the shot as a filmic unity, montage, and the traveling shot, proved to be a wonderfully appropriate means of bearing witness to the exploration of the urban environment through the windscreen of a car. As can be seen in certain films from that period, the cinematic representation of the city was translated by a framed, controlled gaze, resulting in a succession of partial and sometimes chaotic views.

By generating only fixed images, photography could not offer the possibility of the equivalent of the vision or view from a car. However, the medium proved to be a remarkably powerful means of recording the characteristics of the new urban experience to which the car had contributed: the density of the crowd and the traffic, the orderly flow of cars, the continual sense of change, the importance of traffic signals, the lack of communication between individuals, withdrawal into the self, etc. Much of this may be seen in the photographs taken by Walker Evans on the streets of New York in the 1970s (p. 146). Photography also gave substance to the ephemeral or the fleeting: flashes of light, reflections—whether these were reflections in shop windows, windscreens, or car door windows, or the partial views that inserted themselves into one's line of vision, such as the reflections in a rearview mirror. Photography proved to be a formidably efficient means of reflecting the changing urban environment. According to Christopher Phillips: "At the beginning of the 1920s, there was a sudden realization that photography embodied the same principles—economy, precision, objectivity, standardization, and reproducibility—that presided over the emergence of a technological universe." Photography, he writes, "appears as the medium allowing for the understanding of a new metropolitan reality, of an urban milieu on a colossal scale, with a swarm of activity, and where the frenetic pace seems the polar opposite to modes of traditional comprehension."[9] Photographers took urban development

9. Christopher Phillips, "La Photographie des années 1920. L'exploration d'un nouvel espace urbain," in *Les Années 20. L'âge des métropoles* (Paris: Musée des Beaux-Arts de Montréal/Gallimard, 1991), p. 213.

as their subject, sometimes using extreme angles of depth or counter-depth, as László Moholy-Nagy had recommended in a 1925 essay on photography.[10] In 1926, following a trip to the United States, the German architect Erich Mendelsohn published a book of photographs entitled *Amerika*,[11] a remarkable illustration of the way in which photography could serve as an instrument for exploring and understanding the new urban environment. From that point onwards and throughout the twentieth century, photography remained a privileged instrument used to shed light on urban reality, particularly by American urban planners who examined various aspects of urbanization, linked to the growing use of the car over the course of the 1960s.

Today, photography must be linked to the digital image, that is, the fixed or animated image produced, broadcast, and recorded by an ensemble of technologies, ranging from the encoding of information via bits to the technology of LCD screens, as well as Internet networks. Within such a perspective, the relationship between the automobile and photography needs to be reevaluated. Whether used for GPS or driver-assistance systems, the digital image has overwhelmed our spatial awareness and the very action of driving a car. On the basis of these innovations, a new car that "drives itself" has been developed, making the steering wheel and the map relics of a distant past. The concept of digital automobility is now emerging, and is very much in the early stages. The digital image is thus revealed in all its ambivalence. On the one hand, this programmed, modified image, optimized by software, refers to a reality that is increasingly virtual. It therefore loses the informative value of film photography, that is, its value as evidence, reference, witness, and footnote to reality. On the other hand, the digital image aids us in driving, even replaces us, intervening in our relationship to a concrete reality: that of the road or the street, and all their potential dangers. Therein lies a fundamental ambivalence, prompting us to question ourselves about the reality we are given to experience.

Translated from the French by Emma Lingwood

10. László Moholy-Nagy, *Painting, Photography, Film* (Cambridge, MA: MIT Press, 1969).

11. Erich Mendelsohn, *Amerika. Livre d'images d'un architecte* (Paris: Éditions du Demi-Cercle, 1992).

"To understand the complexity of the vast territory that is the United States, I got used to being able to visually differentiate the landscape as either surfaces of containment or pathways. This undoubtedly helps me with the composition of the images in my viewfinder. Containment surfaces are places specifically destined for receiving this or that object, a building, a car park, a reservoir, etc. As for pathways, they are the visible marks of movement, roads but also canals, as well as the many other lines that crisscross the landscape, particularly pipelines, train tracks, and high-tension lines. Containment surfaces and pathways make up the network of infrastructures I have been flying over for nearly thirty-five years, and which always offer me new surprises and perspectives every time I fly. One constant, however, has been the continual growth of the road networks. Our society is based on the idea of 'auto-mobility' and we rely, ever-increasingly, on the automobile." **Alex MacLean**

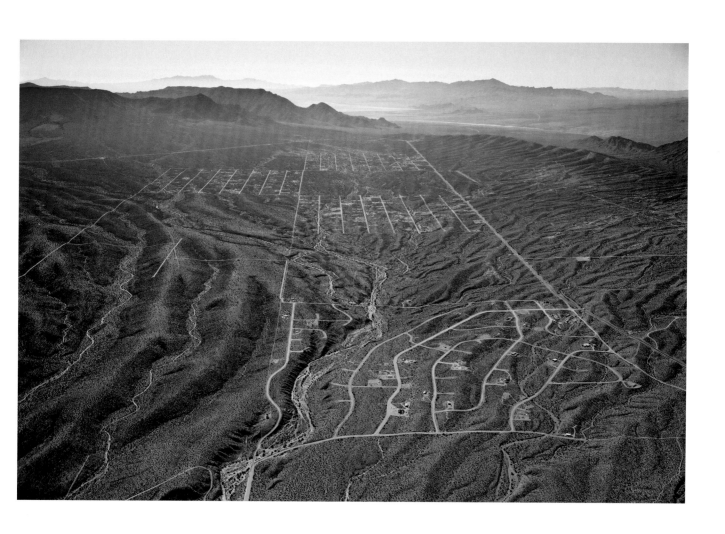

Alex MacLean *Desert Overlay, Meadview, Kingman North, Arizona, USA*, 2009

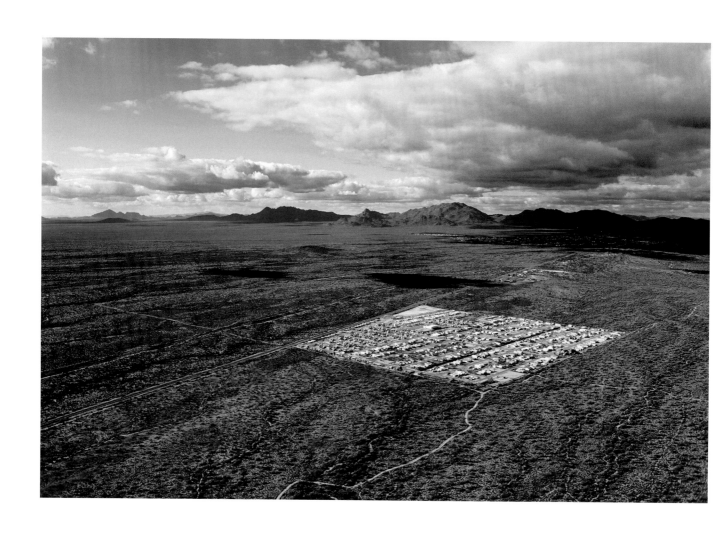

Alex MacLean *Housing Patch on Desert Floor, Escapees North Ranch, Congress, Arizona, USA*, 2005

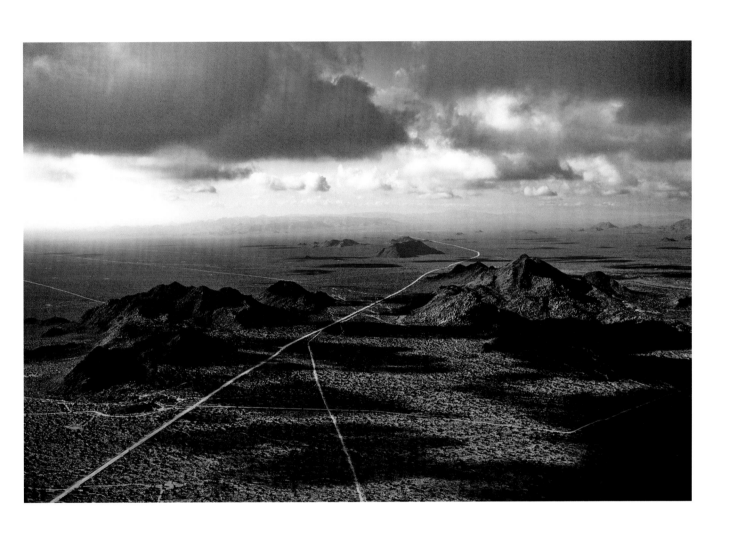

Alex MacLean *Desert Roads and Scattered Hills, County Road 15, Mohave County, Arizona, USA*, 2005

"All the pictures were made in Colorado, along the eastern edge of the Rockies, a geography where our sense of stewardship has nearly collapsed. A landscape where, for example, we're building new suburbs that depend on aquifers, which will be exhausted within one human lifetime." **Robert Adams**

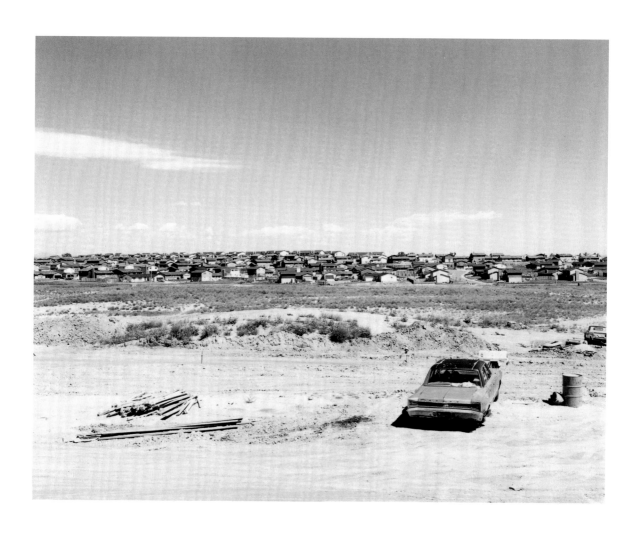

Robert Adams *North Denver, Colorado,* c. 1973

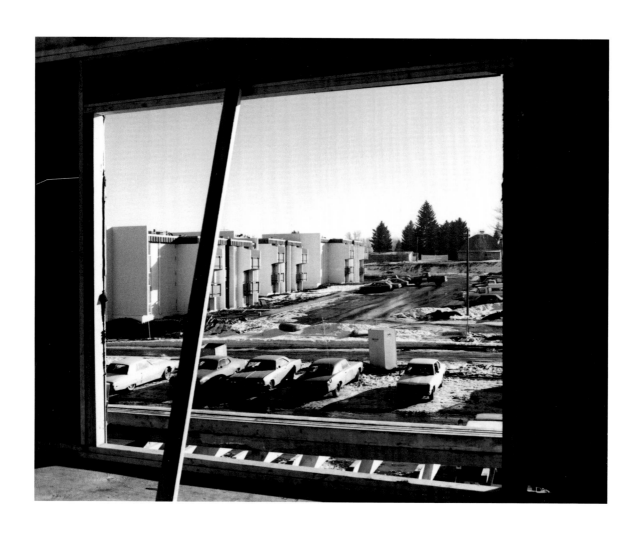

Robert Adams *Colorado, c. 1973*

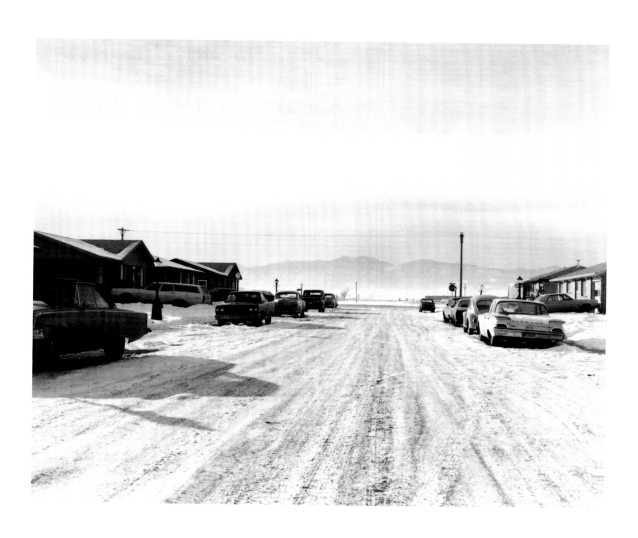

Robert Adams *Longmont, Colorado,* c. 1973

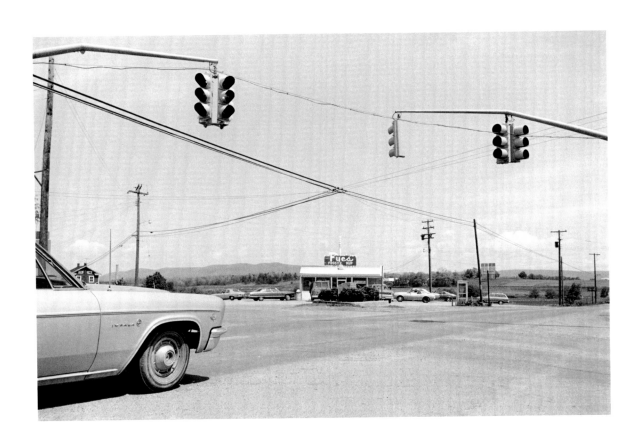

Henry Wessel *Pennsylvania*, 1968

Henry Wessel *Southwest*, 1982

"These images of gasoline stations illustrate a whole kind of photographic culture. It is a signifier for the aesthetics of the mundane and of non-places. But these images are also an explicit nod to Ed Ruscha. When I found them, I found Ruscha." **Luciano Rigolini**

Luciano Rigolini *Pure*, 2013

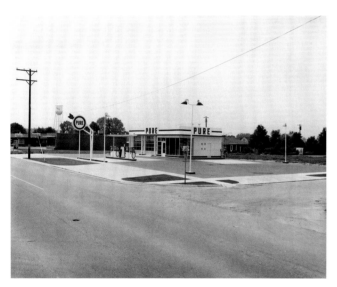

Luciano Rigolini *Pure*, 2013

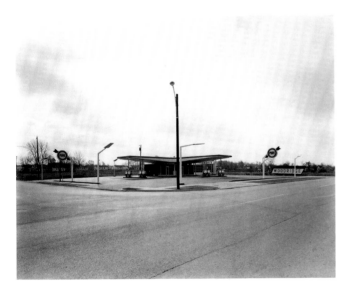
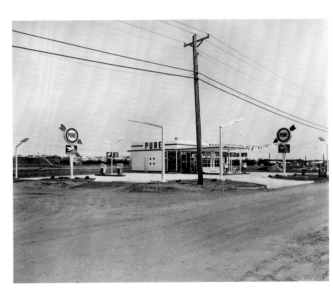

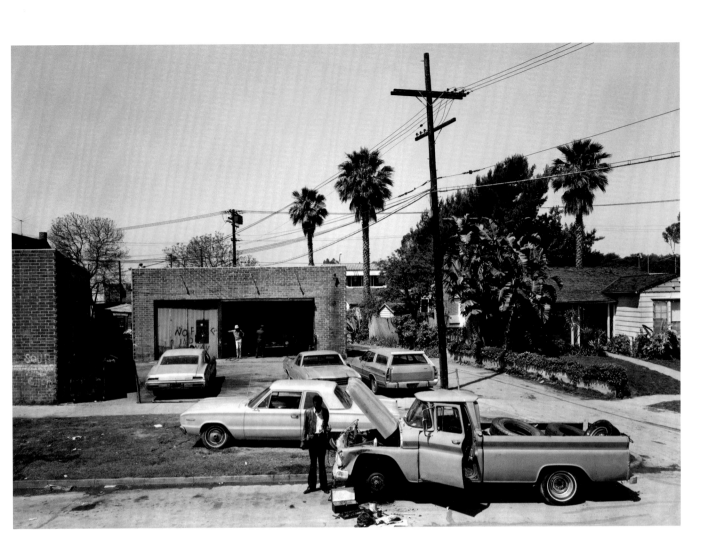

Anthony Hernandez *Pico blvd. & Cochran ave. Automotive Landscapes* series, 1978

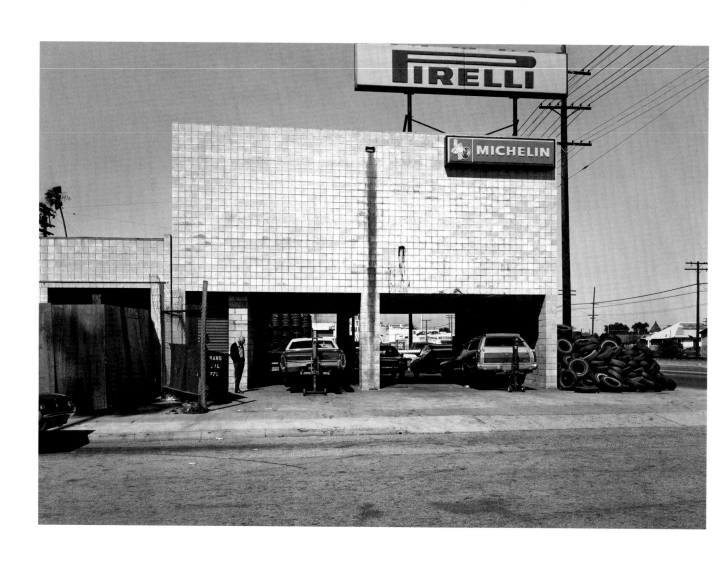

Anthony Hernandez *Denver ave. & Slauson blvd. Looking West. Automotive Landscapes series, 1978*

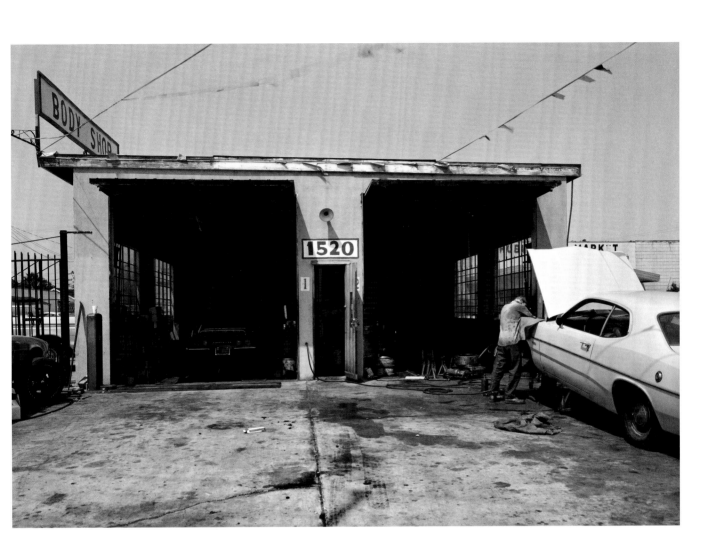

Anthony Hernandez *1520 Adams rd. & Juliet st. Automotive Landscapes* series, 1979

"It has been quite some time since the word 'landscape' ceased to be associated with pristine wilderness—especially in Central Europe.
The basic conflict between nature and civilization is no longer primarily present. Only as a user of the new traffic routes did I become aware of the changes in the perception of the landscape. And only as a seemingly uninvolved observer was it possible to connect the ambivalent fascination of these structures of accelerated progress to the motifs referencing a romantic idea of nature." **Hans-Christian Schink**

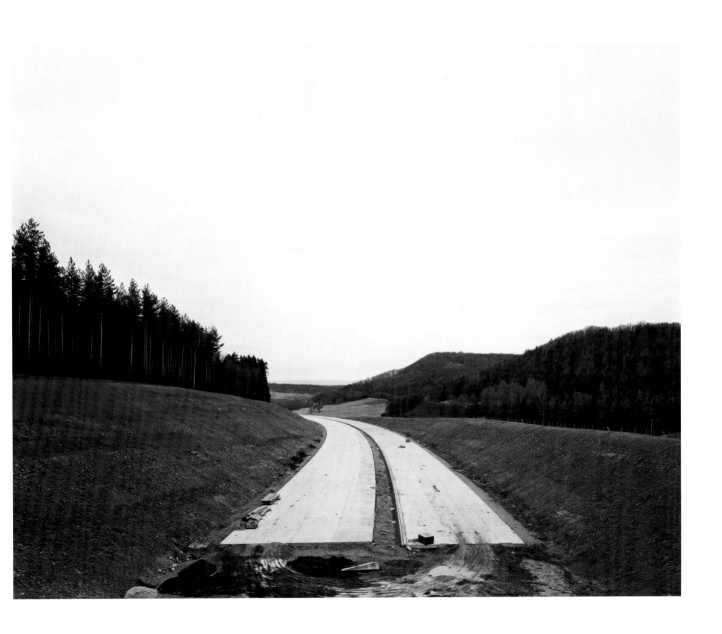

Hans-Christian Schink *A 71, bei Traßdorf. Verkehrsprojekte Deutsche Einheit* series, 1999

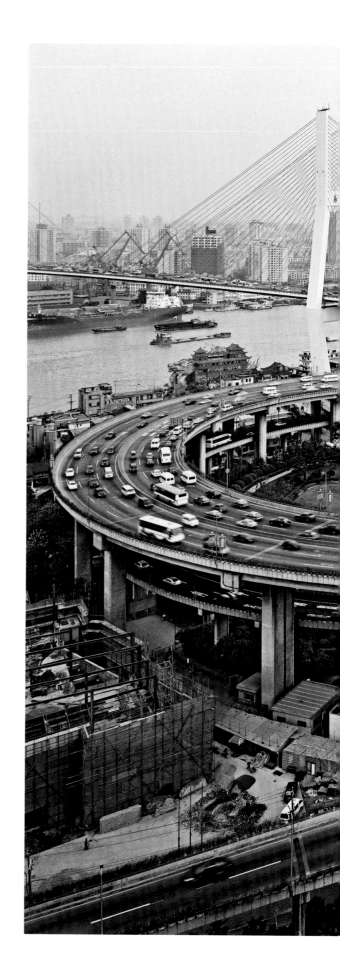

Edward Burtynsky
Nanpu Bridge Interchange, Shanghai, China, 2004

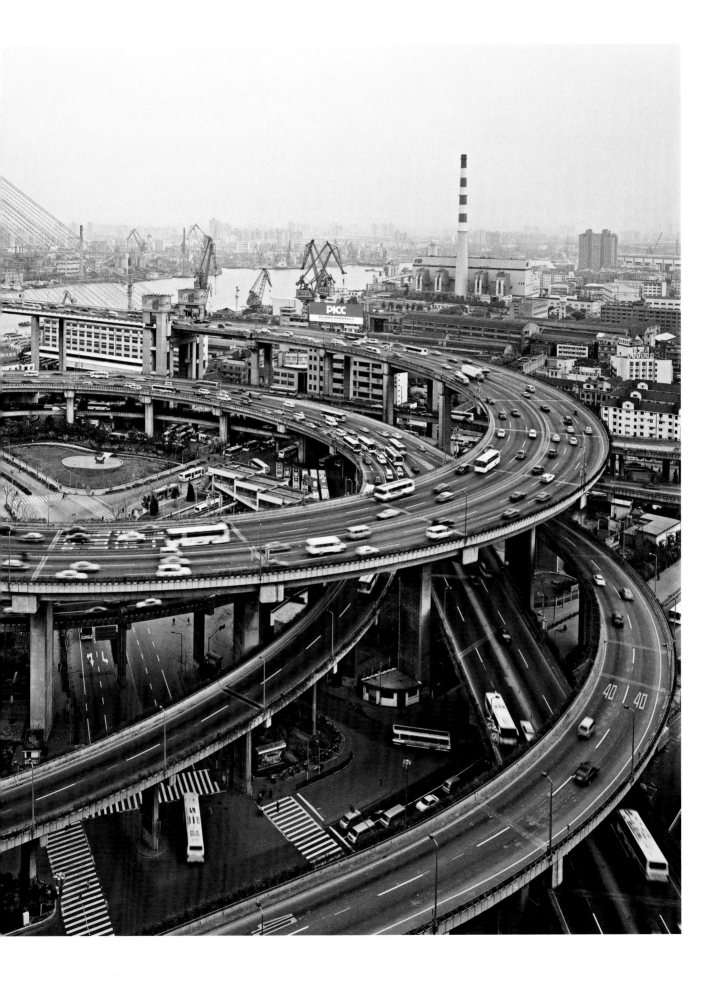

"As far as the *Freeway* series goes, I was looking at people like Maxime Du Camp, and his panoramic photographs of the Egyptian pyramids from the early 1850s. Those who photographed the American West at that time never used that panoramic format. Most of them were doing 11 × 14 or 8 × 10 images, hauling those huge cameras around the West, and hand coating their glass plates. I was thinking, too, of all those historical banquet photographs —those big long panoramas of groups of people—and sometimes panoramic shots were used for landscapes." **Catherine Opie**

Catherine Opie *Untitled #23 — Untitled #26 — Untitled #36 — Untitled #38. Freeway* series, 1994

"Between the Alps and Naples, motorways negotiate complex topographies and urban conditions, often retracing the routes taken by Northern Romantics on the Grand Tour, who journeyed South to experience for themselves the Arcadian and later sublime landscapes painted by De Loutherbourg, Claude Lorrain, and Turner. Where once these landscapes took days to cross we now speed through them via motorways elevated on concrete pilotis, and the galleries and tunnels that have taken the place of Alpine passes. For those on the Grand Tour, confronting the sublimity of an untamed nature became an aesthetic highlight of the journey. But with speed and concrete came a new, accelerated sublime." **Sue Barr**

Sue Barr *Via Olga Silvestri, Naples, Italy. The Architecture of Transit* series, 2014

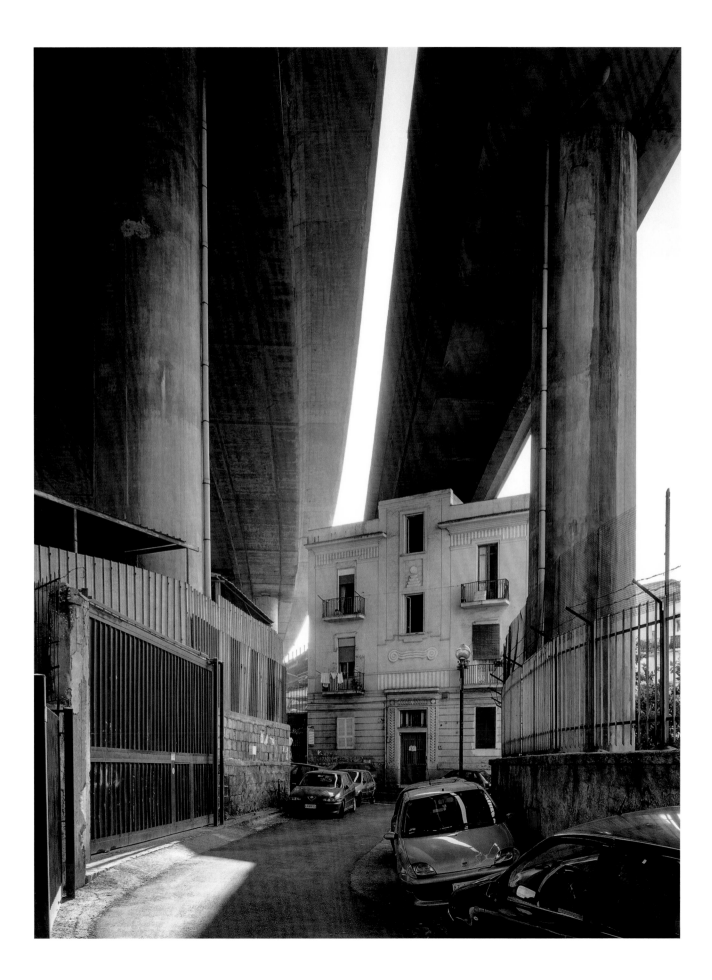

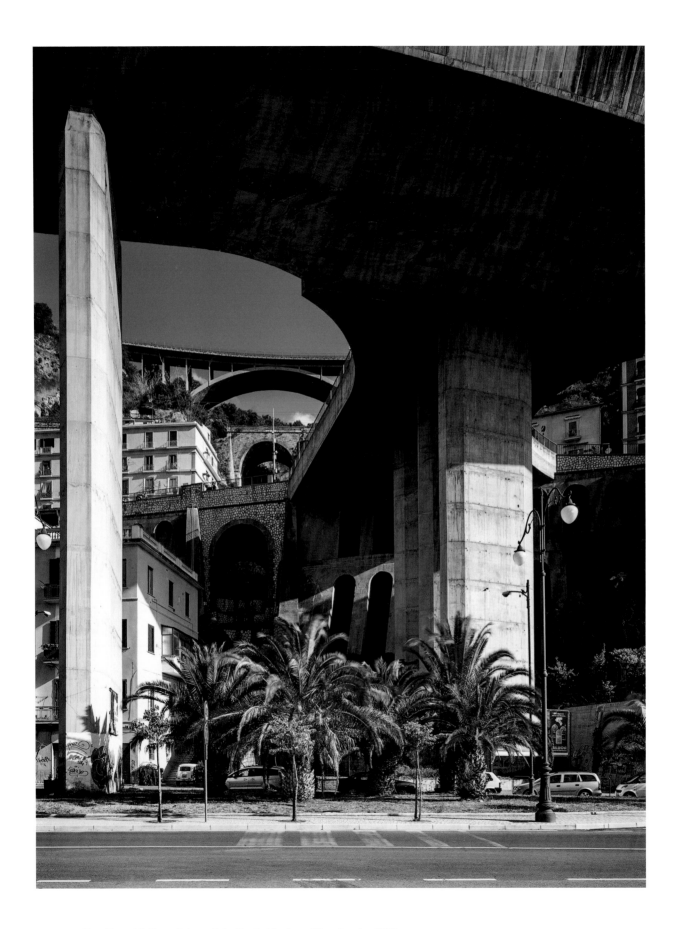

Sue Barr *Via Ligea, Salerno, Italy. The Architecture of Transit series, 2014*

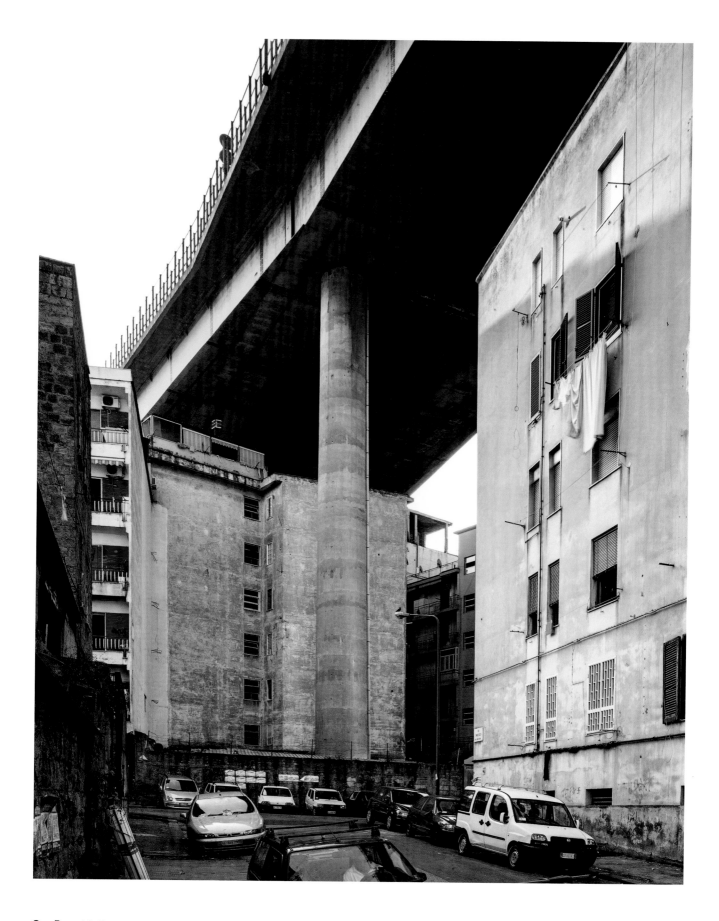

Sue Barr *Via Tommaso Costa, Naples, Italy. The Architecture of Transit series,* 2014

"Around 1994, we decided to work together on a new project. Since our mutual interest was landscape as a metaphor for the rapid transition of the Netherlands we choose the Dutch highway (*Snelweg*) as our subject. We were very much aware that the Dutch territory, with its small historic town centers and huge

Theo Baart and Cary Markerink *Snelweg – Highways in the Netherlands*, 1995–96

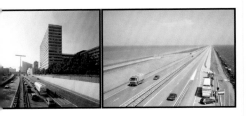

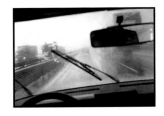
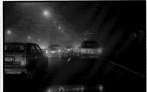

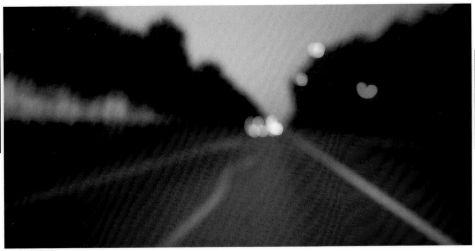

suburbs, could only exist and expand because of the growing mobility and good infrastructure. We decided to look at the connection between these places. We quoted J. B. Jackson who once wrote that 'a road is not only a connection between two places but also a place in its own right.'" **Theo Baart and Cary Markerink**

Seiji Kurata *Toshi no Zokei*, 2008

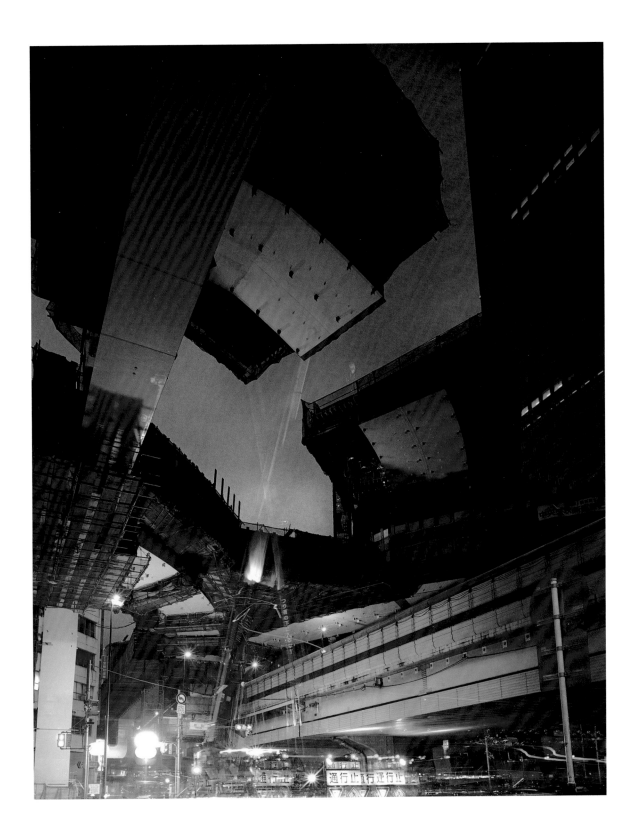

Seiji Kurata *Toshi no Zokei*, 2008

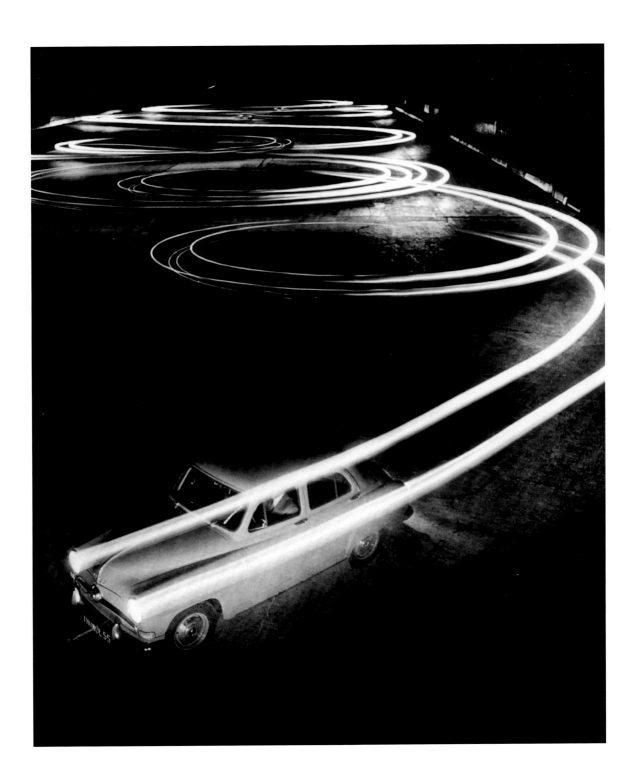

Robert Doisneau *Publicité Aronde, Simca*, 1955

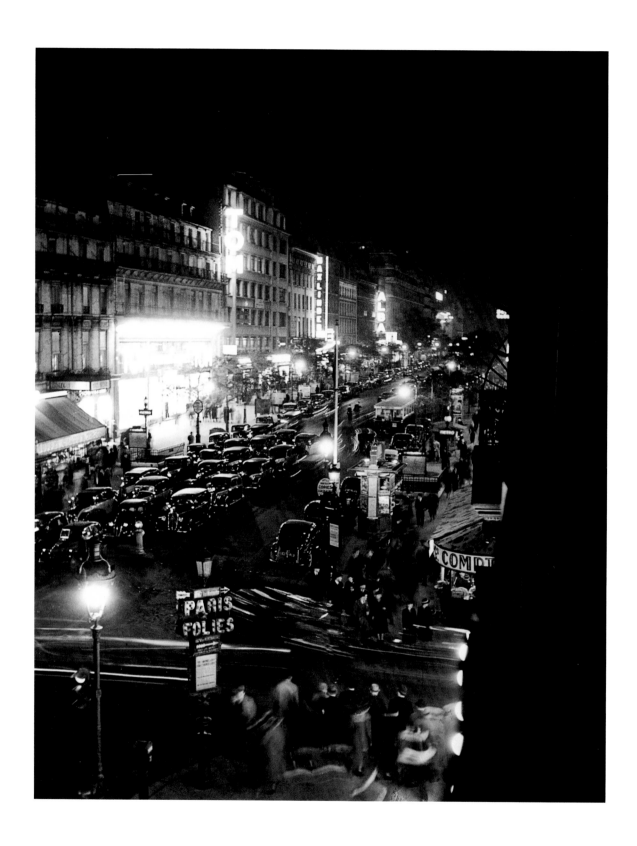

Brassaï *Les Grands Boulevards*, c. 1935

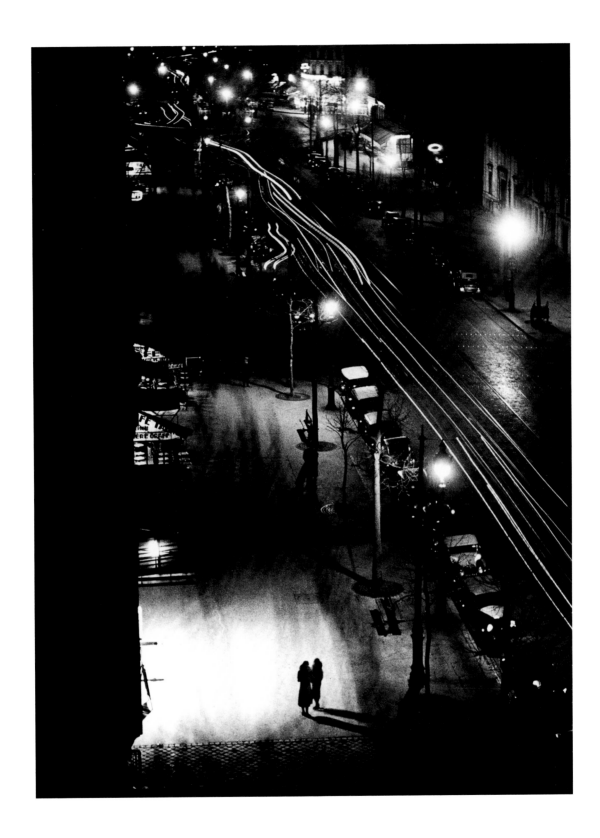

Brassaï *Deux Filles faisant le trottoir, boulevard Montparnasse, c. 1931*

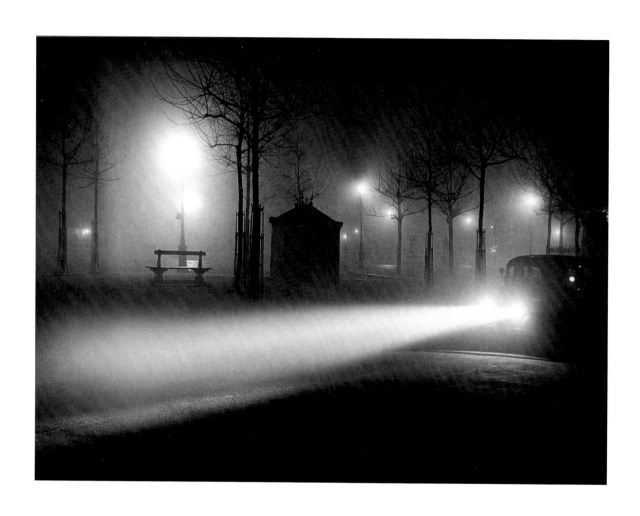

Brassaï *Avenue de l'Observatoire, phares de voiture*, 1934

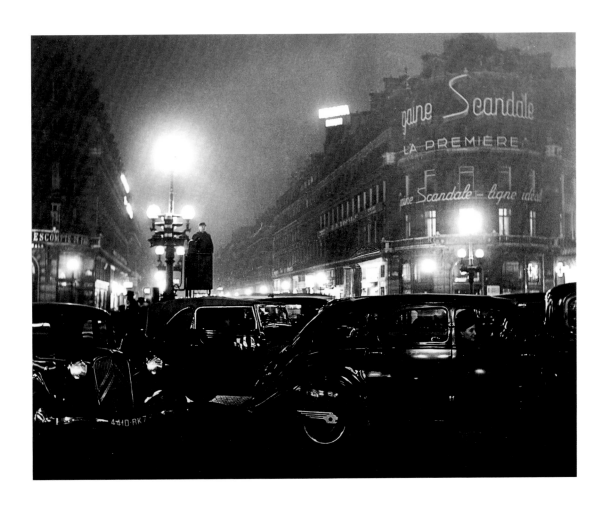

Brassaï *Place de l'Opéra,* c. 1934

"Taking photograph is a trade. An artisan's trade. A trade you learn, that you do well or less well, like any other trade. The photographer is a witness. The witness of his era. The true photographer is the witness of each day's event, a reporter." **Germaine Krull**

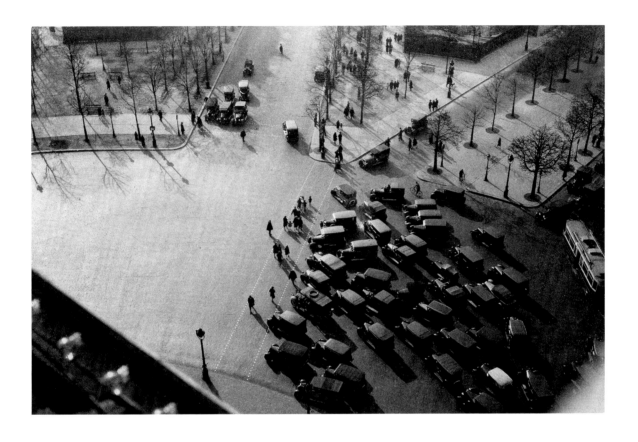

Germaine Krull *Place de l'Étoile, avenue de la Grande-Armée, avenue du Bois-de-Boulogne,* 1926

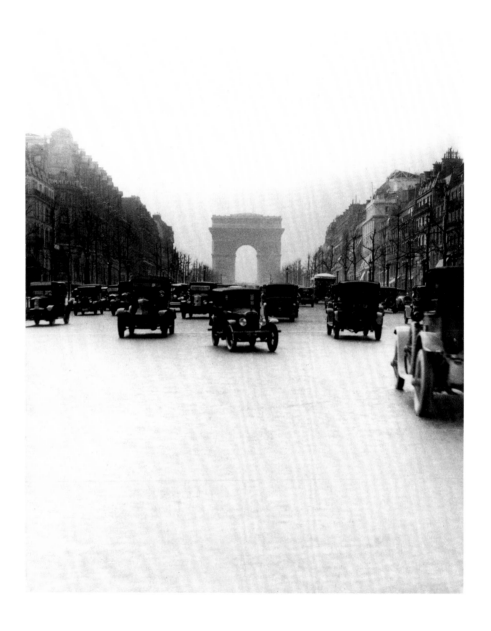

Germaine Krull *Untitled*, undated

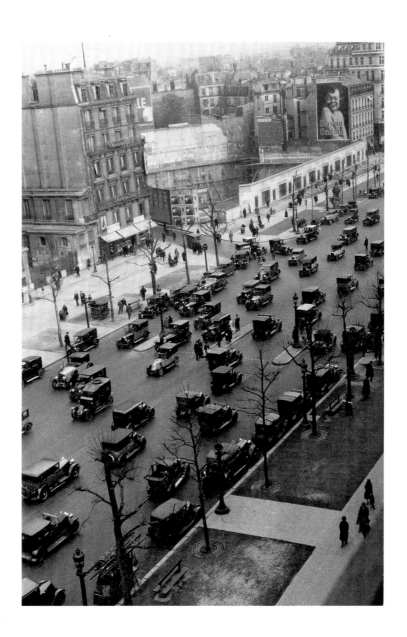

Germaine Krull *Untitled*, undated

Andreas Gursky *Cairo (diptych)*, 1992

Walker Evans *Untitled*, 1973–74

Walker Evans *Untitled*, 1973–74

"Parking lots came about almost by accident. I had an opportunity to go up in a helicopter above LA. I went with a friend of mine and a pilot, and we did the entire city in forty-five minutes. I began to notice swimming pools and parking lots were two elements of the city that really impressed me. I liked it just for the study of it and it just spoke back to me. It had some kind of value to me as to making a work of art. Seeing the top side of something instead of necessarily looking directly on like this baseline perspective, looking over the top of something sort of allows for more view." **Ed Ruscha**

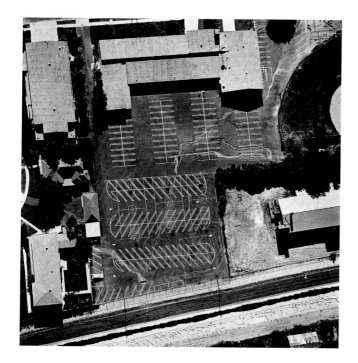

Ed Ruscha *Unidentified Lot, Reseda — Century City, 1800 Avenue of the Stars — May Company, 6150 Laurel Canyon, North Hollywood —*
7133 Kester, Van Nuys. Thirtyfour Parking Lots series, 1967

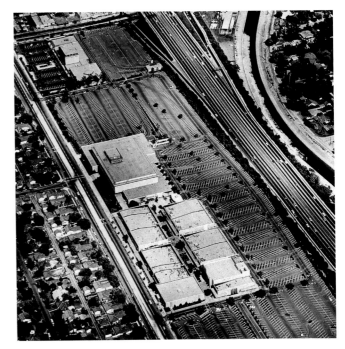

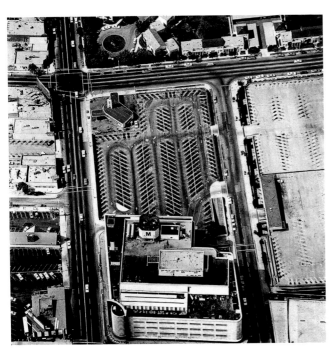

Ed Ruscha *Zurich-American Insurance, 4465 Wilshire Blvd — Fashion Square, Sherman Oaks —*
May Company, 6067 Wilshire Blvd — Pierce College, Woodland Hills. Thirtyfour Parking Lots series, 1967

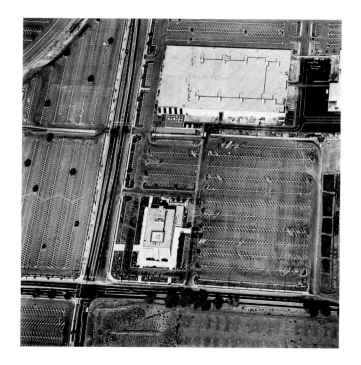

Ed Ruscha *Rocketdyne, Canoga Park — 5000 W. Carling Way — Good Year Tires, 6610 Laurel Canyon, North Hollywood — Sears Roebuck & Co, Bellingham & Hamlin, North Hollywood. Thirtyfour Parking Lots* series, 1967

Ed Ruscha *Gilmore Drive-in Theatre, 6201 W. 3rd St — Litton Industries, 5500 Canoga, Woodland Hills —*
5600-5700 Blocks of Wilshire Blvd — Dodgers Stadium, 1000 Elysian Park Ave. Thirtyfour Parking Lots series, 1967

Ed Ruscha *7101 Sepulveda Blvd, Van Nuys — State Dept. of Employment, 14400 Sherman Way, Van Nuys —*
Eileen Feather Salon, 14425 Sherman Way, Van Nuys — Federal, County and Police Building Lots. Thirtyfour Parking Lots series, 1967

Ray K. Metzker *Philadelphia*, 1963

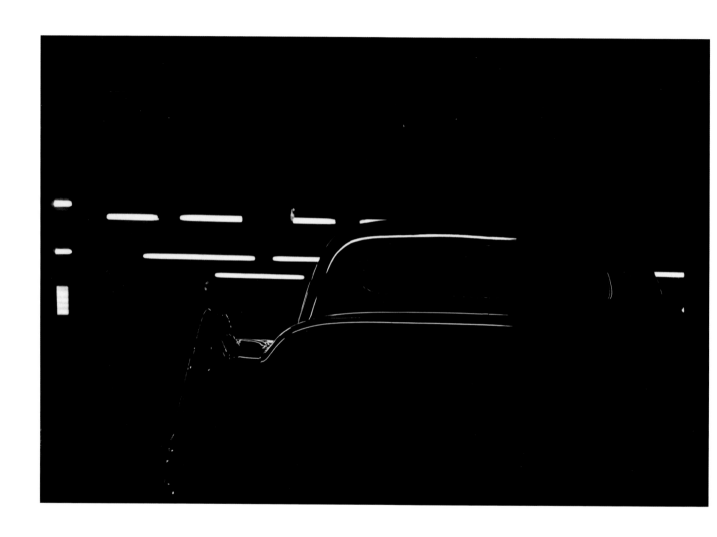

158　**Ray K. Metzker**　*Philadelphia*, 1963

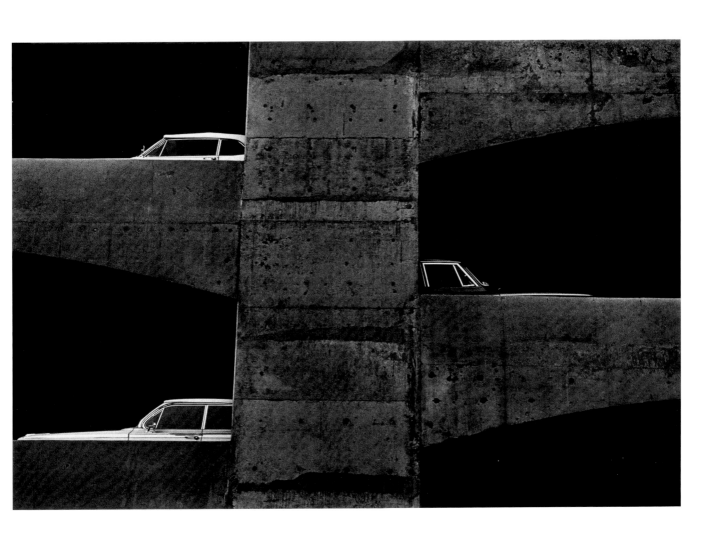

Ray K. Metzker *Washington, DC,* 1964

"The problem with most photographers situated in the documentary genre is that they hold a camera in front of a motif and are content to just reproduce it. They repeat things already seen elsewhere. When I photograph parking spaces all around the world, it is a conceptual project starting from simplistic images. But their assembly is intended to signify how people are looking for their place in the world, have lost their identity in it. A good documentary project is constructed; it doesn't happen by accident." **Martin Parr**

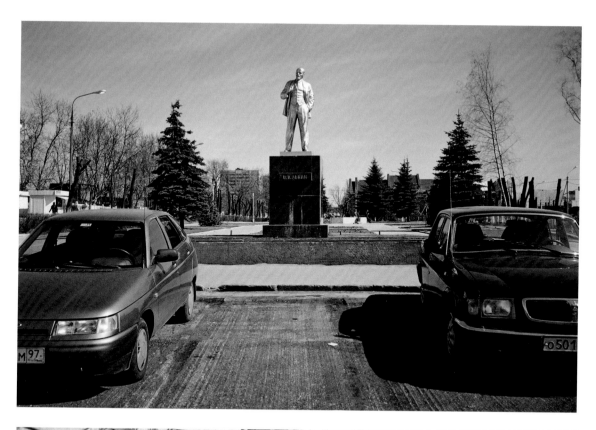

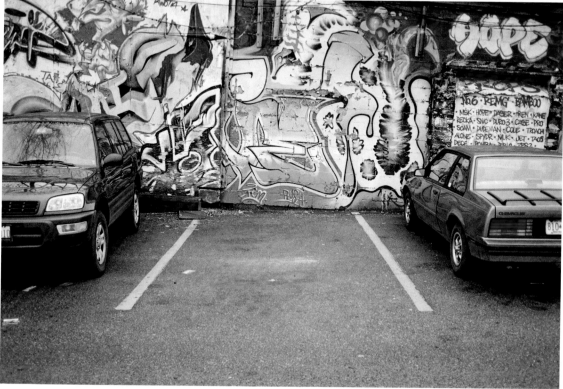

Martin Parr *Istra, Russia — Toronto, Canada. Parking Spaces series, 2002*

Martin Parr *La Paz, Mexico — London, England. Parking Spaces series, 2002–03*

Martin Parr *Amsterdam, Holland — Newcastle, England. Parking Spaces* series, 2002

Martin Parr *Ljubljana, Slovenia — Beirut, Lebanon. Parking Spaces series, 2002*

Martin Parr *Dublin, Ireland — New York, USA. Parking Spaces series, 2002*

Drive-By Shooting

Simon Baker

"I drove back towards the airport. The lights along Western Avenue illuminated the speeding cars, moving together towards their celebration of wounds."[1] *J. G. Ballard*
"Nothing about the car could be said to be a traditional medium."[2]
Rosalind E. Krauss

On the twenty-first of December 1911, the so-called Bonnot Gang became the first criminals in history to use a getaway car, an extravagantly deluxe Delaunay-Belleville.[3] They had stolen the car a week previously, in preparation for a daring bank robbery and, as such technology had not yet made its way into the arsenal of law enforcement, the criminals escaped. The Bonnot Gang, then, have the dubious honor of having imagined a new and radical creative use to which automobiles might be put, on the eve of the era in which the military-industrial engineers of Western Europe were only just beginning to dream of tanks and armored cars. The early years of the twentieth century were full of unbelievable innovations of this kind, both on the ground and in the air, where entirely new perspectives were soon to become commonplace. Man Ray signaled his awareness of this proto-"new vision" as early as 1920 with *Dust Breeding*, a collaboration with Marcel Duchamp, in which Duchamp's sculpture *The Large Glass* (1915–23) was photographed laying flat, cracked, and covered in dust. It is thought that André Breton contributed the poem with which it was published in 1921: "Voici le domaine de Rrose Sélavy / Comme il est aride – comme il est fertile – / Comme il est joyeux – comme il est triste ! / Vue prise en aéroplane par Man Ray – 1921."(Here is the domain of Rrose Sélavy / How arid it is – How fertile it is / How happy it is – How sad it is! / View taken from an airplane by Man Ray 1921).[4]
It is not clear where Man Ray was placed to take the picture that he dedicated to "Francis Picabia at great speed" in 1924 (p. 313), but it is evident that, like the Bonnot Gang, Man Ray was engaging in something that was *only* possible

Simon Baker is Senior Curator, International Art (Photography), Tate, London.

1. J. G. Ballard, "Crash," in *RE/Search #8/9 J. G. Ballard* (San Francisco, CA: RE/Search Publications, 1984), p. 75.

2. Rosalind E. Krauss, *Under Blue Cup* (Cambridge, MA: MIT Press, 2011), p. 76.

3. See Richard Parry, *The Bonnot Gang: The Story of the French Illegalists* (London: Rebel Press, 1987).

4. *Littérature, nouvelle série*, no. 5 (October 1, 1922), p. 6.

due to the speed of the vehicle. Although not the first to have enjoyed the willful and wonderful distortions produced by moving objects (just think of the technophile Futurists), there is a sense in which Man Ray and Picabia, working together (one in the car and one at the side of the road), may well have produced something like the first "avant-garde" performance piece using a car. Picabia's "great speed" left them years ahead of a packed field of twentieth-century artists and photographers for whom the car would become something like a medium, or perhaps, as Rosalind E. Krauss suggests for its use in Ed Ruscha's work, the car was less of a medium than a "technical support."[5]

Whether or not we agree with Krauss that it was "possibly with the example of Kerouac in mind that the car became the continuous frame of his work," it seems clear that by the mid-1960s, Ruscha was not only using cars to make work, but engaging ever more deeply with aspects of automotive culture, from gas stations to car parks and even road tests (p. 151).[6] And the link to Jack Kerouac is an interesting one, as, perhaps more than any other single influence, his 1957 book *On the Road* seems to have crystallized a romantic perception of automotive travel as the epitome of freedom, and by implication freedom of expression, for artists and writers from the United States to Europe and Japan.

Writing about the late 1960s, Daido Moriyama remembers a specific debt to Kerouac and having been "strongly drawn to the sense of Sal Paradise's eyes having 'seen' the road."[7] In his account of Kerouac's impact, however, Moriyama moves well beyond an account of the road trip as a psychological journey (although it is certainly that too), focusing instead on the way in which the car itself directed his vision and so his photographic practice: "With my eyes fixed on the road like a pair of headlights, I became obsessed, until I found it impossible, in body and spirit, to make my way back from the road [and] certainly, when you're in a car and cutting across a steady succession of scenes, an abundance of images flee behind you. In the instant you cross, they leave a faint sensation of brushing past."[8] It is even possible to identify precisely the fields of vision and modes of experience that Moriyama describes in relation to specific photographs: anything, for example, from his 1969 *Tomei Expressway: The Road that Drives People*. Many similar series from this time, such as *Tokyo's Loop Area* (1969), and the 1972 book *Hunter*, were made in direct homage to Kerouac, but in much of Moriyama's work even up to the present day, what he often modestly refers to as his "snapshots" are visions stolen, either while, or as if, driving by (p. 187).[9]

But if for Moriyama, the car as a "technical support," or as an aspect of his photographic practice, was a means of opening up his consciousness to a flow of images from which he could seize passing moments, there were other more formal and conceptual ways in which photography put the car to use.

5. Rosalind E. Krauss, *Under Blue Cup*, op. cit., p. 76.

6. Ibid.

7. Daido Moriyama, "On the Road," in *Memories of a Dog* (Tucson, AZ: Nazraeli Press, 2004), p. 39.

8. Ibid., pp. 40–41.

9. See Simon Baker, "Daido Moriyama in Light and Shadow," in *Daido Moriyama* (London: Tate, 2012); see also Daido Moriyama, *Magazine Work*, 2 volumes (Tokyo: Getsuyosha, 2009).

The following quote is from Joel Meyerowitz, writing about his mid-1960s *European Trip: Photographs from the Car, 1968* but it could as easily be used to describe works by Lee Friedlander (p. 201), Henry Wessel (p. 110) (and many others since), as well as Meyerowitz's own practice: "I began to understand that the car window was the frame, and that in some way the car itself was the camera with me inside it, and that the world was scrolling by with a constantly changing image on the screen. All I had to do was to raise the camera and blink to make a photograph."[10] What Meyerowitz identifies here is not only the specific vision that a car produces—the frames that its windows constitute—but the sense in which its movement generates sequences or series of images (whether selected and related, or found and disconnected). As such the car as a "technical support" for the artist bears a specific and close relationship to the photographic medium itself, which can likewise be characterized in relation to framing/composition, automatism, and seriality.

It is significant perhaps, in this context, that in 1968 the Museum of Modern Art in New York produced its landmark exhibition *The Machine: As Seen at the End of the Mechanical Age*, in which, according to its own classificatory system, "car" and "camera" were neighbors. Few of either made it into the show however, which seems to have had a peculiar blind spot where photography was concerned, largely relegating the medium to a means of recording images of other mechanical objects. Remarkably, however, it was also at MoMA in 1968 that Meyerowitz first exhibited *My European Trip: Photographs from the Car*, which not only preceded *The Machine: As Seen at the End of the Mechanical Age* by just two months, but dramatically superseded its attempt to redefine the relationship between cars and cameras. Giving himself over to the freedom of the road, but also determined to resolve the full potential of the complex interrelationship of the photographic medium and its automotive "technical support," Meyerowitz offers a master class in framing, timing, and focus. The car supports this kind of photographic production in two essential ways. First, as a means of being in the right time at the right place along a string of real-world situations that unfold as an endless series of micro-dramas: the very terrain that Henry Wessel has long since made his own.[11] And secondly, in the almost unbelievable ways in which framing, speed, and precision combine somewhere between the photographer's eye, the camera shutter, and the car window: as though the artist has somehow been able to rewind and freeze-frame reality at moments of heart-stopping serendipity. Not only could such images not have been produced in any other way, but their mode of production, their "capture" is about as incredible (in the true sense of the word) as it is possible to imagine.

10. Joel Meyerowitz, *Taking My Time*, vol. 1 (London: Phaidon Press, 2012), p. 186; see also, Joel Meyerowitz, Daido Moriyama, and John Divola, *Pictures from Moving Cars* (London: Adad Books, 2013).

11. See for example, Henry Wessel, *Incidents* (Göttingen: Steidl, 2013).

Since László Moholy-Nagy's call for photography to expand vision in the 1920s, the medium has never had a problem in dealing with the apparently impossible.[12] It was not long, for example, before Harold Edgerton devised a system of flash triggers to photograph flying bullets and liquid droplets (published as *Flash!* in 1939).[13] And elsewhere in America, by the late 1960s, not only had Ted Serios worked out how to use Polaroid cameras to photograph his thoughts, but even more unthinkably, color photography was on the road to respectability, epitomized by the work of William Eggleston who photographed cars, and from cars, incessantly (p. 18 and 47).[14] In fact, the technological expansion of vision that Moholy-Nagy sought in the 1920s as an avant-garde phenomenon could be said to have been both achieved and popularized by the 1970s, so that smaller, lighter, faster cameras, color film, and drugstore developing took photography "on the road" in previously unimaginable ways. The original version of Stephen Shore's epic 1970s road trip, *American Surfaces*, for example, was printed commercially wherever the photographer parked his car for the night, conveniently reconfirming the intersection of creativity and freedom between the photographic medium and its technical support.

More recently, and rather less conveniently perhaps, John Divola managed both the steering wheel and his camera to take pictures (without crashing) as dogs chased his car in the Californian desert (p. 178). "Here we have two vectors and velocities," he writes, "that of a dog and that of a car and, seeing that a camera will never capture reality and that a dog will never catch a car, evidence of devotion to a hopeless enterprise."[15] But although apparently light-hearted, Divola's work has much to tell us about photography and cars at the limits of their mutual compatibility. What Divola calls a "hopeless enterprise" is precisely the challenge facing anyone who retains a vested interest in the photographic medium in the face of the inevitable distance between reality and representation. Perhaps photography's honorific crisis, the worrying sense that reality will somehow elude it, is why photographs of disasters and accidents retain such a hold over the imagination. Here, it seems, in the face of pain and death, we are somehow returned to the realm of the incontrovertible fact. The link Roland Barthes identified long ago between photography and death finds an awkward, prescient echo in images of collapsed vehicles with their implied, but invisible human contents.[16]

There is also something strangely analogue about photographs of road accidents: the scratchy visceral look of the violently impacted car "bodies;" the bluntly indexical rubber tire tracks; and the inevitable and foreboding sense of bearing witness. Whether the digital age will indeed transform the relationship between the car and the photographic medium is hard to determine, although, at a purely technical level, as many cars are now riddled with parking cameras and networked via satellite, it is not long before driverless cars will

12. László Moholy-Nagy, *Painting, Photography, Film* (Cambridge, MA: MIT Press, 1969).

13. Harold Edgerton and James R. Killian Jr., *Flash! Seeing the Unseen by Ultra High-Speed Photography* (Boston, MA: Hale, Cushman, and Flint, 1939).

14. Ted Serios was a cult figure in studies of spirit photography, who was apparently able to project his thoughts directly onto polaroid film, even under the supervision of psychologists under test conditions. His technique has never been fully explained. See Jule Eisenbud, *The World of Ted Serios: "Thoughtographic" Studies of an Extraordinary Mind* (London: Jonathan Cape, 1968).

15. John Divola, *Dogs Chasing My Car in the Desert* (Tucson, AZ: Nazraeli Press, 2004), p. 1.

16. Roland Barthes, *Camera Lucida: Reflections on Photography* trans. Richard Howard (New York: Farrar, Straus, and Giroux, [1980] 1999).

be free to make their own homages to Kerouac. But a specific and significant aspect of the relationship between cars and the virtual world was predicted early on by J. G. Ballard, the high priest of "auto-eroticism," in terms that also have a resonance with photography. "The car as we know it is now on its way out," he wrote in *The Car, The Future* in 1971, "to a large extent, I deplore its passing, for as a basically old-fashioned machine, it enshrines a basically old-fashioned idea: freedom. In terms of pollution, noise and human life, the price of that freedom may be high, but perhaps the car, by the very muddle and congestion it causes, may be holding back the remorseless spread of a regimented electronic society."[17]

17. J. G. Ballard, "The Car, The Future," in *Drive*, [fall 1971], in *RESearch 8/9*, op. cit. p. 157.

"I chose France's western coast (the Atlantic), from the Pyrénées to the Vendée, because this region seemed to me to have undergone important mutations since 1945. My car journeys sometimes took the form of a trip, or sometimes of a pilgrimage, using three different photographic points of view, the roads, the villages, and the different faces of the departments. These points of view were in a way the constants of my journeys. The roads (from paths to motorways) and their importance in the French landscape have rarely been considered (did you know that the name panels at the entry of villages are due to the automobile, Michelin, and various motoring clubs?). Who is interested in the mud of ancient tracks, or the troubling symbolism of the crossroad, the junction point where sometimes the past, present, and future meet in one moment?" **Pierre de Fenoÿl**

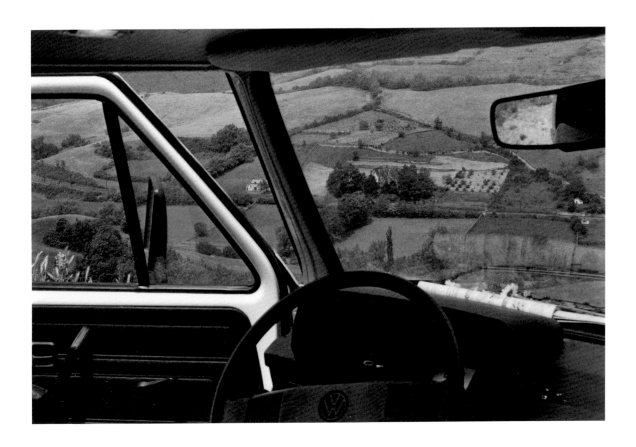

Pierre de Fenoÿl *Untitled, France*, 1985

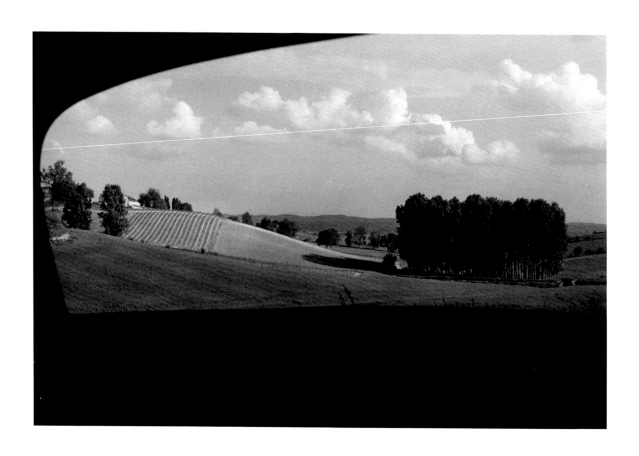

Pierre de Fenoÿl *Untitled, France,* 1985

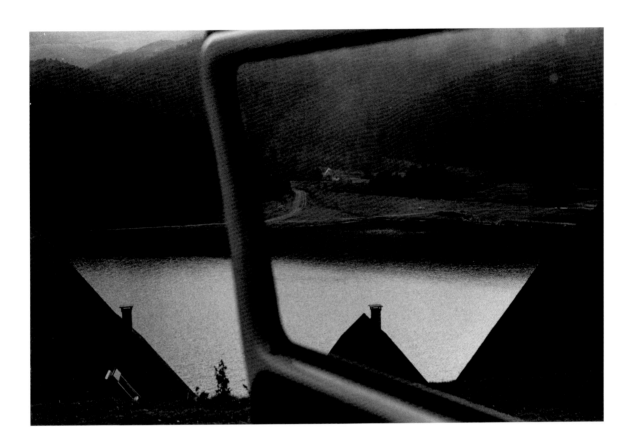

Pierre de Fenoÿl *Untitled, France,* 1985

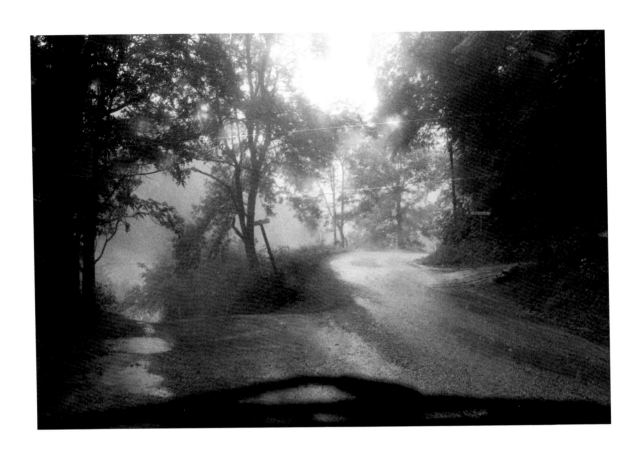

Pierre de Fenoÿl *Untitled, France*, 1985

Pierre de Fenoÿl *Untitled, France*, 1985

"Contemplating a dog chasing a car invites any number of metaphors and juxtapositions: culture and nature, the domestic and the wild, love and hate, joy and fear, the heroic and the idiotic. It could be viewed as a visceral and kinetic dance. Here we have two vectors and velocities, that of a dog and that of a car and, seeing that a camera will never capture reality and that a dog will never catch a car, evidence of devotion to a hopeless enterprise." **John Divola**

John Divola *Dogs Chasing My Car in the Desert* series, 1996–2001

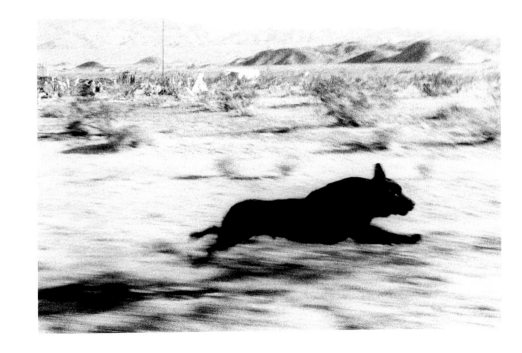

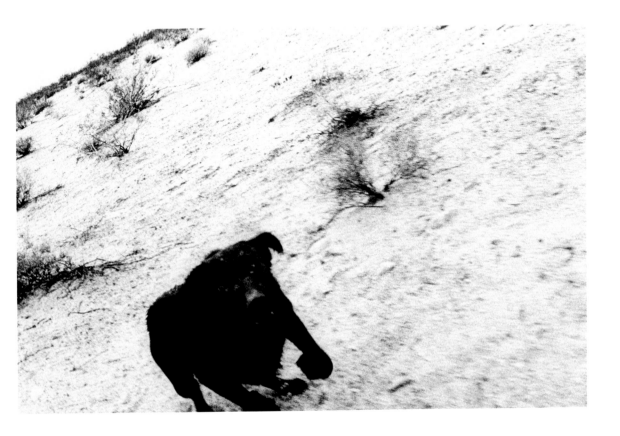

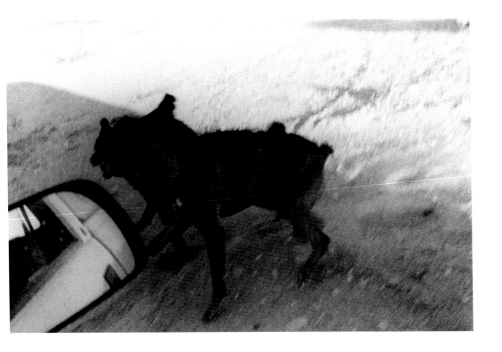

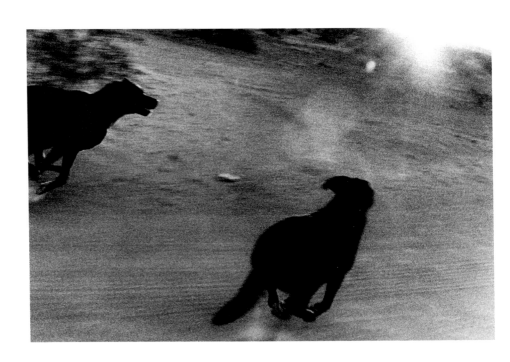

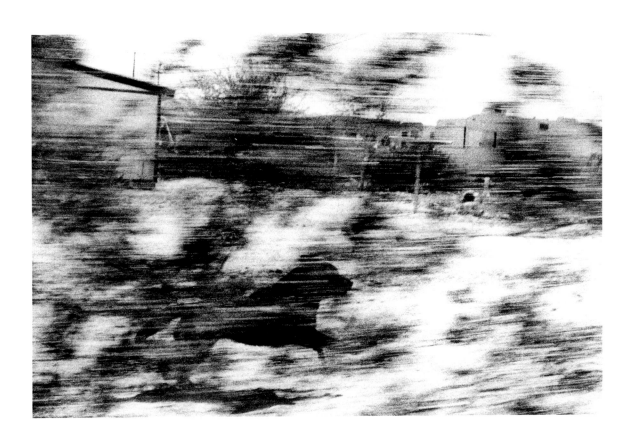

John Divola *Dogs Chasing My Car in the Desert* series, 1996–2001

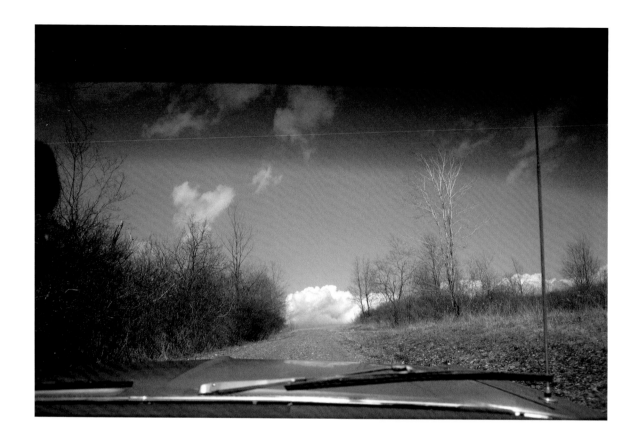

"In 1964, while on my first driving trip around America, I began making photographs from the moving car. I became aware of how fleeting time was at 60 miles per hour. I also realized that there was no way to stop the car and go back to get what had already disappeared, so I started carrying the camera on my lap and readying myself to respond any time something outside called out to me. I began to understand that the car window was the frame, and that in some way the car itself was the camera, with me inside it, and that the world was scrolling by with a constantly changing image on the screen. All I had to do was to raise the camera and blink to make a photograph." **Joel Meyerowitz**

Joel Meyerowitz *Upstate New York*, 1977

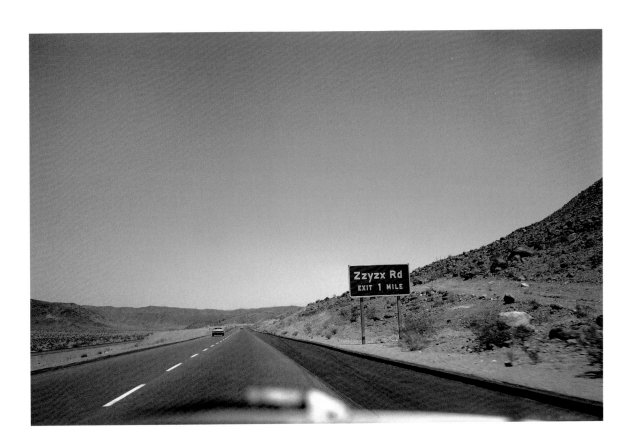

Joel Meyerowitz *California*, 1970

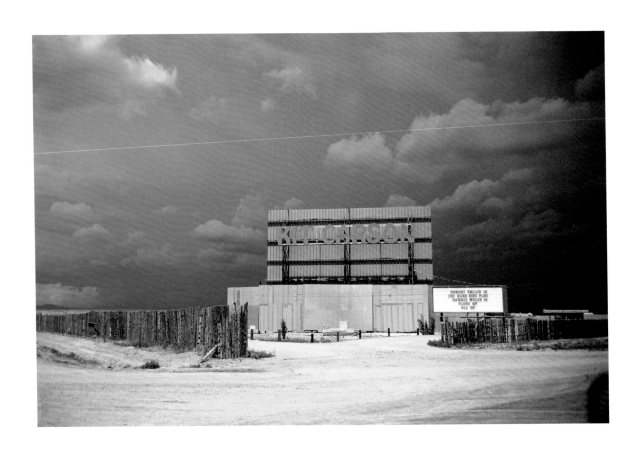

Joel Meyerowitz *From the Car, Taos Drive-in*, 1971

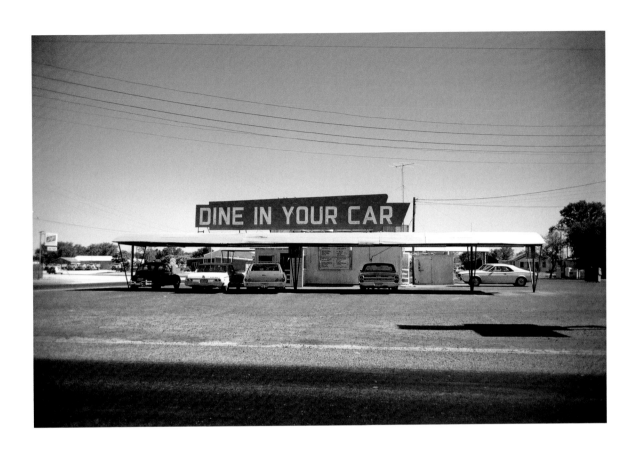

Joel Meyerowitz *Texas*, 1971

"With my eyes fixed on the road like a pair of headlights, I became obsessed, until I found it impossible, in body and spirit, to make my way back from the road and certainly, when you're in a car and cutting across a steady succession of scenes, an abundance of images flee behind you. In the instant you cross, they leave a faint sensation of brushing past." **Daido Moriyama**

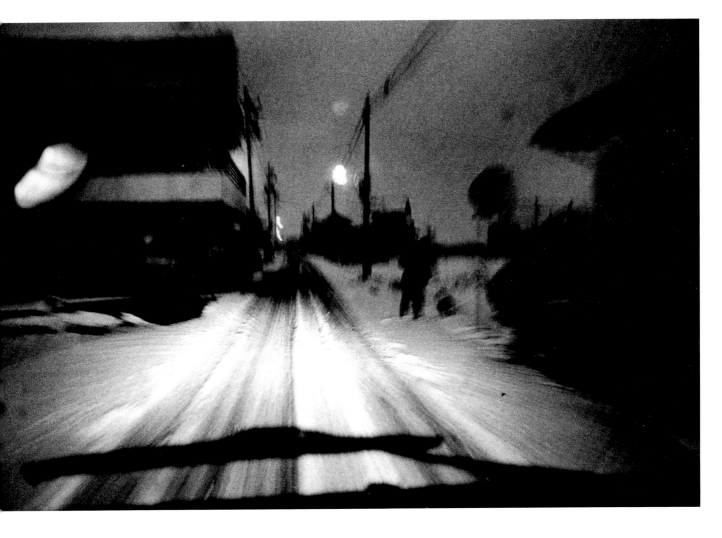

Daido Moriyama *Nagano, 1978*

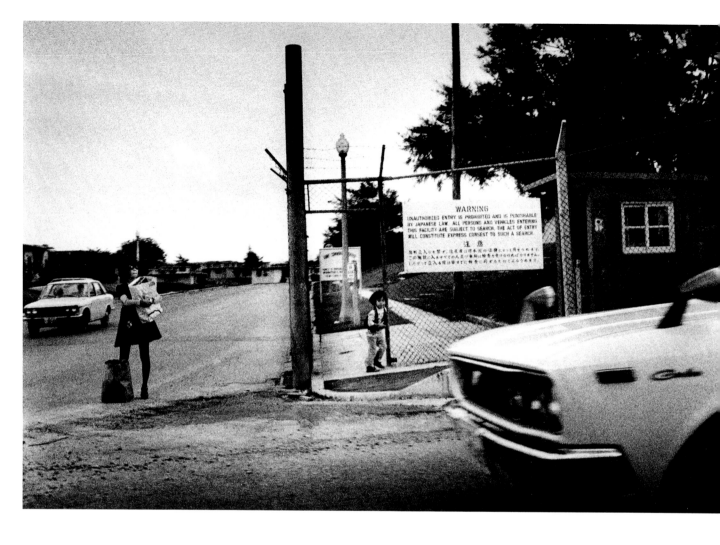

Daido Moriyama *Okinawa, 1975*

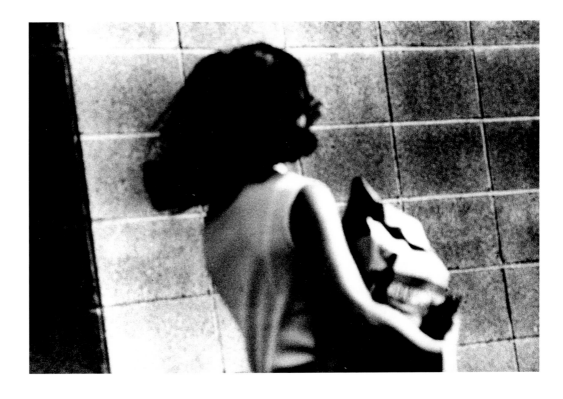

Daido Moriyama *On the Road*, 1969

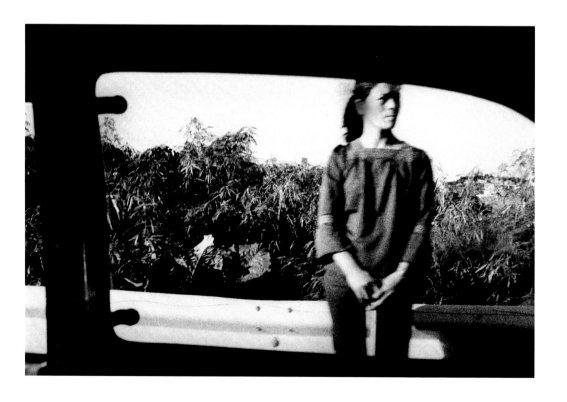

190　**Daido Moriyama**　*Okinawa*, 1975

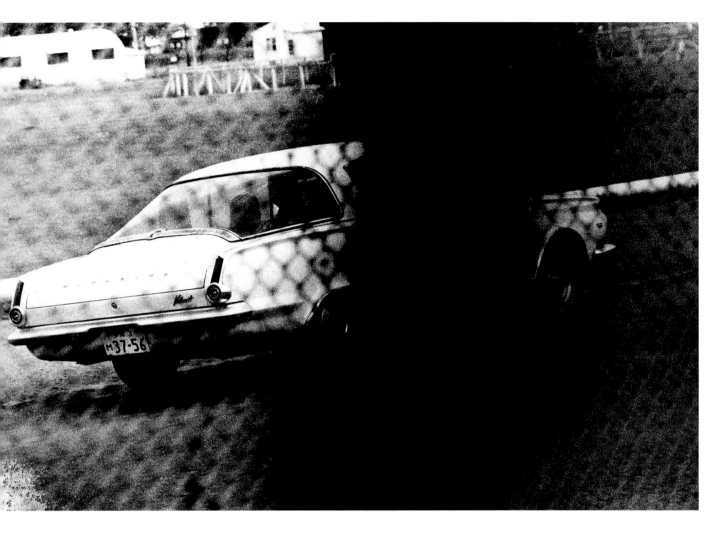

Daido Moriyama *On the Road*, 1969

"In the old 1950 Packard, we speed towards Guanajuato, in the infiniteness of space, the roads, sleeping anywhere, around a fire, under the stars, woken by people on the land, eating in markets or "cantinas," dancing, singing everywhere, chatting with old guys in worn-out straw hats, getting a puncture or two, arriving at San Miguel Allende at night, feeling ill, following the sun, no watches, nothing; Roger, the New Yorker, strumming his ukulele in accompaniment to Juanito on the violin and feeling like all this will never end once we get into the spirit of it and want more, and Karina runs along the road all for her, towards freedom." **Bernard Plossu**

Bernard Plossu *Chiapas, Mexique. Le Voyage mexicain* series, 1966

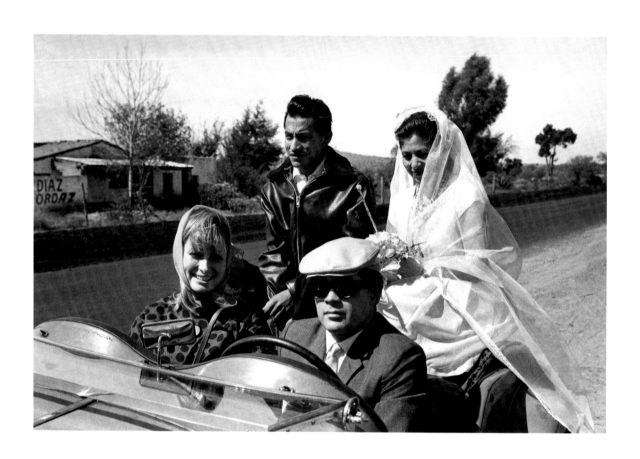

194 **Bernard Plossu** *Mexique. Le Voyage mexicain* series, 1966

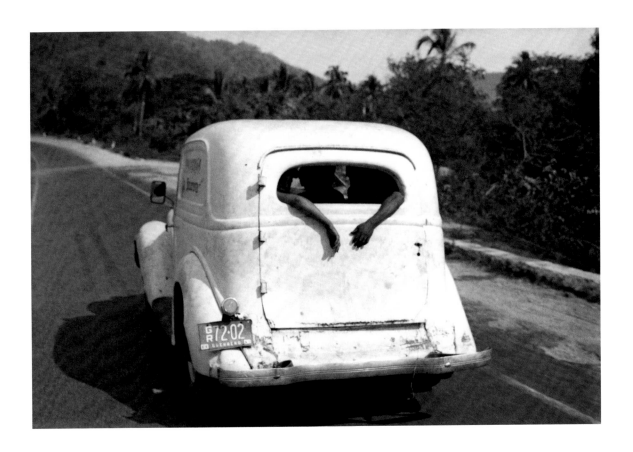

Bernard Plossu *Sur la route d'Acapulco, Mexique. Le Voyage mexicain* series, 1966

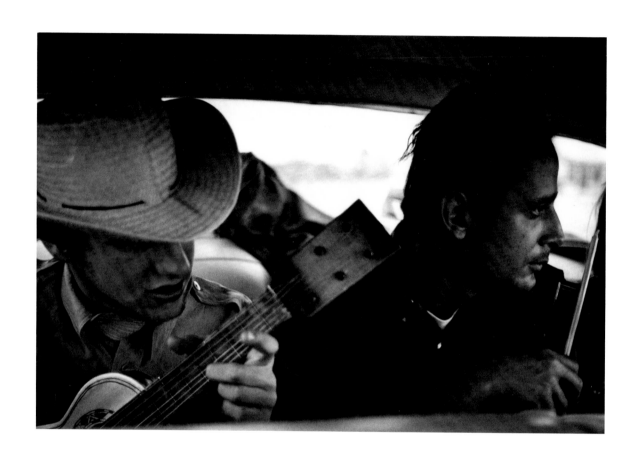

Bernard Plossu *Juan et Roger, Mexique. Le Voyage mexicain* series, 1966

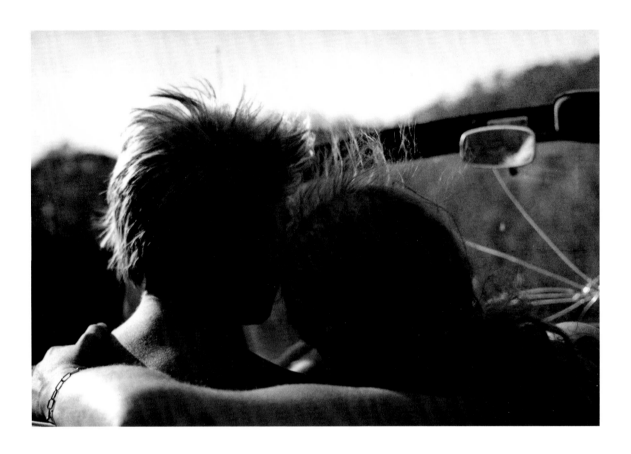

Bernard Plossu *Linda et Georges, route d'Acapulco, Mexique. Le Voyage mexicain* series, 1966

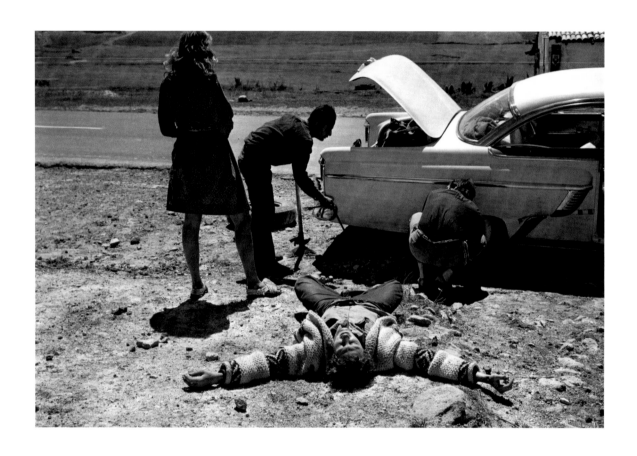

Bernard Plossu *Sur la route de San Miguel, Mexique. Le Voyage mexicain* series, 1966

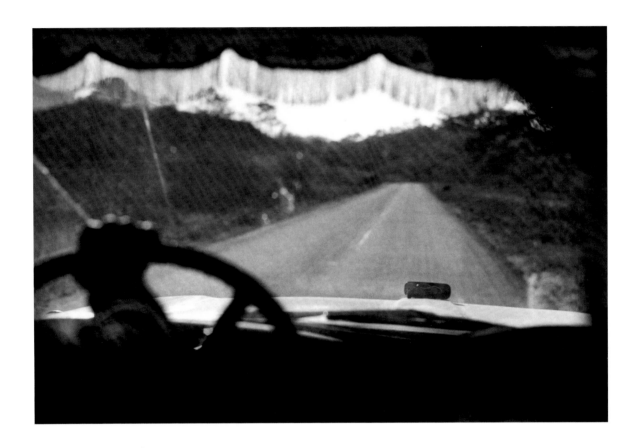

Bernard Plossu *Chiapas, Mexique. Le Voyage mexicain* series, 1966

"I just put the cars out in the world, instead of on a pedestal." **Lee Friedlander**

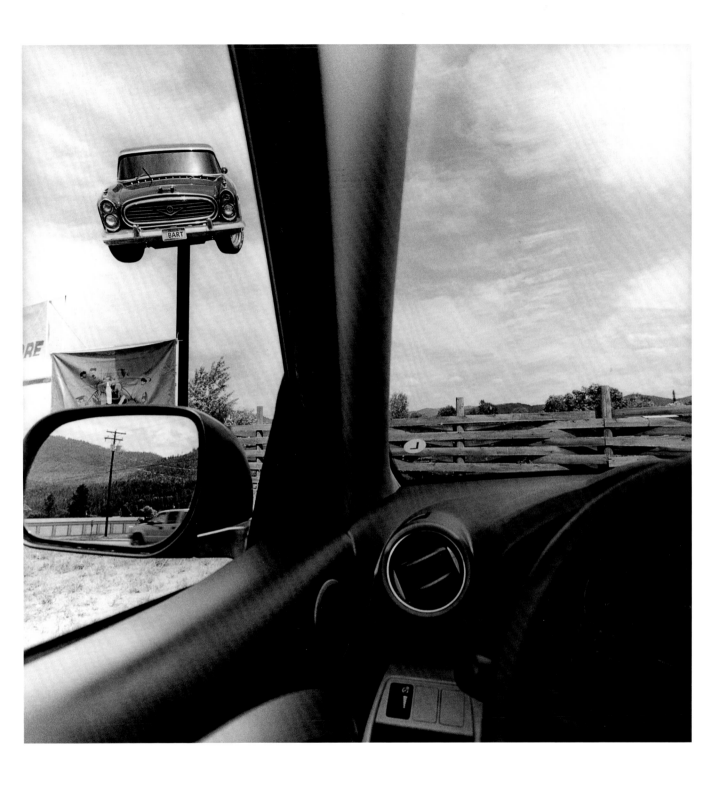

Lee Friedlander *Montana. America by Car series,* 2008

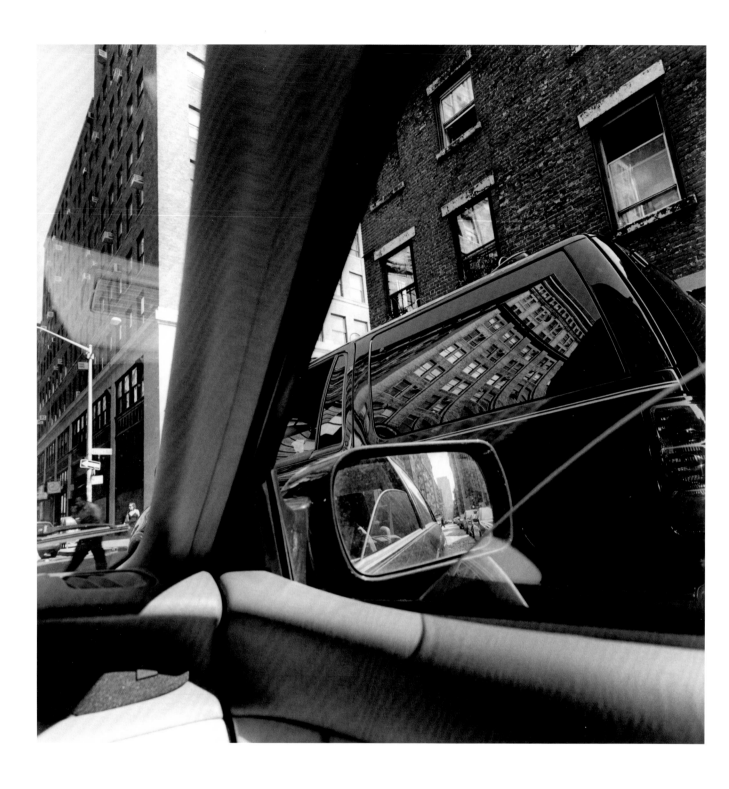

Lee Friedlander *New York City. America by Car series, 2002*

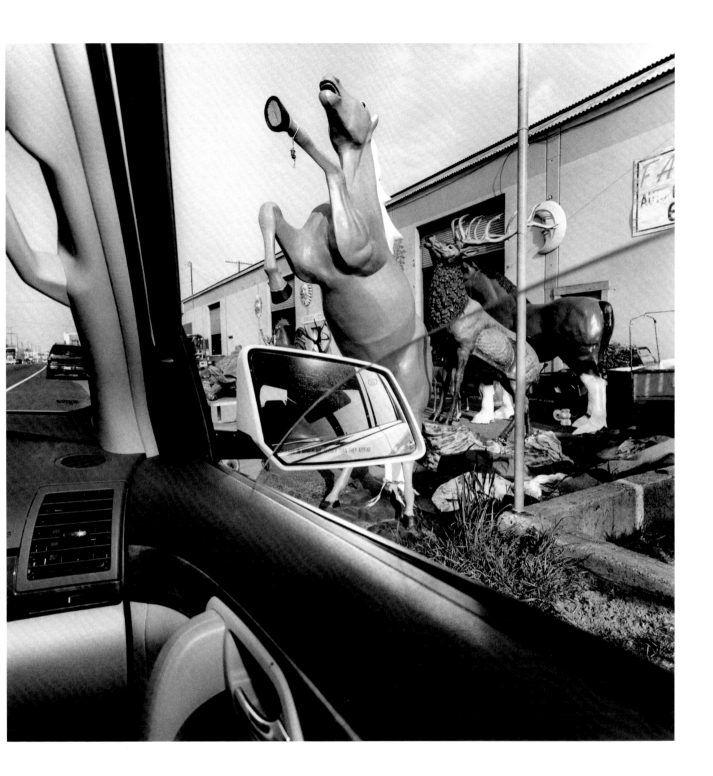

Lee Friedlander *California. America by Car* series, 2008

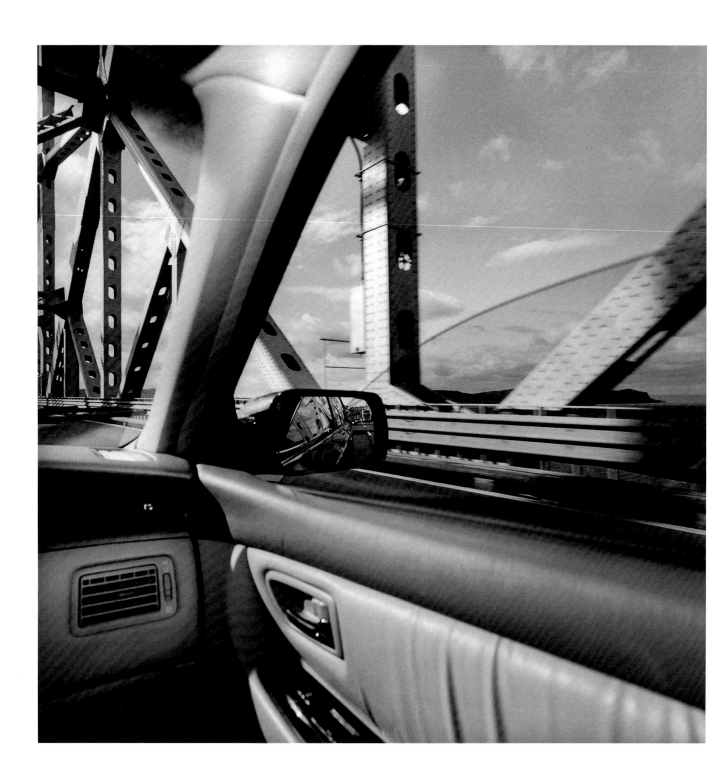

Lee Friedlander *New York State. America by Car series,* 2005

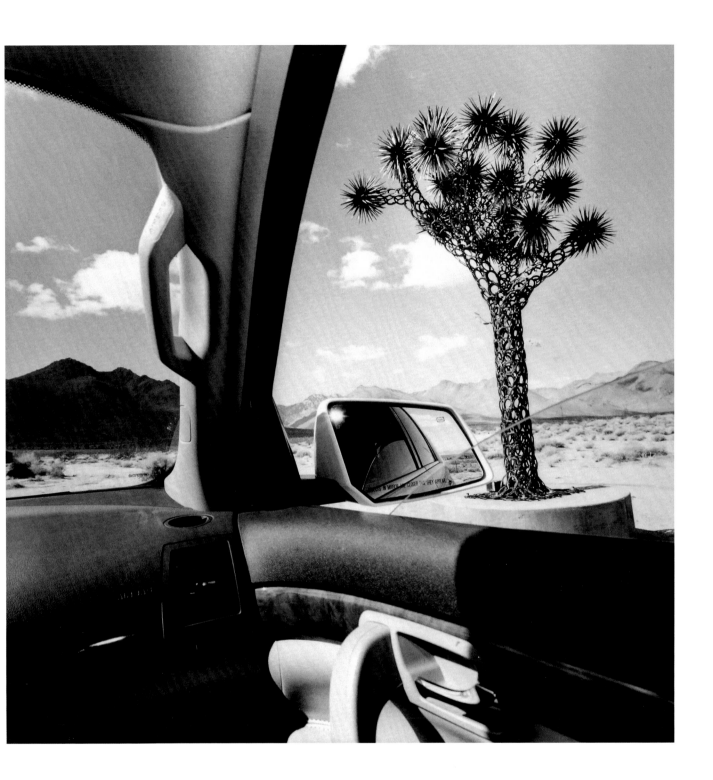

Lee Friedlander *California. America by Car* series, 2008

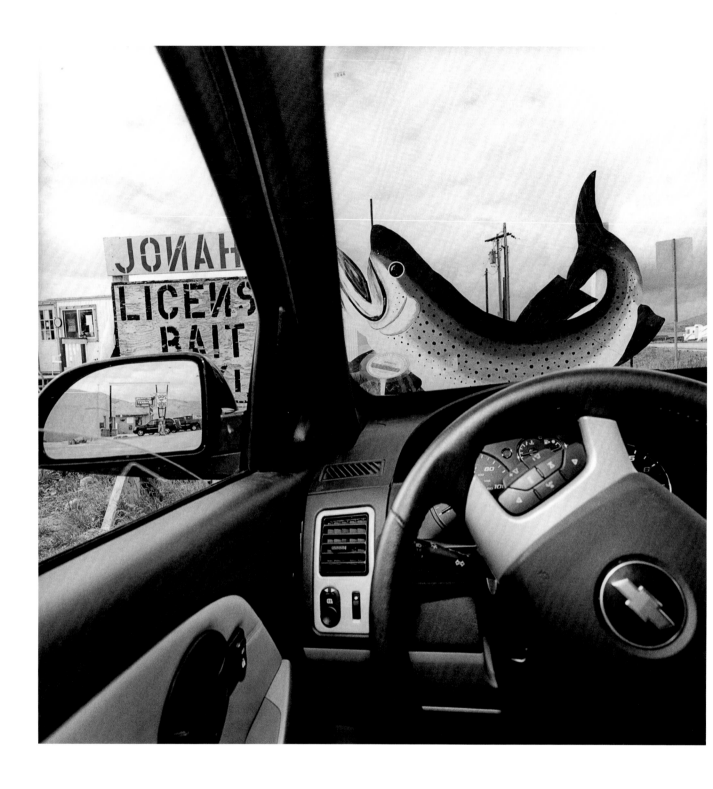

Lee Friedlander *Colorado. America by Car* series, 2007

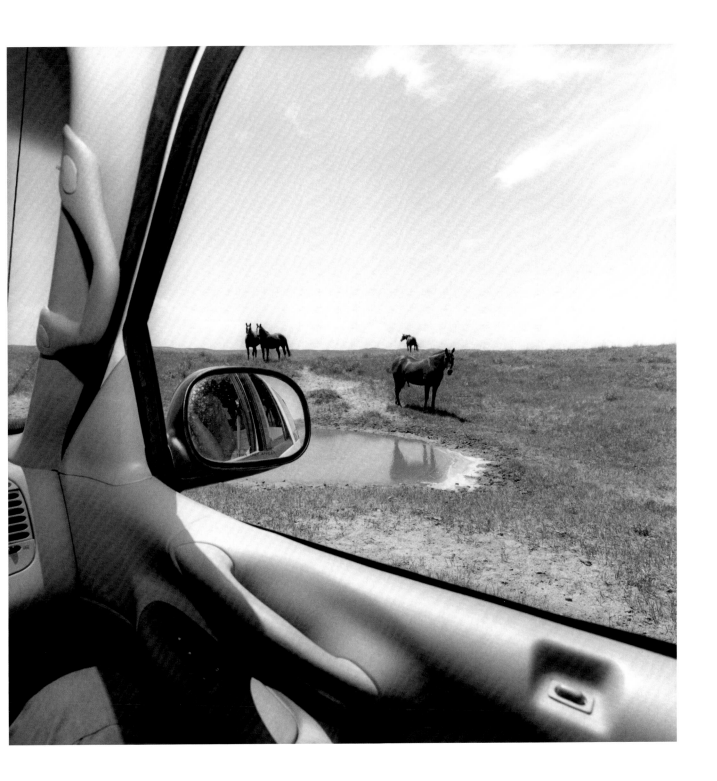

Lee Friedlander *Nebraska. America by Car* series, 1999

"I'm a taxi driver who takes photographs, and a photographer who drives a taxi. I'm two in one. I associate my photography with the taxi. My camera is always by my side when I drive. I never just think about picking up a fare, taking them somewhere and setting them down again. I always think about taking photographs too. For me it would be a waste to drive without my camera. I take photographs without looking through the viewfinder. I imagine what my hand sees. I imagine my hand to be my eye, and my car to be my moving lens. As a human being I'm limited in my movements, the car extends my radius of action, so to speak. Something that moves has a different reality from something fixed." **David Bradford**

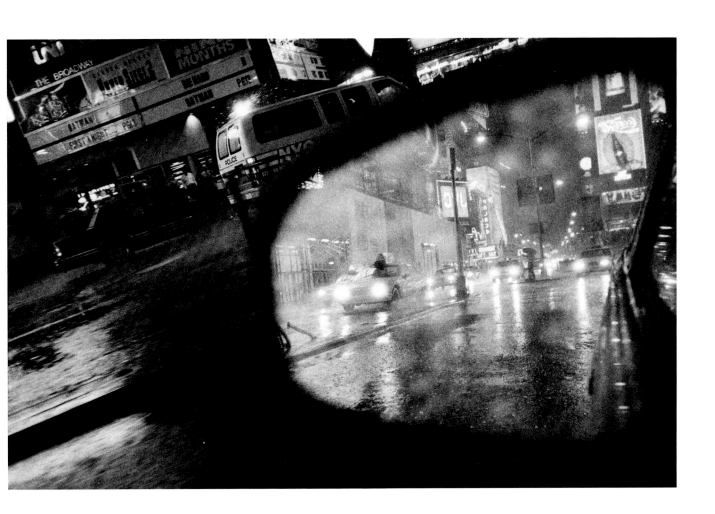

David Bradford *Belly of the Beast. Drive-By Shootings* series, 1995

David Bradford *Holland Tunnel Bullitt. Drive-By Shootings* series, 1993

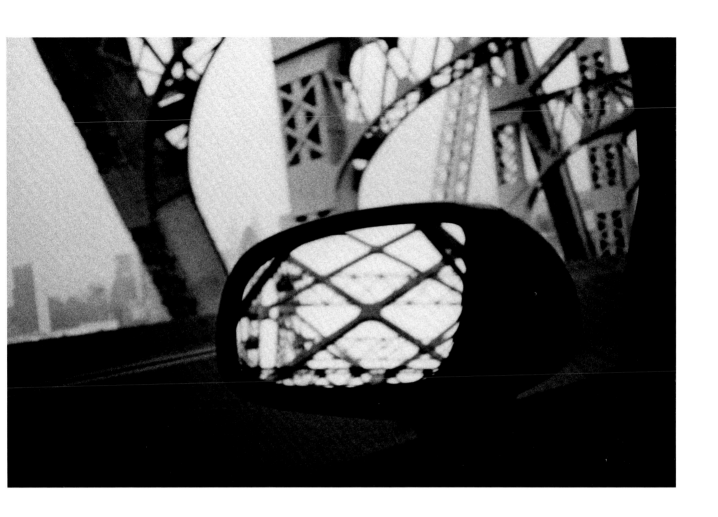

David Bradford *Coaster Ride Stealth. Drive-By Shootings* series, 1994

"From April to September 1994, I was invited to participate as photographer in the urban culture program directed by Néstor García Canclini in the Metropolitan Autonomous University of Mexico City. The idea was to photograph the multiple cultures, transformations, and blends of daily life in Mexico City through various itineraries and journeys—by foot, metro, taxi, bus, or minibus. One of these journeys, from the historic center of Mexico City to its outskirts, led to the Barragán towers in the Ciudad Satélite. These towers were designed and built by the architect Luis Barragán and the sculptor Mathias Goeritz between 1954 and 1958 as a monumental work marking the beginning of town. During my journey in 1994, forty years after the construction of the towers, I realized that the chaos in this part of the city was eating up the towers. The sight from behind the cracked windscreen of the autobus reflected the congestion and the disorder of the recent megalopolis." **Paolo Gasparini**

Paolo Gasparini *Viaje a la Ciudad Satélite, Estado de México,* 1994

"I have worked as a taxi driver for a long time. Taking advantage of this, I carried out this series of pictures through the window of my taxi. Mainly I have photographed the poorer areas of Nuevo León, Mexico, where I too lived in my childhood, so like a self-portrait in a way." **Óscar Fernando Gómez**

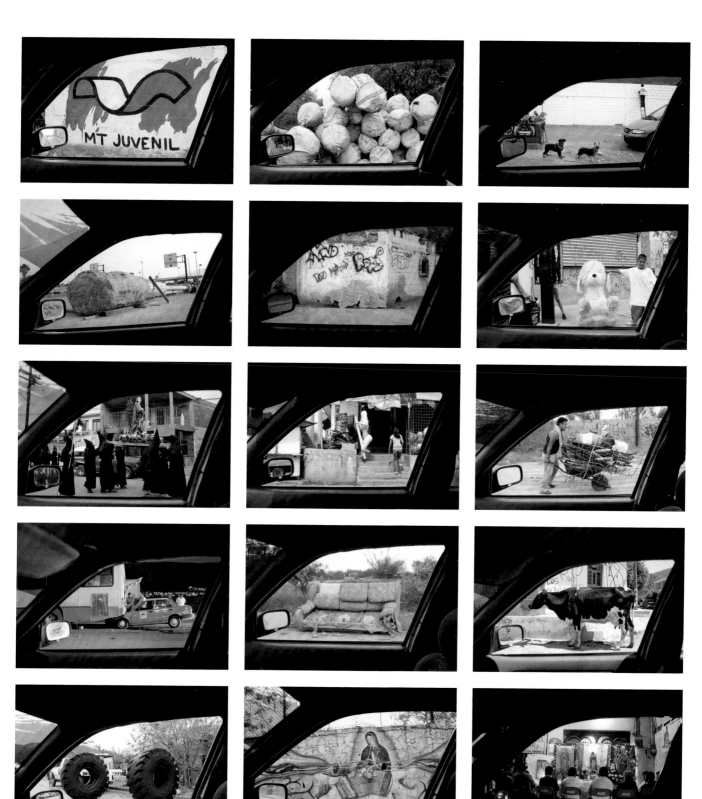

Óscar Fernando Gómez *Windows* series, 2009

Juergen Teller *OJ Simpson no. 5, Miami, 2000*

Juergen Teller *Siegerflieger no. 98, Nurnberg, 2014*

"I am always wondering, 'Does that car belong to that driver?' Or, if I transplanted another person into the car would it seem like a perfect match of driver and car? It is easy to suppose the person driving is driving his own vehicle. As viewers we want to find clues, and we usually succeed in connecting the texture or age of the car to the appearance of the person driving. The pictures work differently when there are multiple passengers. Whether we are conscious of it or not, I think we impose stories on both the drivers and the other people in the car based on our own life experiences and our need to make sense of the world." **Andrew Bush**

Andrew Bush *Woman Waiting to Proceed South at Sunset and Highland Boulevards, Los Angeles, at Approximately 11:59 a.m. One Day in February 1997. Vector Portraits* series, 1997

"I find that other women on the road react to me in a nasty,
hostile sort of way. For some reason this hate comes across. I mean,
I give way to them so why don't they give way to me?"

Martin Parr *From A to B. Tales of Modern Motoring* series, 1994

"If you want to drive from A to B and feel perfectly safe
with no-one looking at you, don't drive an MX5."

"To photograph a nonexistent road, we had to mark it out. At the beginning of 2003, we decided to photograph Europe following a road across the twenty-five countries of the European Union in 2004: the 'Transeuropean' or Nationale Zero. We wanted to return with images of this reality. Our 'road' couldn't be found on any map. Ten of us had the idea to do it. It would begin in Cyprus and end in Gibraltar. It would pass through the ten joining states, all unknown, and the fifteen members, not known enough. We bought a secondhand Peugeot Break. We cut up our imaginary route into ten parts and entrusted each of ourselves a section to cover, one after the other. We only had one obligation: stop every 50 kilometers and take a photo, lay down a photographic marker. When one of us took a photo, we brought a section of the road into existence. Today, this road is 23,000 kilometers long. It is irregular, syncopated, illogical, and anarchic. No shortcuts. The Nationale Zero is not a photographic subject, it is a distinguishing intermediary in the European Union." **Tendance Floue**

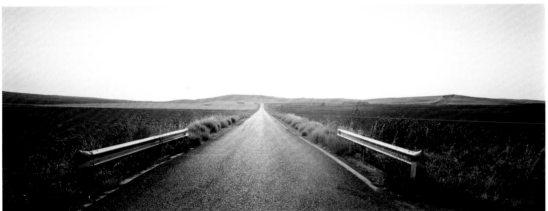

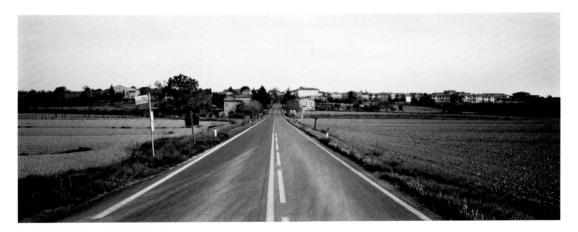

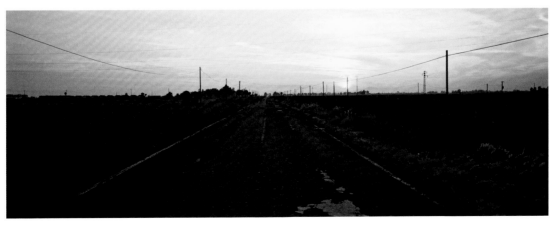

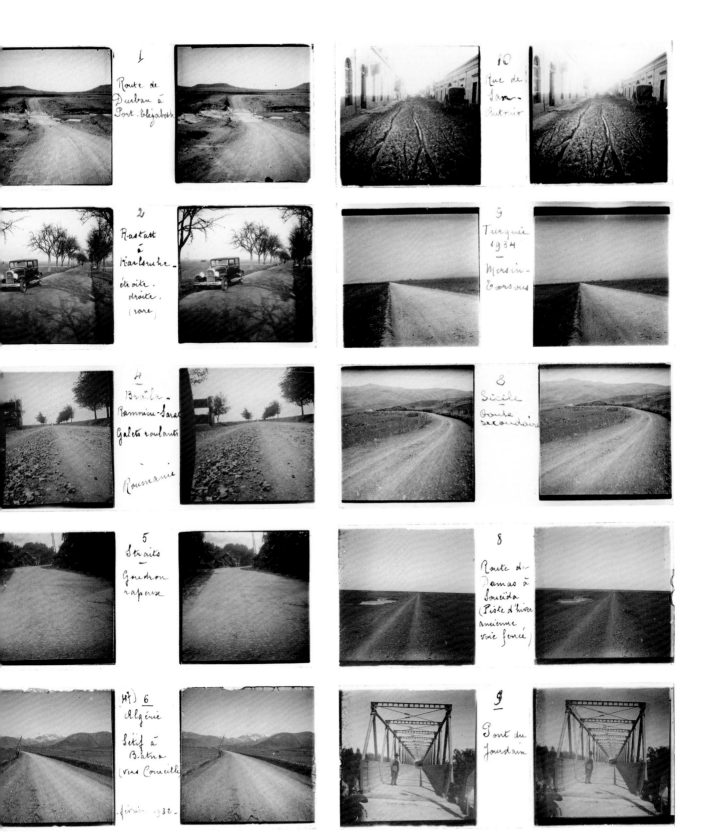

Michelin photographic survey of world roads, c. 1930

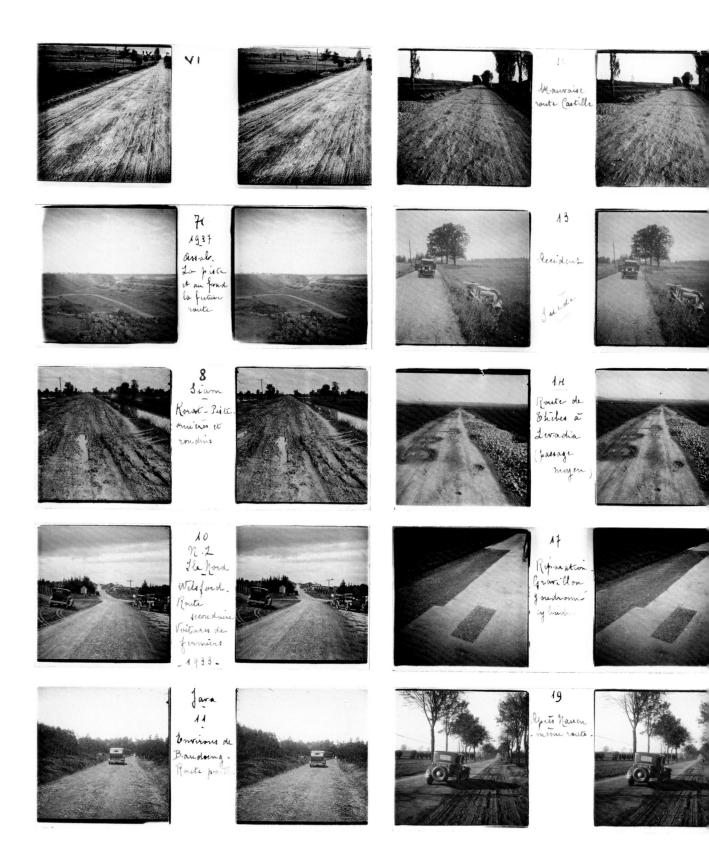

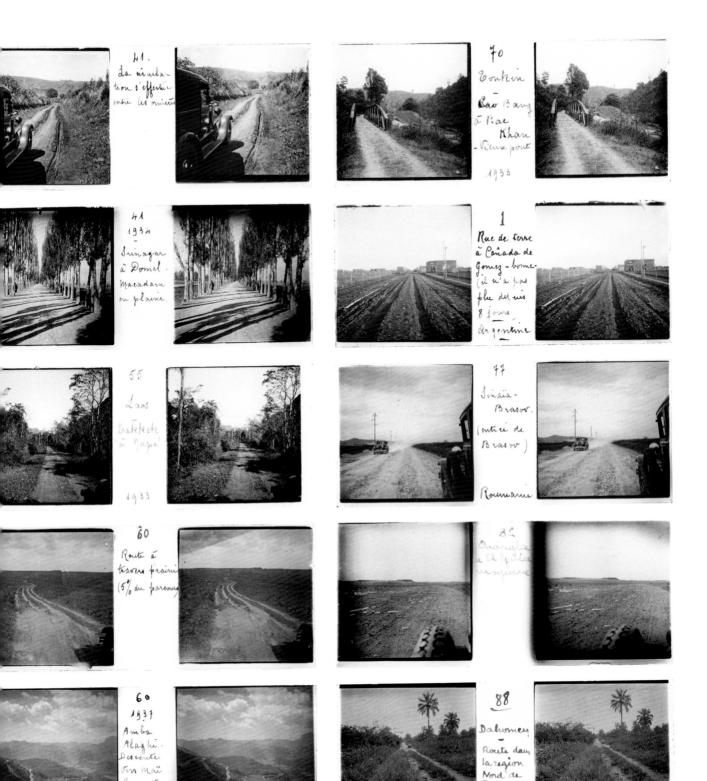

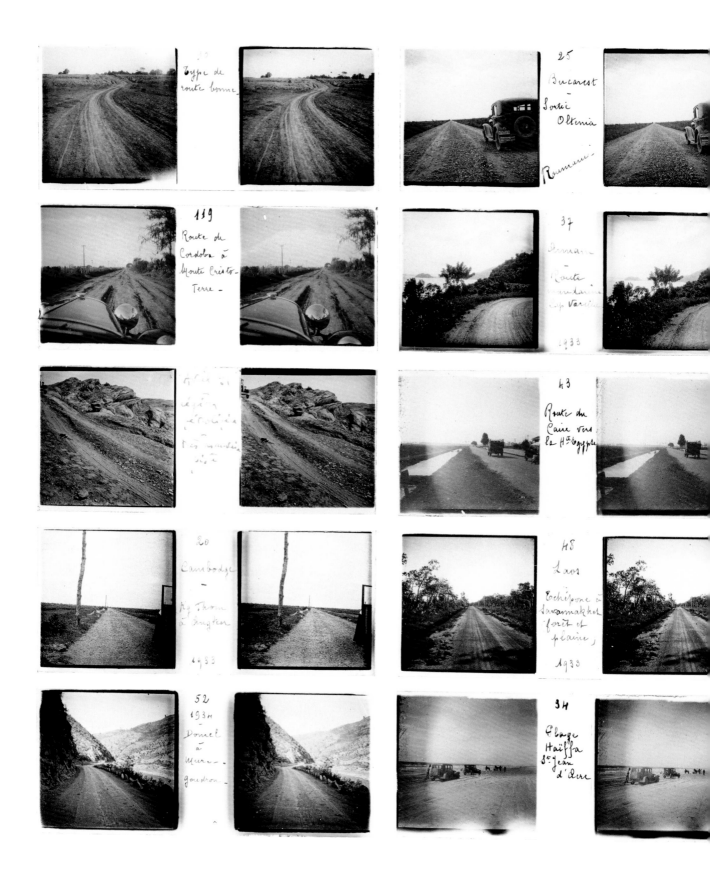

Michelin photographic survey of world roads, c. 1930

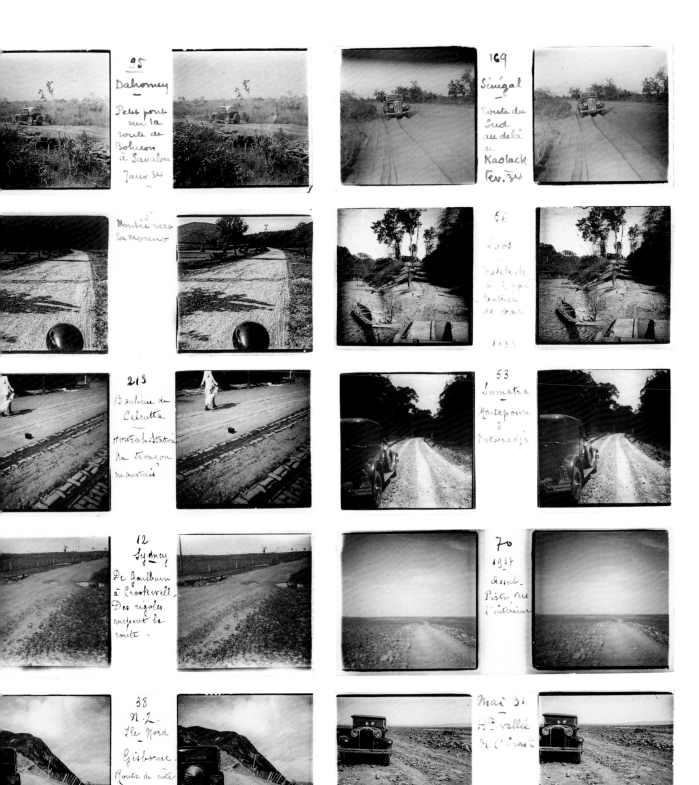

95
Dahomey
Petit pont
sur la
route de
Bohicon
à Savalou
Janv. 34

169
Sénégal
Route du
Sud
au delà de
Kaolack
Fev. 34

Montée vers
la Moreno

56
Laos
...
...
Montée
de bac
1933

213
Banlieue de
Calcutta
Howrah Station
Un tronçon
mauvais

53
Sumatra
Martapoura
à
Batseradja

12
Sydney
De Goulburn
à Crookwell
Des rigoles
coupent la
route.

70
1937
...
Piste ...
l'intérieur

38
N. Z.
Ile Nord
Gisborne
Route de côte
1933

Mai 31
H. vallée
de l'Oued

"Springtime and a road wide open ahead, when you are free to drive on for thousands of miles, free to camp, to stop or change itinerary at will, can give a great exhilaration. Only leaving harbor in one's own boat could one be more deeply stirred, for at sea the whole immensity is offered—no roads to force the keel along given lines." **Ella Maillart**

Ella Maillart *Entre Tabriz et Mâkou, Azerbaïdjan occidental*, 1937

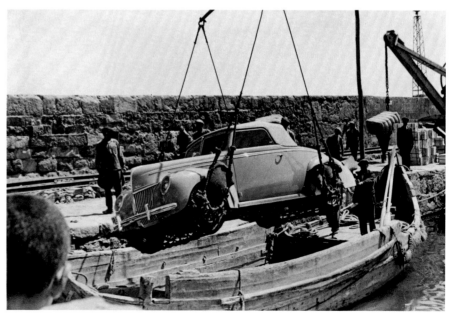

Ella Maillart *Notre Ford traversant la mer Noire dans une barque, Turquie, 1939 — Notre Ford s'apprêtant à traverser la mer Noire, Turquie, 1939*

Ella Maillart *Une « Utchako » japonaise sur une route en construction, Mandchukuo japonais*, 1934 — *Entre Tabriz et Mâkou, Azerbaïdjan occidental*, 1937

The "Croisière Noire" or "Citroën Central Africa Expedition," 1924–25

2872

"You don't travel in order to deck yourself with exoticism and anecdotes like a Christmas tree, but so that the route plucks you, rinses you, wrings you out, makes you like one of those towels threadbare with washing that are handed out with slivers of soap in brothels." **Nicolas Bouvier**

Nicolas Bouvier *Sur la route de Quetta, en direction du Pakistan*, 1954 — *Entre Prilep et Istanbul, Turquie*, 1953 —
Tabriz, Azerbaïjan oriental, 1953-54 — *Quetta, Pakistan*, 1953

Thierry Vernet *Nicolas Bouvier sur
la dépanneuse, route de Shiraz, Iran*, 1954

"To come across people in the desert is quite rare. I took this series of photographs in 1998 in Chad, at dusk. I had been staying in Tibesti for a month with two drivers, and I was heading back down to the south. While there has always been traffic of all kinds through this part of the Sahara, the Fezzan desert, I knew these were illegal immigrants. Back then, numerous migrant convoys were already making their way up to Libya. Only four possible routes exist: via Salvador, Kofra, Korizo, and Tumu. The people smugglers are generally Toubou people. The migrants are dropped off just after the border, before the town of Sheba, where complete anarchy reigns. Some even finish their journey by foot. Their chances of success are extremely low. Many are taken in by Cameroonian or Nigerian communities who help them along the route. Some are put in prison, others work on farms. Still yet a few make it up to Tunisia or Egypt. For them, it would be a dishonor to go back home." **Raymond Depardon**

Raymond Depardon *Tchad, traversée du Djourab*, 1998

"When this journey in the Karoo was initially suggested, environmental threats, stargazing, and the desert all seemed promising approaches. But at the end of the first day, some 400 kilometers later, the results were not looking good. The winter sun was inching towards the horizon. It was 4:28 p.m. An icy wind blew around the tabletop mountains. In the distance, a 4×4 was speeding up a track perpendicular to my own; while in its wake, a plume of dust began to appear, backlit. Desperate all day for even the tiniest 'visual event,' I had taken pictures. But I saw nothing after this until our stop that night. Having arrived at the Jupiter Guest House in Sutherland, I downloaded my memory card. In the very last sequence of pictures, behind a miniscule vehicle, this long trail of dust, encircled with a halo of light, stretched out to the right and left of the picture's composition. I had a brainwave: on my screen was a near-perfect metaphor for the threat of shale gases, which I wanted to report on yet they didn't exist, visually. I decided this cloud would become my common theme; it became the perfect prefiguration for a landscape whose fate hovered in the balance." **Alain Willaume**

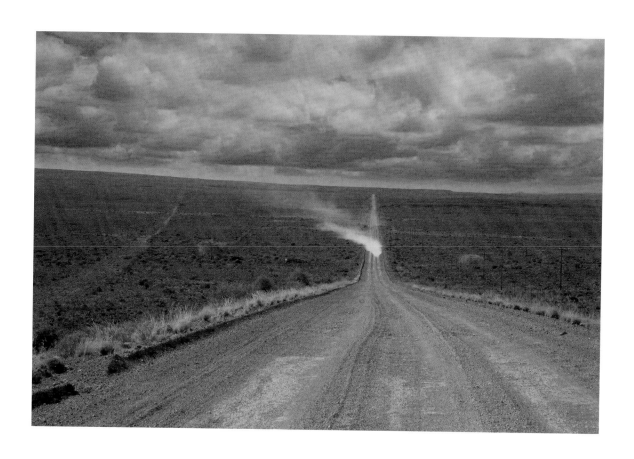

Alain Willaume #5069. *Échos de la poussière et de la fracturation* series, 2012

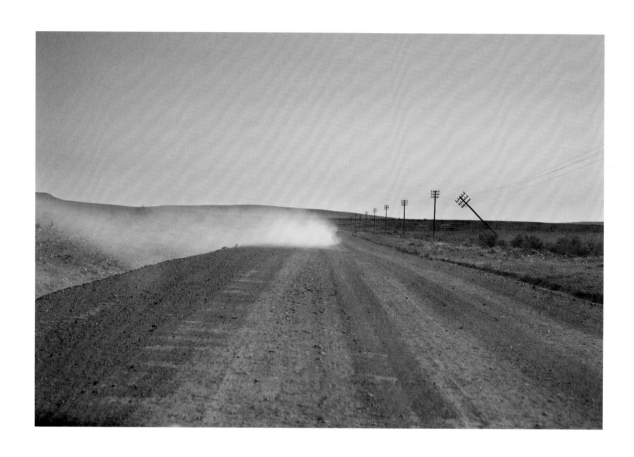

Alain Willaume #5331. *Échos de la poussière et de la fracturation* series, 2012

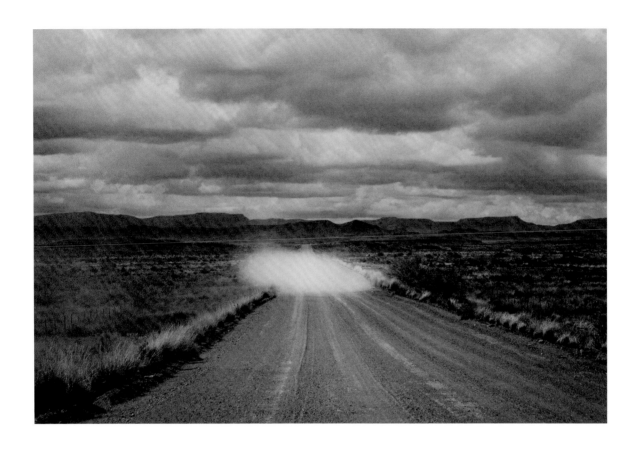

Alain Willaume *#4994. Échos de la poussière et de la fracturation series*, 2012

Motor City Madness

Nancy W. Barr

Since the mid-twentieth century, photographers have steadily turned to the subject of the automobile to elucidate the American Dream, its contradictory nature, triumphs, and failures. Their gaze has often led them to a place synonymous with the car, Detroit, Michigan, the city that put the world on wheels. Celebrated as the birthplace of auto manufacturing, which grew to such a proportion its nickname became the "Motor City," Detroit was known for its large-scale auto factories, assembly-line production, and labor force that enabled mass production as well as mass consumption of goods, most notably the car.[1] Out of this economic cycle—one vulnerable and prone to fluctuations—the automobile gained status as an enduring symbol of the American Dream, for better or for worse. And the mad obsession with cars along with the American Dream became a subject for artists and photographers who documented, investigated, and questioned their representation and meaning for those living in the US.

In the years just following the end of the Second World War, the city of Detroit was known internationally as the center of automobile manufacturing. Its reputation, in part, was built and promoted by business mogul Henry Ford. In 1927, the Ford Motor Company modernized and expanded its automotive production. The company moved operations from a small factory in Highland Park, Michigan, where the Model T had been built, to nearby Dearborn, Michigan, along the banks of the Rouge River, for production of the new Model A. The Ford Motor Company River Rouge factory became a sprawling complex known to locals as "The Rouge."[2] By 1955, the plant was at the height of production, in particular of the Ford Fairlane, and the factory along with its hard-working, blue-collar minions were integral to the era of unprecedented economic expansion and prosperity known to mid-century America. The mass-production of the automobile and its affordable prices for average American helped create a new product called "personal travel" and foster new businesses such as super-

Nancy W. Barr is Curator of Photography at the James Pearson Duffy and Co-Chief Curator at the Detroit Institute of Arts, Detroit

1. See Joel Cutcher-Gershenfeld, Dan Brooks, and Martin Mulloy, *The Decline and Resurgence of the US Auto Industry*, in EPI Briefing Paper #399, May 6, 2015 (Washington, DC: Economic Policy Institute), p. 12.

2. See Joseph Cabadas, *River Rouge Ford's Industrial Colossus* (Saint Paul, MN: Motorbooks International, 2004).

markets, motels, drive-in movies and restaurants, and business opportunities.[3] In the same year, Swiss-born photographer Robert Frank traveled to the city, taking photographs for a series that would become the groundbreaking photo book *The Americans*.[4] Frank's travel to Detroit was part of a year-long journey across the US to photograph how Americans "live, work, and spend their leisure time" and to create "a broad, voluminous picture record of things American past and present."[5] Frank drove across country looking at ordinary, routine, even dreary moments of day-to-day existence of US citizens in pursuit of the American Dream. At other times, he captured regional representations of life—movie stars in Hollywood, Jim Crow-era segregation in the American South, political hubris in the East, and in the industrial Midwest, Detroit auto workers. While in the Motor City, he went to the places where locals ate, played, and relaxed—public parks, drive-in movie theaters, and lunch counters. But critical to his series was a visit to the Rouge, where he could experience first-hand the factory, its auto workers, and the assembly-line production made famous by Henry Ford (p. 259).

When Frank arrived, the Rouge was experiencing its most productive years and had earned a legendary reputation internationally. The complex was unique in the industry and conceived as an all-inclusive, self-sufficient manu-facturing complex needing no outside suppliers. Raw materials were brought in to make steel that was stamped into car parts, which were built on assembly lines by workers. The factory became so famous that daily tours were offered for groups of international visitors who could witness production first hand. In 1955, more than 180,000 people toured the complex.[6]

Frank determined to "do the story on the factory," and spent several days there shooting engine- and final-assembly areas.[7] He described his experience in a letter to his wife Mary:

"Ford is an absolutely fantastic place. Every factory is really the same but this one is God's factory and if there is such a thing—I am sure that the devil gave him a helping hand to build what is called Ford's River Rouge Plant. But all the cars come out at one end … At the other end, the beginning of the plant, ships bring iron-ore from then on the whole car is built."[8]

Although Frank marveled at the automation of the plant, his photographs captured workers surrounded by metal and machinery, toiling away in end-less repetition on assembly lines, under harsh, gritty working conditions in exchange for a good day's wages and a chance to better their lives outside of the factory and attain the American Dream.

Despite the challenging surroundings at the Rouge, auto workers valued their jobs for the lives they were able to live away from the factories. As the cycle of

3. See Robert J. Gordon, *The Rise and Fall of American Growth. The US Standard of Living Since the Civil War* (Princeton, NJ: Princeton University Press, 2016), pp. 374–75.

4. Robert Frank included photographs from Detroit in several of his photo books including *The Americans* (New York: Grove Press, 1959), *The Lines of My Hand* (New York: Lustrum Press, 1972), and *Flower Is …* (Tokyo: Yugensha Kazuhiko Motomura, 1987). Of the fifty proof sheets taken in Detroit and found in the Robert Frank archives at the National Gallery of Art, Washington DC, twenty-four were shot at the Ford Motor Company River Rouge complex.

5. Robert Frank, "Guggenheim Application and Renewal Request," reprinted in *Robert Frank: New York to Nova Scotia*, eds. Anne W. Tucker and Philip Brookman (Houston, TX: Museum of Fine Arts, 1986), p. 20.

6. "All Time Record Set by Rouge Visitors from All over the World during 1955," *Ford Rouge News* (January 6, 1955), p. 4.

7. Robert Frank, telephone interview with the author (January 2001).

8. Robert Frank, letter to his wife Mary Frank, July 1955, reprinted in *Robert Frank: New York to Nova Scotia*, op. cit., p. 22.

mass production and mass consumption peaked at mid-century—car and truck sales jumped from 5.3 million in 1929 and 4.7 million in 1941 to 7.9 million in 1950 and 9.1 million in 1955—jobs related to car manufacturing provided for an abundance of secure employment to support a family and obtain all the materialistic trappings of modern American life, including a house, television, and a car in every driveway or garage.[9] The automobile also deterred development of widespread public transportation in the US, and gave rise to highways and the development of suburbs situated just on the outskirts of the city where Americans could live out their lives and raise their families in safe, clean neighborhoods with new homes, schools, and supermarkets.

In a series of found photographs titled the *American Dream* (p. 58), Sylvie Meunier and Patrick Tournebœuf uncover traditional American life but inadvertently reveal the underlying symbolism of the automobile as more than a convenient mode of transportation. In humble family snapshots from the decades just following the Second World War, the automobile's appearance is de rigueur. Cars appear severely cropped, awkwardly composed, or squeezed to the edge of the frame. But the four-wheeled steel machines of yesteryear, with their elegant long lines and dripping chrome are scene stealers nonetheless. These automobiles appear alongside their owners who transcend pride in ownership to convey a newly found self-determination in the years following the Second World War. They represent a new class of citizens, those that were upwardly mobile, empowered by material things and living the American Dream.

The postwar economic boom would not last forever, yet the automobile sustained a ubiquitous presence in America into the 1960s and 1970s, despite increasingly unstable economic conditions that threatened car sales and subsequently the labor force in the US. Accelerated manufacturing as well as the refinement of design and aggressive marketing strategies ensured continued sales in these decades, even though competition from international constituencies challenged Detroit's preeminence as an industry leader worldwide. As the market evolved, Detroit's major automakers, known as "The Big Three" (General Motors, the Ford Motor Company, and Chrysler), found it difficult to work through market transition and maintain operations exclusively in the city. They also struggled to stay relevant in an era of smaller more energy-efficient cars that could satisfy an increasingly diverse consumer base. Society was changing: automobiles were sought out by women, minorities, and a burgeoning consumer base comprised of a youthful counter-culture generation, who rejected their parents' values and mores.

After 1960, and in keeping with the American Dream, eclectic consumer tastes transformed the automobile market. This led to a greater range of promotional tactics and the creation of unique branding strategies geared toward

9. See Robert J. Gordon, op. cit., p. 379.

formulating lifestyle concepts that became associated with car makes and models—muscle cars for the youth market, station wagons for families, luxury vehicles and sports cars for those wishing to make a statement and enhance their social status. For example, the Cadillac, the Lincoln, and the Chrysler Imperial were associated with the executive suite; the three-hole Buick Century with the rising middle-executive; and the Oldsmobile, the Pontiac, and the Chevrolet with the middle-class.[10] As the so-called market segmentation grew for automobiles, buyers were targeted in advertising print media and commercials produced for television, but more interestingly, the public could peruse next year's makes and models at the annual Detroit auto shows.

As early as 1899, automobile dealers had devised a regionally based annual exhibition for the promotion of new makes and models before they made it to the dealer showrooms. Early auto shows established the formula for a spectacle-like showcase with elaborate displays, comely spokesmodels, and an opportunity to view futuristic concept and prototype cars or even take a seat behind the wheels of new models. By 1957, the show grew to include international automobile companies, and in 1965 the Detroit iteration of the auto show moved to Cobo Hall, a major convention and exhibition center located in the heart of the city.

Native Detroiter and street photographer Bill Rauhauser, whose large archive reflects the leisure time diversions of the Motor City's working-class men and women, took an interest in the auto shows for a series *Detroit Auto Show* (p. 354), made around 1975. The photographs bear witness to an automotive era of design that favored pared down styling, influenced by consumers' desire to own vehicles less ornate and less costly to maintain, as well as in response to pressure from a growing import market of lighter, sporty, fuel-efficient motor vehicles.[11] But Rauhauser's photographs also draw attention to the women in miniskirts or high heels who appear alongside the vehicles—a strategy used to attract visitors and inform potential buyers about the specifications of the cars themselves through scripted and assigned monologues.[12] Rauhauser's photographs render auto-show models as two-dimensional mannequins who stand on display alongside the vehicles spinning on "turntables," enhancing the strange, kitschy decontextualization of the automobile, a visual that came to characterize the auto-show experience.[13]

Around the same time that Bill Rauhauser was snapping photographs at Detroit's local auto show, Langdon Clay photographed parked cars in their real-time surroundings on the streets of New York City—perhaps the most celebrated of US cities, where so many first set foot to stake a claim in the American Dream (p. 21). The automobiles found in Clay's world are an irreverent nod to the Detroit dream machines that were staged and polished for auto-show displays. The late-model cars are dented, scratched, and sometimes

10. Ibid, p. 379.

11. See David Gartman, *Auto Opium: A Social History of American Automobile Design* (New York: Routledge, 1994), p. 169.

12. See Mary M. Chapman, "Car-Show Models Have Come a Long Way, Baby," *The New York Times* (October 20, 2009).

13. See John D. Stoll and Anne Steel, "The Evolution of Auto Show 'Booth Babes'," *The Wall Street Journal* (January 14, 2015).

even held together by duct tape while drenched in the rich ambient light of New York City streets at night. They seem right at home, like local night owls in their colorfully seedy surroundings—shifty rundown motels, sidewalks piled high with garbage, local boutiques, bathhouses, all-night diners, and bars that serve as backdrops in all seasons—rain, snow, sleet, or after the heat of a summer's day.

Clay's photographs show us a grittier time and place, now part of New York City's coveted past. The 1970s were an era of decline and alienation for large urban centers throughout America. No longer living in the boom era known to those just after the Second World War, the US economy of the 1970s slid in and out of economic recession and cities suffered. Although the Motor City would top them all with its new moniker the "Murder Capital," New York City in particular gained a widespread and well-known reputation for its mean streets, muggings, and disconnected citizens. It was then and still remains the US's largest city and its "make it there make it anywhere" slogan of the American Dream perpetuated itself despite the isolation and loneliness that seemed to characterize and stereotype existence there in the 1970s.[14]

It may seem strange that residents from this past era now long for the 1970s. It was a time before AIDS, the collapse of Wall Street, 9/11, and the much maligned and perpetual state of the city's continued gentrification, overpopulation, and high-rent real estate that has become a hallmark of life, if you can afford the experience, in twenty-first century New York City. Looking at Clay's photographs is quite like walking alone along these bygone streets. And these automobiles appear like long-lost relics from the past, as Luc Sante has written, "enormous boats … a testament to America's unlimited natural resources: oil, steel, rubber, naugahyde, and above all space [with] abundant free parking everywhere you went … since most of its population took the subway."[15]

The automotive industry, Detroit, and the notion of the American Dream changed dramatically after 1979, as chronic economic erosion ensued throughout the US.[16] Its citizens experienced blow after blow of cyclical recession influenced by rising gasoline prices due in part to the cut in oil production by the Ayatollah Khomeini, foreign competition, and the subsequent closing of factories and resulting unemployment. The cycle seemed to culminate in 2009 with a government bailout of General Motors (GM) and Chrysler, who were deemed "too big to fail," as their demise would result in cataclysmic economic repercussions throughout the world.

Within this apocalyptic American Dream-turned-nightmare scenario, Detroit and neighboring communities such as Flint, Michigan, suffered to extremes losing employment and population on a vast scale. Flint is like Detroit in respect to their shared dependence on a single industry and subsequent decline and loss of population. They are both places where the American Dream has long

14. See Edmund White, "Why Can't We Stop Talking About New York in the Late 1970s?," *T Magazine* (September 10, 2015).

15. Langdon Clay, *Cars: New York City, 1974–1976* (Göttingen: Steidl, 2016).

16. See Joel Cutcher-Gershenfeld, Dan Brooks, and Martin Mulloy, op. cit., p. 9.

gone into dormancy. Photographer Philippe Chancel's publication *Drive Thru Flint* takes a closer look at the city (p. 333). He offers fragmentary visual cues including aerial views of its decimated neighborhoods and empty lots, along with informal street portraits of its remaining citizens, vignettes of abandoned homes that stand in contrast to a close-up of a chrome-plated grill found on a vintage Buick automobile.[17] Made by GM, the Buick is a remnant from Flint's and the company's former glory days, when it was the largest car company in the world. In 1999, GM ceased Buick production entirely in Flint, where the automobiles had been made since 1904.[18]

In their critical pursuit of the American Dream, photographers have often relied on Detroit as a source of illuminating content and cars as subjects integral to the system and cycle that helped to support the American Dream. But they warn of present and potential dangers, as false perceptions surrounding its sustainability in perpetuity cannot be guaranteed. Looking to the automobile, photographers have shown that its relationship to the American Dream is indeed just that, a dream transformed into reality and enjoyed by some but transient, ephemeral, and lost for so many others. But at the same time these cars loom so large in the history of America that their undoing and eventual demise seems unthinkable. Without automobiles what is the fate of the Motor City? Detroit has experienced a rise in carless households in recent years.[19] The decline of the auto industry has made the cycle of mass production and mass consumption an obsolete economic model for the city and its people. Automobile factory closings, job losses and subsequent depopulation have Detroit's survival contingent upon an alternatively saner and more sustainable economy. And as Detroit moves into this new era—an uncharted territory for the city—the photographers who have immortalized its history have provided an indelible interpretation of its glorious and tarnished past, one shaped by the four-wheeled machines that rolled off its assembly lines. Their photographs have strangely predicted and chronicled the times leading to this present day dilemma, encouraging contemplation over the fate of the city, the automobile, the American Dream, and a destiny unknown.

17. Philippe Chancel, *Drive Thru Flint* (Bentivoglio: L'Artiere Edizioni, 2016). Philippe Chancel's *Drive Thru Flint* is part of a continuing series, *Datazone*, which includes photographs from nine international sites that frequent the news media. In addition to Flint, Michigan, Chancel has documented cities in Afghanistan, South Africa, North Korea, and India, among others.

18. General Motors had built a massive complex "Buick City" to rival Japan's "Toyota City" and combat foreign competition in 1984, but the Buick brand suffered due to its image as an automobile marketed to those over sixty-five years of age (the company has since rebranded the Buick with success but manufacturing is no longer in Flint).

19. Henry Grabar, "Can America's Worst Transit System Be Saved?," *Slate* (June 7, 2016).

"I had a friend that had connections with Detroit. And he said, 'I can help you if you want to photograph in a factory.' And otherwise I wouldn't have gotten in to photograph. And through that connection, that series of Ford started. And it was a very strong experience to get into the Ford factory, called the River Rouge Plant. It was really a fantastic place. It was in the summer and it was so hot in the factory and the noise was so fantastic. It was really like a little hell." **Robert Frank**

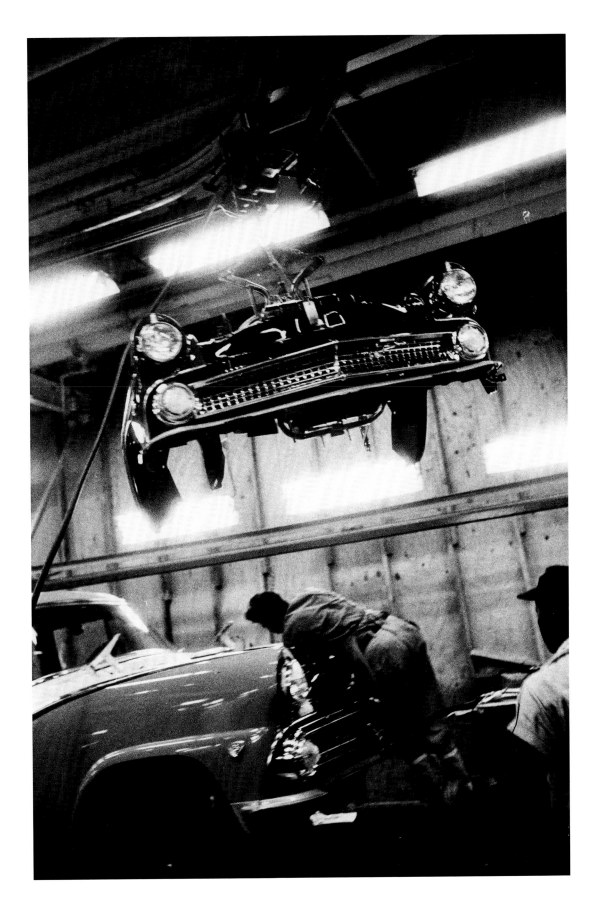

Robert Frank *Assembly Plant, Ford, Detroit*, 1955

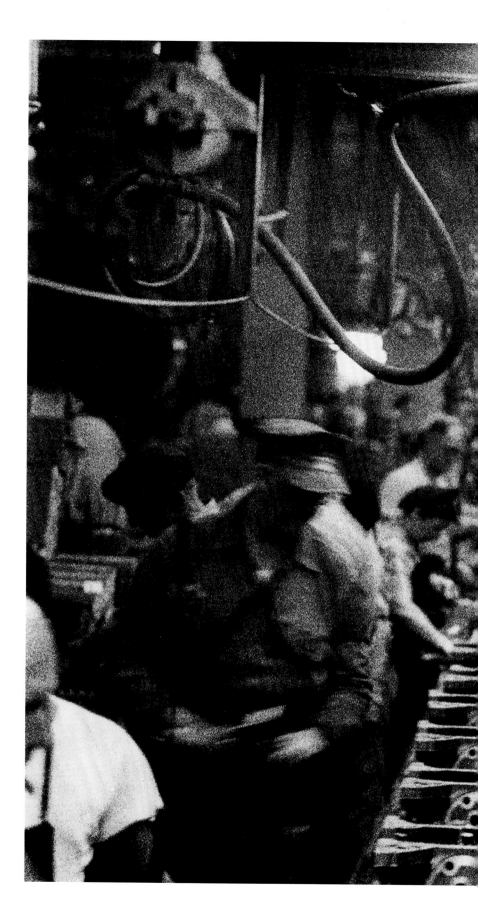

Robert Frank *Assembly Line, Detroit. The Americans* series, 1955

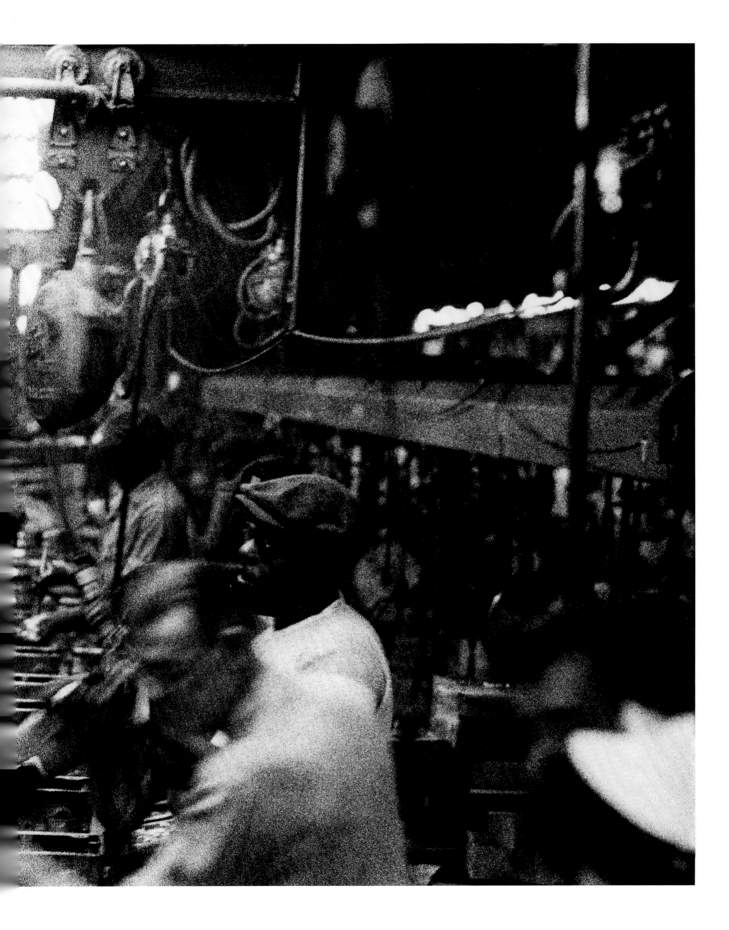

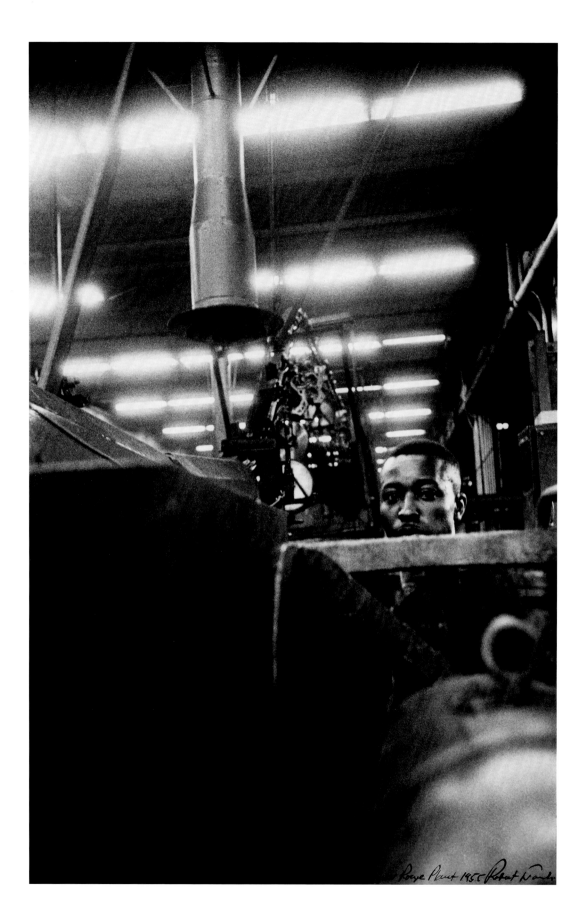

Robert Frank *Ford River Rouge Plant*, 1955

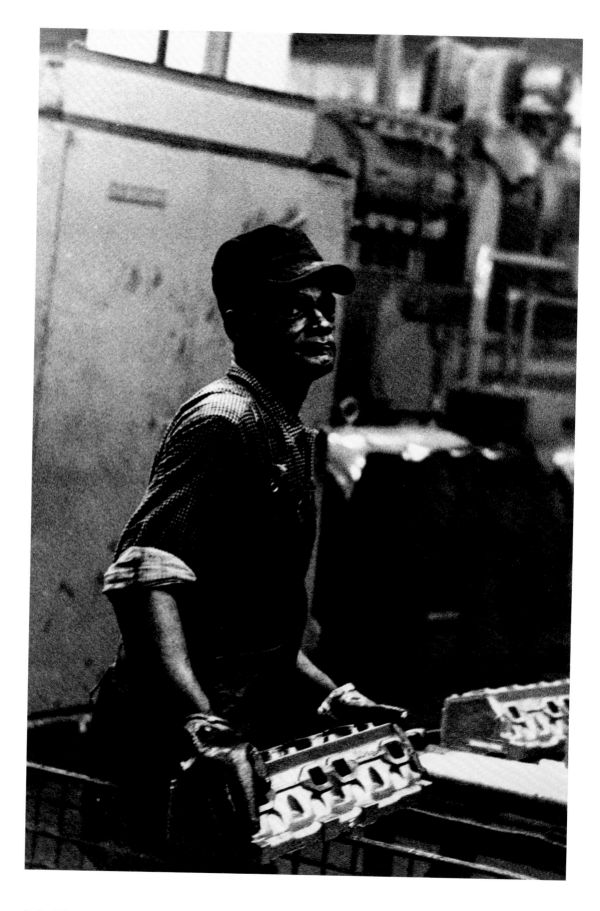

Robert Frank *Untitled*, 1955

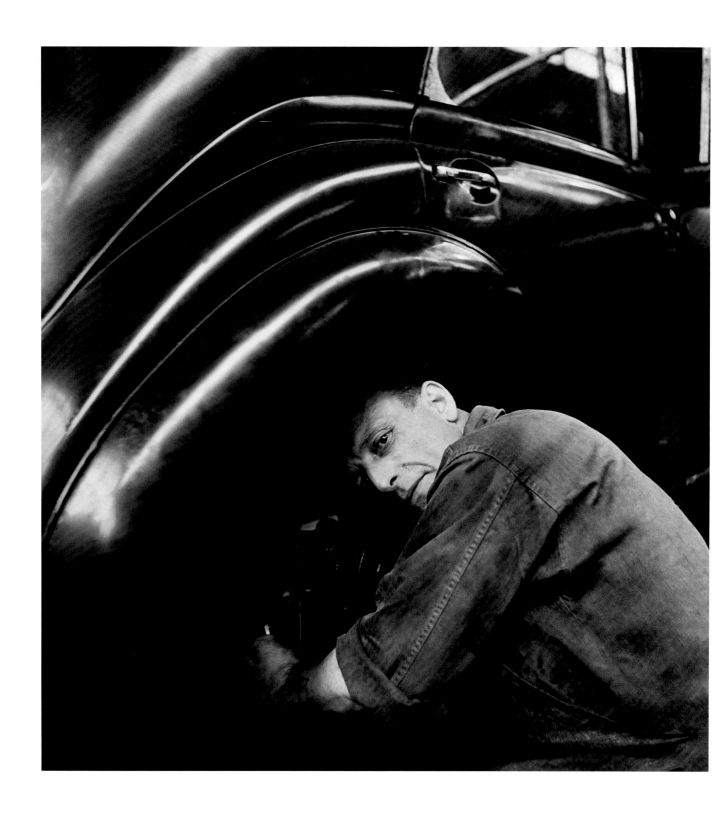

Robert Doisneau *Chaîne de montage, Usine Renault, Boulogne-Billancourt*, 1945

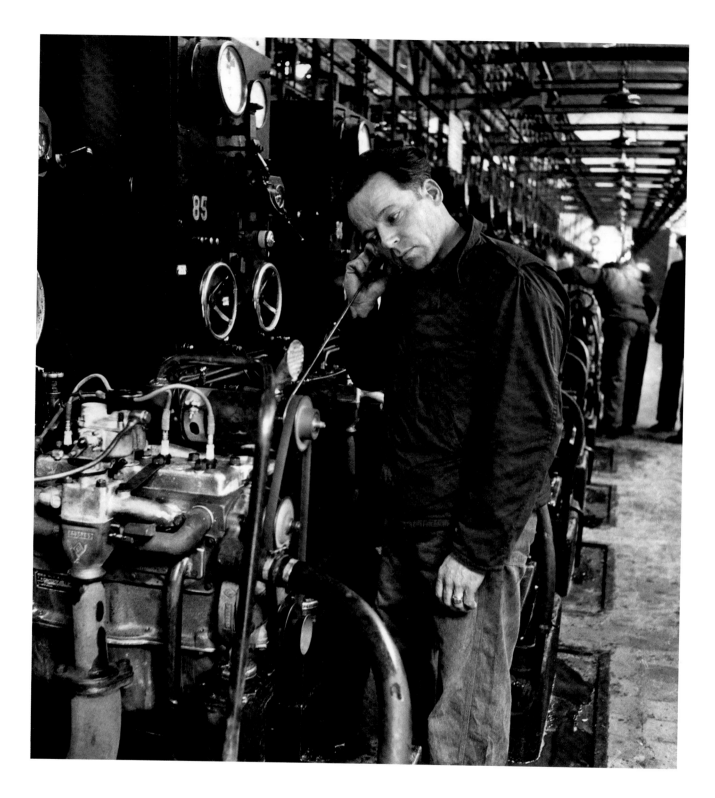

Robert Doisneau *Usine Renault, Boulogne-Billancourt*, 1945

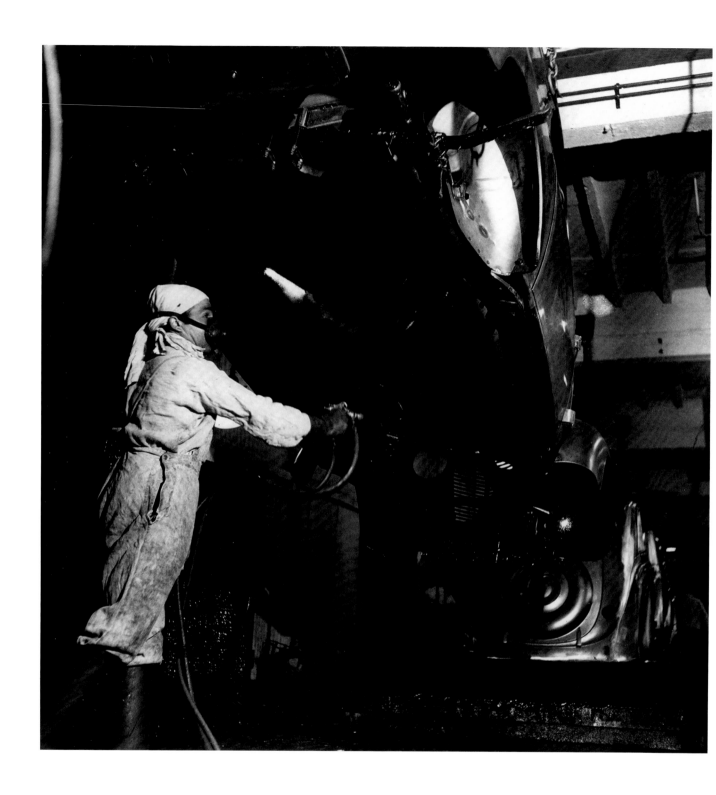

Robert Doisneau *Pistoleteuse, Usine Renault, Boulogne-Billancourt,* 1945

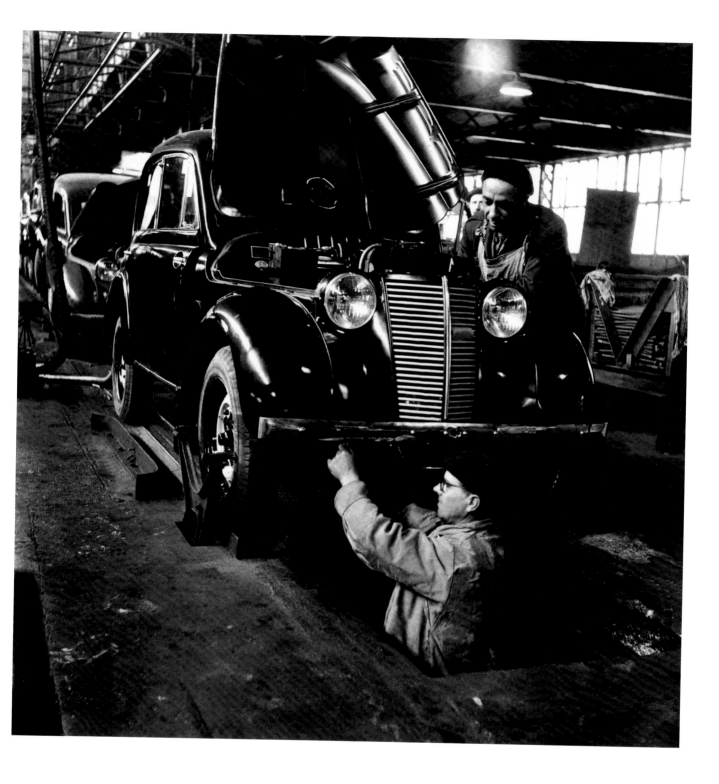

Robert Doisneau *Chaîne de montage Juvaquatre et Primaquatre, Usine Renault, Boulogne-Billancourt, 1945*

Peter Keetman *Stoßstangen. Eine Woche im Volkswagenwerk* series, 1953

Peter Keetman *Vordere Abschlussbleche. Eine Woche im Volkswagenwerk* series, 1953

Peter Keetman *Hinterachskegelräder für das Differential. Eine Woche im Volkswagenwerk* series, 1953

Peter Keetman *Vordere Abschlussbleche. Eine Woche im Volkswagenwerk* series, 1953

Peter Keetman *Hintere Kotflügel. Eine Woche im Volkswagenwerk* series, 1953

Peter Keetman *Türen für den Käfer. Eine Woche im Volkswagenwerk* series, 1953

"I was in New York after September 11 and I saw pieces of scrap metal from Ground Zero being taken to New Jersey by truck. These pieces of scrap metal were covered in white dust and in my imagination, they were mixed with human flesh. Realized one year later, I think my work on car engines is a bit about exorcising what I had felt in New York. Metaphorically, these engines resemble human organs. What creates the organic feel of these images are all the pipes, hoses, nuts, and tiny mechanical pieces—black and white turns the dust recovering these mechanical organs into ash residues." **Valérie Belin**

Valérie Belin *Untitled*, 2002

Valérie Belin *Untitled*, 2002

Valérie Belin *Untitled*, 2002

"I took these negatives to produce, or more precisely, start reproducing, the main volumes of a Ferrari '599.' For the car body, giant metal casts are used to mold sheets of steel or aluminum. For the engine, it is clay casts, intricately formed, into which liquid aluminum will be poured at very high temperatures, and into which, not even the tiniest air bubble is allowed to pass. From these first acts, the forms of a car body, as aesthetic as they are aerodynamic, begin to take shape, as mechanical architecture. The engine, after going through countless processes itself, will be the final piece to breathe life into this dream machine." **Alain Fleischer**

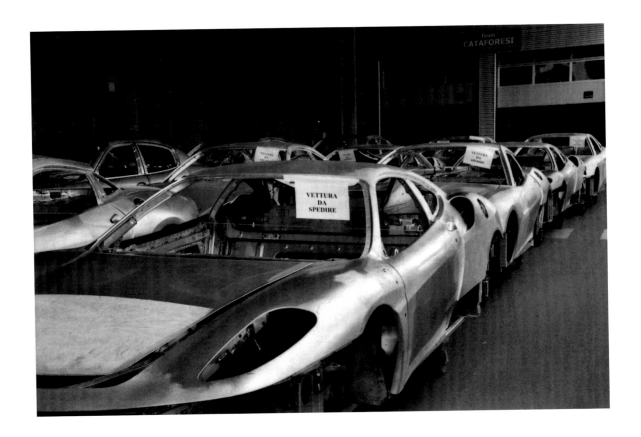

Alain Fleischer *Maranello, sortie de la chaîne carrosserie de la Ferrari 599 Fiorano, 2007*

Alain Fleischer *Ferrari 599 GTB Fiorano, forme d'emboutissage pour le passage de roue avant gauche*, 2007

"For my series *Melting Point*, I chose to play with the positive aspects of film photography by experimenting with the digital format. The actual shots and printing remained film based, but the digital process, meaning scanning my negatives, allowed me to explore how we see, and also to analyze the input of this new technology. Photography is becoming a hybrid, playfully mixing the positives and particularities of the two practices. In this sense, *Melting Point* is close to its subject matter, the assembly line of a car, which symbolizes an alloy of different elements." **Stéphane Couturier**

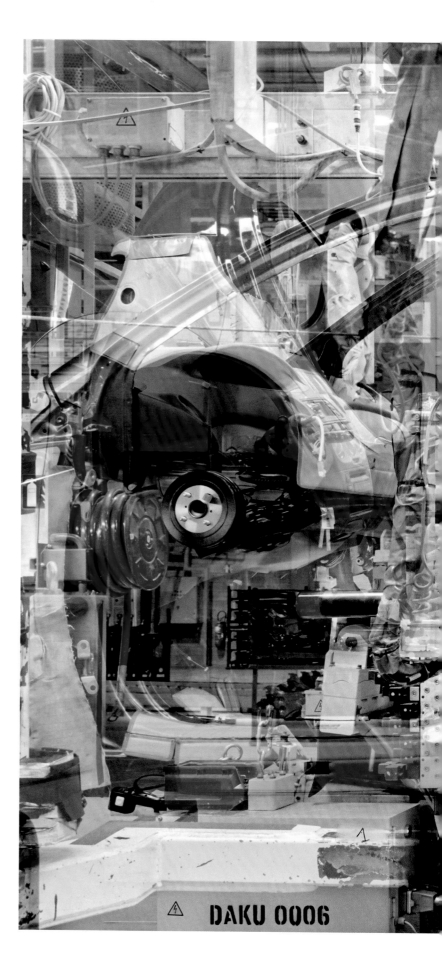

Stéphane Couturier
MELT, Toyota n° 12. Melting Point,
Usine Toyota, Valenciennes series, 2005

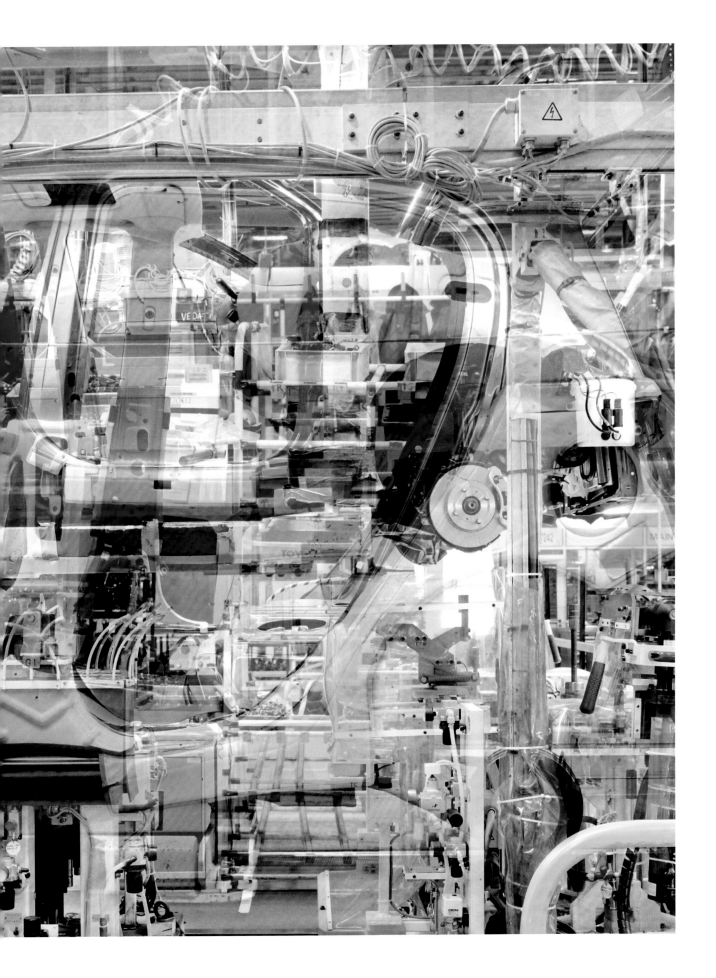

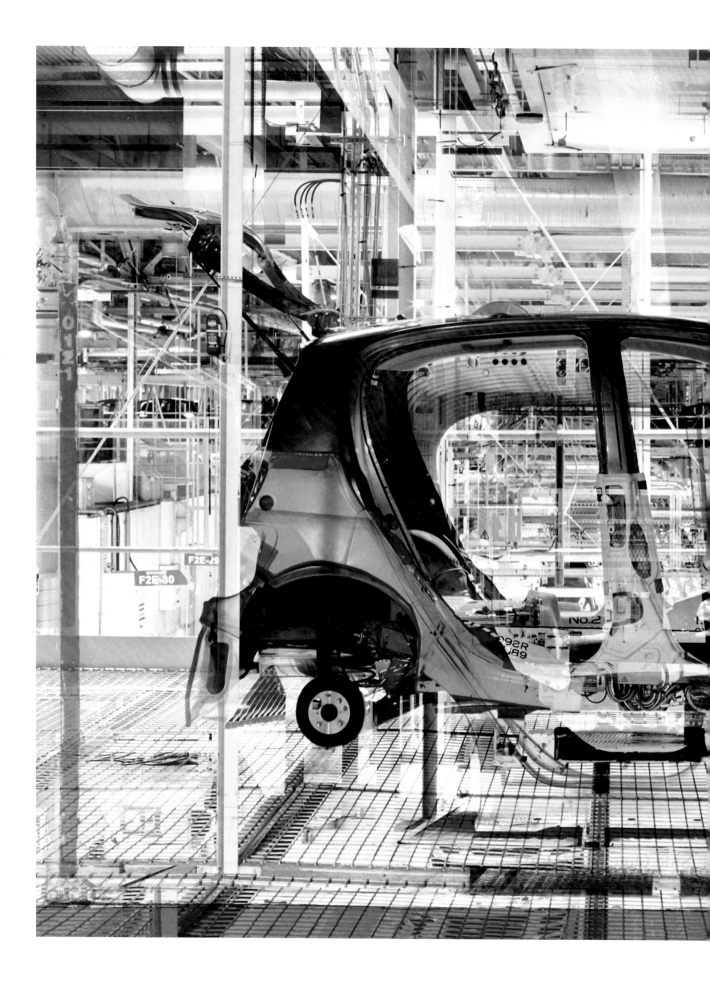

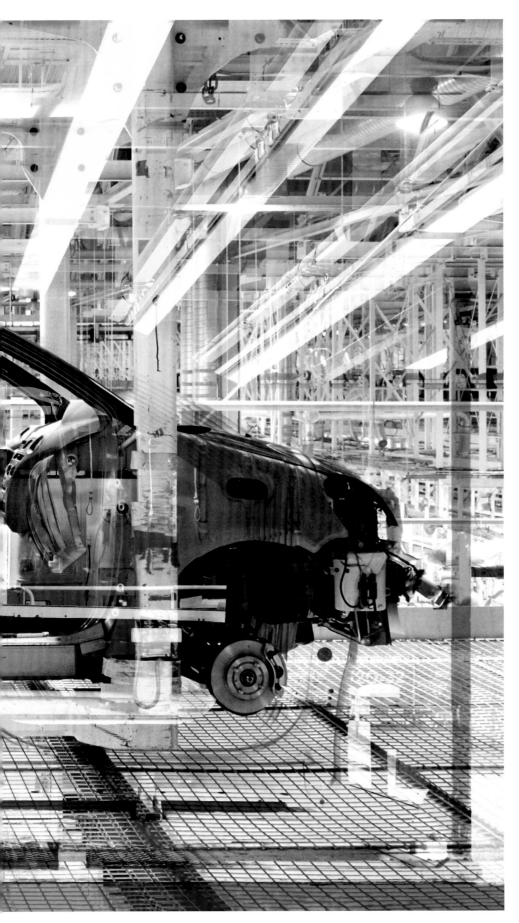

Stéphane Couturier
MELT, Toyota n° 8. Melting Point,
Usine Toyota, Valenciennes series, 2005

"It was a strange moment when we were lying under the car for the first time. The car was flying three meters high above us. Then, when we saw the final photographs we were quite surprised how they looked like. The expensive cars didn't look as good as the cheaper ones. Seeing a Citroën 2CV was much more exciting than looking at the underneath of a beautiful Porsche 911. But then you get used to this kind of dark aesthetics. The cars are not what you would expect from underneath." **Kay Michalak and Sven Völker**

Kay Michalak and Sven Völker *Auto Reverse #13, Mercedes-Benz 230 CE, Model 1984, 232 896 km, 2011–15 — Auto Reverse #11, Volvo 940, Model 1993, 256 271 km, 2011–15 — Auto Reverse #2, Jaguar E-Type, Model 1970, 98 450 km, 2011–15*

"We wanted to build a showcase car that would highlight the creativity and skill of the mechanics and artisans of one of the largest car districts in the world, Suame Magazine in Kumasi, Ghana. We wanted to build it without any preconceived ideas. We were going to let ourselves be led by local preferences and the opportunities on offer around us. It was to be a mix of reused car parts and handmade one-of-a-kinds created by the tinkerers of Suame." **Melle Smets and Joost van Onna**

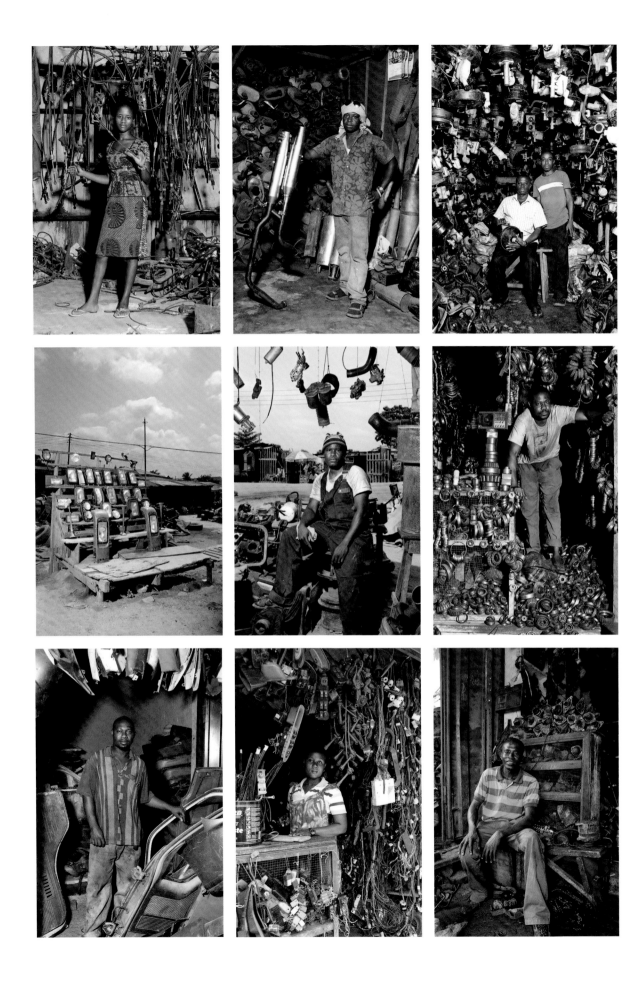

Melle Smets and Joost van Onna *Turtle 1. Building a Car in Africa*, 2016

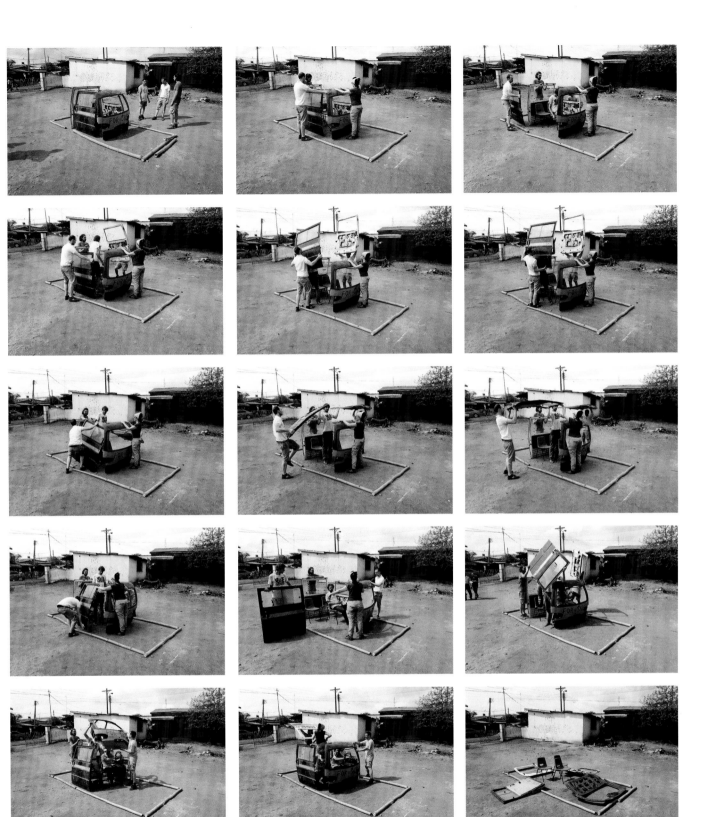

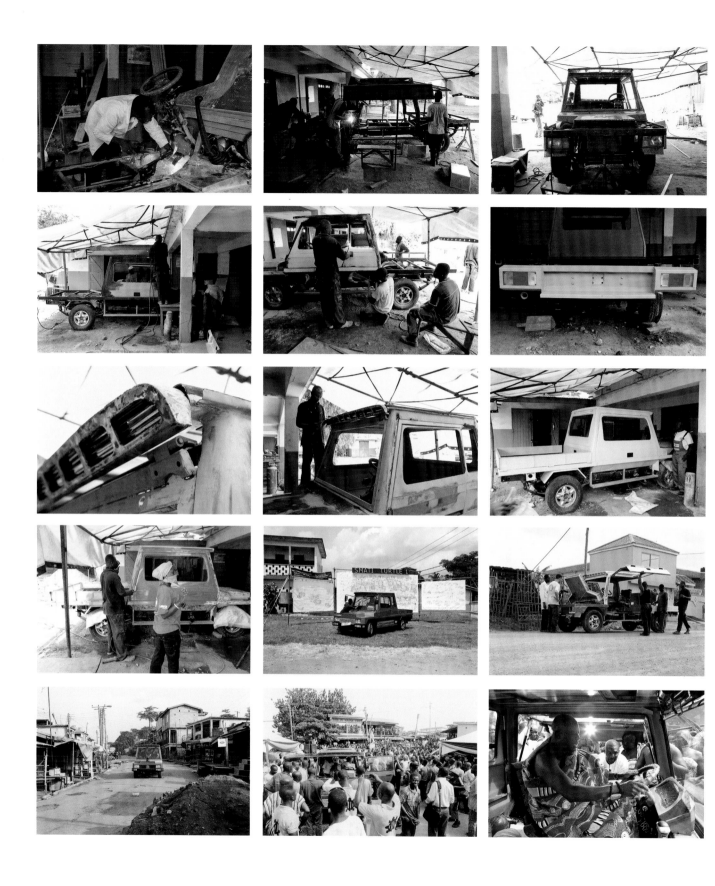

Melle Smets and Joost van Onna *Turtle 1. Building a Car in Africa, 2016*

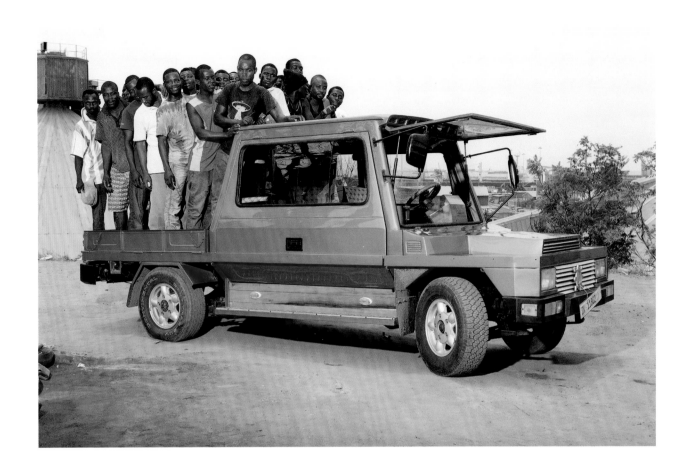

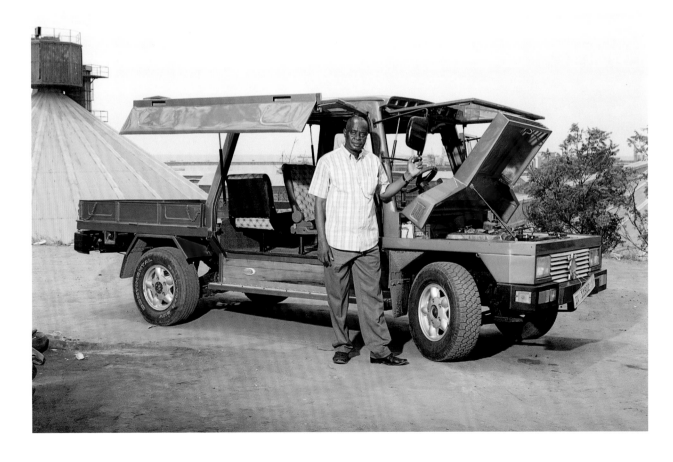

"*Badly Repaired Cars* was conceived when I began spotting some very unusual fix-ups on parked cars when I was walking home from work in London. I soon realized that it didn't matter what type of car it was, how wealthy the area was that I found them in, what ethnicity or how old the owner was —the methods of repair were generally the same. Common denominators are rare nowadays and the whole thing captivated me. So I went around shooting cars in the East End of London with the intention of dedicating a series of photos to bad DIY par excellence." **Ronni Campana**

Miguel Rio Branco *2-1 Perdió, Mexico*, 1985

Miguel Rio Branco *Talons aiguilles en papier, Mexico*, 1985

In Praise of the Photographic Accident

Clément Chéroux

"Failure is completely natural. It is a good lesson. That is why it is important to keep less than satisfactory photographs because in three, five, or ten years, you will perhaps discover something in them you had once felt."[1]

This is how amateur photographer Jacques Henri Lartigue describes a curious phenomenon that has haunted all of photography's history: the changing status of images. Certain photographs that are considered failed: "unsuccessful," "accidents," "bothersome," or "small miseries" (*petites misères* in French) as they were frequently referred to in the nineteenth century, can indeed become interesting over time, as tastes change, as do certain other parameters, which are the subject of this essay. This is the case with one of Lartigue's most famous photographs: *Une Delage au Grand Prix de l'Automobile Club de France de 1912* (p. 312).[2]

According to the rules of photographic propriety that were in effect at the time Lartigue took this image, this was a failed photograph, and indeed a thrice-failed one. The image is blurry, off-center, and distorted.

First of all, part of the main subject has been truncated due to a problem with the photograph's framing. Moreover, Lartigue himself wrote in his journal, on July 22, 1911 and on October 7, 1912, about two other cars that had been cut in a similar fashion, that these photographs had been "badly taken." The car appears squashed, shriveled, as if it had just crashed into the white wall seen in the margins of the image. It is indeed an accident, as much for the photograph, as it is for the car.

Another flaw: the road and the background appear blurry, while the car, despite the fact that it is moving at high speed, is in focus. In an article prosaically entitled "Les Petites Misères du photographe" (The small miseries

Clément Chéroux is photography historian and chief-curator of Photography at the SFMoMA, San Fransico.

1. Jacques Henri Lartigue quoted by Pierre Bonhomme, "L'Indéfinissable Œuvre photographique," *La Recherche photographique*, no. 18 (Spring 1995), p. 56.

2. By a curious effect of repetition, it seems that Lartigue also made a mistake in this image's caption. Car historian Marc Douëzy pointed out to the Association des Amis de Jacques Henri Lartigue that the car was not, in fact, a Delage but a Th. Schneider. There was no car wearing the number six at the ACF Grand Prix of 1912, therefore this car was actually the Th. Schneider driven by Maurice Croquet during the 1913 ACF Grand Prix.

of the photographer), published in *Photo-Revue* in 1901, and intended to solve amateur photographers' problems, René d'Héliécourt comments on a similar example: "Everything that makes up the mobile foreground [is] of a very satisfactory clarity or sharpness, while the figures ... situated in the background—immobile—appear in double."[3] An explanation for the phenomenon is given a few lines later: "Like a marksman whose gaze follows a mobile target, at the moment of pulling the trigger the photographer is involuntarily brought to make his line of vision align with the angular displacement of his model, when he is about to shoot."[4] The camera is therefore endowed with a movement analogous to that of the subject, the latter is clear, while the immobile or fixed decor is no longer so.

Finally, a third accident: the deformation or distortion of the image. Articles devoted to amateur mistakes regularly examine the distortions brought about through the use of the focal-plane shutter.[5] This device is made up of two shutter curtains in front of the camera's focal plane, which form a slot that moves parallel to the plate and open successively. If the shutter curtains open at a slower speed than the object being photographed, the result is a distortion in the direction of the object's movement: towards the right in the case of the car and towards the left for the spectators in the background (even though the spectators are not moving—the movement of the camera to the right results in them leaning towards the left). This is the reason why car No. 6 has improbable oval wheels, and the spectators watching it drive past appear to suddenly defy the effects of gravity.

In this era, Lartigue was not the only one to develop a passion for car races. At the cutting edge of the artistic avant-garde, the Futurist movement also celebrated the car as the symbol of technology, modernity, speed, power, masculinity, the simultaneity of vision ... in short, everything that constituted their ideology. "A roaring automobile that seems to ride on grapeshot—that is more beautiful than the *Victory of Samothrace*," writes Filippo Tommaso Marinetti in 1909 in the Manifesto of Futurism.[6] This passion for the automobile becomes "autolatry" (in the double sense of the term) in the numerous photographic portraits of the Futurists at the wheel of their powerful cars. It is even more obvious in the multiple paintings by Giacomo Balla, Umberto Boccioni, Carlo Carrà, and Luigi Russolo representing racing cars at full speed. Of course, the Futurists wondered about how best to represent speed: "To depict a wheel in motion, it no longer occurs to anyone to observe it at rest, counting the number of spokes and measuring its curves, and then draw it in movement. It would be impossible,"[7] writes Boccioni in 1914. And the visual solutions that they found to represent movement: blurriness, deframing, distortion, etc. are not unlike the effects Lartigue accidentally obtained at the same period.

3. René d'Héliécourt, "Les Petites Misères du photographe," *Photo-Revue*, no. 42 (October 20, 1901), p. 122.

4. Ibid.

5. See C. Welborne Piper, "The Photography of Moving Wheels," *The Amateur Photographer* (January 2, 1902), pp. 12–13 and (April 16, 1903), pp. 311–13; Charles F. Rice, "L'Obturateur focal. Déformations auxquelles il donne lieu," *Photo-Revue* (January 10, 1908), pp. 20–21.

6. Filippo Tommaso Marinetti, "The Found Manifesto of Futurism," in *Futurism: An Anthology*, eds. Lawrence Rainey, Christine Poggi, and Laura Wittman (New Haven, CT: Yale University Press, 2009), p. 51. Originally published in *Le Figaro* (February 20, 1909).

7. Umberto Boccioni, "Absolute Motion + Relative Motion = Dynamism," in *Futurism: An Anthology*, op. cit., p. 189.

However, these effects persisted, and in Lartigue's work and in the handbooks destined for amateurs,[8] were categorized as accidents. Retrospectively, as is common in the history of photography, it was necessary to wait several years before photographers accepted these same effects, which emerged as the iconographic codes of mobility and speed.

In the 1920s, photographs similar to those of Lartigue's begin to regularly appear in illustrated magazines.[9] In 1929, in *Es kommt der neue Fotograf!*, a veritable iconographic and programmatic repertoire of the New Vision movement, Werner Gräff published a photograph of a car deformed by speed, writing: "The distortions which were once a headache for opticians are now more sought after than ever before, [the new photographer] is familiar with and makes use of the distorting effects brought about through the use of the focal-plane shutter."[10]

In 1924, Man Ray sent to his friend Francis Picabia, who also enjoyed "being photographed at the wheel of one of his big cars," a photograph of a distorted car, accompanied by the following inscription: "À Francis Picabia en grande vitesse" (To Francis Picabia at great speed) (p. 313).[11] Man Ray who willingly called himself a "fautographe"[12] and championed the importance of accidents in his own discoveries (photograms, solarization and even the haziness in his portrait of the Marquise Casati), could not help but notice how the blurriness of the car and its accidental distortion considerably increased the dynamism and energy of the image.

In the space of several years, these incongruous images thus went from the status of a "failed photo" to that of a successful one. Lartigue, who regularly drew photographs he had taken in his notebooks, did not draw the one taken at the ACF Grand Prix. It was not until the 1950s that he would unearth the image for the same reasons that had forced him to put it aside three decades previously: the blurriness, the distortion, and the misframing. The image that was initially judged as failed was reproduced in large numbers and celebrated, becoming a remarkable feat, or even "a splendid idea," in the words of the former director of the photography department of the Museum of Modern Art, John Szarkowski.[13] However, it was most likely in 1999 that this photograph reached its apogee of success. The image was repeatedly selected by some of the most important photography reviews at the turn of the millennia as being one of the century's most significant images: *Les 100 Photos du siècle*; "Un siècle en France, les plus belles photos"; *Fotografie! Das 20. Jahrhundert*; *100 al 2000. Il secolo della fotoarte*, etc. Lartigue's failed photograph had become one of the most "striking," most "beautiful" images of the twentieth century.[14]

What are the reasons for such a reversal? How is it that an image that was initially deemed to have failed could succeed to the extent that it is today classified as one of the most iconic images of the twentieth century? In more general

8. See Georges Brunel, *Les Insuccès et la Retouche* (Paris: Bernard Tignol, 1899); V. Cordier, *Traité des insuccès en photographie. Causes et remèdes* (Paris: Liébert, 1895); Léopold Mathet, *Les Insuccès dans les divers procédés photographiques* (Paris: Charles Mendel, 1893); G. Naudet, *Insuccès photographiques. Comment les éviter, comment y remédier* (Paris: H. Desforges, 1900); Étienne Wallon, *Les Petits Problèmes du photographe* (Paris: G. Carré, 1896).

9. See for example *The Illustrated London News* (July 14, 1923), p. 88.

10. Werner Gräff, *Es kommt der neue Fotograf!* (Berlin: Verlag Hermann Reckendorf, 1929), p. 62.

11. Man Ray, *Autoportrait* (Paris: Seghers, 1986), p. 172. The same photograph was published in 1925 without an author or caption in *La Révolution surréaliste*, no. 2 (January 15, 1925), p. 30. To my knowledge, nothing proves that the image was taken by Man Ray (other photographs by the artist in the same publication are signed) nor that Picabia was the subject of the image. What remains is the appropriation of the image and its dedication to Picabia.

12. "Fautographe" is based on a play on words between the French words for "*faute*" (mistake) and "*photographe*" (photographer).—Trans.

13. John Szarkowski, quoted by Marie-Monique Robin, *Les 100 Photos du siècle* (Paris: Chêne, 1999), p. 6.

14. See "Un siècle en France, les plus belles photos," *Le Figaro Magazine*, no. 17227 (December 31, 1999), n.p.; *Fotografie! Das 20. Jahrhundert* (Munich: Prestel, 1999), p. 23; *100 al 2000. Il secolo della fotoarte* (Bologna: Photology, 2000), p. 51.

terms, why is it that the majority of the twentieth century's technical accidents: blurriness, double exposure, distortion, misframing, solarization, etc., were transformed by the twentieth century's avant-gardes into artistic proposals?

In order to understand this, it is enough to compare photography to a type of software. The French-language dictionary *Robert* defines software as an ensemble of rules and programs relative to the processing of information. The photographic tool is indeed made up of a whole host of adjustable parameters: the shutter speed, the film sensitivity, focus and focal length, the opening of the aperture, etc., which manage the visual data so as to transform it into an image.[15] However, it may so happen that this well-calibrated mechanism sometimes produces failed shots. Like a potentiometer that has been pushed to its limit, whether by chance or inadvertence, one of the parameters has been changed and the entire device is altered, thereby resulting in accidents.

As for the avant-garde artists, nothing interested them more, in fact, than adjusting or changing the parameters of the device to test the medium's potential. "The most surprising possibilities can be discovered in photography. The detailed analysis of each of these aspects provides us with a quantity of indications as to the value of their application, adjustment, etc.," writes László Moholy-Nagy.[16] Therefore, a certain photographer will intentionally modify the parameter of exposure time, providing, through the blurriness, a sense of movement to his or her image. Another photographer may choose to make use of a very wide angle resulting in an abnormal distortion of bodies, etc. It is these parameter variations, these shifts in terms of the norms established by the professional photographers of the nineteenth century (to which amateur photographers attempted to conform) that determine much of the photographic aesthetic from the avant-garde onwards.

But whether these are involuntary (in the case of amateur accidents) or premeditated (in the case of avant-garde experimentation), these parameter variations have always had the same visual consequences on the image. This is the reason why the accidents of the nineteenth century are so close in appearance to the aesthetic proposals of the twentieth century.

It remains to understand why avant-garde artists were interested in the business of systemically readjusting the medium's parameters. If they strove to such an extent to pervert the rules of the photographic doxa, it was not merely because of their penchant for provocation, or their spirit of contradiction, but also because they had likely understood that photography was not just a simple tool of mimesis.[17] For example, Moholy-Nagy once claimed that he wished to go "against the traditional conception that considers photography to have reached its apogee when it is imitative."[18] If photography was not then this objective, sincere, and transparent machine that we had wanted to make it appear, why not turn it on its head in order to explore other modes

15. An image-processing software like Photoshop has, for example, made the process of photography and all its parameters more streamlined.

16. László Moholy-Nagy, "A fotografia: napjaink objectiv latasi formaja (The objective vision of our day)," *Korunk*, vol. 8, no. 12, pp. 911–13.

17. See André Gunthert, "La Photographie, laboratoire du visible," in *Vive les modernités! Rencontres Internationales de la Photographie – Arles* (Arles: Actes Sud, 1999), pp. 31–33.

18. László Moholy-Nagy, "La Photographie dans la réclame" [1927], in op. cit., p. 137.

of representation? "The unexpected virtues of the photographic process," to again cite Moholy-Nagy, "were more likely than not revealed to us through the accidental results of amateur photography."[19] In this exploration of representation, supported by a veritable crusade against mimesis, photographic accidents justly proved themselves to be useful allies. They were even, most likely, the worst enemies of mimesis.[20] Because if a successful photograph is one that resembles reality most closely, a failed photograph is one that alters the mimesis, transforming reality until it is no longer recognizable. In this regard, the failed photograph par excellence would be one that is completely black, white, or gray.

The veritable triggers of a modern vision, photographic accidents allowed avant-garde artists to deconstruct an already obsolete mimetic representation while at the same time, opening up new visual perspectives.

I would like to thank Martine d'Astier and Michaël Houlette from the Association des amis de Jacques Henri Lartigue for their invaluable advice in the writing of this article.

Translated from the French by Emma Lingwood

Text first published in Photographies / Histoires parallèles. Collections du musée Nicéphore Niépce *(Chalon-sur-Saône: Musée Niépce / Paris: Somogy, 2000).*

19. László Moholy-Nagy, quoted in *László Moholy-Nagy. Compositions lumineuses, 1922-1943* (Paris: Centre Georges-Pompidou, 1995), p. 99.

20. See Peter Geimer, "Noise or nature? Photography of the Invisible around 1900," in *Shifting Boundaries of the Real: Making the Invisible Visible*, eds. Helga Nowotny and Martina Weiss (Zurich: Hochschulverlag, 2000), pp. 119–35.

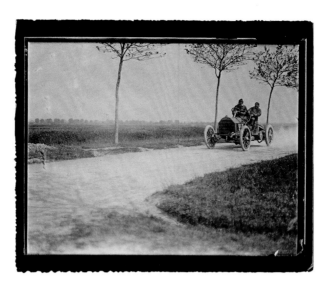

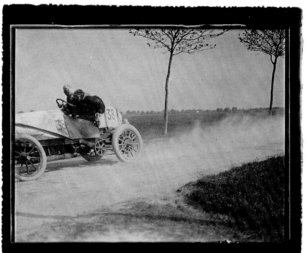

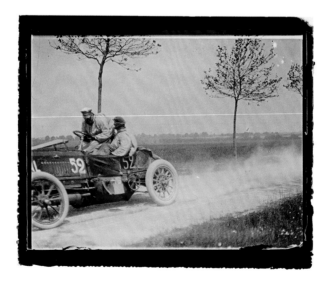

Guido Sigriste *Gasteaux sur Mercedes 60 HP, 1903 — Farman sur Panhard & Levassor, 1903 — Turr sur Panhard & Levassor 40 HP, 1903 —*
Koechlin sur Gobron Brillié 110 HP, 1903 — De Brou sur De Dietrich 45 HP, 1903 — Marcel Renault sur Renault Frères 30 HP, 1903

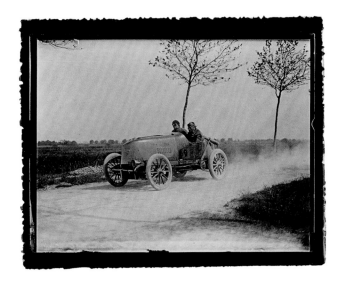

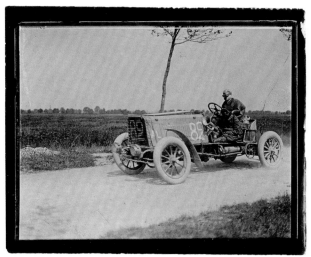

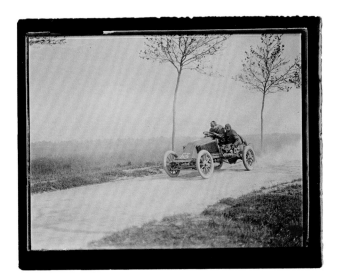

These photographs were taken by Guido Sigriste during the 1903 Paris-Madrid race with a camera he invented that enabled him, through its ingenious shutter system, to capture rapid movement for the first time.

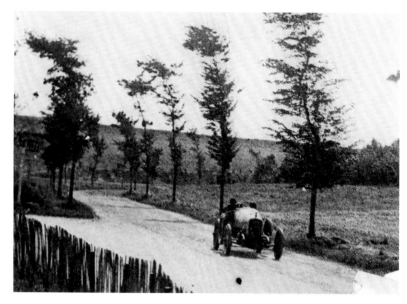

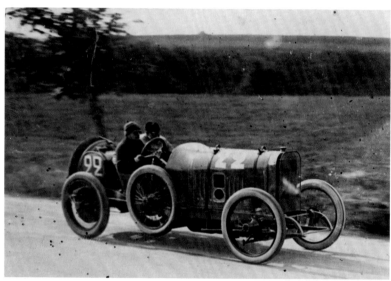

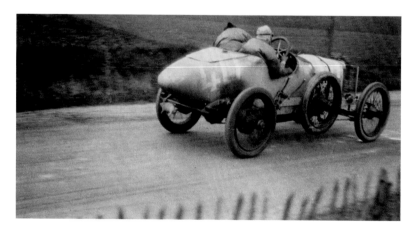

Jacques Henri Lartigue *Grand Prix de l'Automobile Club de France, circuit de Dieppe*, June 26, 1912. Excerpts from the 1912 original album
Victor Rigal sur Sunbeam — Georges Boillot sur Peugeot — Léon Duray sur Alcyon —
Richard Wyse sur Arrol-Johnston — Georges Boillot sur Peugeot — Paul Bablot sur Lorraine-Dietrich

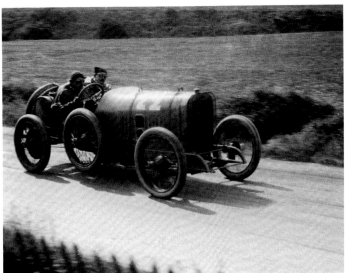

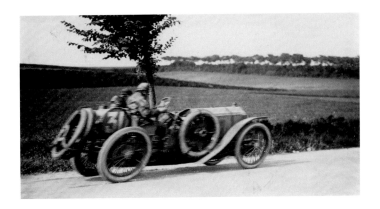

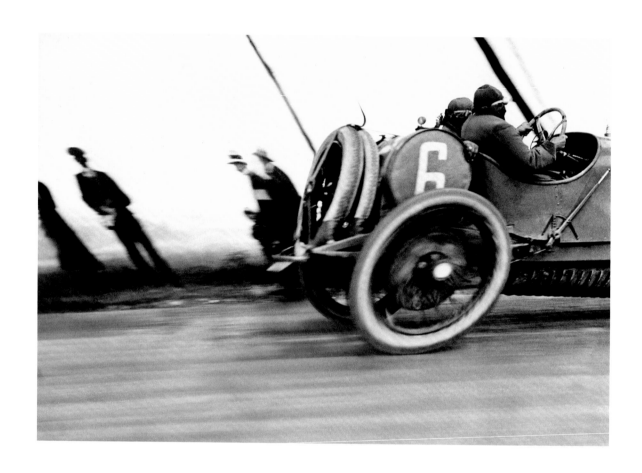

Jacques Henri Lartigue *Une Delage au Grand Prix de l'Automobile Club de France, circuit de Dieppe*, June 26, 1912

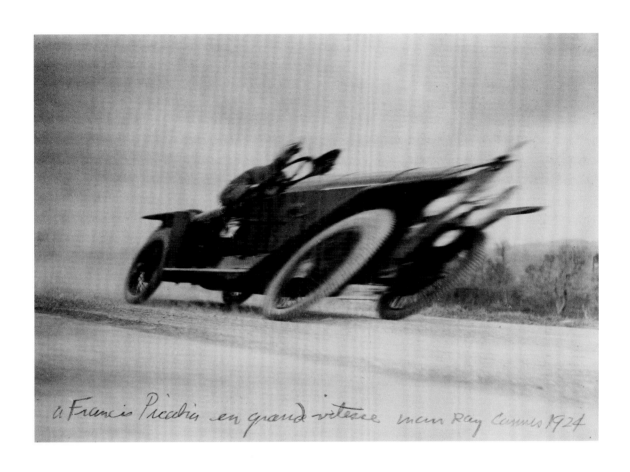

Man Ray *À Francis Picabia en grande vitesse, Cannes*, 1924

Robert Doisneau *Publicité Simca,* 1952

Interview with Alain Prost

As a former Formula One world champion, what is your conception of speed? Whether you are on the road or circuit, above all else, speed is a question of mastery. From one person to the next, the knowledge of cars is not the same. The more knowledge you have of mechanics and aerodynamics, the more you can control the risk and the speed. To go fast, you must be in total control. Someone who does not drive very well will have the impression of going at 200 km/h when the speedometer is only registering 130. This relates to the flow of what you see: the less mastery you have of speed, the faster the things flow by. Finally, the perception of speed is completely relative. In Formula One there has been a lot of research to improve drivers' performances. For a long time, for safety reasons, drivers wore helmets with a very small opening. But then we realized that by widening the field of vision on the left and right sides, the drivers' perception of things improved and they became more efficient.

This question of speed is also very important in photography. It took nearly eighty years before photographers were able to account for it. Do you think an image can recreate the impression of speed? I find that because of the static images it produces, photography renders speed less successfully than video. Of course, the blur of photographed objects can communicate their movement, but it is not enough. Then again, with video, the image can be so good that you have less of a sensation of speed. Video can even give the impression that driving at great speed is an easy thing to do. This is particularly true when the camera is placed inside the vehicle: you get that sense of mastery I was talking about.

Do you think that, fundamentally, there is a genuine need for speed? Yes, in a certain way. Today, the tendency is to want to always go faster, but I'm not sure it is a good thing in all areas. A train that allows you to cover 1,000 kilometers in three hours instead of eight, that is of value. Rapid progress in medicine is also important. You can't say that speed does not bring advantages, but I think that, once again, it is all about the mastery of it.

Translated from the French by Sarah Robertson

Four times Formula One world champion in the 1980s and 1990s, and former driver for Renault, McLaren, and Ferrari, **Alain Prost** is a living legend of motor racing. Co-owner of a team engaged in the new single-seater electric racing-car championships and special advisor to Renault Sport Formula One Team, he continues to display his expertise in cutting-edge technology.

Interview by Xavier Barral and Philippe Séclier in November 2016.

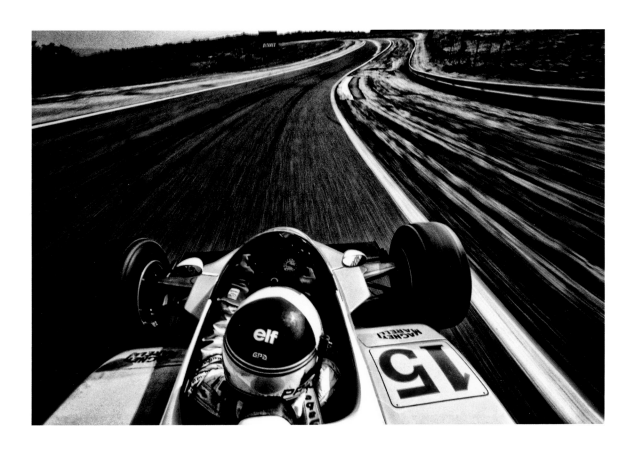

Bernard Asset *Passager d'Alain Prost (Alain Prost au volant d'une Renault RE30B, tests F1 sur le circuit Dijon-Prenois)*, 1982

Antoine Schneck *F1*, 2007

Interview with Jean Todt

Since 2009, you have been president of the Fédération Internationale de l'Automobile (FIA). What is your connection to the automobile? I've always been passionate about cars. When I began to race cars, I was very impressed by Jim Clark. I believed in my natural aptitude and imagined my future would be like this. Life ensured things turned out differently, but nevertheless, fifty years on, I am still tied to cars thanks to my role at the heart of the FIA and as the United Nations Secretary-General's Special Envoy for Road Safety.

One of the themes of the exhibition *Autophoto* is the way in which road systems have transformed the landscape. Over time, gaps in infrastructure have widened between countries. Do you think they can be bridged? In every country in the world, each human being is a road user, whether a pedestrian, a cyclist, or motorized. Over time, road networks have evolved differently, according to the means of each country. It is impossible to compare Kenya's road networks with those of Norway or France, which are some of the best. I can't know what the situation will be in five hundred years. Perhaps the age of the car will have passed. In any case, today it seems impossible to me that in fifty years Kenya's road network will equal Norway's. In addition, the number of cars is increasing every year, particularly in emerging countries, where the infrastructure does not have the capacity to absorb this development. This clearly influences accidentology. These countries are attempting to stop the huge number of accidents, especially by trying to advance attitudes to road safety. Today, when you get on a two-wheeled vehicle or into a car, you need to wear a helmet or put on a safety belt. Sadly, there are still too many countries where people know nothing of these basic safety measures.

These considerable contrasts foster very different representations of death from one country to the next. It is quite surprising to see how certain photographs of accidents have become works of art. Do you think images can play a role in road accident prevention? Seeing a photograph of three people dead on the road is like watching a war film; it elicits emotion. But this feeling is completely relative. The FIA has asked Luc Besson to direct a video on road safety. We hope, through it, to shine a particular light on safety, which I believe is a question of education. At school, we are taught all kinds of subjects, but unfortunately, we rarely learn about the right way to drive safely.

In the 1970s, **Jean Todt** became one of the leading professional co-drivers in rally racing, before being appointed head of the Peugeot Talbot Sport team in 1981, and then head of Scuderia Ferrari in 1993. Since 1999, he has been president of the Fédération Internationale de l'Automobile (FIA). In 2015, Jean Todt was named by the Secretary-General of the United Nations as Special Envoy for Road Safety.

Interview by Xavier Barral and Philippe Séclier in November 2016.

Traffic regulations were rapidly organized in terms of signage. In the 1910s, only four road signs existed, whereas in 2016 there are almost four hundred. The automobile has given rise to a universal code and genuine international coordination. Indeed. And I want to underline the role of FIA and its founding clubs played in initiating this codification process at the beginning of the twentieth century. Today, there is a working group in the UN Economic Commission for Europe dedicated to road regulations. There are fifty-six rules to which each country must adhere. France has done so, but 90 percent of developing countries have not. I went to countries where even today, there is not one road sign or traffic light. Additionally, we support organizations that monitor vehicle quality, because, from one country and manufacturer to another, vehicles that may appear identical have fundamentally different equipment, and so different resistance in the event of an accident.

So car manufacturers have a role to play in improving road safety? Their role is different from ours. Depending on the country, certain manufacturers will have more, or less, standards to comply with. For example, the Tata Nano, built in India, is a car that resists impact less well than other cars, but it also provides access to a vehicle for $2,000. Overall, it is certainly not a car I'd want to see in Paris, but it is still better than five people on a moped without helmets.

In the exhibition, we also see photographs linked to the "disappearance" of the vehicle. Generally, automobiles necessarily lead to a form of pollution. What can we do to battle this scourge? Today, new legislation insists on the production of less polluting vehicles. Hybrid, electric, and even hydrogen cars are appearing. We are also much better at taking on board the issue of vehicle recycling. All of this fits into the constant evolution the automobile has seen since its creation. I believe motor sports have also played a considerable role in the improvement of everyday cars, providing both a laboratory and a technological showcase for improving the motorization and safety of vehicles. Formula E has allowed us to make great progress in electric cars: within five years, the self-sufficiency of electrical power methods will have doubled, resulting in one car being able to complete a race instead of the two required today. It is fascinating to see the degree of progress between a racing car from 1910 and its equivalent a century later.

Translated from the French by Sarah Robertson

Arnold Odermatt *Oberdorf, 1973. Karambolage* series, 1973

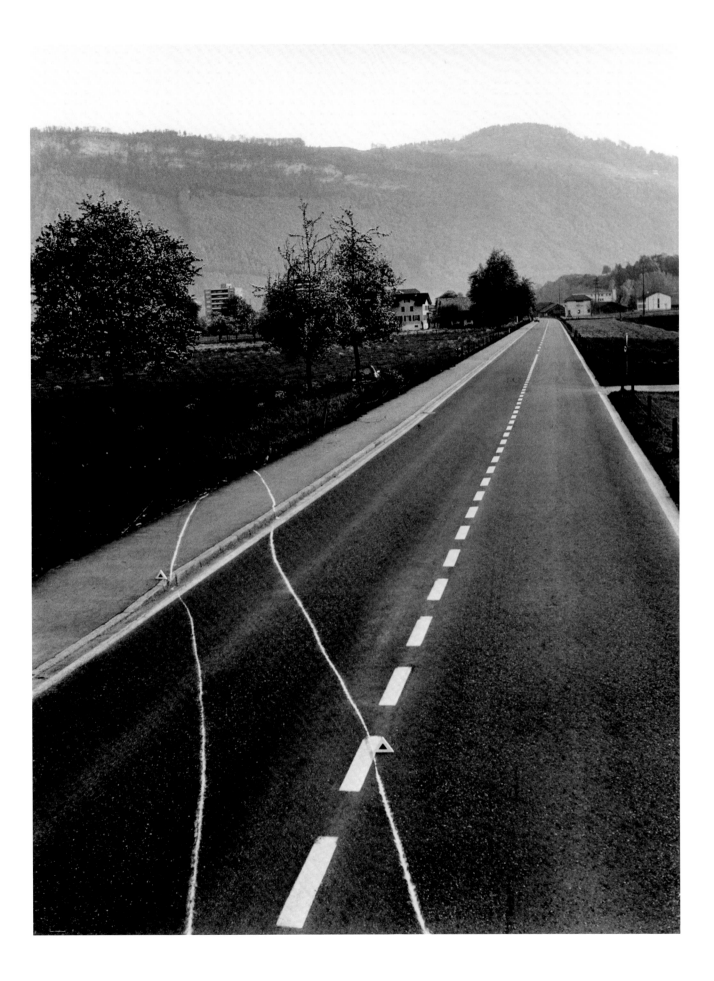

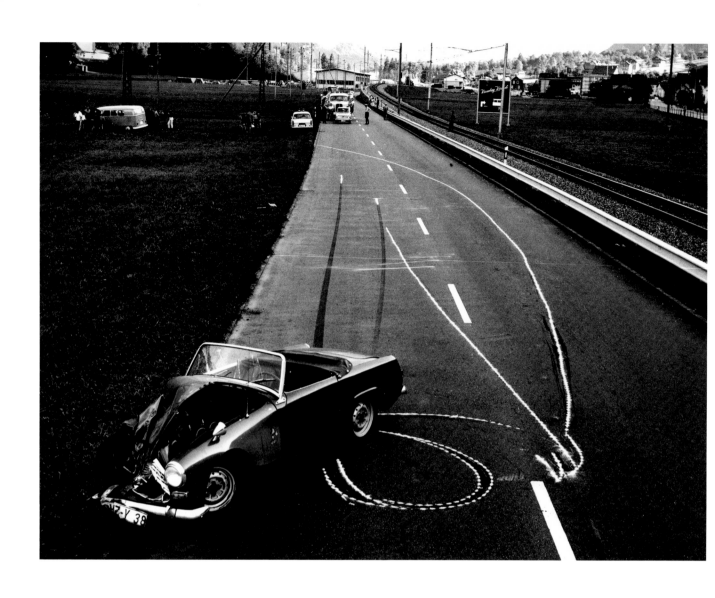

Arnold Odermatt *Oberdorf, 1964. Karambolage* series, 1964

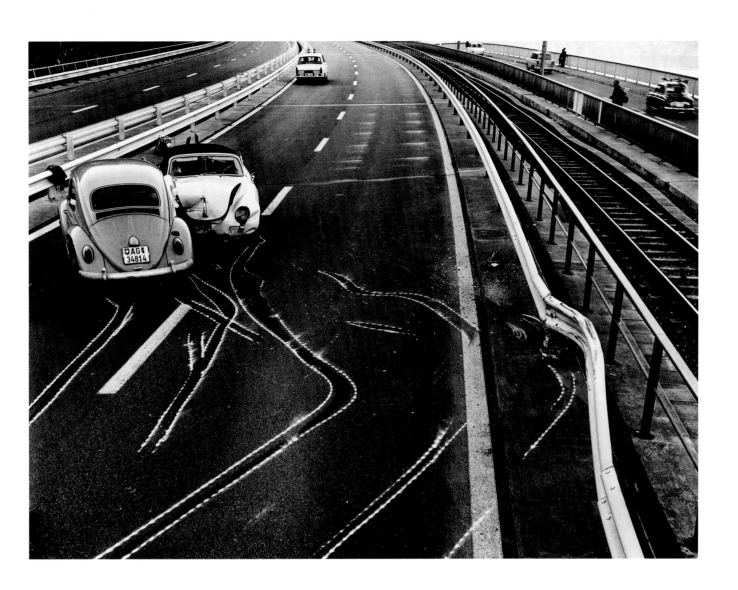

Arnold Odermatt *Stansstad, 1969. Karambolage* series, 1969

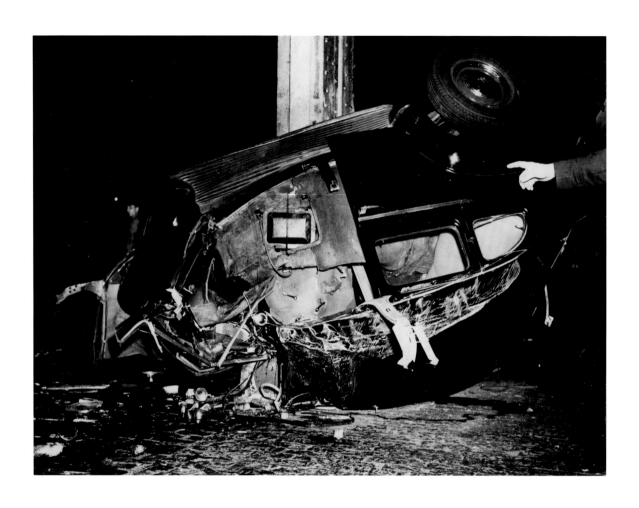

326 **Weegee** *Car Crash*, c. 1940

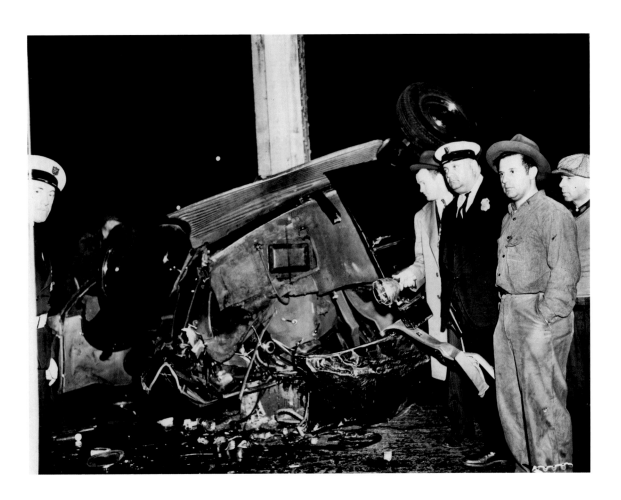

Weegee *Car Crash*, c. 1940

"*Siniestros* is a series of close-ups of smashed-up cars. Landscapes appear in the deformations of car bodies, while the paintwork evokes accidents and their own particular geographical terrains. In a way, this work is close to certain practices in abstract art." **Mateo Pérez Correa**

Mateo Pérez Correa *Siniestros* series, 2015

"I discovered this pile of windscreens in a rubbish tip in Soissons, France, in 2006. In places, the site was flooded; the landscape almost became a hallucinatory image to me, with a low and heavy sky, because I lost all sense of spatial scale and I was seeing mountains and roads of glass." **Éric Aupol**

Éric Aupol *Paysages de verre #1*, 2006

"Flint, USA, called the 'murder town' then the 'poison town,' and Detroit's neighbor, has now been abandoned to catastrophic deindustrialization. It was once the fiefdom of General Motors, the great purveyor of jobs and symbol of the American Way of Life. I had the sense that Flint was the capitalist metaphor for a very violent economic tsunami, following the 2008 financial crisis. In Flint, it often felt like I was in a Gordian knot, caught between my fascination for the subject and the feeling of constant outrage, my only photographic way out to see the beauty in disaster." **Philippe Chancel**

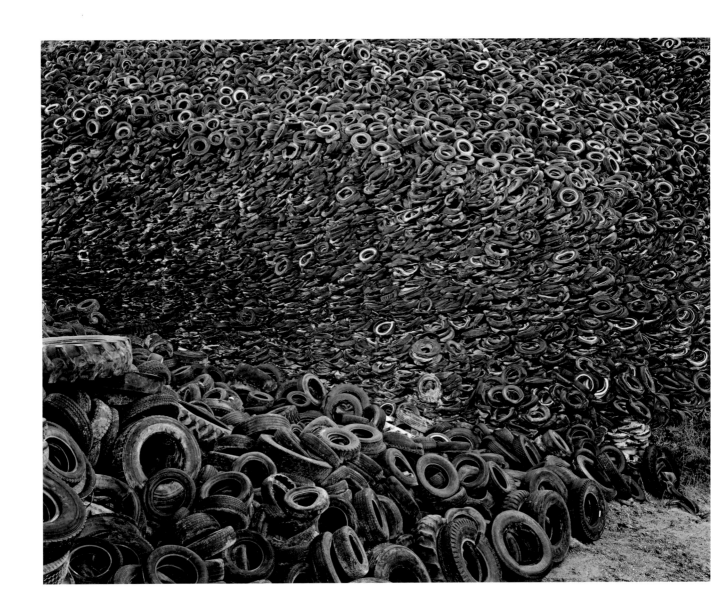

"It started in the very early 1980s. Having come out of a deep respect for nature and wilderness, it seemed to me that starting to photograph how we change the land to provide for our daily existence was more in line with our times than a celebration of the pristine landscape. So I go to places where human imprint is shown on a vast scale, so that scale has become a signature element of my work. I'm in those landscapes not for the beauty but for what we as humans have intentionally altered and unconsciously transformed. I see myself more as a photographer of human systems within the landscape rather than a landscape photographer." **Edward Burtynsky**

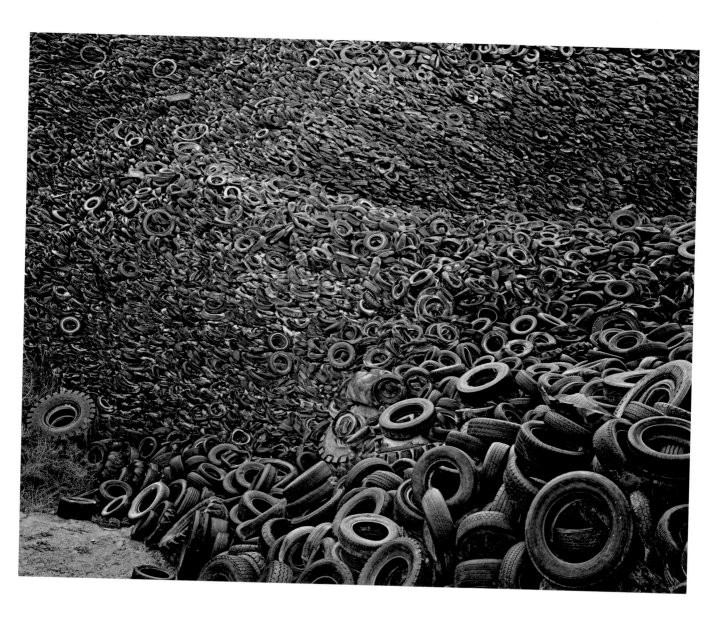

Edward Burtynsky *Oxford Tire Pile #9a/#9b, Westley, California, USA*, 1999

Peter Lippmann
Peugeot 201. Paradise Parking series, 2012

Peter Lippmann
Citroën Traction 7. Paradise Parking series, 2012

"In 1990, I visited the seas of New Zealand. The southern hemisphere is so sparsely populated that there were neither boats on the sea, nor people on the shore. One day I came across an unusual cluster of things strewn over a beautiful beach. Vaguely familiar looking, they turned out to be hundreds of car parts, probably from the sixties, judging by the design. Around thirty years before, someone must have junked a whole fleet of cars there. With the waves washing over them, day in, day out, they had rusted to the point that their chassis had melted into the beach. For a while, I turned my lens away from the horizon to focus on the *objets* in the sand. Persevering with my lonely task on the deserted beach, I half-succumbed to the notion that human civilization had ended. The sight of crafted objects rotting away is at once dreadful and beautiful. Time foments corrosion. It does not take long for civilization to decay. Just a few decades are enough for a car, one symbol of our modern civilization, to decompose into nothing." **Hiroshi Sugimoto**

Hiroshi Sugimoto *On the Beach 011*, 1990 — *On the Beach 007*, 1990 — *On the Beach 001*, 1990

"I lived in Los Angeles for thirty years or so. LA is a city with a car culture. It's not what you own or where you live that matters, but what you drive. I have always been fascinated with the expensive cars there and now here in New Mexico. That is why the symbolic role of the cars is very important in the *Excavations* work. My interest in astronomy and the universe coupled with my interest in the history of earth through archaeology propelled the narrative of the series. I put myself in the shoes of a photographer working for a Japanese archaeologist called Ryoichi. The magic was in the research, narrative, and construction of the sets. I chose the cars according to the recreated site I wanted to put them in. My selection was based on each site's history along with the type of car used in that country. My choice was to give the audience a sense of 'contemporary' time in relationship to the often distance past of the sites." **Patrick Nagatani**

Patrick Nagatani *Mercedes, Grand Canyon, Arizona, USA, 1994 — Lincoln Continental, Ukok Plateau, Siberian Altai, Russia, 1995 — Infiniti, Jemez Pueblo, New Mexico, USA, 1996 — Cadillac Eldorado, Sandy Point Site, Albuquerque International Sunport, New Mexico, USA, 1996 — Jeep Cherokee, Shahr-I Sokhta, Seistan, Iran, 1990 — Aston Martin, Hazor, Israel, 1990. Excavations series*

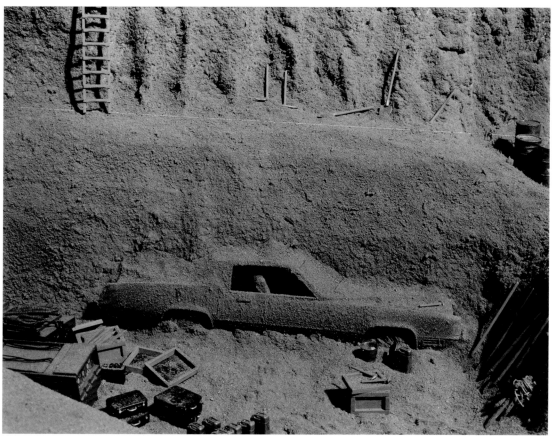

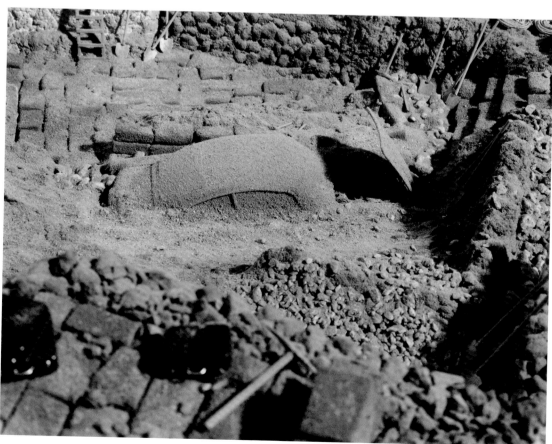

Becoming One

Pascal Ory

The idea of the body lies in the very idea of the automobile. Until the invention of the car, other bodies pulled and pushed the various forms of transportation: the body of an ox, a horse, or of a man was needed to transform a wooden and leather cabin on wheels into a sedan or a phaeton. With the revolution that gave vehicles their autonomy, everything changed, like a slave being freed. The means of transport was now moved by its own machine. This was the beginning of a long process that gradually and discreetly returned the human body to its mechanical condition. During this period, mirroring the body-machine, a machine-body took shape before our very eyes.

And in the century that invented the automobile, these eyes were none other than *photography*. Photo, cine, phono—the entire nineteenth century shared a common preoccupation, which on this scale and with this consistency, resembled an obsession: capturing, recording, and conserving the fleeting, the momentary, and the ephemeral. The century referred to this act as *graphy*. It was as if the century had vaguely understood that it had to take back with one hand what it had let go of with the other, by making these vehicles "auto."

Things then became complicated because this human body, now the master of a machine as it had once been the master of an animal, sought to appropriate that machine so completely that it would multiply the ways in which human and machine became one.

The Beauty, the Beast, and the Objective

Essentially, the strangest way of photographing the human body in relation to the automobile is something that many may recall as one of the classics of photography, particularly in advertising, a beautiful woman with a car body. This kind of sexist metaphor has gradually been erased from our memories, but there was once a time when men would speak of a "chassis" or "build" and not just in reference to a Cadillac. At that time, the portrait of such a pair was a well-defined photographic genre, featuring an adorned and purportedly attractive woman, as well as a car shown off in all its splendor, leaving us to wonder exactly what it is they are trying to tell us. At a time when drivers, car owners, were predominantly male, the pretty woman with the car appears as

Pascal Ory is historian.

the female-object par excellence, a decorative and seductive element similar to the allegory of the Rolls-Royce radiator mascot. The woman is homologous with the vehicle in question, and the game is in the way in which the potential customer's desire can match that of the fantasy lover. Moreover, the *car girl* is always shown touching or caressing the car.

The work of both Bill Rauhauser (p. 354)—the quintessential Detroit photographer—and Jacqueline Hassink—known for her series of sites emptied of human beings—explores this relationship. These two artists make use of the commercial and surreal spectacle that is the car show. Hassink's *Car Girls* each have the physical, ethnic, and aesthetic diversity that suits a particular brand: the Lancia car girl is elegant and sleek, sitting in the passenger seat, one leg in, the other out; the Fiat brand uses a sexy, Western-style model wearing black hot pants and a red bolero; while a 4×4 is paired with an attractive black car girl wearing dark sunglasses, etc. (p. 357).

This direct and obvious correlation between the human body and the automotive chassis—where "ownership" clearly contains the meaning of "possession"—takes on less sensual forms when expressing the vernacular dreams of average families, such as those captured by Martin Parr or collected by Sylvie Meunier and Patrick Tournebœuf. Parr's color series, *From A to B. Tales of Modern Motoring* (p. 220 and 389), his second collaboration with the BBC, was a further exploration of the notions of "good" and "bad" taste, challenging elitist definitions. Meunier and Tournebœuf's series summarizes the American dream in black-and-white, square format, white bordered Kodak prints, where the heroes of Middletown modernity pose in front of their homes, as much products of an assembly line as their Studebakers (p. 58).

This concept of the car as either a trophy or a kind of large pet is not exclusively the property of Western photographers: it can also be seen in the work of artists such as Jean Depara, Seydou Keïta, and Malick Sidibé, whose variations on the African Dream show bodies stretched over the hood, climbing over the body of the car, or lying on the seats (p. 63, 66, 64).

Taking the analogy a step further, the photographer's gaze doesn't fail to notice the extent to which the human body enjoys handling or manipulating vehicles. Obviously, the movements are somewhat limited: from hands on the steering wheel to hands covered in grease and oil, but with an observant gaze like that of Justine Kurland's, the body of the mechanic lying under the car is indicative of not only care for the automobile, but of a kind of body-to-body contact, as definitively organic as it is technical (p. 393).

Enter the Bodies

After such preliminaries, it is only more striking to note that this strong erotic charge expresses itself, essentially, somewhat discreetly when it comes to

photographically representing "automobile" sex. A lack of opportunity or a lack of imagination? Doubtful. Instead, it is most likely due to the vestiges of Puritanism—clothed as a declination of pornography, that is to say, money. Nevertheless, there exists a group of artists who explore the paradoxical intimacy of the human body as soon as it crosses the threshold of this little house on wheels, all the more valuable to our contemporaries in that the car offers all the freedom of a house, in societies where most people live in apartments. Violating this privacy with flash photography and a telephoto lens, Óscar Monzón takes nocturnal aerial shots of cars stopped at a red light. The artist plays on the words *karma* and *car man* to stage people in a car (p. 362). However, the absence of depth and the brutal framing of the windscreen, which cuts off part of their heads—thus circumventing copyright issues—reduce these lustful and argumentative bodies to animated trunks, similar to those captured in Kurt Caviezel's black-and-white shots at a red light (p. 416). Rosângela Rennó resolves the issue in her own way, by introducing the bodies of young newlyweds in the "compartment": the word here more than usually apt (p. 382). The couples photographed are not just couples from anywhere: Rennó shows just-married Cubans, celebrating their union in an American car destined—as the author reminds us—to never take them beyond their island-prison. Jules Spinatsch deals with the problematic by visiting the sleeping bodies of "ravers" in the abandonment of the long mornings that follow the nights of rave parties (p. 410). Alejandro Cartagena, like Óscar Monzón, chooses a bird's-eye view to shoot recumbent bodies on the beds of pick-up trucks: construction workers and carpoolers for example, enjoying a moment's rest or sleeping like babies (p. 367). In works such as these, we see that all walks of society are on-board, making the automobile a place for all hours of the day and night, for all of life's milestones, making it all that is possible and necessary, a concentration of life at the same time as it is a concentration of bodies, for better and for worse.

Imprisoned Bodies

There are even more violent ways of entering the car, of entering by car. Perhaps the most thriller-like of these was the way in which citizens from East Germany were surprised—or not—by the Stasi as they tried to cross the border between the two countries, hidden in the trunk of the car or in another more unusual compartment. Arwed Messmer explores these "reenactments," where bodies locked up at a national level desperately tried to escape, following an elementary but subtle economy—for example, two children occupying the space of a single adult (p. 374). But the best way of entering into contact, as well as the most trivial—the *trivium* is a crossroads—is not you entering the car but the car entering your flesh.

While the photographers exhibited here rarely depict couples making love on an uncomfortable backseat or on a scorching hood, those framing the shattered metal after accidents are legion, including Arnold Odermatt's *Karambolage* (p. 323). Odermatt, a Swiss police officer, was fascinated by off-road collisions and other accidents, and spent much of his career fixing not the dynamic but the static on film, transforming the dramatic event into a work of art, according to the rules of the most ancient art. That this is an act of sublimation is confirmed by Mateo Pérez Correa in *Siniestros*: he sees the twisted, battered skeletons of cars as modern variants on the *vanitas* of still-life painting (p. 328). Pérez's selection gives his work a moral dimension that provides its strength, but is, if we are honest, the moralizing discourse of religions. However, the statistical reality of car accidents reminds us that ordinary mortals find themselves just as much, if not more so, crushed, flattened, and ground by the mortar of bad luck.

Making images of an accident—or the aftermath, the vestige, or residue—is also a way of getting closer to the human, when one struggles in the present day and age to represent this human. Yet, these images are not representative of what we could call *car trash*: they do not show us the broken, bloody, or dismembered bodies evocative of crime photography, the literary talent of J. G. Ballard, or the cinematic finesse of David Cronenberg.

The Car as Body

If we observe and interpret Valérie Belin's engines, we understand that it progresses toward "humanizing" the automobile by applying the dignified practice of the memento mori to car engines (p. 275). In this particular series, she creates a kind of table "fashioned like those in Zurbarán's paintings," which she paints black—and repaints with engine oil to blacken it further. Against a backdrop of black velvet, two spotlights positioned at a 45-degree angle create the atmosphere of a classical painting. Thus magnified, the engines begin to resemble "a human body, devoid of life," says the artist, finishing with the admission that for her this project was also a catharsis, "a way of evoking those amalgams of flesh and metal that [she] imagined were what [she] saw pulled out of Ground Zero every day before they were moved to New Jersey."

In reality, many photographers seek to humanize, or at the very least animalize, the body of the car. It can be seen in the bellies of large beasts lying on their backs in the *Auto Reverse* series by Kay Michalak and Sven Völker (p. 285). Seen from this particular angle, at the antipodes of the lust and luxuries of car shows, a Trabant, a Volvo, a Citroën 2CV, and a Porsche 911 are returned to their organic state, leading viewers to conclude that the car's bottom is no uglier than the top.

Photographed by amateurs and professionals alike, the automobile object, which has become the subject of portraits and still lifes in the style of the Golden Age, can no longer be reduced to the mere "heap of metal" referenced in newspaper accounts of accidents. As Stéphane Couturier enthusiastically propounds, the car can be promoted to the rank of the aesthetic, even on the assembly line (p. 280). In order to do this, it is enough to shoot the car like a star, treating it like an icon, with the best silver salts and photo paper, taking multiple shots and printing it in large format.

Certainly, herein lies the test of truth: associating the car with a pretty woman to underline its sensuality is unnecessary. All that is needed is a gaze devoid of prior assumptions, a gaze capable of reorganizing everything, that is to say, capable of reintroducing the natural into everything. In short, it takes only the human gaze: it transforms all the objects it touches into subjects. *Nihil humanum alienum*—"nothing human is foreign to me"—goes an old and beautiful adage. After all, anything that results from the human genius is, in principle, not foreign, indifferent, or hostile. Everything has form and movement, therefore everything makes sense. The car thus becomes painting in the work of Valérie Belin, sculpture in Arnold Odermatt's, and theater in that of Óscar Monzón's. The true "museum of the car" is there: a museum of fine art.

Translated from the French by Emma Lingwood

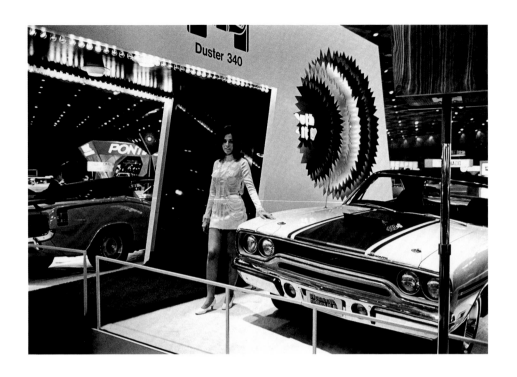

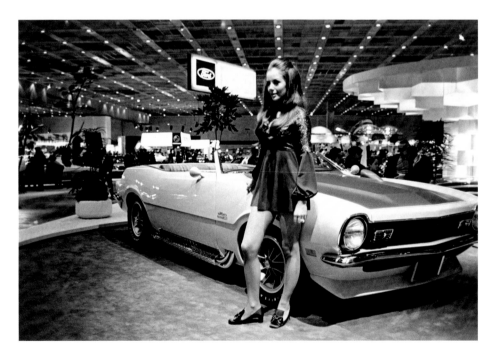

Bill Rauhauser *Detroit Auto Show* series, c. 1975

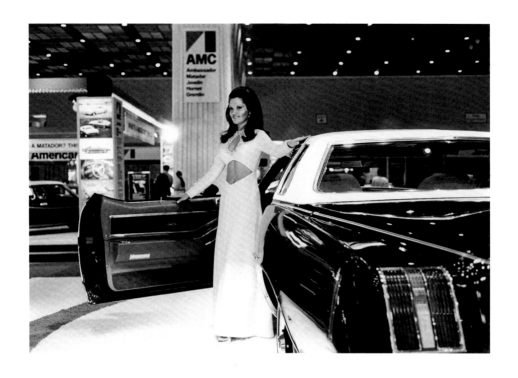

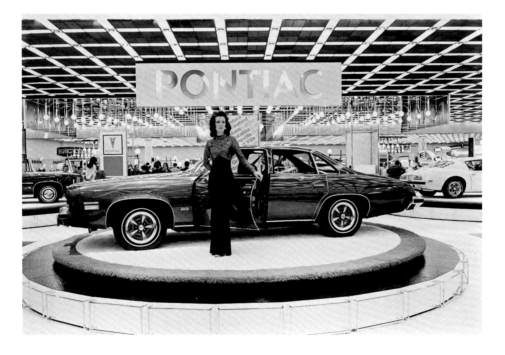

"The shiny hair, the shiny skin of the car, the shiny displays—the luxury of it all. Then there's the eroticism of speed, when a man drives a car very fast, and he feels the same sensation as when he sees a beautiful woman. There are so many different elements that really come together at car shows. The whole package is a sales strategy. But to me, this theatre is extremely interesting as a microcosm of contemporary society.

Within the visual chaos of the car show, I waited for moments of isolation in which the car girls were not conscious of their role. The cars, the visitors, and the display played a key role in the composition. One thing I found very interesting is the body language of the car girls: they always touch the car. There is always this moment that they touch the surface of the car. The male viewer might think: 'If I possess that car, I can possess the girl.' This act of touching is very sensual and seductive. The car symbolizes the male and the hand of the girl, the female." **Jacqueline Hassink**

Jacqueline Hassink *Car girl hair color: blond. Car Girls, 2002–08*

Abarth girl,
Frankfurt

Alfa Romeo girl 1,
Frankfurt

Alfa Romeo girl 2,
Frankfurt

Alfa Romeo girl 2,
Geneva

Alfa Romeo girl 4 (A),
Frankfurt

Audi girl 1,
Detroit

Chevrolet girl,
Frankfurt

Chevrolet girl,
Geneva

Chrysler girl,
Shanghai

Daihatsu girl 1,
Tokyo

Dodge girl,
Detroit

Dodge girl,
New York

Ferrari girl,
Geneva

Fiat girl 2 (A),
Frankfurt

Fiat girl 3 (B),
Geneva

Fiat girl 5,
Frankfurt

Infiniti girl,
Detroit

Lamborghini girl,
Detroit

Lancia girl,
Frankfurt

Land Rover girl,
Paris

Mazda girl,
Detroit

Opel girl 2,
Paris

Porsche girl (A),
Detroit

Porsche girl (B),
Detroit

Rolls-Royce girl,
Frankfurt

SEAT girl 2,
Geneva

Toyota girl (A),
Detroit

Toyota girl,
New York

Volkswagen girl,
Tokyo

Volvo girl (B),
Detroit

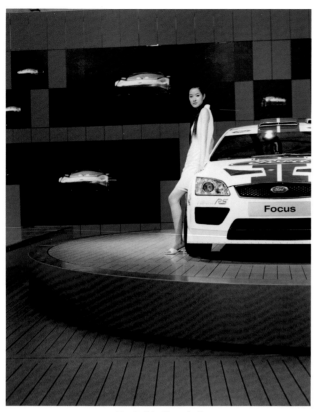

Ford girl, Shanghai

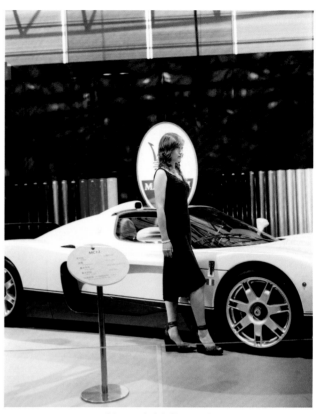

Maserati girl, Shanghai

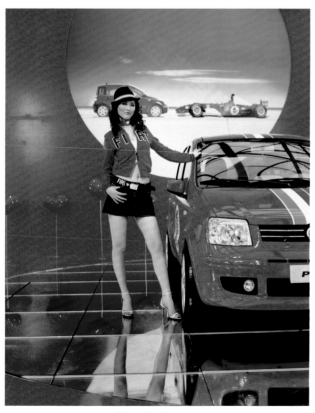

Fiat girl, Shanghai

Chery girl 1, Shanghai

Jeep girl, Shanghai

Lexus girl, Shanghai

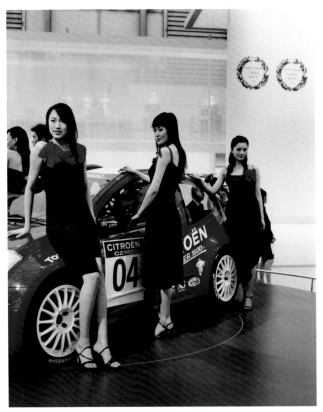

Citroën girl, Shanghai

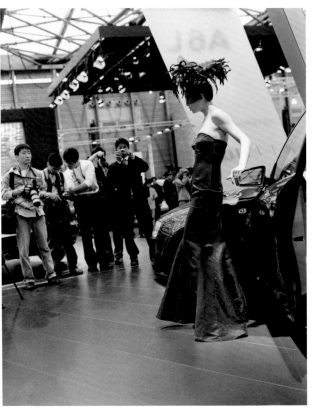

Audi girl 1, Shanghai

Ferrari girl, Shanghai

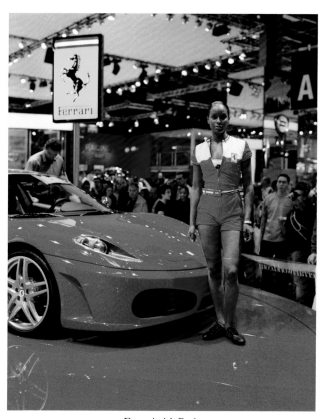

Ferrari girl, Paris

Ferrari girl 4, Detroit

Ferrari girl 1, Frankfurt

Jacqueline Hassink *Car brand: Ferrari. Car Girls*, 2002–08

Ferrari girl 3, Detroit

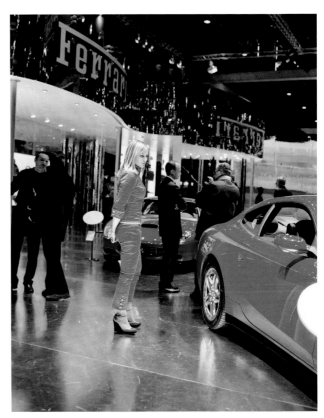

Ferrari girl, Geneva

Ferrari girl 3, Frankfurt

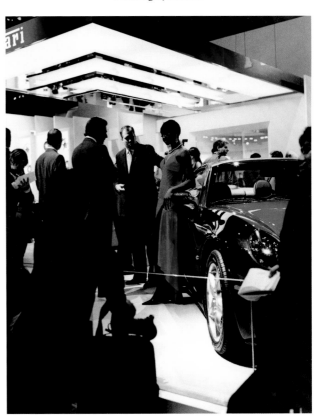

Ferrari girl 1, Detroit

"I like to regard the automobile as a technological object not separated from the person using it, as having a look and character and manifesting the human being's attitudes and desires of the unconscious—aggression, rivalry—and as an extension of their body, also capable of alienating its driver by drawing them into a hypnotic state. These questions allow me to speculate about the traces in our memory of the predatory animal we once were, as well as our future fusion with technology." **Óscar Monzón**

Óscar Monzón *Karma,* 2009–13

Basile Mookherjee *Fully Fueled* series, 2012–14

"I shoot from a pedestrian overpass that looks over the cars coming out of a small tunnel and 'predict' which trucks might have people in the back. These images present a not-so-subtle observation of overgrowth issues in Mexico; where suburbs are being built in faraway lands, far from the urban centers, causing greater commutes and consumption of gas." **Alejandro Cartagena**

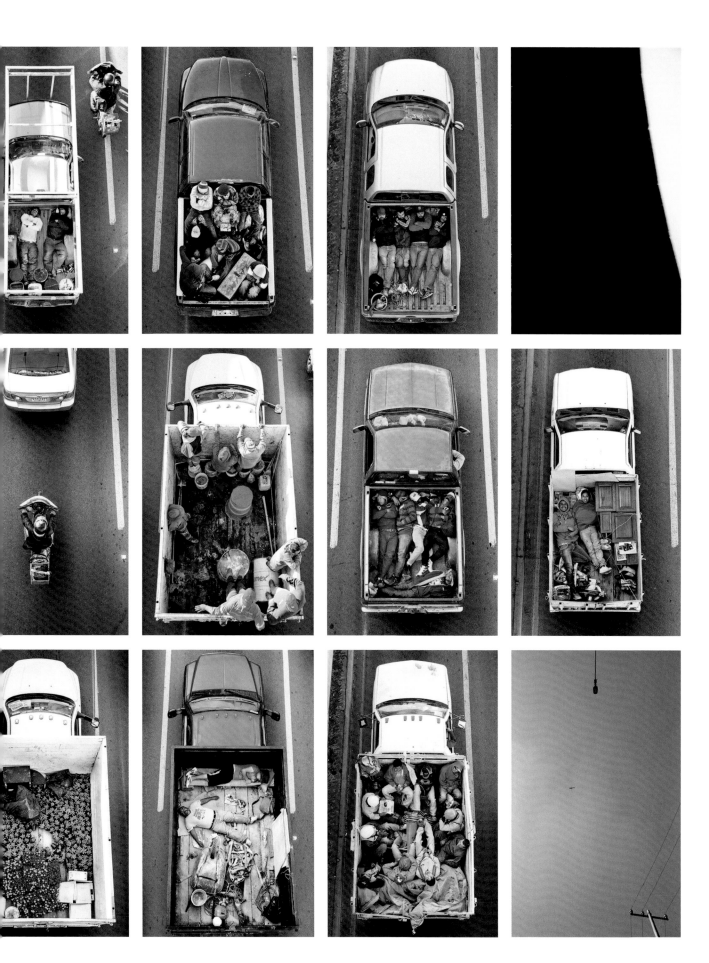

"The point of departure for this work was to record one of the symbols of repression during the last military dictatorship (1976–83). The Ford Falcon is the Argentine car par excellence, one of the rare Ford models completely built in Argentina and appreciated for its robustness. It became a symbol for the military dictatorship. Employed as much by the security forces—the army, the navy, the air force, the police—as by the paramilitary groups, the car evolved into an object of terror on the streets, and a symbol of illegal repression for its inhabitants. As I had worked for many years around the theme of human rights, and after having seen so many of these cars abandoned in the streets, in the process of deteriorating, or brought back to life for continued use, I decided to make them the central axis of my project." **Fernando Gutiérrez**

Fernando Gutiérrez *Secuelas* series, 2000–03

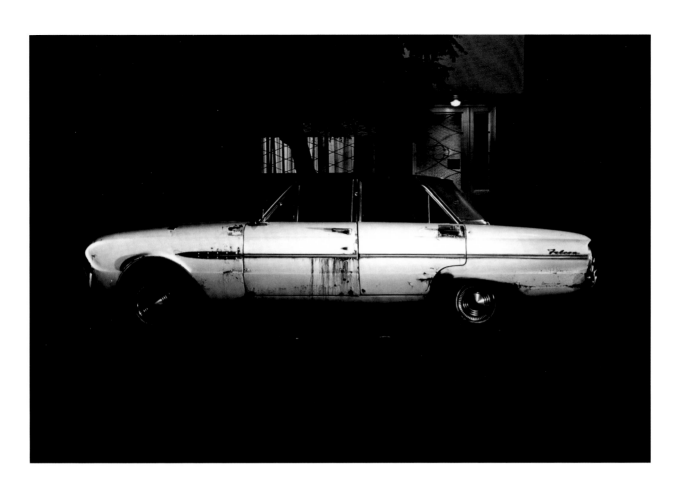

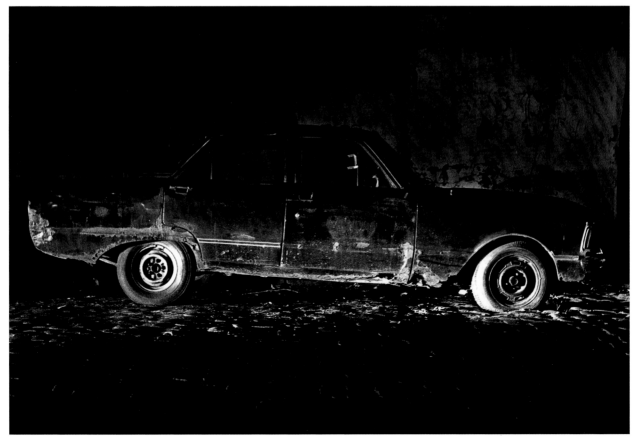

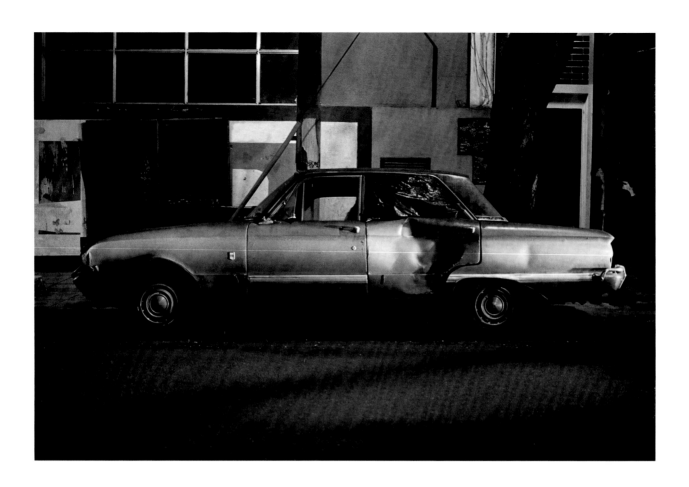

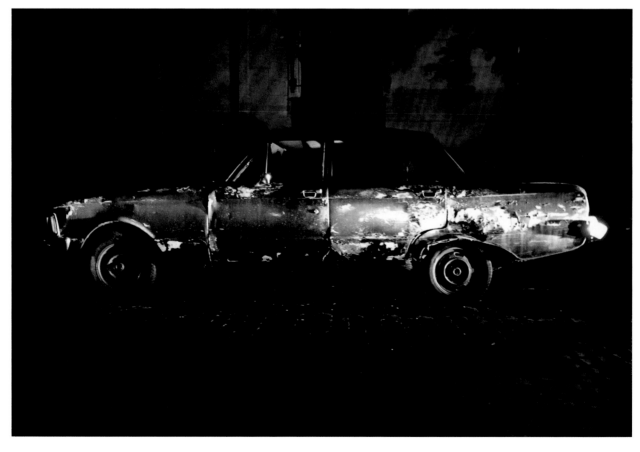

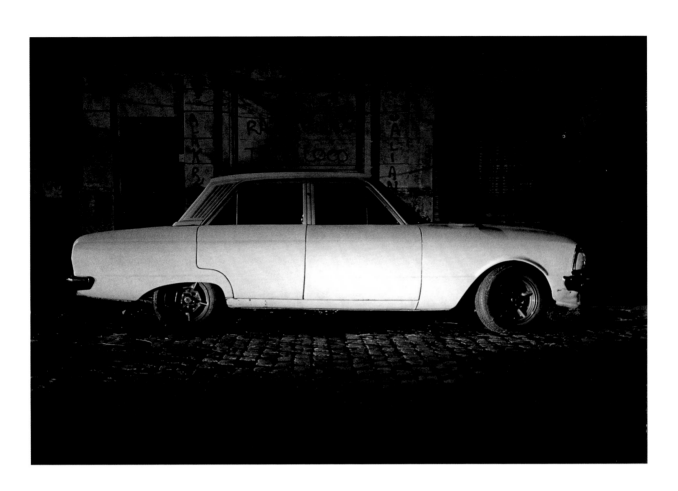

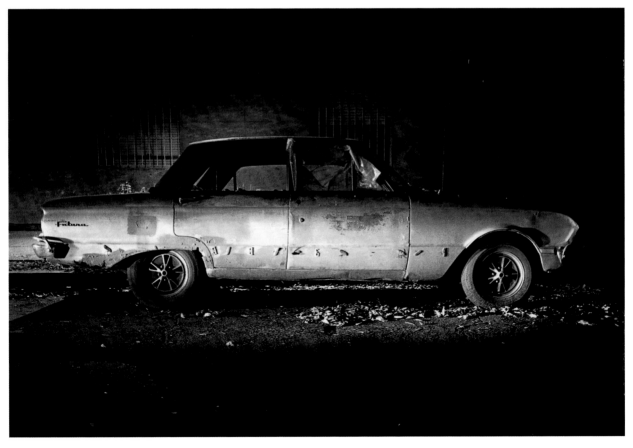

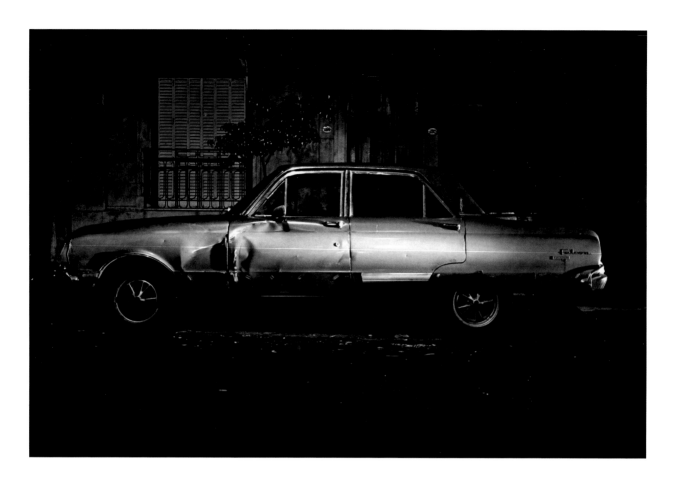

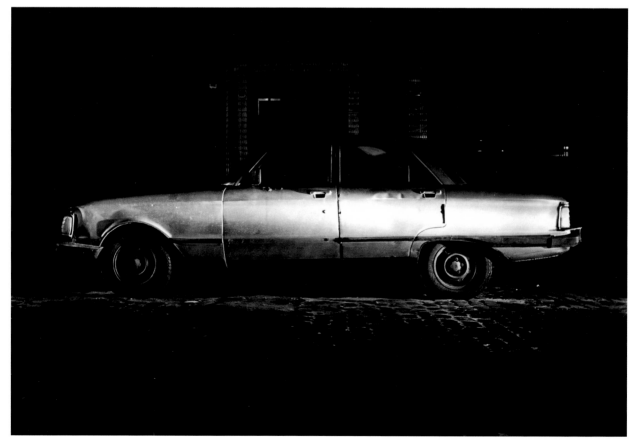

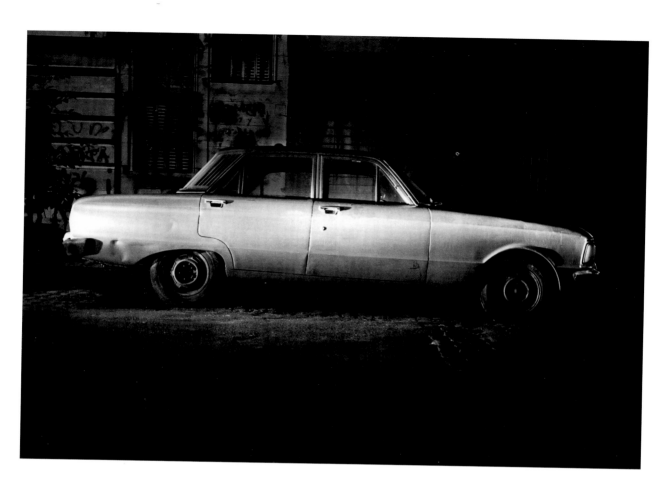

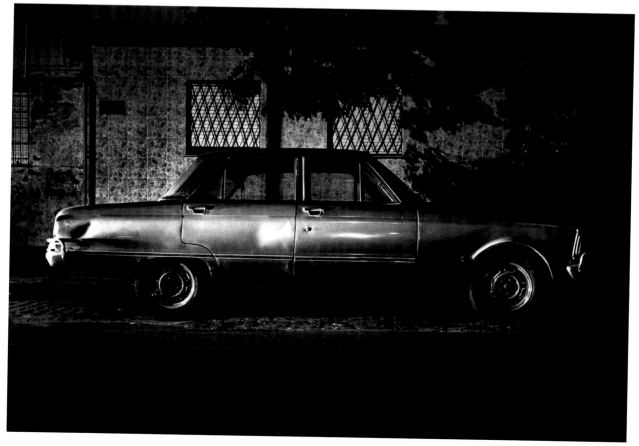

Picture of a Volkswagen K70 L with West Berlin license plates, which was confiscated on July 17, 1972, after an attempted escape on the transit route between West Berlin and West Germany. Forced reenactment with escape helper (standing) and the escapee in the trunk of the car.

Call number BStU MfS HA XX Fo 0235, page 6 images 16 and 17, page 14 image 40, and page 15 image 42

"Many of these pictures were surely made within the kind of standard crime investigation routine you can find all over the world. In these reenactments I suspect that the East German authorities wanted to at least keep up the semblance of the rule of law, by giving state prosecutors visual evidence, even if a later trial verdict was already pretty certain at the time of arrest. I would say that the humiliation caused by this form of documentation was more like collateral damage, and that it was accepted as simply part of the process." **Arwed Messmer**

Police parade a couple and their helpers after a failed smuggling attempt and the forced reenactment of the hiding place in the trunk of an Opel Kadett car with West Berlin plates, no year.

Call number BStU MfS HA VIII 7484, page 0011 image 10, page 0012 images 7–8, and page 0013 image 4

Arwed Messmer *Reenactment MfS, Car #13*, 2017

On February 26, 1972, a Cadillac with the American license plate number USA EK6233 was stopped
at kilometer 71.5, exit Wollin, on the transit route between Dreilinden and Marienborn. Three adults and a small child
were found in the trunk. The incident was reenacted and photographed at the scene of the arrest.

Documentation of a failed escape attempt by a mother and son on September 12, 1983, around half past midnight, at border-crossing point Marienborn/freeway in the trunk of BMW car with Munich license plates. Both the escape helper and the mother and son were forced to reenact the attempt in a custom's building immediately after they were caught.

Call number BStU MfS AIM 2818, page 0025 image 2, page 0027 images 5–6, page 0028 image 7

Arwed Messmer *Reenactment MfS, Car #04, 2017*

Presentation of an East German family and their West Berlin escape helpers Oliver Mierendorf
and Karlheinz Hetschold after a failed smuggling attempt in an Opel Admiral car on September 21, 1973.

Call number BStU MfS HA IX Fo 2180, sheet 0003 image 9, sheet 0003 back image 11, sheet 0004 images 13–14

On January 2, 1986, at 6:22 p.m., a brown Ford Taunus from West Germany with Mainz license plates wished to enter West Berlin at the border-crossing point at Drewitz. The car was conspicuous because it had a slight backward tilt and a lot of luggage on the back seat. The border guards found a young woman in the trunk. The driver said he was a member of the West German army who wished to move to West Berlin to avoid his army service. The woman, also a West German, was his girlfriend, who also wanted to move to West Berlin but had no valid documents and had thus hidden in the trunk since the border crossing between West and East Germany at Helmstedt. Both were arrested.

Call number BStU MfS HA VI 1120, no page numbers

Arwed Messmer *Reenactment MfS, Car #06, 2017*

"*Fonce Alphonse* represents one of the most intimate and yet coded events in the life of a couple: marriage. For the occasion, my fiancée and I intentionally exceeded the speed limit on our wedding day, put the pedal to the metal in order to have the Police Nationale snap our nuptial portrait. At the exact moment the police deploy its apparatus in an attempt to identify us, our identities are in flux, marriage bringing about a series of changes to our social and civil status." **Jeff Guess**

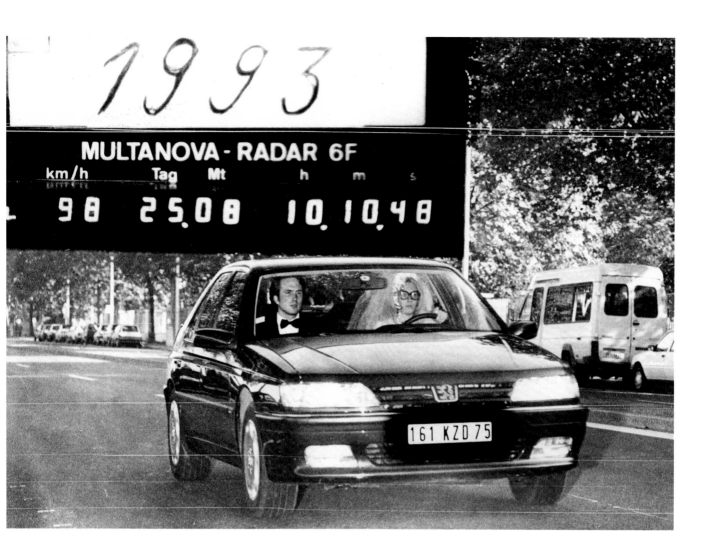

Jeff Guess *Fonce Alphonse*, 1993

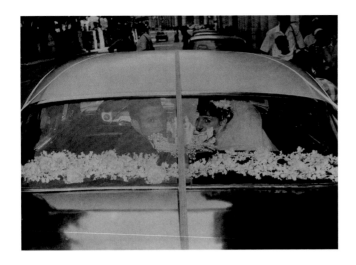
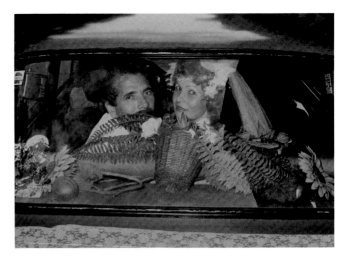

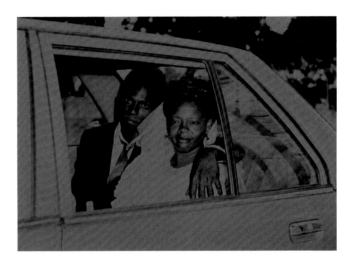

"What motivated me were my own memories of seeing wedding couples inside cars, as the last photograph of the ceremony. Many family albums had one. This last shot somehow symbolizes the end of the passage ritual and occurs in almost all wedding documentation in Brazil and in Cuba, mostly after the Second World War. At least in our respective countries, cars always represented new and prosperous lives, connected with the American way of living. My father had photographed one of my aunts inside the car agitating the hand as saying goodbye through the window in the mid-1950s and I used this image for the first time in 1988. Then, in 1994, when I went to Cuba for the V Havana Biennial, I visited a photo studio and got kilos of negatives of wedding series of portraits. →

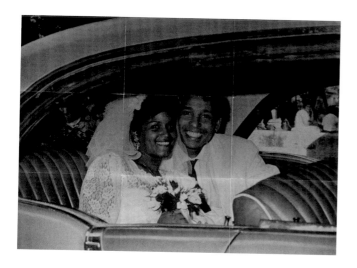 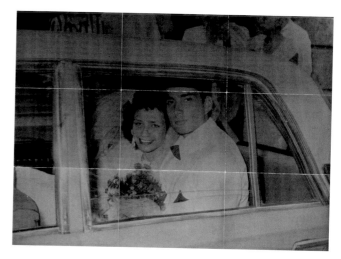

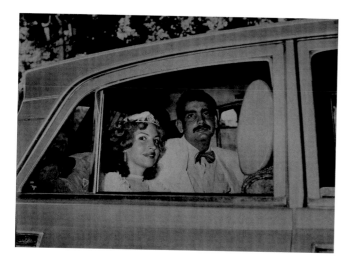 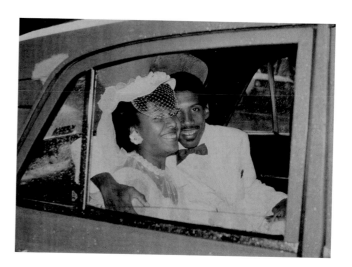

Rosângela Rennó *Cerimônia do Adeus* series, 1997–2003

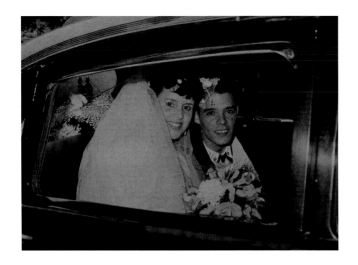

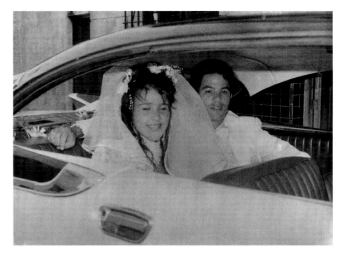

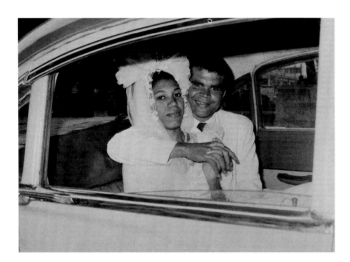

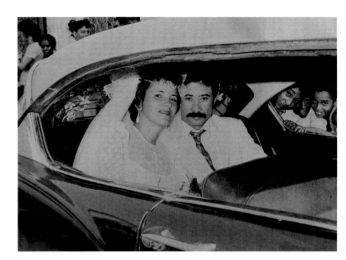

The whole ritual was documented exactly the same way—in front of the mirror, on the sofa, the couple signing the book, the farewell inside the car. The repetition of the poses amazed me a lot and I decided to do a series on portraits of couples inside the car, which I finally presented in the next Havana Biennial, in 1997. What also interested me was something that was much further of the framed scene: no one can escape from an island using a car. The symbolic representation of the farewell to the old and consequently the welcoming of the new seems to be broken or awkward. In addition, those specific cars—American models from the 1950s, reminiscence of the pre-Revolution era—meant everything that the Cuban political system wanted to deny or combat but, even so, they were strong symbols of a life changing." **Rosângela Rennó**

Rosângela Rennó *Cerimônia do Adeus* series, 1997–2003

Raymond Depardon *Glasgow, Écosse*, 1980

"A lot of people don't like Volvos. A lot of people wouldn't
dream of going out and buying one. But it suits us as a family and as far as
I'm concerned we're sticking with Volvo."

Martin Parr *From A to B. Tales of Modern Motoring* series, 1994

"Before the recession we had a Montego Estate which we were madly in love with. That was the hardest part, going from a decent car to this. It's like wearing a placard round your neck saying we're poor."

Martin Parr *From A to B. Tales of Modern Motoring* series, 1994

"The sooner we get rid of the Mercedes the better. It's too smooth. I think we're more of a rough and ready family. We don't suit this car at all."

"I noticed at certain times an erotic charge between the mechanics and the cars, muscle on muscle, especially in cases where the men were under the cars. In combining mechanic and car I am objectifying the men as much as the cars. This is as much a function of photography as my own sexuality. At one point, I toyed with the idea of naming the series 'Autoerotic,' but felt like it was too over determined and ironic. The name I settled on, *Sincere Auto Care* (which was the name of a shop I photographed), replaces the idea of erotic with care. What I liked about the title is that it can be read as sincere self-care, which implies that there could also be insincere self-care." **Justine Kurland**

Justine Kurland *Heart Throb*, 2014

Justine Kurland *280 Coup*, 2012

Justine Kurland *Rebuilt Engine*, 2013

Martin Bogren *Tractor Boys* series, 2010–12

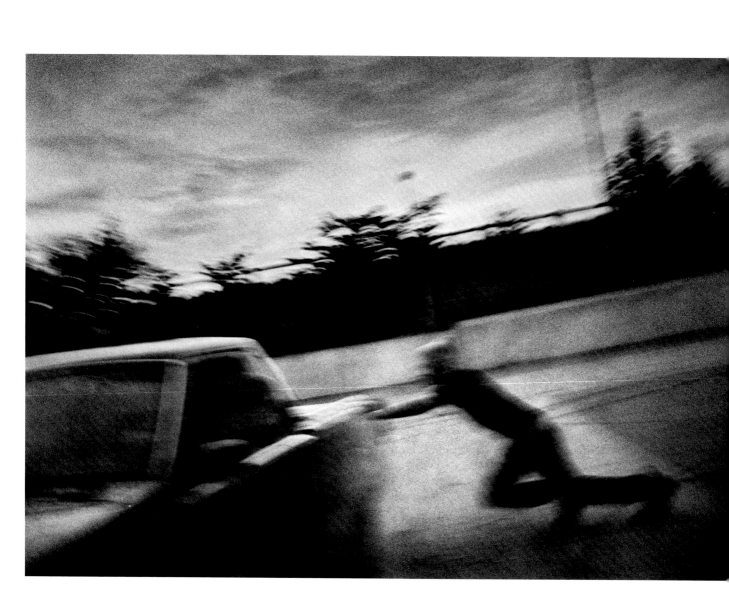

Martin Bogren *Tractor Boys* series, 2010–12

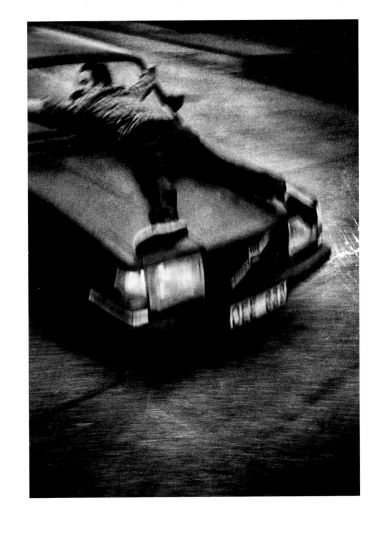

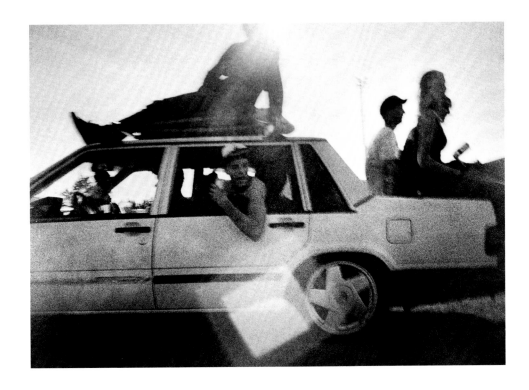

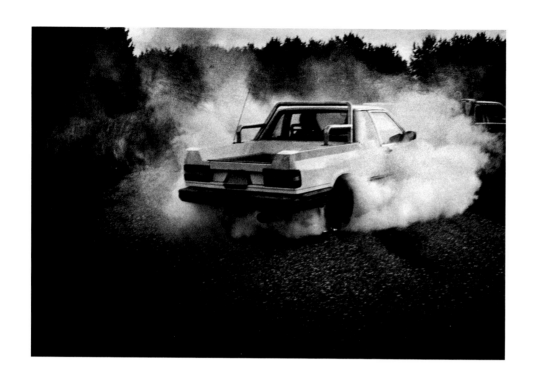

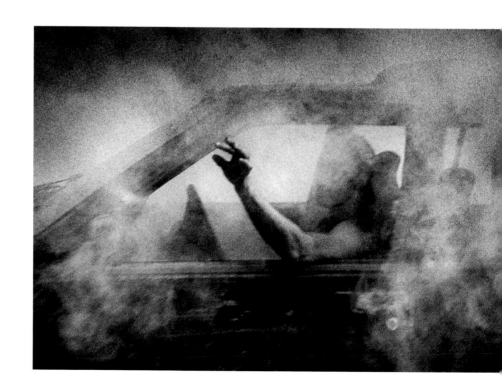

Martin Bogren *Tractor Boys* series, 2010–12

Robert Frank *Mary, Pablo and Andrea, U.S. 90, Texas. The Americans* series, 1955

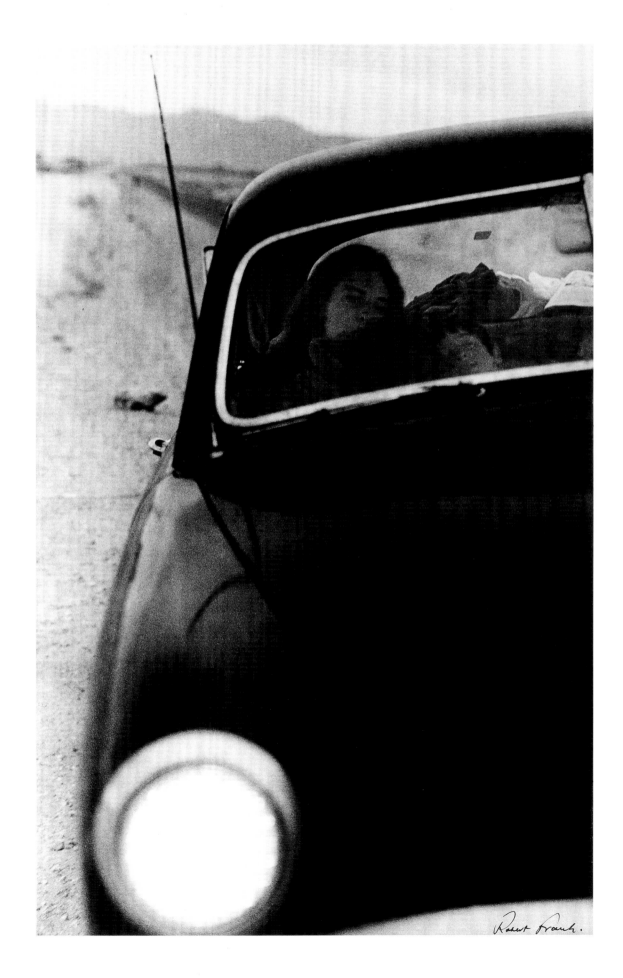

Robert Franck.

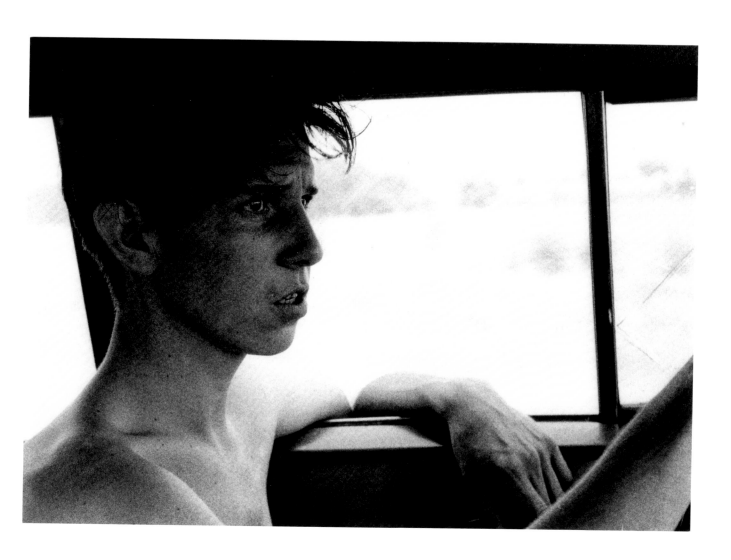

Larry Clark *Untitled. Tulsa* series, 1963

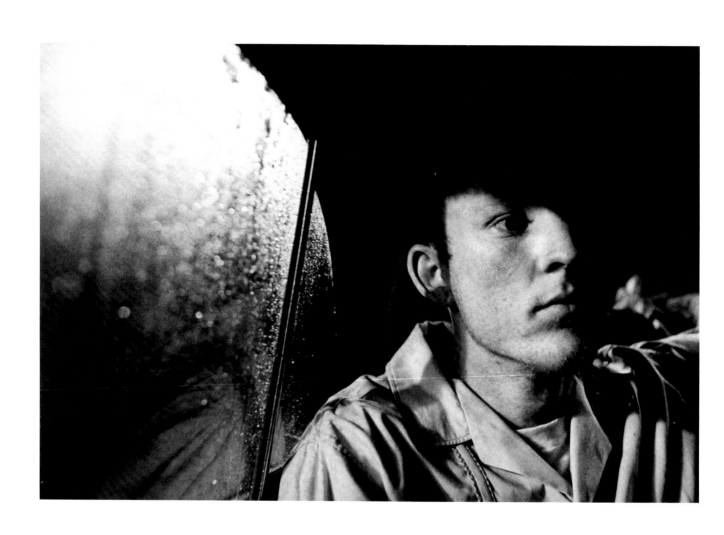

Larry Clark *Untitled. Tulsa* series, 1963

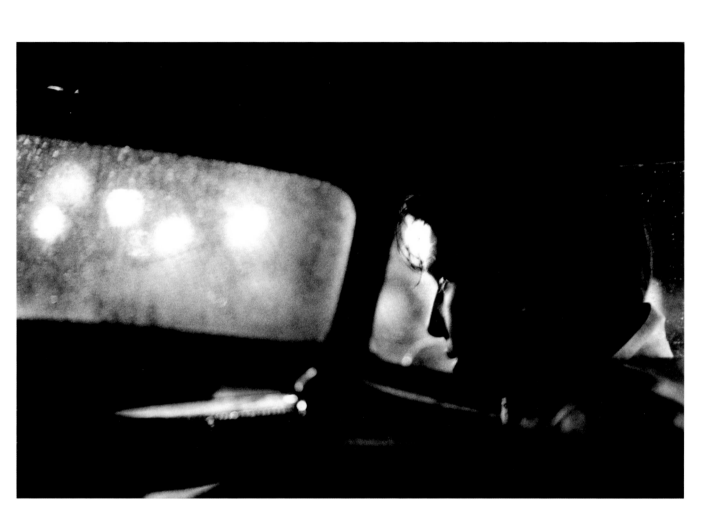

Larry Clark *Untitled. Tulsa* series, 1963

"I spent a lot of time with the Damm family. I met them on an assignment about homelessness for *LIFE* magazine. They had been kicked out of the shelter where they lived and were living in their car along with their dog, a mean pit bull named Runtly, and were clearly under stress. I made several good pictures but I knew I still needed a picture of them in their car since they were living in it. Taking a picture in a car is complicated in and of itself because there's very little space, but how do you take a picture of a whole family in a car? On the last day, I saw a good location, and asked them to stop the car. The spot was across from some railroad tracks so the car would have a little bit of landscape behind it. I must have worked on this picture for at least forty-five minutes. It's lit with strobe just to fill it. I opened the door to show more of the family. This is a very deliberate and directed portrait. But I didn't tell Crissy to put her hand on Jesse's face. That just happened, and it made the picture." **Mary Ellen Mark**

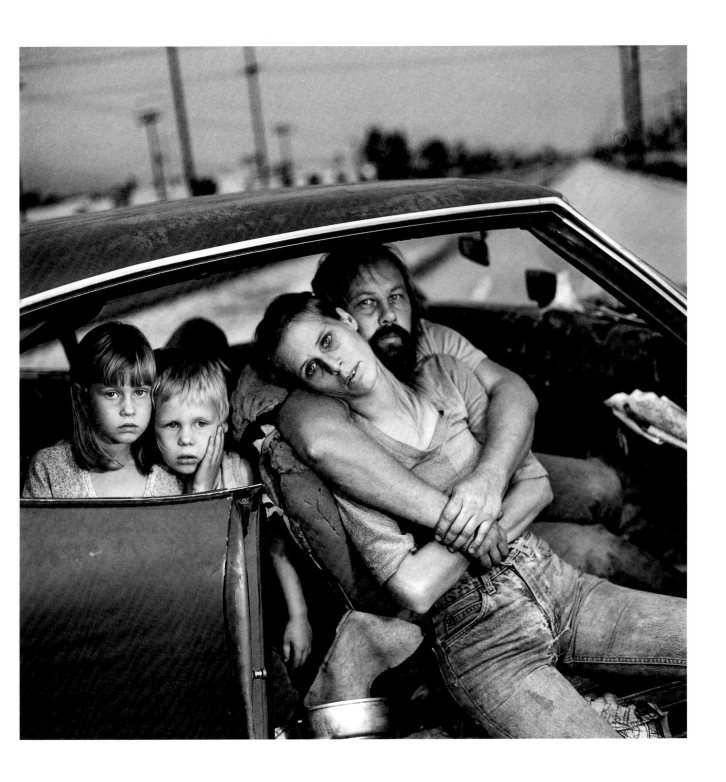

Mary Ellen Mark *The Damm Family, Los Angeles,* 1987

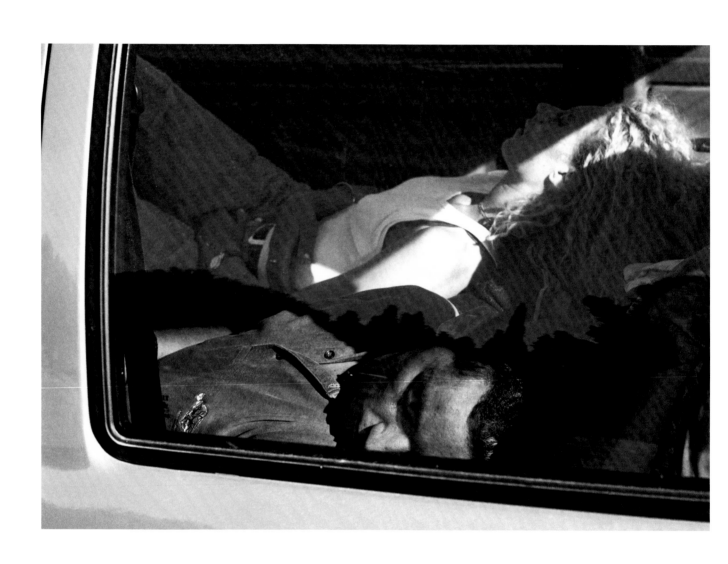

Jules Spinatsch *Sleep no. 6*, 1998–2009

Jules Spinatsch *Sleep no. 4*, 1998–2009

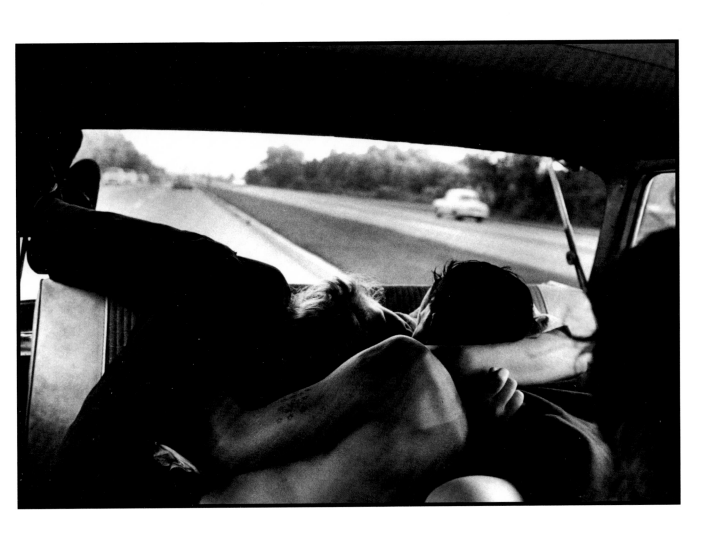

Bruce Davidson *Brooklyn Gang, New York City, USA*, 1959

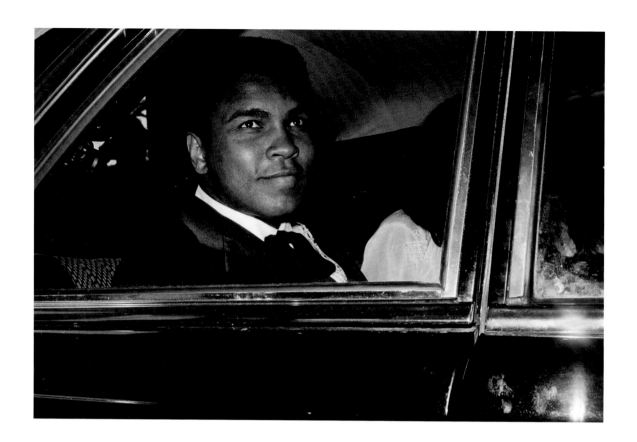

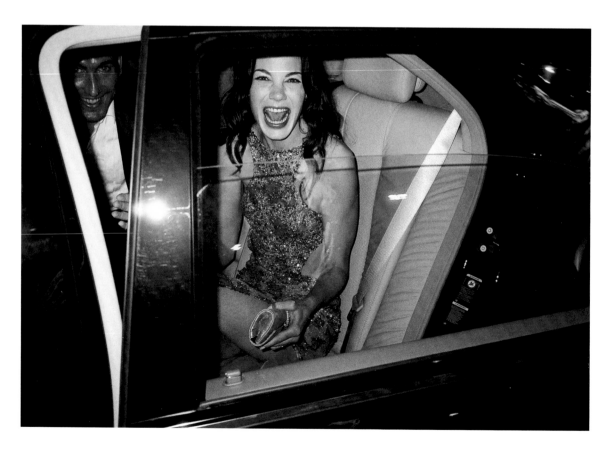

Jean Pigozzi *Muhammad Ali, New York, 1974 — Liv Tyler, Paris, 2006*

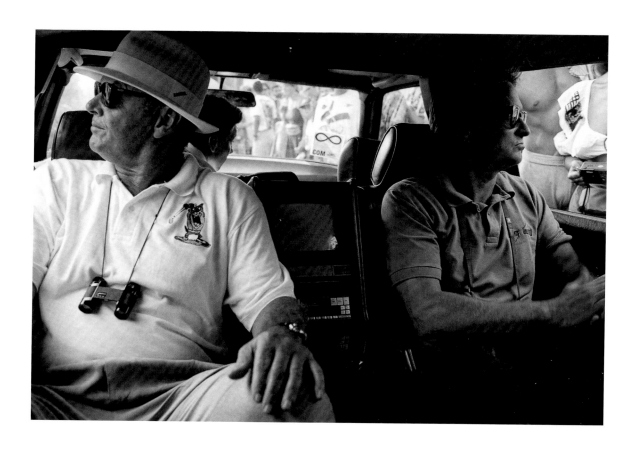

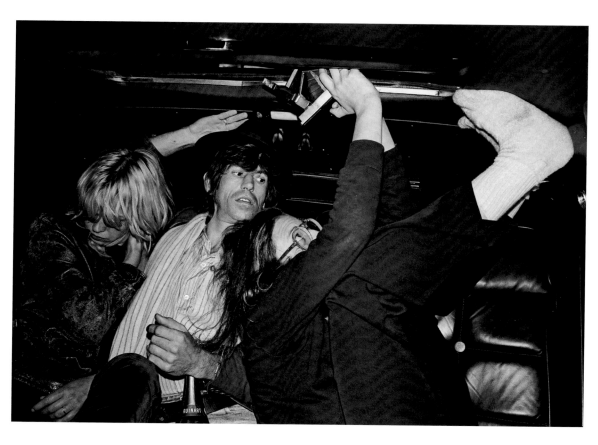

Jean Pigozzi *Jack Nicholson and Michael Douglas, Summer Olympics, Barcelona, 1992 —*
Keith Richards, Annie Leibovitz and Patti Hansen, New York, 1978

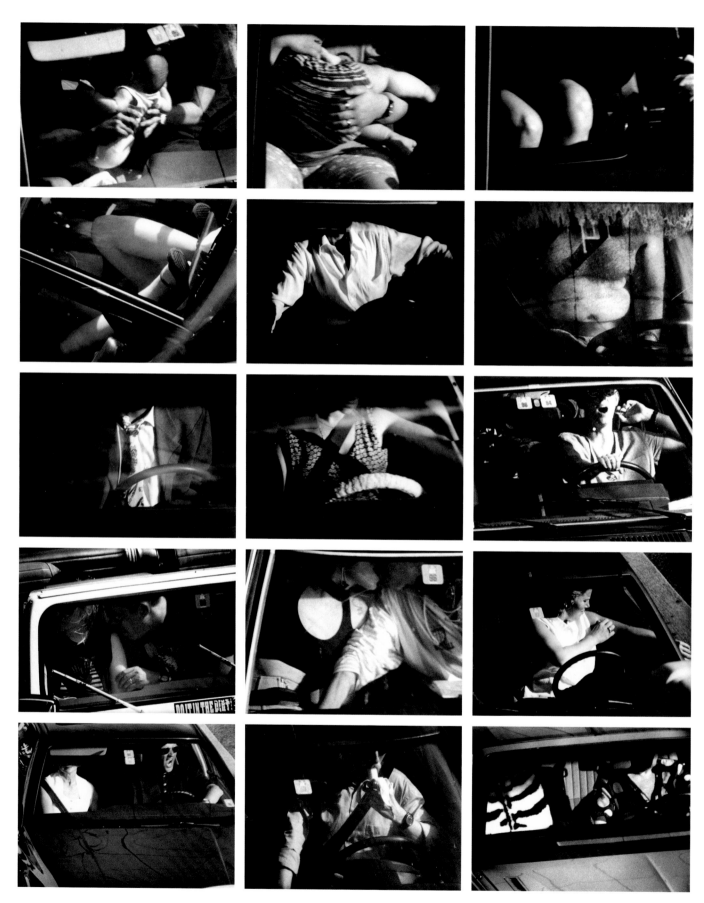

Kurt Caviezel *Red Light* series, 1999

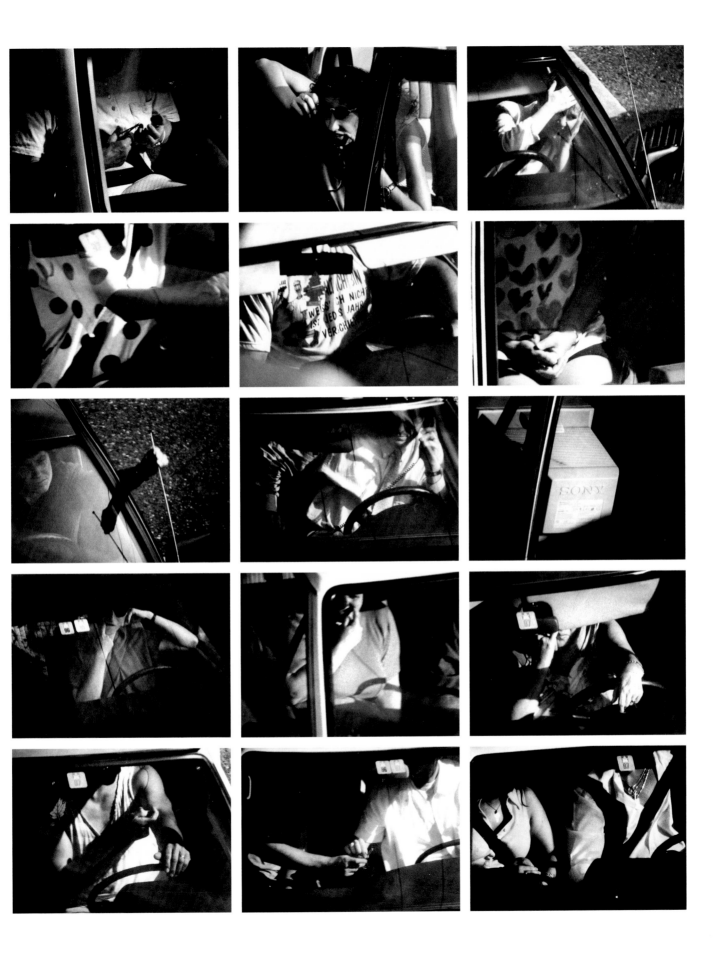

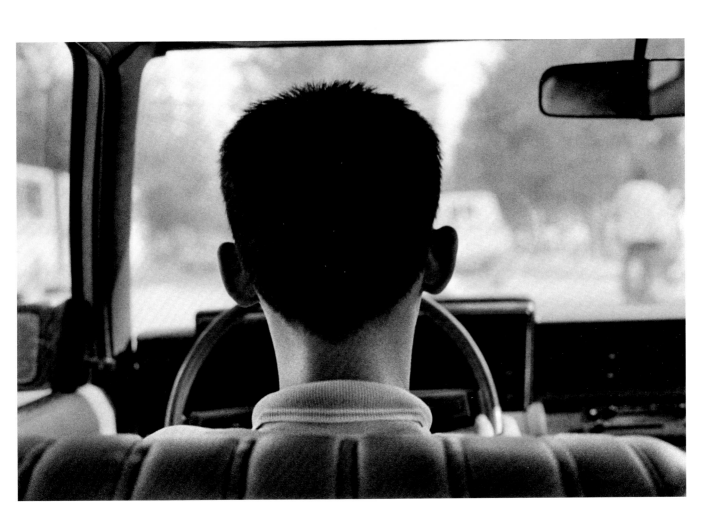

Raymond Depardon *Pékin, Chine*, 1985

Sheltered from the Wind and Rain

A Brief History of Automobile Design

Alain Bublex

Writing a story always involves a beginning, a point of departure to determine when it starts. Any history of the automobile, even a brief one, should begin with the first of its kind, the very first motor car, or the very first self-powered vehicle. Ours will be a short account. I have decided to focus on thirty innovative cars, all of which have significantly contributed to the evolution of the automobile. Firstly, we shall examine the overall architecture or form: the way in which the different parts and features that make up the contemporary car have evolved over time, as well as the assembly and the interrelationship of these parts, resulting in innovative new forms and new uses. This is not a history of technical innovation concerned with mechanical characteristics, nor a history of body styles. Rather, it is a history of the relationship between the technical aspects, forms, and use. Notoriety (a deceptive quality) was not a criterion for this selection. While some of the cars are very famous, whenever possible I have deliberately chosen lesser-known models, so that this account is not just another opportunity to succumb to nostalgia by showcasing old favorites, but is instead an opportunity to unveil the detours, doubts, and pressures, inherent to any creative activity.

For a long time, the history of the automobile was said to have begun in 1769, with the *fardier* designed by Nicolas Joseph Cugnot, a wooden machine driven by a steam engine. The *fardier* was an artillery tractor, and so the first innovation was military, intended to transport guns to the battlefield. It proved to be completely ineffective. On the other hand, it offers a rather open interpretation of history: all independently mobile machines could be considered automobiles. For example, the great steam coaches that started service in England in the 1830s, such as the Church, could then be classified as automobiles. But this definition of automobiles (things that move by their own means) no

Alain Bublex is an artist and a former industrial designer for Renault.

longer corresponds to the way in which we understand the term. The automobile is now understood as a machine for individual and domestic use, in a world paved with asphalt and filled with gasoline fumes. Therefore, the Marcus of 1875 is a model that is much closer to the object and definition of the automobile we have today. Unless what characterizes the automobile is having been designed for industrial as opposed to handcrafted production, that is, the fact that it is not merely a type of wooden cart equipped with an engine, but rather a machine designed to be used for the motorized transportation of people and mass production. In this case, the tricycle designed by Karl Benz in 1885, with its tubular steel chassis, can be the first automobile. Or perhaps the Benz quadricycle, designed the same year, if we are to stipulate that for a vehicle to be defined as a car it must have four wheels. Apart from their mainly personal use, the Marcus and the Benz attracted attention because they were the first automobiles equipped with internal combustion engines, which until just thirty years ago seemed indispensable to the definition of a car. Today, it would be foolhardy to define automobiles as only those machines driven by such an engine. However, if the internal combustion engine is no longer a defining characteristic, then steam-powered vehicles re-enter the history, and then Amédée Bollée's Mancelle from 1878 would be the first car made in at least two identical examples.

As we can see, determining the starting point of automobile history requires first defining the object. To say that a particular model was the first car is to circumscribe all others. Indeed, an entire book could be devoted to the subject. Therefore, in order to keep our account brief, I suggest that we begin our journey at the beginning of this chronological history by taking to the road with the Renault Type B sedan.

Translated from the French by Emma Lingwood

Alain Bublex, *Sheltered from the Wind and Rain*, 2017
1:10-scale 3D models presented in the exhibition *Autophoto*

| Renault
Type B |
| France |
| 1900 |

| Paul Jaray
Ley T6 |
| Germany |
| 1923 |

| Tatra 77 |
| Czechoslovakia |
| 1934 |

| **Nissan Be-1** |
| Japan |
| 1985 |

| **Citroën GS** |
| France |
| 1970 |

| **Lamborghini Marzal** |
| Italy |
| 1967 |

| Meunier-Béraud Car |
| France |
| 1946 |

| Mario Bellini Kar-a-sutra |
| Italy |
| 1972 |

| Jeep Wagoneer |
| United States |
| 1962 |

1900

Renault Type B

The Renault Type B sedan was the first car to accommodate passenger and driver within the same closed compartment, an invention that was not necessarily self-evident. Our history of the automobile therefore begins sheltered from the wind and rain, driving along roads seen through the filter of the windscreen for the very first time. We can imagine the landscape flying by, framed by the structure of the bodywork. Traveling in a closed car was quite different from driving

in the open air, without a windscreen and with an unrestricted panoramic view. While the Renault Type B associated the car and the image for the first time, providing a novel experience—undoubtedly a fortuitous consequence—it is thanks to this early sedan that the automobile became what it still is today: the most voluminous of personal items, an enclosed space that contains and transports us.

1900

Mercedes 35 HP

At first glance, the Mercedes 35 HP was not particularly innovative. It looks a bit like any other old car. But it is this similarity that makes it so important: the Mercedes 35 HP was the very first car to have this look. In other words, it is the archetype upon which other cars were based, and in terms of our history, another possible contender for first car. The Mercedes 35 HP was the first model to be equipped with the main elements of a car in the order in which they still frequently appear today: a radiator grille at the front with a motor placed just behind it, under a hood. After this, there

is the body comprising two front seats, including the driver's seat and then the passengers' seats or a trunk for transporting luggage. The passengers all faced the road. Entrance to the car was by means of side openings. A metal chassis supported the bodywork, making it possible to increase the distance between the wheel sets as required. The position of each element had been carefully considered. While the Renault Type B is part of our history in terms of its use (here was a car sheltering us from the elements, letting us see the road through the windscreen), the Mercedes makes the list through its technical prowess: the arrangement of all its parts in such a way as to ensure a powerful engine performance.

1902

Baker Electric Torpedo

Aerodynamics—the study of the forces exerted by the air on an object—remains one of the fundamental dimensions of car design. Generally, in automobiles the aim is to minimize the forces opposed to their movement. The less resistance a car meets, the more economically efficient its movement. When facing lower resistance, a car moves more quietly and is safer, but more importantly, faster. Walter Baker's aerodynamically streamlined Electric Torpedo appeared to have found the perfect solution. Just three years after Camille Jenatzy's Jamais Contente, the Torpedo

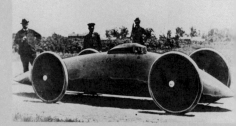

prototype was expertly streamlined: a low body, disc wheels, and a fully enclosed cockpit for the driver. Near perfection! And curiously, the photograph of the Torpedo at the starting line gives the same impression of speed as those of cars in motion taken by Jacques Henri Lartigue around that time.

1912

Rauch & Lang Electric Brougham

In 1912, the Electric Brougham by Rauch & Lang was one of the most luxurious and expensive cars on the American market. At that time, electric cars were in a league of their own. Silent, comfortable, and extremely easy to drive, they were very popular among the urban upper classes. Their interior was particularly striking. Luxuriously upholstered and spaciously designed, the Electric Brougham resembled a living room, with its two swivel armchairs facing the sofa at the rear. In 1913, Rauch & Lang introduced the dual-control coach, allowing the car to be driven from either

the front or the rear seats, with the pedals integrated into the floor and the steering wheel replaced by a steering bar. More than a simple means of transportation, this car was a veritable extension of the bourgeois interior, a mobile lounge primarily dedicated to conversation. A space in which the passengers' ease of interaction and comfort took precedence over all other considerations.

1921

Rumpler Tropfenwagen

The unprecedented design of the Tropfenwagen, or "Rumpler drop car" had the sole objective of providing the best possible aerodynamic performance. Aeronautical engineer and airplane manufacturer, Edmund Rumpler did not incorporate any of the usual characteristics of cars at that time into his design, nor did he take into account the constraints specific to their use. While the dimensions of his Tropfenwagen were more than generous, the car had only three seats, including the driver's seat on its own, at the front.

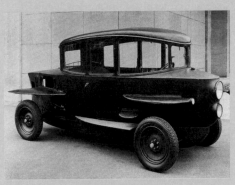

The car's engine, meanwhile, was located to the rear of the vehicle, in a central position. Despite its highly unusual vertical form, it offered an aerodynamic performance that has rarely been rivalled, even today. The adventure ended in commercial failure. Only around one hundred Tropfenwagens were put into circulation, mostly as taxis in Berlin: this rarity provided them with an exceptional reputation and visibility. Most of the avant-garde cars in Central Europe borrowed many of the Tropfenwagen's features and patents, including the early Porsche models.

1923-24

Jaray Ley T6, Audi K 14/50, Dixi 6/24 HP

While the aim was the same, the method Paul Jaray used to create an aerodynamic car was the opposite of that employed by Edmund Rumpler. This entry is not in reference to a specific model, but a type of streamlined bodywork that could be laid over most chassis then in existence. Between 1923 and 1924, Jaray created models for three different car manufacturers (Ley, Audi, and Dixi). More than a prototype, Jaray's design could be altered and adapted in innumerable versions. Over the course of the following two decades, the design was

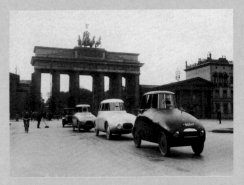

constantly modified and improved. Despite its demonstrated efficiency, no manufacturer ever took the risk of mass production. Admittedly, the elevated bodywork resulted in a somewhat unusual or awkward appearance (although the model itself was in no way inelegant). Similar in appearance to the Renault sedan, its contours were slightly softer, like a pebble on a beach, eroded over time. The model's organic aspect contributed to its distinctive appearance. It was to be a long time before it was commonplace to see cars without radiators, fenders, and hoods on the roads.

1930

Automobiles Avions Voisin

Avions Voisin automobiles are technically original: a host of anti-conformist principles hide behind their somewhat classic lines. Looking closely, none of the typical features of car design can be seen: it is as if the Voisins were designed using only a ruler and a compass, with a meticulous degree of attention to their proportions. The brand was the official supplier of the French presidential office, and was the

car of choice of many well-known figures, including Le Corbusier. His Voisin was often in the foreground of photographs he took of his buildings. While these images attest to his willingness to associate this model (rather than a Ley or a Rumpler) with the modernism he advocated, they can also prompt a reassessment of the unconventional reputation often attributed to him. These photographs also reveal the mimicry by which the Avions Voisin automobiles integrated into the urban landscape of their time: they seem designed less to be noticed than to elegantly blend with their environment, as with a well-cut suit. Such a quality is rare in creations of such originality.

1933

Dymaxion Car

The Dymaxion car was above all a sketch: the imagination of its inventor, Richard Buckminster Fuller, could have taken us much further. The Dymaxion was designed to be a vehicle capable of both flying and driving. The three prototypes built represent only the terrestrial version of the project, which was the intermediary stage. The prototypes were nevertheless received as full-fledged automobiles. For this project, Buckminster Fuller worked with a naval architect and the sculptor Isamu Noguchi. Everything about the car was original and different, in terms of the approach and its

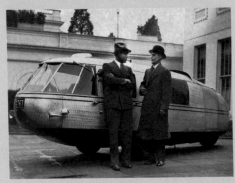

general appearance, its technical choices, architecture, and features. The car's inventor admitted that despite the interest in it, the Dymaxion would have had to have been considerably improved before entering production. Extremely difficult to pilot, it was hard to control when driving at higher speeds (the rear of the vehicle tended to lift at speeds above 80 km/h). It was also extremely sensitive to wind and impossible to control in rough conditions. A fatal accident, in which the invention itself was not at fault, brought the project to an abrupt end.

1934

Tatra 77

Between 1931 and 1933, the design team of the Czech car manufacturer, Tatra, developed a new small car that was both modern and economical: the V570. Paul Jaray was involved in its design. While the V570 was inspired by the latest technical advances in car manufacturing and design, it was the upscale Tatra 77 model that skillfully combined all of these advances. The Tatra 77 was a long and exceptionally low car, taking advantage of its rear engine. Luxurious, with a passenger compartment divided into two sections, it could transport up to six passengers at speeds of over

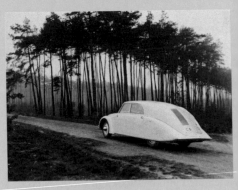

140 km/h in an appreciable silence: a feat for the time. Moreover, the Tatra 77, in contrast to many other top-of-the-range cars, was extremely rational (performance and comfort being measured then, as now, through tremendous proportions). The Tatra is one of the few cars from the 1930s that would hold its own in today's heavy traffic, able to teach us a lesson in terms of compactness and efficiency.

Citroën 7A

The Citroën 7A, or Traction, shared some of the same technical concerns as the Tatra: the aim of improving performance by reducing the frontal surface and lowering the center of gravity. By removing the transmission and exhaust from under the passenger compartment, thereby reducing the height, the Tatra had transferred the engine to the rear, attaching it to a central tube-steel frame that replaced the chassis. With even more originality (despite the Traction's more classic appearance), Citroën opted for a front-wheel drive and a self-supporting body. The Traction was

surprisingly compact family car. Thanks to nimble handling, it outclassed all its competitors, and although the Traction was not very powerful, it was extremely fast. In terms of design, the Traction was also particularly inventive: it made use of new manufacturing techniques from the United States to design a model suitable for mass production, allowing for variations to the bodywork.

KdF-Wagen

In every respect, the KdF-Wagen appeared to be modeled on the Tatra V570 prototype. It shared the same receding lines and rear engine, and like the V570, its bodywork was connected to a central tubular steel frame. It seems that Ferdinand Porsche simply resumed the designs for the Tatra where it had been abandoned. His contribution, however, was decisive. Under his guidance, emphasis was on reliability (excellent), fuel economy, and suitability for mass production. Porsche reversed Ford's paradigm: instead of organizing the production of cars in large numbers,

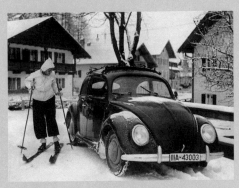

the former's response was to create a factory and an economic model specifically tailored to each other. Changing its name to Volkswagen after the Second World War and produced until 2003, the KdF-Wagen holds the record for the longest production, with more than twenty-one million made. However, it is extremely difficult to separate the Porsche company from its historical context: this model was created as part of the Nazi Party's political project.

Citroën TPV

Although the TPV ("Très Petite Voiture" or Very Small Car) is often considered as an awkward first draft or early prototype of the 2CV, this was, in fact, not the case. The TPV was approved in August 1939, and by the time the Second World War had broken out, 250 models had already been produced. So, where did these rudimentary forms come from if not a prototype? The answer is probably to be found outside the automotive world, among the designs for objects made at the Bauhaus. There was

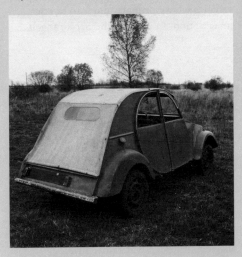

undoubtedly a stronger connection between the TPV and the Wassily Chair designed by Marcel Breuer or the LC/4 Chaise Longue by Le Corbusier, Pierre Jeanneret, and Charlotte Perriand than with a Letourneur & Marchand Delage. Similar shapes can be found in some of the most powerful vehicles of the day: race cars like the Tank Bugatti, military vehicles, or even in the domains of long-haul aviation or transportation. The TPV was light (the weight of a large modern-day motorbike). With an engine like today's scooter, it could easily carry four passengers and their luggage. Its quest for beauty, despite its small size, make it an aesthetic and technical achievement.

1939

Ava Schlörwagen

To measure the speed and the extent of technical progress made in the 1930s, the Schlörwagen must be compared with the Ley T6, built sixteen years previously. The Schlörwagen marked the culmination of aerodynamic research in the interwar period. Its performance in this area was, and remains, exceptional, with only a handful of contemporary experimental prototypes capable of matching it. Despite this, the car does not fit into the same category, that of fantastic but unusable vehicles whose primary aim is to fire the imagination. In a sense, the Schlörwagen

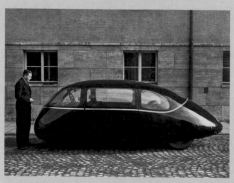

was an ordinary family car. However, its elegant design was rather striking, particularly when considering the context of its initial presentation: the Berlin Motor Show of 1939.

1946

Meunier-Béraud Car

In the era of shortage following the Second World War, the Meunier-Béraud car was created by an independent mechanic assisted by his carpenter brother-in-law. The car was built using a small three-seater cabriolet from the 1930s. To transform it into a six-seater sedan with a large trunk, they raised the steering wheel and moved the driver's compartment forward while straightening the two front seats, which allowed sufficient space to install a second row of seats in front of the rear axle. The design was simple yet ingenious. The same method would be used by Matra forty

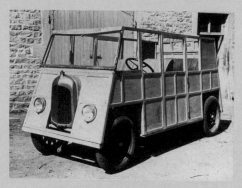

years later for the creation of the Espace, and subsequently for all other MPVs. The Meunier-Béraud car was designed and built using the least possible means. Its design was based on practical experience and observation and was far from showy. Originality was neither one of its aims nor its features. It was a vernacular car, inspired by experience rather than principles.

1954

Panhard & Levassor Dyna Z

The Dyna Z was one of the most radically innovative sedans ever created for mass production. Like an experimental prototype, everything was reconsidered and refined: the architecture, engine, chassis, volumes, bodywork, and even the materials. Its design was almost entirely devoid of decorative effects: in the streets of the 1950s, it stood out. By using an innovative process to manufacture each part of the car, the Dyna Z was a veritable technological showcase of its time. An engineer's dream. Everything was calculated as accurately as possible, apart from the cost price. Its performance was exceptional: the

Dyna Z was faster than other sedans while consuming less, with a smaller and simpler engine, and being larger and lighter than a Volkswagen, it could carry six people and their luggage. All of this, however, failed to save Panhard, one of the oldest of the French brands.

Citroën DS

While the DS is certainly the best-known car of this selection, it is also one of the most recognized in the history of the automobile. At once unusual and seductive, symbolized innovation and invention. Although it shared these qualities with many other models, its bodywork had something flamboyant and quite unique: you sense the rationality, while feeling its organic, almost minimalistic quality. The lines that Roland Barthes dedicated to it are often mentioned. In rereading them, we learn that what astonishes first with this car is the way in which the forms are joined together. How the eye seamlessly passes from one plane to

another, a remark applicable to both its solid and glazed surfaces. Moreover, the driving position appears to be in perfect harmony with the exterior. The throttle and clutch lever were replaced by buttons and levers. The DS brought the car into the modern era, characterized in the mid-1950s by the rise of electronics and household appliances. Its success was rather a surprise. While the 2CV was inspired by the most efficient planes of its time, the DS, for its part, seems to have been inspired by food processors.

Austin Mini

Despite its ultra-compact design, the Mini is as spacious as most of the cars in this selection: four reasonably comfortable seats for four adults and space for their luggage. Long and narrow, it measured only three meters in length. The search for maximum compactness seemed to have influenced the design, from key components such as the engine—the Austin Mini boasted a transverse engine and was the first mass-produced front-wheel-drive car, a feature that is now standard. It also featured space-saving fixtures such as storage baskets under the rear seat and the trunk door

could be used open, becoming a luggage rack on which the luggage could be placed. A small car, suited to city driving, the Mini was not, however, a discount car: its engine performance made it a formidable sporting car. Yet despite its versatility, it never became the family car it was designed to be. On the other hand, it was the first economically priced car embraced by the upper classes, and launched the market for second cars in Europe. Which was not necessarily an advantage …

Renault 4L

This car seems somewhat unsurprising. Yet, prior to its creation, cars were either sedans (or limousines) with a passenger compartment and a trunk, or utility vehicles, with a larger, more accessible cargo space, but without seating at the rear. The Renault 4L series offered as standard a modular interior that could be configured according to user needs. The folding seat with a fifth door in the rear (a hatchback) made it possible to transform the sedan into an SUV, or vice versa, making the Renault 4L a car that could be used for a wide variety of purposes.

1965

Meyers Manx

Originally, the Manx, or Dune Buggy, was a successful racing car built by a boat manufacturer and designed for desert competitions. Its unibody shell was made from fiberglass, attached to the suspension and a Volkswagen engine. The car was incredibly simple, exceptionally light, and its curves provided it with excellent stability. The Manx was very fast on rough terrain. The idea of selling it as a kit quickly became an option. Too expensive and

difficult to make, the unibody shell was soon abandoned in favor of a simpler Volkswagen chassis. Its success was immediate, and gave birth to a category of vehicles in their own right, most of which were copies or variations of the Manx. Users could now assemble the dune buggies themselves, with a kit costing around three hundred dollars. This last feature was a shift away from the 1960s, when you could use a car built in your garage from old parts to drive to the beach.

1967

NSU Ro 80

For the launch of the Ro 80, NSU announced that they had created the car of the future, hoping to repeat the success of the Citroën DS. The car was not a total hit however, despite the surprising fact that most status sedans still resemble this model. Unlike its predecessor, whose eye-catching architecture was combined with tried-and-tested technology used by the latest generation of front-wheel drives, the Ro 80 had a somewhat more classic design, but

boasted many avant-garde technical features. These included the new Wankel twin-rotor engine, the latest model internal combustion engine (major advances to this type of engine had not been made since its adoption by the automobile in 1886). Thus, its engine was powerful and compact, providing the car with great stability. At the same time, the Ro 80 was not as efficient as anticipated, and consumed too much fuel; indeed, early models of the car were not very reliable. The Ro 80 led to the downfall of NSU. All that remains is the subtlety of the Ro 80's design, and its exceptional aerodynamic performance.

1970

Citroën GS

Often, the models that go down in history are the first. This one, however, was the last. The last modern car. The problems that had appeared at the beginning of the century were (finally) resolved. Up until the 2000s, sedans resembled either the Ro 80 by NSU or the Citroën GS. We can say that these two models formed a couple. Both had the same type of engine (supplied by the same manufacturer). However, the Citroën's popularity was waning. Innovation was no longer a feature of the GS. The Citroën model marked the evolutionary pinnacle

of classic family cars. It was fantastically rational. One of its best features was its trunk. Although it had a two-box body, it did not benefit from the modular interior initiated by Renault with the 4L. On the other hand, its trunk was by far the best ever designed: a rectangular hold with a low, smooth sill. Luggage simply slid under the passenger compartment, as in an airplane. The modernity of the GS was that it was a classic sedan, and perfectly so.

972

Mario Bellini, Kar-a-sutra

Since the 1950s, the invention of new forms had been dominated by independent Italian car manufacturers. All other manufacturers looked to their modern designs, and many model series were inspired by them (the design of the Citroën GS, for example, owes much to the 1800 made by Pininfarina for BMC). From the mid-1960s, there was a great deal of rivalry between several prolific designers, and at car shows a fantastic array of sports car prototypes succeeded each

other. However, for the 1972 exhibition, *Italy: The New Domestic Landscape*, the Museum of Modern Art commissioned a car prototype from an architect known for his office equipment (for Olivetti). Mario Bellini's Kar-a-sutra played a significant role in the evolution of automobile history. The architect's ambition was to reconnect the public with the very essence of the automobile: for Bellini, the car was a moving space in space. A mobile place dedicated to exploration. The shell of the Kar-a-sutra could be raised when the car was stopped; the car's unusual seating arrangement could be reconfigured endlessly, thereby allowing the car to be a comfortable capsule from which to observe the landscape or do whatever you liked. The Kar-a-sutra expressed a certain conviction: that the automobile's evolution was no longer solely connected to the improvement of its intrinsic qualities, but rather, by the re-evaluation of the car's relation to the world as a whole.

1972

Witkar

The Witkar (White car) was a system of urban electric vehicles available for car sharing in Amsterdam between 1974 and 1986. The system was invented, promoted, and implemented by Luud Schimmelpennink, a designer, town councilor, and member of the Provo counterculture movement. The project dates to 1969, but due to a lack of municipal support, it could only be set up in the form of a cooperative. Witkar was very simple: each user had an ID card, and cars were put at their disposal at charging stations

around the city. When users had finished with the car, they returned it to one of the stations. Due to the lack of city support, and despite the four thousand registered users, the Witkar system never went beyond the experimental stage, with only thirty-five cars and five stations in service.

1975

Chris Burden, B-Car

The relationship between art and the automobile had remained unchanged for several decades. A string of well-known artists had all attempted to transfer their distinctive pictorial practice to a brand model, thus reducing their work to a series of flat colors. Chris Burden's project for his exhibition at De Appel in Amsterdam in 1975 was different in every respect: he undertook to design and build, in his California studio, in just a few weeks, a car capable of driving at 160 km/h, consuming only two and a half liters of gas per hundred

kilometers traveled. The car was to be reassembled in Holland as part of a four-day performance. A work of art is always a symbolic form that allows its audience to explore a possible interpretation of reality. In terms of cars, Chris Burden moved representation towards production. With his work, the attraction was no longer the car's aesthetic dimension (enhanced by the artist's contribution), but a constructive practice combining invention and production. With the B-Car project, the aim was not to create a thing of beauty, but to build an object intelligently.

1984

Matra/Renault Espace

Heir to the Kar-a-sutra, or what the 1970s left to the 1980s, the Espace boasted several new features, primarily its high, flat floor with numerous anchor points on which seven independent seats could be fixed as needed. The high-backed seats combined with a low-slung seatbelt and a large window surface meant that the interior was resolutely open to the exterior, towards the road, the sky, and the landscape. Despite its radical design and the fact that it was marketed as a luxury crossover vehicle, the Espace was highly successful, much to the surprise of Renault who had agreed to its launch without really believing in its potential. This is surely the reason why the

flexible seating structure has never been altered, nor the large windows. MPVs took their inspiration from the Espace's raised chassis, progressively becoming a costly and voluminous imitation of all-terrain vehicles (ATVs). By the 2000s, there was little of the 1970s to be seen.

1985

Nissan Be-1

The prototypes displayed in car shows generally take their inspiration from a somewhat stereotypical vision of the future: steering wheels are replaced by joysticks, holographic counters, improbable door openings, and exaggerated elongated, sculptural lines that naively represent speed and power. The Be-1, presented by Nissan at the Tokyo car show in 1985, was a radical departure from all these generic features. Surprisingly, this model drew its inspiration from the automobile's recent history: since the mid-1960s and the creation of the Excalibur sports car by

Brook Stevens, a market for collector's or retro vehicles was born. The Be-1 was much less flamboyant in its design: evocative of the Mini, without copying its lines, the Be-1 successfully blended into the traffic on the road at that time. Based on a mass-produced model, it boasted no innovative features. It was simply not modern. Its success was immediate. Nissan made it a limited series, sold only on pre-order (which was new for an auto manufacturer). The experiment was repeated several times, using the same marketing protocol for the Nissan S-Cargo, Pao, and Figaro.

1996

General Motors EV1

General Motors designed the EV1 to comply with California's 1990 Zero Emission Vehicle Act. This required the seven largest automakers in the US to produce and sell a minimum of 2 percent of zero-emission cars in 1998 and 10 percent in 2003, with the state government committed to subsidizing research into new models. The EV1 was not available for sale, but could only be leased for a period of three years. Well designed, the EV1 was remarkably smooth and silent. However, the production period was particularly slow, with customers placed on a long waiting

list. General Motors used weak demand as justification for this slowness, which prevented the company from achieving its required objectives. The company, like the other manufacturers, opposed the law, calling for its withdrawal. Supported by the oil companies, they had it repealed, with the new Bush administration directing support to hydrogen vehicles (thereby leaving a considerable future to the oil industry). Despite the insistence of some customers who wished to purchase their car, an attempt was made to prevent this: the company recalled all the EV1 cars in circulation in order to destroy them. Today approximately ten EV1 models can be found in museums and are prohibited from use. A future-looking project relegated to the past.

Smart Fortwo

The Smart Fortwo owes its existence to Nicolas Hayek, the entrepreneur and consultant responsible for the Swiss watch industry's restructuring in the 1980s. In the blaze of the Swatch watch's phenomenal success—inspired by a model that had never gone beyond the drawing-board that he found in the boxes of a Swiss watchmaker—Hayek aimed to replicate his success in the automobile industry, convinced that the European market was ready for a small, versatile electric city car: the Swatchmobile. Of all the manufacturers consulted, Mercedes was the only one to

show interest. The project, though, soon lost its momentum. Over time, most of the original ideas were abandoned, including the electric motor, the idea to rent or purchase without pre-ordering, as well as the suggestion to display the cars in glass towers outside car dealerships. Even the concept of interchangeable color door panels fell by the wayside. The overall result was a rather unremarkable small car, renamed Smart, which looked something like a high-tech sports shoe. In 1998, Hayek withdrew from the project, the public response to which was a far cry from the enthusiasm surrounding the Swatch. A missed opportunity, even if the Smart became the only two-seater city car that has continued to retain its position on the market.

Toyota Prius II

In 1998, Toyota sold an electric version of the RAV (an urban all-terrain vehicle) in California to comply with the Zero Emissions Policy. At the same time, in Japan, the company was researching and marketing a car with a new engine, the Prius. This model used a hybrid electric system powered by a regenerative brake system that converted the vehicle's kinetic energy into electric energy. Five years later, Toyota launched its second version of the Prius on the international market. A risky bet. Even more so, given the car's low, compact design, influenced by a strong attention to

aerodynamics. It arrived in California at a time when GM had abandoned the EV1 and launched the Hummer (an arrogant all-terrain vehicle derived from a military carrier). A touchscreen dominated the dashboard of the Prius, and the ignition key was replaced by a prominent push button. While these features are reminiscent of the DS, the Prius had well and truly entered the computer age. The Toyota lacked the Citroën's aura, but its commercial success and influence were remarkable, especially in California. Toyota announced it had sold one million Priuses as of 2008, and two million by 2010, thus demonstrating the possibility of, finally, evolving how automobiles are powered.

Google Car

Concluding a history is always difficult, to observe the present as the past, especially when it is impossible for us to truly grasp its significance, but only to imagine it. The influence of the last car in this selection remains a hypothesis that has yet to be verified. The Google Car is a self-driving car that has received permission to be test-driven on the open road. It is controlled automatically by a combination of cameras, sensors, and a GPS. Imagine the luxury of being driven by the Google Car through the slow-moving traffic of a large city, and of being able to concentrate on a conversation

or reading, allowing the car to take us home while making the most of our free time. It is just as easy to imagine that one day, driving assistance systems may prevent us from using our car as we see fit and not as the manufacturer had intended—to an extent, this is already the case. The car refuses to start if we did not respect the programmed protocol, or to drive along a muddy road, to change direction, or to get lost for the sheer pleasure of getting lost. Imagine a car that would drive itself of its own accord to the garage for inspection and maintenance. The Google Car will not arrive in the future like this, but its technologies will soon be integrated into many other models. It will be a question of guidance, comfort, and safety, but also of manufacturers acquiring data about our movements.

Appendices

Auto/Photo: Parallel Histories

1514

Making use of an Aristotelian principle, Leonardo da Vinci coins the term *camera obscura* (dark room). Considered the ancestor of the camera, this optical instrument consists of a black box, with one of its walls pierced by a hole through which light penetrates, projecting onto the inner wall opposite it an inverted representation of the reality outside the box, which could then be drawn. Seventeenth- and eighteenth-century Dutch and Italian painters were the first to use this technique.

1769

The French military engineer Nicolas Joseph Cugnot invents the *fardier* (steam dray), the first self-powered vehicle. This three-wheeled cart was powered by a steam boiler, and could run for fifteen minutes at speeds of approximately 4 km/h.

1807

In France, brothers Nicéphore and Claude Niépce develop the Pyréolophore, a prototype of an internal combustion engine operating with a mixture of coal and resin, a rudimentary version of the fuel injection system.

c. 1824

Nicéphore Niépce develops heliography, the first photographic process to produce a negative using a tin plate covered with bitumen of Judea. Two years later, he would succeed in realizing the first ever photograph, *View from the Window at Le Gras*.

1839

Furthering the research of Nicéphore Niépce, Louis Daguerre develops the daguerreotype, a method of fixing an image onto a polished copper plate, covered with silver. Following François Arago's announcement of this invention at the Académie des Sciences, the French State acquires the patent. The daguerreotype is then commercialized and spreads quickly throughout France, Europe, and the rest of the world.

1841

Englishman William Henry Fox Talbot creates the calotype: the image is fixed in negative onto a sheet of silver nitrate, photosensitive paper and then multiple copies can be reproduced in positive. Three years later, Talbot would publish *The Pencil of Nature*, the first work illustrated with photographs.

1849

French physicists and astronomers Hippolyte Fizeau and Léon Foucault invent the guillotine shutter, a mechanism built into the camera that causes a plate, pierced with a hole, to drop behind the lens, at the time of shooting. The weight and size of the shutter determine the exposure time of the film.

1851

Englishman Frederick Scott Archer invents the wet-collodion process, which consists of applying a cellulose nitrate, ether, and alcohol emulsion to a glass plate that, when dry, is immersed in a nitrate bath to sensitize it. The photograph is then taken before the ether evaporates and the plate is developed immediately. This inexpensive technique, boasting a short exposure time and a high quality of reproduction, dethrones the daguerreotype and the calotype.

The French Minister of the Interior launches the Mission Héliographique. Calling on the services of photographers Édouard Baldus, Hippolyte Bayard, Henri Le Secq, Gustave Le Gray, and Auguste Mestral, the aim of this first large-scale public commission is the constitution of a photographic collection destined for the Monuments Historiques, and would prove a useful resource in the restoration of some of France's most iconic monuments and landmarks.

1854

The photographic portrait becomes increasingly popular. Well-known Parisian figures such as Gérard de Nerval, Victor Hugo, Honoré de Balzac, George Sand, and Sarah Bernhardt all have their portrait taken by French photographer Nadar.

The British government appoints Roger Fenton as official photographer of the Crimean War. The first war reporter in the history of photography, Fenton loads an armored photographic van with five cameras and seven hundred collodion plates. He would produce some three hundred photographs, mixing portraits of soldiers with shots of military bases, hospitals, and places devastated by combat.

1861

The American Mathew B. Brady brings together a team of twenty photographers to cover the American Civil War. They would produce over seven thousand photographs of the conflict.

1871

Englishman Richard Leach Maddox experiments with a new process replacing wet collodion with a silver bromide gelatin emulsion. Once applied to a glass plate, the gelatin dries while conserving its sensitivity: plates no longer have to be prepared just before use.

1873

Frenchman Amédée Bollée designs L'Obéissante, the first steam-powered vehicle. It can transport up to twelve people and reach speeds of 40 km/h.

1876

In Germany, Gottlieb Daimler develops the first stationary gasoline engine, based on the principle of the compressed charge, four-stroke engine developed by the French engineer, Alphonse Beau de Rochas, in 1862.

1878

Englishman Charles Harper Bennett perfects the technique of the gelatin silver process by increasing the sensitivity of the silver bromide emulsion. This improvement

makes it possible to take photographs without a tripod, at speeds of 1/25 of a second, and to produce larger photographs of better quality. In the late 1870s, ready-to-use negatives were commercially available.

1883
In France, Étienne-Jules Marey develops chronophotography, a procedure allowing photographers to record a succession of images taken at fixed intervals in order to deconstruct and study the movement.

1885
German engineer Karl Benz patents the Patent-Motorwagen, a tricycle powered by an internal combustion engine running on gasoline. Capable of attaining speeds of 16 km/h, this tricycle is considered the first true industrial vehicle.

1888
Seven years after founding the Eastman Dry Plate Company in Rochester, for the commercialization of gelatin-bromide plates, George Eastman launches the Kodak No. 1, a lightweight, easy-to-use, portable camera, sold for 25 dollars, preloaded with a film for one hundred circular photos. The development of instant cameras makes photography accessible to a large audience of amateurs, and leads to the first international photographic artistic movement: pictorialism. Built around the idea of incorporating photography into the fine arts, this movement placed the artistic act at the heart of the photographic practice, searching for special effects (special lenses, blurriness, movement) and manual interventions during the developing of the prints.

1889
Kodak markets the first flexible, synthetic cellulose nitrate-based film in the form of a roll. The film simplifies the use of the camera and makes the user even more autonomous.

1890
Panhard & Levassor becomes the first French car company to market cars equipped with Daimler two-cylinder V-engine

1891
In France, brothers Édouard and André Michelin patent the first removable pneumatic tire with an inner tube, an improvement on the pneumatic rubber tire for bicycles invented by the Englishman John Boyd Dunlop in 1888.

In the United States, Thomas Edison presents the kinetoscope, which allows a 17-meter-long film to run on a loop at a speed of 48 frames per second.

1895
Brothers Charles and Frank Duryea create the Duryea Motor Wagon Company, the first American car company.

The Michelin brothers build the Éclair, the first car equipped with pneumatic tires.

Following the Paris–Bordeaux–Paris race, the first major car race organized in France, Count Albert de Dion and Baron Étienne de Zuylen de Nyevelt found the Automobile Club de France.

The Lumière brothers patent the cinematograph, the first motion-picture film camera and film projector. The first public film screening, showing *La Sortie de l'usine Lumière à Lyon*, takes place in Paris, with a running time of under a minute.

1896
In the United States, Henry Ford develops his first Quadricycle prototype. On the other side of the Atlantic, the Frenchman Armand Peugeot founds the Peugeot Automobile Company in Lille.

1897
The American Ransom Eli Olds establishes Olds Motor Vehicle Company, which by 1901 would become the primary car manufacturer in the US.

German engineer Rudolf Diesel develops an internal combustion engine that runs on vegetable oil.

1898
Louis Renault creates the Renault Voiturette Type A car by adding a gearbox, transmission, a direct-drive gearshift, and a fourth wheel to the De Dion-Bouton tricycle, equipped with

Camera obscura, 1867

The *fardier* by Nicolas Joseph Cugnot, Paris, 1770

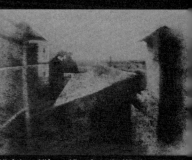

Nicéphore Niépce, *View from the Window at Le Gras*, 1826

The *Éclair* by the Michelin brothers, 1895

a gasoline motor. The following year, his two brothers, Marcel and Fernand would establish the Renault Brothers Company.

The first international Salon de l'Automobile et du Cycle (which would become the Paris Motor Show in 1988) is held in Paris, in the Tuileries Gardens.

1899

In France, a license is made obligatory for all drivers. A driver's license would become mandatory in the United States in 1900, and in Great Britain in 1903.

The Belgian automobile engineer Camille Jenatzy breaks the speed record by going above 100 km/h at the wheel of his Jamais Contente, a highly streamlined electric vehicle.

1900

The first Kodak Brownie camera, sold with a six-exposure film, appears on the US market at a retail price of one dollar.

French inventor and cinema pioneer Léon Gaumont creates the first speed detector radar from a photographic device onto which he installs a shutter with a dual-aperture system in order to obtain two images on the same plate. Given that the time elapsed between the two shots is known, to calculate the speed of the vehicle, it is enough to measure the distance covered by the vehicle between each image.

Over 1,600 automobiles are in circulation on French roads, and 8,000 in the US. Just five years earlier, only 350 cars could be found in France, 85 in the US, and a mere 15 in Great Britain.

The first edition of the Michelin Guide (*Guide Michelin offert gracieusement aux chauffeurs*) is published. This guidebook informs drivers where to sleep, eat, fill up on gas, and find a mechanic as they drive around France.

In Germany, Austrian businessman Emil Jellinek commissions thirty-six sports car models from Daimler, which he names Mercedes, in honor of his daughter. This 35 HP Mercedes model is very successful.

The first edition of the Gordon Bennett Cup takes place on a 565-km circuit between Paris and Lyon. France wins the cup in nine hours and nine minutes, with an average speed of 62 km/h.

1902

American photographer and art dealer Alfred Stieglitz launches the straight photography movement. Privileging the effects of sharp focus and high contrast, and limiting photographers to the parameters of the frame, this movement celebrated the snapshot, the aesthetics of composition, and black-and-white photography.

1903

The 8th Grand Prix organized by the Automobile Club de France, between Paris and Madrid, is canceled halfway through by the French government following a number of fatalities, including the accident in which Marcel Renault loses his life.

1904

One year after Henry Ford creates the Ford Motor Company in Detroit, the United States becomes the world leader in car production, a position until then occupied by France, which, with its 30,024 vehicles manufactured since the birth of the automobile, was once responsible for 48.8 percent of world production.

A massive campaign of roadworks is undertaken in France: roads are surfaced with tar. In the United States, concrete is used.

1905

The first service station is built in the United States, following the invention of the gas pump by the Norwegian immigrant, John J. Tokheim, in 1901.

1906

Charles Stewart Rolls and Frederick Henry Royce establish Rolls-Royce Limited, with the ambition of designing "the best car in the world."

The Automobile Club de France organizes its first Grand Prix on a closed circuit, totaling 103 km in the Sarthe Region.

1907

The Lumière brothers commercialize autochrome plates, making color photography widely accessible. This

technique involves coating a glass plate with fine grains of transparent potato starch, dyed blue, green, and red, which act as filters. The plate restores the original colors when processed.

The global car fleet is estimated at 250,000 vehicles.

1908

Henry Ford introduces assembly-line production for a single car model in his factories. The Model T is the first mass-produced car. Between 1908 and 1927, the Rouge River Plant in Detroit produces 16.5 million cars.

William Crapo Durant buys the Olds Motor Vehicle Company and renames it General Motors. The company manufactures and sells five car models, each targeting a different kind of end user: Buick, Oldsmobile, Oakland, Cadillac, and Chevrolet.

An international congress is held in Paris to discuss various problems connected to the growing numbers of cars on the road, and to regulate traffic and road signs. Other congresses would be held in Brussels in 1910, London in 1913, Seville in 1923, Milan in 1926, and Washington in 1930.

1909

Michelin provides French towns with signposts and a series of four warning signs: intersection, sharp bend, railroad crossing, and speed bump. A century later, 384 different road signs would be in use.

1910

Kodak launches the Vest Pocket, a small size camera that would be used by numerous soldiers during the First World War.

By this time, there are 100,000 cars in circulation on British roads, 495,000 in the United States, and 47,000 in Germany. In 1908, Japan had approximately twenty cars on its roads.

André Michelin develops the first road maps at a scale of 1/200,000. A system of cross-references between the map and numbered markers placed along the roads allow users

The Jamais Contente by Camille Jenatzy, 1899

Henry and Edsel Ford in a Model T, 1927

Traffic tower in Detroit, c. 1920

Advertisement
for the Rolleiflex,
Art Déco
Magazine, 1931

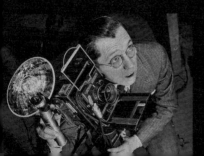

to orient themselves. In the space of three years, all of France is mapped on forty-seven maps.

1912
The Italian car company Fabbrica Italiana Automobili Torino (Fiat), founded in 1899 by Giovanni Agnelli, manufactures the Zero, its first mass-produced model.

1913
The United States remains the world leader in car production with 485,000 cars manufactured in one year, as opposed to 45,000 in France, 34,000 in Great Britain, 23,000 in Germany, and 18,000 in Italy.

1914
The First World War is the first motorized war in history. Parisian taxis are requisitioned to transport troops to the Battle of the Marne.

The American Traffic Signal Company installs the first electric traffic lights in Cleveland, Ohio. These traffic lights have two colors, red and green, and are manually controlled by a policeman in a booth; a ringing sound is heard during light changes. It is not until 1923 that a similar traffic light system is installed in Paris. The first tricolor stoplight is installed in New York in 1918, and in Paris in 1936.

1920
The global car fleet is estimated at 18 million vehicles.

1921
The first traffic code is implemented in France, with speed limits set at 12 km/h. In order to prevent traffic jams, French police devise a one-way system on certain streets and regulate parking. A similar system would be adopted in New York four years later.

1922
At the Salon de l'Automobile et du Cycle in Paris, Lancia presents the Lambda, the first car to feature a unitary body, made of galvanized steel, inspired by boat-hull design. The car is also equipped with an independent front suspension system and

1923
The first edition of the 24 Hours of Le Mans car race sees thirty-three cars competing fo the title.

1924
André Citroën launches the "Croisière Noire, a motor expedition led by eight half-tracks across the African continent, from Colomb-Béchar in Algeria to French Tananarive, Madagascar.

The First World War weakened the Europear car industry but had a positive effect on that of the United States. The latter would now become the undisputed world leader in car production: in 1914, 3.5 million cars were manufactured in the US, as opposed to 147,000 in Great Britain, 145,000 in France, 49,000 in Germany, and 50,000 in Italy.

1925
German engineer Oskar Barnack markets the Leica. This small instant camera in a 24 × 36 format allows users to take thirty-six shots per roll of film. Its success is enormous: in 1932, 100,000 units are sold The invention of small-format cameras result in the increasing popularity of photo reportage in the press. In the years that follow, many news magazines employ professional photographers such as Brassaï, Germaine Krull, Robert Capa, and Henri Cartier-Bresson to file stories about historic events.

German scientist Paul Vierkötter invents the electric flash, consisting of an aluminu filament in a glass bulb filled with oxygen. The flash was caused when an electric current passed through the filament. Patented in 1927 by the German engineer Johann Ostermeier, these bulbs would replace the magnesium powder that, until then, had been used in open spaces: the powder that was highly flammable and therefore extremely dangerous. In 1935, the French physicist Marcel Laporte would invent the electronic flash, consisting of a electronically powered xenon tube, which could be used more than once.

1926

French police car equipped with cameras and electric flash, c. 1950

army Jeep, Pine Camp, United States, 1941

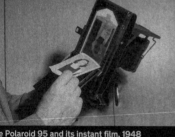

The Polaroid 95 and its instant film, 1948

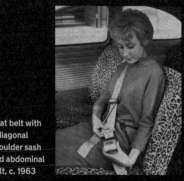

Seat belt with diagonal shoulder sash and abdominal belt, c. 1963

company, born from the fusion of Mercedes and Benz, specializing in the production of luxury and sports models.

1928

German company Franke & Heidecke launches the Rolleiflex, a compact, light-weight photographic device equipped with two lenses, offering users a high level of precision and square-format pictures.

Walter Percy Chrysler founds Chrysler Motors Corporation, a third American car manufacturer, which together with General Motors and Ford, would constitute the "Big Three."

1931

André Citroën launches the "Croisière Jaune," a motor expedition across Asia. From Beirut to Beijing, this ten-month trip over 12,000 kilometers would bring together forty-three men onboard of fourteen half-tracks. The expedition showcases the quality and durability of Citroën's cars, while providing the brand with an international reputation.

1933

Since his rise to power, Hitler, who viewed the automobile as the industry of the future, announces plans to massively develop Germany's road infrastructure, boosting employment. He claims the honor of having invented the autobahn, designs for which had already been drawn up under the Weimer Republic.

1934

The technique of the front-wheel drive is adopted in France on the Citroën 7CV. This car combines a unitary body and four-wheel independent suspension, and front-wheel drive.

At the New York Motor Show, Chrysler launches the Airflow, whose aerodynamic design and unibody frame would be used by car manufacturers the world over.

1936

A year after the launch of Kodak's Kodachrome, Agfa launches its first color

Italian engineer Dante Giacosa designs the Fiat 500. Nicknamed "Topolino" (Little mouse), this compact, reasonably-priced car can accommodate up to two passengers.

1937

At Bonneville Salt Flats, in the United States, the Thunderbolt by the Englishman George Eyston is the first car to ever reach speeds of 500 km/h.

1938

Hitler presents the KdF, the first Volkswagen, developed by Ferdinand Porsche, which would become the Volkswagen Beetle.

1939

Ford launches the Lincoln Continental, a model that would be produced up until 2002. President John F. Kennedy would be assassinated in this model in a motorcade through Dallas in 1963.

1940

General Motors installs the first automatic gearboxes in its cars.

1943

The oil shortage forces engineers to consider alternatives, including the electric car. French artist Paul Arzens creates the "Electric Egg," a car equipped with an aluminum body and powered by an electric motor, with a battery life of up to 100 km and capable of speeds up to 70 km/h.

1945

Production of the Beetle is resumed following the end of the Second World War. The car is very successful: in 1950, 100,000 units are produced at the Wolfsburg manufacturing plant. In 1955, one million units are produced.

During the Second World War, to meet the needs of the United States Army, almost 650,000 Jeeps are produced by Bantam, Willys, and Ford. Great Britain and the Soviet Union also place orders.

1946

Renault unveils its 4CV at the 33rd Paris Salon de l'Automobile.

1948

The German brand Porsche launches its first model, the Porsche 356, a sporting variant of the Beetle.

The American scientist and inventor Edwin Land creates the Polaroid, an instant camera that allows users to produce a sepia monochrome image on photo paper in under a minute. In the 1960s, the Polaroid would become Kodak's principal rival.

1949

Citroën launches the 2CV. The model is very popular with the French public and there are so many orders that Citroën is forced to sell its cars in priority to farmers, rural doctors, priests, etc. The 2CV becomes the symbol of the Trente Glorieuses, the thirty years of prosperity in France following the Second World War.

1950

The International Automobile Federation creates the Formula One Grand Prix, with the first edition held at Silverstone, England.

The global car fleet is estimated at 53 million vehicles.

1951

Ford carries out its first crash tests.

1952

Austin Motor and the Nuffield Organization merge to create the British Motor Corporation. England gains a reputation on the world market as the manufacturer of prestigious luxury and sporting cars, such as the Jaguar XK120 and the Austin 100.

Italian driver Alberto Ascari wins six races onboard the Ferrari 500 F2, reinforcing the reputation of the brand, founded and managed by Enzo Ferrari since 1929.

1954

According to a study carried out by Kodak, over 70 percent of American homes have a camera.

1955

The Japanese automobile industry grows in strength with the increasing success of Toyota and Nissan, who commercialize their first mass-produced series and begin to compete with Detroit for market dominance.

Citroën launches the DS 19. Nicknamed the "driving saucer" because of its aerodynamic and streamlined contours, this technically innovative model would become General de Gaulle's official car.

1956

The Federal-Aid Highway Act, popularly known as the National Interstate and Defense Highways Act, anticipates the expansion of the American highway infrastructure by over 65,000 kilometers, to harmonize road surfaces, intersections, and the national road-sign network. Filling stations, motels, and diners sprout up along the highways, while drive-ins and carparks flourish in cities and suburban areas.

1957

Fiat becomes Italy's leading car manufacturer. The company relaunches the 500, offering a lighter, more streamlined model. With its excellent performance and competitive price, an impressive 3.6 million Fiat 500s would be sold before production is stopped in 1975.

1958

Mao Zedong unveils the Dongfeng (East wind), China's first car.

1959

The Big Three begin to produce compact cars, such as General Motors' Chevrolet Corvair, Ford's Falcon, and Chrysler's Valiant.

The English automaker, Austin launches the Mini, a compact, fuel-efficient family car, sold at a retail price of 520 pounds. Over 5.3 million would be produced before production ceases in 2000.

Volvo patents the seat belt with a diagonal shoulder sash and abdominal belt, which it installs in all its models.

1960

Peugeot launches the 404, the first car equipped with a fuel-injection engine, capable of reaching speeds of 155 km/h. The car is very successful in France and throughout the African continent, where its sturdiness is apparent throughout the East African Safari Rally.

1961

The Renault 4L replaces the 4CV. This innovative models meets the needs of French consumers with the practical addition of front and back doors, and a hatchback. Manufactured in France and twenty-seven other countries, including Chile and Australia, this model is the second most successful model in the history of car manufacturing, with 8.1 million units sold, after the Peugeot 206 (8.4 million units sold).

Combining high-level performance (240 km/h) with an extremely competitive retail price (three times less expensive than a Ferrari), the Jaguar E-Type finds great commercial success in England.

1963

Aston Martin launches its famous DB5. This model boasts an aluminum body, and a six-cylinder engine capable of reaching speeds of 225 km/h; it would become the car of special agent James Bond, at the time played by Sean Connery.

Polaroid launches the Polacolor, capable of producing an 8 × 10 cm color image in a minute, which could then be enlarged. Kodak launches the Instamatic, a camera equipped with a built-in flash, capable of producing square-format prints.

1964

Ford commercializes the Mustang. A favorite with American youth, the car privileges individualization by allowing consumers to choose from a range of bodies, motors, transmissions, and accessories. In just two years, Ford would sell over one million Mustangs.

The Trabant is produced in factories in Zwickau, East Germany. Capable of reaching speeds of 100 km/h, up until the fall of the Berlin Wall in 1989, this car would be the most popular model in the Eastern bloc countries.

The electronic flash, functioning on the principle of a discharge lamp, replaces single-use bulbs.

1965

The American automobile industry beats its production record, with 9.3 million units

manufactured in one year, versus 2.4 million units in Germany and 696,000 in Japan.

Peugeot launches the 204, the brand's first car equipped with a transverse engine and front-wheel drive.

1967

Volkswagen commercializes the Type 2. This functional vehicle, inspired by the Beetle, is capable of transporting up to eight people and rapidly becomes the symbol of the hippie generation.

1970

The global car fleet is estimated at close to 193 million vehicles.

1971

While the seat belt is a standard feature on all mass-produced models since the previous year, in Australia it is now mandatory to wear it. France would do the same in 1973, having recorded 18,000 road deaths in 1972, its worst year on the roads. Germany would also pass this law in 1976, Great Britain in 1983, and the United States in the 1990s.

The Lunar Roving Vehicle carries out its first expedition on the moon as part of the Apollo 15 Mission. The vehicle is powered by four electric motors installed in the wheels.

1972

Polaroid launches the SX-70 model with an autofocus feature.

Renault commercializes the R5. This urban model boasts a folding rear seat and is very economical in terms of fuel consumption. From 1974 onwards, it becomes the most popular model in France.

1973

The first oil crisis hits the automobile industry, forcing European and American car manufacturers to decrease the size of their car designs, to improve energy efficiency.

1974

Volkswagen commercializes the Golf, the symbol of a new generation of compact, functional, hatchback cars. One year later, the company launches the Golf GTI. Capable of reaching 180 km/h, this model makes the sports car accessible to everyone. Three million are produced in the years following its release.

1975

The exhibition *New Topographics: Photographs of a Man-Altered Landscape*, organized at the George Eastman House in Rochester, showcases a new generation of photographers keen to represent the urban landscape: Robert Adams, Joe Deal, Nicholas Nixon, John Schott, Stephen Shore, and Henry Wessel Jr., whose work consists of sequences on a fixed theme, primarily in black and white.

1976

Kodak develops a prototype filmless camera, which allows users to broadcast the images captured onto a TV screen. The first electronic camera in the world, it would never be marketed, however, due to Kodak's lack of faith in its commercial potential.

Following the takeover of Citroën by Peugeot in 1974, the PSA Peugeot Citroën group is born.

1977

The Japanese company Konica launches the C35 AF, the first autofocus camera destined for amateurs. From 1980 onwards, Japanese companies such as Olympus, Canon, Fujifilm, Konica, Bronica, Minolta, and Mamiya hold 70 percent of the world market for consumer cameras.

1978

BMW and Mercedes-Benz adopt the ABS, an anti-braking system that ensures that a vehicle's tires maintain traction with the road during braking, thereby preventing the wheels from locking and skidding. Developed by Bosch, this system would quickly be adopted by other car manufacturers.

The first edition of the Dakar Rally, a competition open to motorbikes, trucks, and cars.

1980

The second oil crisis results in fierce competition between carmakers experiencing heavy losses and struggling to invest in the renewal of their models. The crisis pushes the car industry towards improved profitability.

Japan dethrones the United States by becoming the world's largest producer of cars. Japanese companies such as Honda, Nissan, and Toyota increase production in the West.

Developed in the 1970s by American manufacturers who were initially forced to abandon it, the airbag is first seen in the Mercedes-Benz, which offers this safety feature on the driver's side in the S-Class model. In the 1990s, two frontal airbags would become generalized for the front seats of cars. Progressively, car manufacturers would install them in the rear and in different parts of the car compartment.

1981

Sony releases its Mavica prototype (MAgnetic VIdeo CAmera), an electronic camera capable of digitally storing fifty color images on a mini disk. These images could be looked at on a TV screen, printed, or sent via the telephone network. Mavica digital models would only be released in 1997. These consumer cameras would allow Sony to dominate the world market for a long time.

1982

Nissan develops the Prairie, a compact but roomy MPV with sliding doors, the predecessor to the American van and the French people carrier.

1983

Peugeot launches the 205, one of the most famous models in the history of the company, with over 5.2 million sold.

1984

Inspired by the Nissan Prairie, Renault markets the Espace, an innovative single-hatch sedan that helps boost the car market by creating new demand. Despite a rocky start, the car would sell 60,000 units a year in the 1990s and 2000s.

1985

The world car fleet is estimated at 375 million vehicles.

1986
Canon launches the RC-701, the first analog electronic camera to be commercialized, destined for professionals.

1988
Fujifilm presents the Fujix DS-1P, the first digital camera, which would never be sold on the market. Its removable memory card is capable of storing 2 MB which must remain charged at all times or else content would be lost. The card can store digital data for a maximum of ten photographs.

1989
The Magellan NAV 1000, the first mobile satellite Global Positioning System (GPS), is sold in the United States.

1990
The Gulf War weakens American car production and the number of units produced decreases by one million in the space of twelve months. In order to reduce costs, companies outsource production or work together around shared projects.

According to the Institute for Health Metrics and Evaluation (IHME), the number of deaths on the road increases to 907,900 people worldwide in 1990. In France, the measures taken by the road safety council lead to a decrease in the number of fatalities: 10,289 as opposed to 12,510 in 1980; 7,643 in 2000 and 3,992 in 2010.

The global car fleet is estimated at close to 600 million vehicles.

Logitech commercializes the FotoMan, the first consumer digital camera (also produced by Dycam under the name the Dycam Model 1). Capable of storing thirty-six photos on its integrated 1 MB memory, it comes with a retail price of 995 dollars.

The digital SLR is born with the Kodak DCS 100, the first in a long series of professional cameras, mounted on a Nikon body.

The first image-editing software appear: Adobe launches Photoshop (1990), preceded by Digital Darkroom (1988),

PhotoMac (1988), and Letraset Color Studio (1989).

1992
Renault reestablishes its reputation as the designer of "user-friendly cars" with the launch of its urban car, the Twingo. In 1996, they would launch the compact model, the Scenic, and in 1997, the Kangoo.

1994
Toyota launches the concept of the sport utility vehicle (SUV) with the RAV4, a multipurpose car suited to both city and off-road driving. Over 6 million have been sold worldwide. The fourth-generation hybrid version, released in 2016, is the biggest-selling car in the US.

1996
Together Kodak, Canon, Fujifilm, Minolta, and Nikon launch the Advanced Photo System (APS), allowing users to produce photographs in three different formats (classic, high definition, and panoramic). It also features a film cartridge holder for easy loading and a mid-roll change function, wich enables users to remove the film before it has been completely exposed. Designed as an economical alternative to 35 mm film, the APS however, is not a commercial success. Its 24-mm format has an impact on the image quality and production is eventually stopped in 2011.

1997
Toyota designs the Prius, the first hybrid car using regenerative braking technology.

Mercedes-Benz launches the Smart, a compact, urban two-seater car. Although, the car did not reach the levels of success anticipated by its manufacturer, on average 100,000 units are sold per year.

1998
Global car production is put at 53 million. Japan is the world's largest producer, with 8 million units manufactured, followed by the US (over 5.5 million) and Germany (over 5.3 million).

1999
The Nikon D1 is the first digital SLR camera entirely designed by a manufacturer.

The Type 2 by Volkswagen, c. 1970

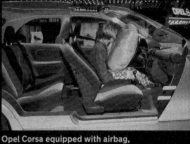
Opel Corsa equipped with airbag, Geneva International Motor Show, 1993

The Mavica by Sony, 1981

The FotoMan by Logitech, 1990

The first mobile phone with built-in camera is designed for the South Korean market: the Samsung SCH-V200. Capable of storing up to twenty photos with a resolution of 0.35 megapixels, users must connect to a computer to view the photos.

The Sharp J-SH04, commercialized in Japan, is considered the first camera phone in that it allows users to send and receive photos.

2004

Increasing to 76 million, the sales of digital cameras throughout the world surpasses the sale of film cameras for the first time (their sales peak at 43 million). Two years later, this gap would be even wider: 107 million digital cameras to 12 million film cameras sold.

The French company TomTom launches a portable navigation device destined for the general public. In ten years, over 75 million would be sold throughout the world.

Renault commercializes the Logan under the Romanian brand, Dacia, acquired in 1999. Keen to mass-produce a family car less expensive than a small city car, the Logan, produced in Romania, was originally destined for consumers in Eastern Europe, but met with great success once it was launched on the French market in 2005.

2005

The global car fleet is estimated at 890 million vehicles.

2006

The annual global production of vehicles rises to 69 million units.

For the first time, a diesel engine is seen on the podium of the 24 Hours of Le Mans, with Audi's two R10 TDIs placing first and third in the race.

2007

The American company Apple launches the first iPhone, a mobile phone equipped with a camera, video camera, GPS, digital music player, and Wi-Fi. The iPhone is one of the first smartphones to become a mass consumer item.

Nokia commercializes the N95 featuring a built-in 5-megapixel sensor with Carl Zeiss optics and autofocus, making it the best-selling phone camera on the market for several years.

Fiat relaunches its activity with the release of a new version of the Fiat 500. The success of the model can be seen in the 1.6 million sold by the end of 2015.

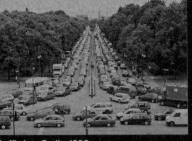

Traffic jam, Berlin, 1998

Google launches Street View, a platform enabling users to have a 360-degree view of a particular place, from multiple positions along an urban or rural road, throughout the world. These images are stitched together, taken from multiple photographs and combined to produce a panoramic view. Users can also move around virtually within the images. All of the photographs are taken by cars equipped with a camera on their roof, which travel the world to make these images.

The GPS TomTom GO 700, 2005

2010

Progress in mobile phone technology completely transforms amateur photographic use by allowing consumers to instantly upload and share their images. Platforms such as Flickr and Instagram make the instantaneous sharing of images on the Internet accessible to a wide public. Instagram attracts 100 million users in just one year.

Smartphones, 2000s

According to figures from the WHO, the number of global road fatalities rises to 1.3 million in 2010, compared with 1.2 million in 2000.

2011

With the iPhone 4S, Apple makes use of a Sony sensor for the first time. Sony and Samsung launch the Xperia Ray and Galaxy S II respectively, both equipped with the same sensor. Apple, however, boasts a more powerful image-processing software and dominates the camera-phone market.

NASA's Curiosity rover and its Chemical Camera, 2015

Polaroid returns to the instant photography market, after having stopped production of its instant cameras in 2007 and closed its film-manufacturing plant in 2008. In order to cope with the competition from digital cameras, the brand develops a hybrid camera capable of both storing images

Google Street View car, Calais, France, 2015

on a memory card and of printing them.
It continues to market its instant film
camera range.

2012
Canon is the world leader on the digital-
camera market for the tenth consecutive
year.

American businessman Elon Musk
manufactures the Tesla S, an upscale electric
car, capable of going from 0 to 100 km/h
in just 2.7 seconds. Equipped with two
electric motors, this car, with its cutting-
edge autopilot system, can reach speeds
of 250 km/h. In 2015, 120,000 units would
be sold.

NASA's Mars Curiosity rover lands on the
"red planet" to explore the soil in search of
traces of microbial life. This rover, equipped with
75 kilos of scientific equipment and seventeen
cameras can travel 4.5 cm per second.

2013
The camera is the key selling feature of
the smartphone, more important than SMS,
calls, and Internet access. Competition is
fierce between Apple, Sony, LG, Samsung,
HTC, and Panasonic, all of whom privilege
the performance of the camera. One digital
camera is now sold for every thirty-two
smartphones sold.

2015
Since their launch in 2003, 2,181 fixed speed
radars have been deployed on French roads.

Five years after announcing the design of a
self-driving car, Google is allowed to test the
Google prototype on US roads. This driverless
car, without steering wheel or pedals, is
equipped with an automatic control system
assisted by radars, GPS, cameras, and digital
sensors. The first prototypes, with a speed
limit of 40 km/h, are test-driven over
a distance of 1.5 million kilometers in 2015.
By the end of 2016, Google announced its
decision not to commercialize the Google
Car and to refocus on its automatic control
system.

2016
The global car fleet is 1.3 billion cars, or one
car for every six people in the world.

Biographies of the Authors

Simon Baker

Simon Baker began his career as professor of art history at the University of Nottingham, where he taught the history of photography, surrealism, and contemporary art. He joined Tate Modern in 2009 as its first curator of photography, and has worked on acquisitions and displays of the permanent collection and exhibitions at both Tate Modern and Tate Britain. His research interests encompass the history of photography from the nineteenth century to present day, with focuses on early to mid-twentieth century modernist photography, the postwar avant-garde in Japan, and contemporary photographic practice. Simon Baker has curated many exhibitions at Tate Modern, including *Exposed* (2010), *William Klein + Daido Moriyama* (2012), *Harry Callahan: Photographs* (2013), and *Conflict, Time, Photography* (2014). He has also contributed to various exhibition catalogs and books, including *Undercover Surrealism: Georges Bataille and Documents* (London: Hayward Gallery, 2006); *Close-Up: Proximity and Defamiliarisation in Art, Film and Photography* (Edinburgh: Fruitmarket Gallery, 2008); *Chris Shaw: Before and After Night Porter* (Heidelberg: Kehrer, 2012); and *George Condo* (London: Thames & Hudson, 2015).

Nancy W. Barr

Nancy W. Barr earned degrees in photography and art history from the College for Creative Studies and Wayne State University in Detroit. She has worked with collections at Wayne State University's Reuther Labor Archives and the Detroit Historical Museum, and in 1993 joined the curatorial staff of the Detroit Institute of Arts (DIA), where she is the James Pearson Duffy Curator of Photography and Co-Chief Curator. A specialist in modernist and contemporary photography, in recent years her research interests have turned to historical and contemporary photographic practice in Detroit. In addition to her work at the DIA, she has served on the faculties at the College for Creative Studies, Detroit and the University of Michigan, Dearborn. Nancy W. Barr has organized over twenty-five exhibitions for the DIA, including *Picturing Paris* (1995); *Dawoud Bey: Detroit Portraits* (2004); *Detroit Experiences: Robert Frank Photographs, 1955* (2010); *Detroit Revealed: Photographs, 2000–2010* (2011); *Motor City Muse: Detroit Photographs, Then and Now* (2012); *Foto Europa* (2013); and *Detroit After Dark* (2016). As an author, she has contributed essays and articles to *Encyclopedia of Twentieth-Century Photography* (New York: Routledge, 2006); *Detroit: Unbroken Down* (Photographs by Dave Jordano, New York: PowerHouse Books, 2015); *Big Magazine*; *Bulletin of the Detroit Institute of Arts*; and *Photography Quarterly*.

Xavier Barral

After graduating from the École Supérieure d'Arts Graphiques Penninghen in 1977, Xavier Barral went on to study scenography, and then embarked on numerous sea voyages. In the 1980s, he worked as a press photographer, then as artistic director for several journals and magazines, including *Impact médecin*, *Photographies*, *L'Autre Journal*, and *L'Événement du jeudi*. In 1992, he and Annette Lucas founded Atalante, a visual creation and cultural communications agency, responsible for the visual identities of several major arts institutions. He has also collaborated with many publishing houses. In 2002, he founded Éditions Xavier Barral, specializing in the arts and sciences. He regularly accompanies his books with exhibitions in France and internationally.

Alain Bublex

Alain Bublex was an industrial designer with the Renault Group before leaving in 1992 to devote himself to his artistic activity, at the crossroads of urban design, photography, and installation. His work is often based on the uncompleted or unfinished designs of engineers and architects, which he completes using his own sketches, and documentary and archival elements. The car occupies a central place in his work, acting as subject, a tool of movement, and a medium, in the same manner as the camera. For *Glooscap*, a project begun in 1985, Bublex has imagined an entire city from scratch, and created a corpus of documents attesting to its existence and history: from the first paper map, dated 1605, to digital photographs of urban landscapes. In 1995, he created *Aérofiat*, an automotive prototype designed to be at once an illustration of modernity as it had been conceived in the 1950s and the missing link in the history of the automobile. In 2009, he led the project *Expérience Wabi-Sabi*, a car journey from Paris to Tokyo with the aim of observing the natural transformation of the vehicle over the course of its long trip.

Alain Bublex's work has been featured in several exhibitions, including at the Palais de Tokyo in Paris and the Massachusetts Museum of Contemporary Art in North Adams in 2003; the APT Gallery in London in 2005; the Centre Pompidou in Paris in 2009; the Centre de Création Contemporaine in Tours in 2000 and 2010; and the Musée d'Art Moderne et Contemporain in Geneva in 2007 and 2012. He is the author of *Impressions de France* (Caen: PUC, 2013) and he co-authored *Le Futur n'existe pas. Rétrotypes* with philosopher Elie During (Paris: B42, 2014). In 2010, the publishing house Flammarion released *Utopies Urbaines*, the first monograph devoted to his work.

Clément Chéroux

Following his studies at the École Nationale Supérieure de la Photographie (ENSP) in Arles, Clément Chéroux obtained his PhD in Art History in 2004 from the Université Paris I – Panthéon-Sorbonne. A founding member of the Laboratoire d'Histoire Visuelle Contemporaine (Lhivic) at the EHESS, he has lectured on the history of photography at several universities, including Paris I –

Panthéon-Sorbonne and Paris VIII, ENSP, and the University of Lausanne. In 2007, he joined the Centre Pompidou in Paris as curator of photography, then worked as the Department of Photography's chief curator from 2013 to 2016. Since 2017, he has been senior curator of the San Francisco Museum of Modern Art's Department of Photography. Clément Chéroux has curated numerous exhibitions, including *Mémoire des camps. Photographies des camps de concentration et d'extermination nazis, 1933-1999* at the Hôtel de Sully in Paris in 2001; *The Perfect Medium: Photography and the Occult* at the Maison Européenne de la Photographie in Paris in 2004, followed by the Metropolitan Museum of Art in New York in 2005; *La Subversion des images. Surréalisme, photographie, film* at the Centre Pompidou in Paris in 2009; and *Derrière le rideau. L'esthétique Photomaton* at the Musée de l'Élysée in Lausanne in 2012. Formerly editor of the review *Études photographiques*, since 2009 Clément Chéroux has overseen the collection "L'Écriture photographique" for Éditions Textuel. He is the author of many works, including *Fautographie. Petite histoire de l'erreur photographique* (Crisnée: Yellow Now, 2003); *Henri Cartier-Bresson. Le tir photographique* (Paris: Gallimard, 2008); *La photographie qui fait mouche* (Paris: Librairie Serge Plantureux, 2009); *Ombres portées* (Paris: Centre Pompidou, 2011), and *Avant l'avant-garde. Du jeu en photographie, 1890-1940* (Paris: Textuel, 2015).

Marc Desportes

A graduate of the École Polytechnique (1985), holder of a civil engineering degree (1988), and PhD in urban planning (1995), Marc Desportes began his engineering career at the Ministère de l'Équipement, then the Conseil Régional d'Île-de-France, and later the Ville de Boulogne-Billancourt. In 1999, he was responsible for the sites and environmental planning aspects of the application for the French capital's bid for the 2008 Olympic Games. In 2001, he was employed by François Pinault to oversee the construction of his foundation on the Île Seguin, and later for the Palazzo Grassi and the Punta della Dogana in Venice. Since 2006, Marc Desportes has managed construction projects through his agency, Kerso.

In 1997, Marc Desportes curated the exhibition commemorating the 250th anniversary of the École des Ponts et Chaussées at the Archives Nationales in Paris, and in collaboration with Antoine Picon published *De l'espace au territoire. L'aménagement en France, XVIᵉ-XXᵉ siècle* (Paris: Presses de l'École Nationale des Ponts et Chaussées). In 2005, he published *Paysages en mouvement. Transports et perception de l'espace, XVIIIᵉ-XXᵉ siècle* (Paris: Gallimard), exploring the ways in which transportation has influenced humanity's relationship to space and the landscape, a topic hefirst explored in his doctoral dissertation in 1995.

Pascal Ory

A specialist in history, a recipient of the Fondation Thiers grant, and a PhD in Humanities, Pascal Ory is professor of contemporary history at the Université Paris I – Panthéon-Sorbonne, and lectures at the Sciences Po School of Journalism, and at the Ina SUP, the national institute of audiovisual and digital media. He is a founding member of the History Department, the MPhil of Social and Cultural History, and the Centre d'Histoire Culturelle des Sociétés Contemporaines (today the Institut d'Études Culturelles) at the Université de Versailles – Saint-Quentin-en-Yvelines. His research focuses on contemporary French social history, particularly culture, national identity, contemporary mythology, and the modern body. Since the 1970s, he has contributed to the definition of notions of cultural history, and in 1999, founded the Association pour le Développement de l'Histoire Culturelle (ADHC), of which he is now president. Pascal Ory has published many essays in specialized publications such as *Le Débat, Hypothèses, Revue d'histoire moderne & contemporaine*, and *Sociétés & Représentations*. He is also the author of several books including *Nouvelle histoire des idées politiques* (Paris: Hachette, 1987); *L'Histoire culturelle* (Paris: PUF, 2004); *La Culture comme aventure. Treize exercices d'histoire culturelle* (Paris: Complexe, 2008); *Grande encyclopédie du presque rien* (Paris: Éditions des Busclats, 2010); and *Ce que dit Charlie. Treize leçons d'histoire* (Paris: Gallimard, 2016). Since 1975, Pascal Ory

has been a regular guest on the French radio station, France Culture. He is also an administrator for the Société Civile des Auteurs Multimédias (SCAM) and regent for the Collège de 'Pataphysique.

Philippe Séclier

Philippe Séclier has been the editor-in-chief for the magazine *AUTOhebdo* since 2008, and is the former assistant editor of *Le Parisien* and *Aujourd'hui en France*. In parallel to his career as a journalist, he is a photographer whose favored subject is movement. Between 1995 and 2000, he traveled all over the world photographing ports and cargo ships, images that he published in *Hôtel Puerto* (Marseille: Images En Manœuvres Éditions, 2001). In 2000, Philippe Séclier began a two-month journey along the Italian coast following in the footsteps of the writer and filmmaker, Pier Paolo Pasolini. The photographs from his journey, as well as rare documents on the life of the artist, were published in *La Longue Route de sable* (Paris: Éditions Xavier Barral, 2005), winner of the Thomas Cook Prize in 2005. Following trips to Chile between 1999 and 2002, he related the life story of the Chilean photographer Sergio Larrain in *El camino de Tulahuén. En busca de Sergio Larrain* (Santiago de Chile: LOM Ediciones, 2014). In 2004, he directed a documentary *Instants d'année*, devoted to French photographer Marc Riboud. In 2005, he embarked on a journey retracing the story behind American photographer Robert Frank's iconic photography book, *The Americans*. The result of his numerous visits to the United States between 2005 and 2008 was the documentary film *Un voyage américain* (2009). Since 2007, Philippe Séclier has collaborated with the photographer and filmmaker, Raymond Depardon.

Selected Bibliography

General works on photography

Pierre-Jean Amar. *L'ABCdaire de la photographie*. Paris: Flammarion, 2003.

Quentin Bajac. *La Photographie. Du daguerréotype au numérique*. Paris: Gallimard, 2010.

Roland Barthes. *Camera Lucida: Reflections on Photography*. Translated by Richard Howard. New York: Hill and Wang, [1980] 1999

Alan Buckingham. *Photography*. London: DK, 2004.

Clément Chéroux and Karolina Ziebinska-Lewandowska. *Qu'est-ce que la photographie ?* Paris: Centre Pompidou/Xavier Barral, 2015.

Michel Frizot. *A New History of Photography*. Cologne: Könemann, 1998.

Rosalind Krauss. *Le Photographique. Pour une théorie des écarts*. Paris: Macula, 1990.

Jean-Claude Lemagny and André Rouillé, eds. *Histoire de la photographie*. Paris: Larousse, 1998.

Michel Poivert. *Brève histoire de la photographie*. Vanves: Hazan, 2015.

Naomi Rosenblum. *A World History of Photography*. New York: Abbeville, [1984] 2008.

André Rouillé. *La Photographie*. Paris: Gallimard, 2005.

General works on the automobile

Diane Bailey. *How the Automobile Changed History*. Minneapolis, MN: Abdo, 2016.

Serge Bellu. *Histoire mondiale de l'automobile*. Paris: Flammarion, 1998.

Joseph Cabadas. *River Rouge: Ford's Industrial Colossus*. Saint Paul, MN: Motorbooks International, 2004.

Car: The Definitive Visual History of the Automobile. London: DK, 2011.

Alex De Rijke and Jonathan Bell. *Carchitecture: When the Car and the City Collide*. Basel: Birkhäuser, 2001.

Marc Desportes. *Paysages en mouvement. Transports et perception de l'espace, XVIII^e-XX^e siècle*. Paris: Gallimard, 2005.

James J. Flink. *The Automobile Age*. Cambridge, MA: MIT Press, 1988.

Mathieu Flonneau. *Les Cultures du volant, XX^e-XXI^e siècles. Essai sur les mondes de l'automobilisme*. Paris: Autrement, 2008.

Mathieu Flonneau and Vincent Guigueno, eds. *De l'histoire des transports à l'histoire de la mobilité ?* Rennes: Presses universitaires de Rennes, 2009.

Patrick Fridenson. *Histoire des usines Renault*. Paris: Seuil, 1998.

David Gartman. *Auto Opium: A Social History of American Automobile Design*. New York: Routledge, 1994.

Hermann Harz. *Das Erlebnis der Reichsautobahn. Ein Bildwerk*. Munich: Callwey, 1943.

John Heitmann. *The Automobile and American Life*. Jefferson, NC: McFarland, 2009.

Beverly Rae Kimes. *Pioneers, Engineers, and Scoundrels: The Dawn of the Automobile in America*. Troy, MI: Society of Automotive Engineers, 2004.

Jean-François Krause and Serge Bellu. *La Grande Histoire de l'automobile*. Neuilly-sur-Seine: Cobra, 2010.

David L. Lewis and Laurence Goldstein. *The Automobile and American Culture*. Ann Arbor, MI: University of Michigan Press, 1983.

Peter E. Marsh and Peter Collett. *Driving Passion: The Psychology of the Car*. Boston, MA: Faber and Faber, 1986.

Gerald Silk. *Automobile and Culture*. New York: Abrams, 1984.

Penny Sparke. *A Century of Car Design*. Hauppauge, NY: Barron's Educational Series, 2002.

Christopher W. Wells. *Car Country: An Environmental History*. Seattle, WA: University of Washington Press, 2013.

Peter Wollen and Joe Kerr. *Autopia: Cars and Culture*. London: Reaktion, 2002.

Artist's monographs and exhibition catalogs

Robert Adams. *The New West*. New York: Aperture, 1974.

Robert Adams. *Along Some Rivers. Photographs and conversations* (New York: Aperture, 2006).

Bernard Asset. *Génération Turbo*. Argelès-sur-Mer: Abac, 1988.

Valérie Belin. *Unquiet Images*. Paris: Centre Pompidou/Dilecta, 2015.

Martin Bogren. *Tractor Boys*. Villejuif: Aman Iman, 2013.

Hartmut Böhme, ed. *Car Fetish: I Drive, Therefore I Am*. Basel: Museum Tinguely, 2011.

David Bradford. *Drive-By Shootings*. Cologne: Könemann, 2000.

David Bradford. *The New York Taxi Back Seat Book*. Cologne: Daab, 2006.

Brassaï. *Paris by Night*. New York: Bulfinch, 2001.

Alain Bublex. *Utopies urbaines*. Paris: Flammarion, 2010.

Alain Bublex and Elie During. *Le futur n'existe pas. Rétrotypes*. Paris: B42, 2014.

Andrew Bush. *Drive*. New Haven, CT: Yale University Press, 2008.

Ronni Campana. *Badly Repaired Cars*. London: Hoxton Mini Press, 2016.

David Campany. *The Open Road: Photography and the American Roadtrip*. New York: Aperture, 2014.

Kurt Caviezel. *Red Light*. Zurich: Patrick Frey, 1999.

Philippe Chancel. *Drive Thru Flint*. Bentivoglio: L'Artiere Edizioni, 2016.

Larry Clark. *Tulsa*. New York: Lustrum Press, 1971.

Langdon Clay. *Cars: New York City, 1974–1976*. Göttingen: Steidl, 2016.

Stéphane Couturier. *Melting Point*. Salzburg: Fotohof, 2010.

Pierre Darmendrail. *Lartigue et les autos de course*. Pau: Motors Mania, 2008.

Bruce Davidson. *Brooklyn Gang*. Santa Fe, NM: Twin Palms Publishers, 1998.

Raymond Depardon. *Errance*. Paris: Seuil, 2000.

Raymond Depardon. *La France de Raymond Depardon*. Paris: Seuil, 2010.

John Divola. *Dogs Chasing My Car in the Desert*. Tucson, AZ: Nazraeli Press, 2004.

William Eggleston. *Before Color*. Göttingen: Steidl, 2010.

William Eggleston. *The Democratic Forest*. Göttingen: Steidl, 2015.

Elliott Erwitt. *Personal Exposures*. New York: W. W. Norton & Company, 1988.

Walker Evans. *American Photographs*. New York: Museum of Modern Art, 1938.

Walker Evans. *Polaroids*. Zurich: Scalo, 2002.

Pierre de Fenoÿl. *Une géographie imaginaire*. Paris: Xavier Barral, 2015.

Alain Fleischer. *599*. Rome: Agarttha Arte, 2007.

Robert Frank. *The Americans*. New York: Grove Press, 1959.

Lee Friedlander. *America by Car*. San Francisco, CA: Fraenkel Gallery, 2010.

Lee Friedlander. *The New Cars 1964*. San Francisco, CA: Fraenkel Gallery, 2011.

Michel Frizot. *Germaine Krull*. Paris: Jeu de Paume, 2015.

Bernhard Fuchs. *Autos Fotografien*. London: Koenig Books, 2006.

Fabienne Fulchéri. *Pleins phares. Art contemporain et automobile*. Vanves: Hazan, 2007.

Paolo Gasparini. *La llave de la carretera*. Paris: Toluca, 2012.

Jacqueline Hassink. *Car Girls*. New York: Aperture, 2009.

Simon Henley and Sue Barr. *L'Architecture du parking*. Marseille: Parenthèses, 2007.

Anthony Hernandez. San Francisco, CA: SFMoMA, 2016.

Yasuhiro Ishimoto. *Someday Somewhere*. Tokyo: Geibi Shuppansha, 1958.

Peter Keetman. *Volkswagen: A Week at the Factory*. San Francisco, CA: Chronicle Books, 1992.

Seydou Keïta. Paris: RMN, 2016.

Seiji Kurata. *Toshi no Zokei*. Kanagawa: Super Labo, 2015.

Justine Kurland. *Highway Kind*. New York: Aperture, 2016.

Le Renault de Doisneau. Besançon: Musée des Beaux-Arts et d'Archéologie/Paris: Somogy, 2005.

O. Winston Link. *Life Along the Line: A Photographic Portrait of America's Last Great Steam Railroad*. New York: Abrams, 2012.

Marcos López. Buenos Aires: Larivière, 2010.

Alex MacLean. *Over: The American Landscape at the Tipping Point*. New York: Abrams, 2008.

Manufactured Landscapes: The Photographs of Edward Burtynsky. Ottawa: National Gallery of Canada/New Haven: Yale University Press, 2003.

Mary Ellen Mark. *American Odyssey. 1963–1999*, New York: Aperture, 1999.

Mary Ellen Mark. *On the Portrait and the Moment*. New York: Aperture, 2015.

Cary Markerink and Theo Baart. *Snelweg – Highways in the Netherlands*. Amsterdam: Ideas on Paper, 1996.

Arwed Messmer. *Reenactment MfS*. Ostfildern: Hatje Cantz, 2014.

Ray K. Metzker. *AutoMagic*. Berlin: Only Photography, 2009.

Sylvie Meunier and Patrick Tournebœuf. *American Dream*. Paris: Textuel, 2017.

Joel Meyerowitz, Daido Moriyama, and John Divola. *Pictures from Moving Cars*. London: Adad Books, 2013.

Joel Meyerowitz. *Glimpse*. Kamakura: Super Labo, 2014.

Joel Meyerowitz. *Retrospective*. New York: DAP/Cologne: Buchhandlung Walther König, 2014.

Kay Michalak and Sven Völker. *Auto Reverse*. Artist's book, 2014.

Óscar Monzón. *Karma*. Paris: RVB Books, 2014.

Basile Mookherjee. *Fully Fueled*. Zurich: Patrick Frey, 2016.

Daido Moriyama. *Memories of a Dog*. Tucson: Nazraeli Press, 2004.

Daido Moriyama. *On the Road*. Tokyo: Getsuyosha, 2011.

New Topographics: Photographs of a Man-Altered Landscape. Rochester, NY: George Eastman House, 1975.

Arnold Odermatt. *Karambolage*. Göttingen: Steidl, 2013.

Martin Parr. *From A to B. Tales of Modern Motoring*. London: BBC Books, 1994.

Martin Parr. *Parking Spaces*. London: Chris Boot Books, 2007.

Bernard Plossu. *Le Voyage mexicain, 1965-1966*. Paris: Contrejour, 1979.

Bernard Plossu and Pierre Devin. *2CV. Un air de liberté*. Crisnée: Yellow Now, 2013.

Edward Quinn. *Stars and Cars of the '50s*. Kempen: TeNeues, 2008.

Bill Rauhauser. *20th Century Photography in Detroit*. Livonia, MI: Saint Paul's Press, 2010.

Luciano Rigolini. *Surrogates*. Paris: Les Presses du Réel/Lausanne: Musée de l'Élysée, 2012.

Luciano Rigolini. *Mask*. Zurich: Patrick Frey, 2015.

Miguel Rio Branco. *Maldicidade*. São Paulo: Cosac Naify, 2014.

Ed Ruscha. *Twentysix Gasoline Stations*. Los Angeles: National Excelsior Press, 1963.

Ed Ruscha. *Thirtyfour Parking Lots*. Artist's book, 1974.

Hans-Christian Schink. *Traffic Projects German Unity*. Ostfildern: Hatje Cantz, 2004.

Stephen Shore. *A Road Trip Journal*. London: Phaidon, 2008.___

Malick Sidibé. Zurich: Scalo, 1998.

Raghubir Singh. *A Way into India*. London: Phaidon, 2002.

Melle Smets and Joost van Onna. *Turtle 1: Building a Car in Africa*. Edam: Paradox/ Dortmund: Verlag Kettler, 2016.

Jules Spinatsch. *We Will Never Be So Close Again*. Baden: Kodoji, 2006.

Hiroshi Sugimoto. *On the Beach*. Tokyo: Amana, 2014.

Juergen Teller. *Siegerflieger*. Göttingen: Steidl, 2015.

Tendance Floue. *Nationale Zéro*. Trézélan: Filigranes/Enghien-les-Bains: Centre des arts d'Enghien-les-Bains, 2004.

Transition, paysages d'une société (with photographs by Philippe Chancel, Patrick Tournebœuf, and Alain Willaume). Paris: Xavier Barral, 2013.

Anne W. Tucker and Philip Brookman, eds. *Robert Frank: New York to Nova Scotia*. Houston, TX: Museum of Fine Arts, 1986.

Weegee. *Naked City*. Boston, MA: Da Capo Press, 2002.

Henry Wessel. *Traffic*. Göttingen: Steidl, 2016.

Thomas Zander, ed. *Henry Wessel*. Göttingen: Steidl, 2007.

Biographical and autobiographical essays

Martine d'Astier. *Jacques Henri Lartigue. Une vie sans ombre*. Paris: Gallimard, 2009.

Nicolas Bouvier. *L'Usage du monde*. Geneva: Droz, 1963.

Nicolas Bouvier, *The Scorpion-Fish*. Oxford: Carcanet, 1987.

Ella Maillart. *The Crual Way: Switzerland to Afghanistan in a Ford*. Boston, MA: Beacon Press, 1987.

Acknowledgments

The Fondation Cartier pour l'art contemporain
expresses its deepest appreciation to
Xavier Barral and Philippe Séclier for having
initiated and directed this ambitious project
and for their unfailing commitment to it.
Their knowledge of photography, their way
of seeing, and their sensitivity guided us
throughout the preparation of the exhibition.

We wish to express our gratitude to all
the artists involved; our exchanges greatly
enriched the exhibition:
Robert Adams
Bernard Asset
Éric Aupol
Theo Baart
Sue Barr
Valérie Belin
Martin Bogren
David Bradford
Edward Burtynsky
Andrew Bush
Ronni Campana
Alejandro Cartagena
Kurt Caviezel
Philippe Chancel
Larry Clark
Langdon Clay
Stéphane Couturier
Bruce Davidson
Raymond Depardon
John Divola
William Eggleston
Elliott Erwitt
Alain Fleischer
Robert Frank
Lee Friedlander
Bernhard Fuchs
Paolo Gasparini
Óscar Fernando Gómez
Jeff Guess
Andreas Gursky
Fernando Gutiérrez
Jacqueline Hassink
Anthony Hernandez
Seiji Kurata
Justine Kurland
Peter Lippmann
Marcos López

Alex MacLean
Cary Markerink
Arwed Messmer
Sylvie Meunier
Joel Meyerowitz
Kay Michalak
Óscar Monzón
Basile Mookherjee
Daido Moriyama
Patrick Nagatani
Arnold Odermatt
Joost van Onna
Catherine Opie
Trent Parke
Martin Parr
Mateo Pérez Correa
Jean Pigozzi
Bernard Plossu
Matthew Porter
Bill Rauhauser
Rosângela Rennó
Luciano Rigolini
Miguel Rio Branco
Ed Ruscha
Sory Sanlé
Hans-Christian Schink
Antoine Schneck
Stephen Shore
Melle Smets
Jules Spinatsch
Hiroshi Sugimoto
Juergen Teller
Tendance Floue
Patrick Tournebœuf
Sven Völker
Henry Wessel
Alain Willaume

We are particularly grateful to Alain Bublex
for his work *Sheltered from the Wind and
Rain*, which he created for the exhibition
and the catalog. We also thank him for his
commitment and his advice during the
preparation of the exhibition, and for having
shared his love of automobiles with us.

We extend our warmest thanks to
Constance Guisset, as well as Amandine
Peyresoubes, and Annabel Faye from

Constance Guisset Studio for their sensitivity,
their expertise, and their involvement during
the creation of the design of the exhibition.

We wish to express our sincere appreciation
to all the lenders, without whom this
exhibition would not have been possible:
303 Gallery, New York
Akio Nagasawa Collection, Tokyo
Amsab-Institut d'histoire sociale, Ghent
Andrea Rosen Gallery, New York
Archives Pierre de Fenoÿl, Paris
ArteF Galerie Zurich
Atelier Robert Doisneau, Montrouge
CAAC – The Pigozzi Collection, Geneva
Centre Pompidou, Paris
Chipmunk Collection
Christophe Guye Galerie, Zurich
Collection Beijing Silvermine/Thomas
Sauvin, Paris
Collection DK, Paris
Collection Isabelle and Hervé Poulain, Paris
Collection Leticia and Stanislas Poniatowski
Collection Mathé Perrin, Brussels
Collection Michelin, Clermont-Ferrand
Collection of the Museum of Art, Kochi
Cristina Guerra Contemporary Art, Lisbon
Detroit Museum of Arts, Detroit, Michigan
Dominique Carré, Paris
Donation Jacques Henri Lartigue,
Charenton-le-Pont
Edward Burtynsky Studio, Toronto
Estate Brassaï, Paris
Flowers Gallery, London
Fondation Gilles Caron, Geneva
Fraenkel Gallery, San Francisco
Galerie 127, Marrakech
Galerie Berthet-Aittouarès, Paris
Galerie Camera Obscura, Paris
Galerie Magnin-A, Paris
Galerie Melanie Rio
Galerie Nathalie Obadia, Paris/Brussels
Galerie Springer Berlin
Galerie Thomas Zander, Cologne
Howard Greenberg Gallery, New York
International Center of Photography,
New York
Joel Meyerowitz Photography, New York
Juergen Teller Ltd, London

Kicken Berlin Gallery, Berlin
L'Aventure Peugeot Citroën DS
La Galerie de l'Instant, Paris
La Galerie Particulière, Paris/Brussels
Laura Bartlett Gallery, London
Laurence Miller Gallery, New York
Les Douches la Galerie, Paris
M+B Gallery, Los Angeles
Magnum Photos, Paris
Martin Parr Studio, London
Mitchell-Innes & Nash, New York
Musée de l'Élysée, Lausanne
Nachlass Peter Keetman/Stiftung F.C.
Gundlach, Hamburg
Nicholas Metivier Gallery, Toronto
Paradox, Edam
Patricia Conde Galería, Mexico City
Regen Projects, Los Angeles
Sprüth Magers
Succession Raghubir Singh
Taka Ishii Gallery, Tokyo
The Bluff Collection
Urs Odermatt, Windisch
VU', Paris
Walker Evans Archive, The Metropolitan
Museum of Art
Winston Eggleston, Eggleston Artistic Trust,
Memphis
As well as all the lenders who wish
to remain anonymous.

For their close collaboration, we wish
to sincerely thank:
Andréa Holzherr, Magnum Photos, Paris
Stéphane Nicolas, Michelin, Clermont-Ferrand
Jean-Michel Policar, who supported
the production of Alain Bublex's work
Bas Vroege from Paradox, for his collaboration
on the project Turtle 1. Building a Car in Africa
by Melle Smets and Joost van Onna

For their valuable expertise and advice
during the preparatory research for the
exhibition, we thank:
Serge Bellu, Paris
Luc Lagier, Camera Lucida Productions, Paris
Luce Lebart, Canadian Photography Institute,
Ottawa

Through their essays for the exhibition
catalog, the authors provide meaningful
insights into the issues raised by the
exhibition. We sincerely thank:
Simon Baker, Nancy W. Barr, Clément
Chéroux, Marc Desportes, and Pascal Ory.

We also wish to thank Alain Prost and
Jean Todt for their interviews.

For the graphic design of the catalog and of
the signage of the exhibition, we thank Agnès
Dahan and Raphaëlle Picquet from Agnès
Dahan Studio. We also thank François Dézafit
for the exhibition's visual communication.

We sincerely thank the team at Éditions
Xavier Barral for their collaboration in the
publishing of this catalog, in particular
Emmanuelle Kouchner and Charlotte Debiolles.

We thank everyone who contributed
to the exhibition or the catalog:
Deepak Ananth, Paris
Martine d'Astier, Donation Jacques Henri
Lartigue, Charenton-le-Pont
Melanie Bazil, The Henry Ford, Dearborn
Audrey Bazin, La Galerie Particulière, Paris
Hélène Bocquet, Publicis Events,
Boulogne-Billancourt
Hans Brooymans, ZOXX Gallery, Almere
Jean-Pierre Cap, Palmeraie et Désert, Clamart
Dominique Carré, Dominique Carré Éditeur,
Paris
Hervé Charpentier, Musée de l'Aventure
Peugeot, Sochaux
Joshua Chuang, The New York Public Library,
New York
Xavier Crespin, Aventure Peugeot Citroën DS
Jacques Damez and Catherine Dérioz,
Galerie Le Réverbère
Winston Eggleston, Eggleston Artistic Trust,
Memphis
Alexis Fabry, Toluca Fine Art, Paris
Félix Fouchet, Rosny-sous-Bois
Jean-Kenta Gauthier, Galerie Jean-Kenta
Gauthier, Paris
Jean-Marc Greuther, The Henry Ford,
Dearborn
Markus Hartmann, Hartmann Projects,
Stuttgart
Reimund Heinisch, Porsche Museum,
Stuttgart
Uwe Heintzer, Mercedes-Benz Classic
Archive, Stuttgart
Hans-Eberhard Hess, Photo International,
Munich
Ann Hindry-Royer, Collection Renault/
Renault Classic, Boulogne-Billancourt
Bart Hofstede, Netherlands Embassy, Paris
Lisa Hostetler, George Eastman House,
Rochester

Adélie de Ipanema, Polka Galerie, Paris
Michael Jerch, Ruth / Catone, New York
Jean-Yves Jouannais, Paris
Nadine Junod, Centre d'archives de Terre
Blanche, Hérimoncourt
Ross Knapper, George Eastman House,
Rochester
Nolwenn Lapeyre, Paris
Marie-Thérèse Lardeur, musée de l'Aventure
Peugeot, Sochaux
Cyrille Lollivier, Gaumont Pathé Archives,
Saint-Ouen
André Magnin, Galerie Magnin-A, Paris
Carole Marlot, media library Renault Group,
Boulogne-Billancourt
Alex Mor and Philippe Charpentier, mor
charpentier, Paris
Patricia Morvan, Agence VU', Paris
Mariam Mousisian, Perles d'Histoire, Paris
Akio Nagasawa, Akio Nagasawa Gallery/
Publishing, Tokyo
Loïc Perois, Classic Car Design, Saint-Martin-
de-Valgalgues
Mathieu Petitgirard, Perles d'Histoire, Paris
Laure Peugeot, DSTY/DIR, Paris
Emmanuel Piat, Automobile Club de France,
Paris
Jean Pigozzi, CAAC – The Pigozzi Collection,
Geneva
Thomas Sauvin, Beijing Silvermine, Paris
Marcus Schubert, Edward Burtynsky Studio,
Toronto
Françoise Souchet, Perles d'Histoire, Paris
Andrew Strauss, Sotheby's, Paris
Christine Tebbe, Galerie Thomas Zander,
Cologne
Anne Teffo, Fondation d'entreprise Michelin,
Paris
Elisa Uematsu, Taka Ishii Gallery, Tokyo
Bernard Utudjian, Galerie Polaris, Paris
Annette Völker, Sprüth Magers, Cologne
Elisabeth Whitelaw, CAAC – The Pigozzi
Collection, Geneva
Thomas Zander, Galerie Thomas Zander,
Cologne
Yvo Zijlstra, Antenna-Men, Rotterdam

Xavier Barral and Philippe Séclier wish
to extend their sincerest thanks to:
Alain Dominique Perrin, Hervé Chandès,
Isabelle Gaudefroy, Aideen Halleman, Sonia
Perrin, Leanne Sacramone, Marie Perennes,
Adeline Pelletier, Camille Chenet, as well as
the team of the Fondation Cartier pour l'art
contemporain for having warmly welcomed
them and supported them during this project;
Alain Bublex for his contagious love of cars;
Constance Guisset and her team for the
design of the exhibition;
Agnès Dahan and her team for the exhibition
signage and catalog;
François Dézafit for the exhibition's visual
communication;
as well as Martine d'Astier, Nathalie
Chapuis, Raymond Depardon and Claudine
Nougaret, Alexis Fabry, Luce Lebart, Bernard
Plossu, Jensen Samoo, Sonia Voss and the
team at the Éditions Xavier Barral (Jordan
Alves, Yseult Chehata, Charlotte Debiolles,
Emmanuelle Kouchner, Céline Moulard,
Perrine Somma).

Xavier Barral would like to personally thank:
Pierre Arnau, Christian Caujolle, Sylviane
de Decker, Annette and Francine Doisneau,
Diane Dufour, Véronique and Aliette de
Fenoÿl, Tatyana Franck, Markus Hartmann,
Anne-Françoise Jumeau, Annette Lucas,
Stéphane Nicolas, and Agnès Sire.

Philippe Séclier would like to personally
thank:
Stuart Alexander, Serge Bellu, Inès
de Bordas, Flo Tina Camporesi, Laure
Flammarion, Jean-Kenta Gautier, Taka Ishii,
Alain Julien, Clément Kauter, Walther and
Franz König, Alessandra Mauro and Roberto
Koch, Peter MacGill and Lauren Panzo,
Françoise Morin, Sohey Moriyama,
Hervé Poulain, Yoko Sawada, Djan Seylan,
Elisa Uematsu, Natacha Wolinski, and
Thomas Zander.

Pages 13 to 420 of the catalog were printed
on Phoenixmotion Xantur 150 g/m^2
by the papermaker Scheufelen, Lenningen.
We sincerely thank them for their contribution
to the production of this book.

This catalog was published in conjunction
with the exhibition *Autophoto*, presented at the
Fondation Cartier pour l'art contemporain in Paris
from April 20 to September 24, 2017.

The exhibition *Autophoto* was organized with support
from the Fondation Cartier pour l'art contemporain,
under the aegis of the Fondation de France, and with
the sponsorship of Cartier.

EXHIBITION

Curators: Xavier Barral and Philippe Séclier
Co-Curator: Leanne Sacramone
Associate Curator: Marie Perennes
Interns: Simon Depardon, Antinéa Garnier, and Nadiia Kovalchuck

Production: Camille Chenet assisted by Claire Pierson
Coordination: Justine Aurian
Registrar: Corinne Bocquet and Alanna Minta Jordan
assisted by Paola Sisterna
Signage: Jessica Chèze and Pierre-Édouard Couton
Technical Director: Christophe Morizot
Audiovisual Design: Gérard Chiron
Lighting: Gerald Karlikow (design) and Victor Burel (manager)
Installation: Gilles Gioan and Heiner Scheel

Exhibition Design: Constance Guisset assisted by Amandine
Peyresoubes, Annabel Faye, Manuel Becerra, Avril de Pastre, Bruno
Scotti, Lucie Verlaguet, and Inès Waris, Constance Guisset Studio, Paris
Graphic Design (signage): Agnès Dahan Studio, Paris
with Raphaëlle Picquet

CATALOG

Publishing Directors: Xavier Barral and Philippe Séclier
Artistic Direction: Agnès Dahan Studio, Paris
Graphic Design: Agnès Dahan Studio, Paris
with Raphaëlle Picquet

Fondation Cartier pour l'art contemporain, Paris
Editorial Manager: Adeline Pelletier
Editor: Nolwen Lauzanne assisted by Iris Aleluia
Editorial Project Coordinator: Cécile Provost

Éditions Xavier Barral, Paris
Edition: Emmanuelle Kouchner assisted by Jordan Alves,
Pierre Arnau, and Charlotte Delavigne
Production: Charlotte Debiolles
Communications: Yseult Chehata and Perrine Somma
Foreign Rights: Céline Moulard

Translation from the French: Jennifer Kaku, Emma Lingwood,
and Sarah Robertson
Proofreading: Bronwyn Mahoney
Photoengraving: Daniel Regard, Les Artisans du Regard, Paris

List of Reproductions

Robert Adams
Born in 1937 in Orange, United States
Lives in Astoria, United States
Pages 107 to 109
North Denver, Colorado, c. 1973
Colorado, c. 1973
Longmont, Colorado, c. 1973
Vintage gelatin silver prints,
33 × 28 cm (each)
Courtesy Fraenkel Gallery, San Francisco
© Robert Adams, courtesy Fraenkel
Gallery, San Francisco

Eve Arnold
Born in 1912 in Philadelphia, United States
Died in 2012 in London, United Kingdom
Page 87
*Marilyn Monroe in Her Car Studying Lines
for "The Misfits," Nevada,* 1960
Gelatin silver print, 24 × 30 cm
Collection of the artist
© Eve Arnold/Magnum Photos

Bernard Asset
Born in 1955 in Le Raincy, France
Lives in Astoria, United States
Page 317
*Passager d'Alain Prost (Alain Prost au
volant d'une Renault RE30B, tests F1
sur le circuit Dijon-Prenois),* 1982
C-print, 80 × 120 cm
Collection of the artist
© Bernard Asset

Éric Aupol
Born in 1969 in Charlieu, France
Lives in Paris, France
Pages 330 and 331
Paysages de verre #1, 2006
C-print, 65 × 129 cm
Collection DK, Paris
© Éric Aupol, courtesy Galerie Polaris,
Paris

Theo Baart
Born in 1957 in Amsterdam, The Netherlands
Lives in Hoofddorp, The Netherlands
Cary Markerink
Born in 1951 in Medan, Indonesia
Lives between Amsterdam, The Netherlands,
and Relíquias, Portugal
Pages 130 and 131
Snelweg – Highways in the Netherlands,
1995–96
Installation of 15 C-prints, 180 × 500 cm
Collection of the artists
© Theo Baart and Cary Markerink

Sue Barr
Born in 1971 in London, United Kingdom
Lives in London
Pages 127 to 129
Via Olga Silvestri, Naples, Italy, 2014
Via Ligea, Salerno, Italy, 2014
Via Tommaso Costa, Naples, Italy, 2014
From *The Architecture of Transit* series
C-prints, 100 × 80 cm (each)
Private collection, London
© Sue Barr

Valérie Belin
Born in 1964 in Boulogne-Billancourt, France
Lives in Paris, France
Pages 275 to 277
Untitled, 2002
Untitled, 2002
Untitled, 2002
Gelatin silver prints, 61 × 71.5 cm
(each work, framed)
Courtesy of the artist/Galerie Nathalie
Obadia, Paris/Brussels
© Valérie Belin/ADAGP, Paris 2017

Martin Bogren
Born in 1967 in Malmö, Sweden
Lives in Malmö
Pages 6 and 7, 397 to 401
Tractor Boys series, 2010–12
Gelatin silver prints, 44 × 57 cm or
57 × 44 cm
Courtesy of the artist/VU', Paris
© Martin Bogren/VU', Paris

Nicolas Bouvier
Born in 1929 at Le Grand-Lancy,
Switzerland
Died in 1998 in Geneva, Switzerland
Pages 242 and 243
*Sur la route de Quetta, en direction
du Pakistan,* 1954
Entre Prilep et Istanbul, Turquie, 1953
Tabriz, Azerbaïjan oriental, 1953–54
Quetta, Pakistan, 1953
Gelatin silver prints, 25 × 37.5 cm (each)
Musée de l'Élysée, Lausanne
© Fonds Nicolas Bouvier/Musée de
l'Élysée, Lausanne

David Bradford
Born in 1951 in New York, United States
Lives in New York
Pages 209 to 211
Belly of the Beast, 1995
Holland Tunnel Bullitt, 1993
Coaster Ride Stealth, 1994

From *Drive-By Shootings* series
C-prints, 28 × 35.5 cm (each)
Courtesy of the artist
© David Bradford

Brassaï
Born in 1899 in Braşov, Hungary
(now Romania)
Died in 1984 in Beaulieu-sur-Mer, France
Pages 136 to 139
Les Grands Boulevards, c. 1935
*Deux Filles faisant le trottoir, boulevard
Montparnasse,* c. 1931
*Avenue de l'Observatoire, phares de
voiture,* 1934
Place de l'Opéra, c. 1934
Vintage gelatin silver prints, 28.5 × 22.5 cm/
23 × 17 cm/22.5 × 29 cm/24 × 30.5 cm
Estate Brassaï, Paris
© Estate Brassaï, Paris

Alain Bublex
Born in 1961 in Lyon, France
Lives in Paris, France
Pages 423 to 425
Sheltered from the Wind and Rain, 2017
1:10-scale 3D models
© Alain Bublex/ADAGP, Paris 2017

Edward Burtynsky
Born in 1955 in St. Catharines, Canada
Lives in Toronto, Canada
Pages 123, 334 and 335
*Nanpu Bridge Interchange, Shanghai,
China,* 2004
*Oxford Tire Pile #9a/#9b, Westley,
California, USA,* 1999
C-prints, diptych, 122 × 152.5 cm (each)
Courtesy of the artist/Flowers Gallery,
London/Nicholas Metivier Gallery,
Toronto
© Edward Burtynsky, courtesy Flowers
Gallery, London/Nicholas Metivier Gallery,
Toronto

Andrew Bush
Born in 1956 in St. Louis, United States
Lives in Los Angeles, United States
Pages 218 and 219
*Woman Waiting to Proceed South
at Sunset and Highland Boulevards,
Los Angeles, at Approximately 11:59 a.m.
One Day in February 1997,* 1997
From *Vector Portraits* series
C-print, 122 × 151 cm
Courtesy M+B Gallery, Los Angeles
© Andrew Bush

Ronni Campana
Born in 1987 in Milan, Italy
Lives in Milan
Pages 295 to 299
Badly Repaired Cars series, 2016
Inkjet prints, 60 × 40 cm (each)
Collection of the artist
© Ronni Campana

Gilles Caron
Born in 1939 in Neuilly-sur-Seine, France
Died in 1970 in Cambodia
Pages 88 and 89
*Jean-Luc Godard sur le tournage
de son film « Week-end »,* 1967
*Jean-Luc Godard sur le tournage
de son film « Week-end »,* 1967
Gelatin silver prints, 24 × 36 cm (each)
Fondation Gilles Caron, Geneva
© Gilles Caron/Fondation Gilles Caron,
Geneva

Alejandro Cartagena
Born in 1977 in Saint-Domingue,
Dominican Republic
Lives in Monterrey, Mexico
Page 367
The Carpoolers series, 2011–12
Installation of 15 inkjet prints,
55.5 × 35.5 cm (each)
Courtesy Patricia Conde Galería,
Mexico City
© Alejandro Cartagena

Kurt Caviezel
Born in 1964 in Chur, Switzerland
Lives in Zurich, Switzerland
Pages 416 and 417
Red Light series, 1999
Slide show
Collection of the artist
© Kurt Caviezel

Philippe Chancel
Born in 1959 in Issy-les-Moulineaux,
France
Lives in Paris, France
Page 333
Drive Thru Flint, 2015
Inkjet print, 160 × 213 cm
Courtesy Galerie Melanie Rio
© Philippe Chancel

Larry Clark
Born in 1943 in Tulsa, United States
Lives in Los Angeles, United States

Pages 405 to 407
Untitled, 1963
Untitled, 1963
Untitled, 1963
From *Tulsa* series
Gelatin silver prints,
28 × 35.5 cm (each)
Gift of Tom Wright, 1991, courtesy
International Center of Photography,
New York
© Larry Clark, courtesy of the artist
and Luhring Augustine, New York

———

Langdon Clay
Born in 1949 in New York, United States
Lives in Sumner, United States
Pages 21 to 25
No Parking Car, Volkswagen Beetle (Bug),
North of West Village, 1975
Sign of Good Taste Car, Plymouth Duster,
Hoboken, NJ, 1975
Colonial Car, Chevrolet Nova 230,
Hoboken, NJ, 1975
American Hotel Car, Volkswagen 1600
Squareback, Hoboken, NJ, 1974
24 Checker Car, Checker Marathon,
in the Twenties near 6th Avenue, 1975
Cars – New York City series
Slide show
Collection of the artist
© Langdon Clay

———

Stéphane Couturier
Born in 1957 in Neuilly-sur-Seine, France
Lives in Paris, France
Pages 280 to 283
MELT, Toyota n° 12, 2005
MELT, Toyota n° 8, 2005
From *Melting Point, Usine Toyota,*
Valenciennes series
C-prints, 92 × 124 cm/92 × 137 cm
Collection of the artist, courtesy
La Galerie Particulière, Paris/Brussels
© Stéphane Couturier

———

Bruce Davidson
Born in 1933 in Chicago, United States
Lives in New York, United States
Page 413
Brooklyn Gang, New York City, USA, 1959
Gelatin silver print, 40 × 60 cm
Collection of the artist
© Bruce Davidson/Magnum Photos

———

Jean Depara
Born in 1928 in Kibokolo, Angola
Died in 1997 in Kinshasa, Democratic
Republic of the Congo
Page 63
Femme sur le capot d'une Cadillac
Zéphyr, 1970
Gelatin silver print, 50 × 40 cm
Courtesy Galerie Magnin-A, Paris
© Jean Depara

Raymond Depardon
Born in 1942 in Villefranche-sur-Saône,
France
Lives in Paris, France
Page 31
Wissembourg, Bas-Rhin, France, 2005
C-print, 50 × 60 cm
Collection of the artist
© Raymond Depardon/Magnum Photos
Page 245
Tchad, traversée du Djourab, 1998
Gelatin silver print, 61 × 51.5 cm
Collection of the artist
© Raymond Depardon
Page 387
Glasgow, Écosse, 1980
C-print, 40 × 60 cm
Collection of the artist
© Raymond Depardon/Magnum Photos
Page 419
Pékin, Chine, 1985
Gelatin silver print, 50 × 60 cm
Collection of the artist
© Raymond Depardon/Magnum Photos

———

John Divola
Born in 1949 in Los Angeles,
United States
Lives in Riverside, United States
Pages 178 to 181
Dogs Chasing My Car in the Desert series,
1996–2001
Gelatin silver prints, 50.5 × 61 cm (each)
Courtesy Laura Bartlett Gallery, London
© John Divola

———

Robert Doisneau
Born in 1912 in Gentilly, France
Died in 1994 in Montrouge, Paris
Pages 135, 264 to 267, 314 and 315
Publicité Aronde, Simca, 1955
(vintage print)
Chaîne de montage, Usine Renault,
Boulogne-Billancourt, 1945
Usine Renault, Boulogne-Billancourt, 1945
Pistoleteuse, Usine Renault, Boulogne-
Billancourt, 1945
Chaîne de montage Juvaquatre et
Primaquatre, Usine Renault, Boulogne-
Billancourt, 1945
Publicité Simca, 1952 (vintage print)
Gelatin silver prints, 30 × 24 cm/
24 × 18 cm/24 × 18 cm/24 × 18 cm/
24 × 18 cm/23.5 × 30 cm
Atelier Robert Doisneau, Montrouge
© Robert Doisneau/Gamma-Rapho

———

William Eggleston
Born in 1939 in Memphis, United States
Lives in Memphis
Cover
Chromes series, 1971–74
Dye-transfer print, 40.5 × 50.5 cm
Eggleston Artistic Trust, Memphis
© Eggleston Artistic Trust, Memphis

Pages 18 and 19
Los Alamos series, c. 1974
Dye-transfer print, 56 × 73.5 cm
Eggleston Artistic Trust, Memphis
© Eggleston Artistic Trust, Memphis
Pages 47 to 57
Los Alamos series, 1965–68
Los Alamos series, 1971–74
Chromes series, 1971–74
Chromes series, 1971–74
Untitled, c. 1970
Chromes series, 1971–74
Los Alamos series, 1971–74
Chromes series, 1971–74
Los Alamos series, 1965–68
Chromes series, c. 1970
Dye-transfer prints, 40.5 × 50.5 cm/
40.5 × 50.5 cm/40.5 × 50.5 cm/
40.5 × 50.5 cm/40.5 × 50.5 cm/
52 × 76 cm/50.5 × 40.5 cm/
50.5 × 40.5 cm/40.5 × 50.5 cm/
40.5 × 50.5 cm
Eggleston Artistic Trust, Memphis
© Eggleston Artistic Trust, Memphis

———

Elliott Erwitt
Born in 1928 in Paris, France
Lives in New York, United States
Page 77
California, USA, 1955
Gelatin silver print, 40 × 60 cm
Collection of the artist
© Elliott Erwitt/Magnum Photos

———

Walker Evans
Born in 1903 in St. Louis, United States
Died in 1975 in New Haven, United States
Pages 146 to 149
Untitled, 1973–74
Color Polaroids, 10 × 7.5 cm (each)
Walker Evans Archive, The Metropolitan
Museum of Art
courtesy Andrea Rosen Gallery, New York
© Walker Evans Archive, The Metropolitan
Museum of Art
courtesy Andrea Rosen Gallery, New York

———

Barry Feinstein
Born in 1931 in Philadelphia, United States
Died in 2011 in Woodstock, United States
Pages 90 and 91
Steve McQueen, "Bullitt," 1968
Gelatin silver print, 40 × 50 cm
La Galerie de l'Instant, Paris
© Barry Feinstein/La Galerie de l'Instant,
Paris

———

Pierre de Fenoÿl
Born in 1945 in Caluire-et-Cuire, France
Died in 1987 in Castelnau-de-Montmiral,
France
Pages 173 to 177
Untitled, France, 1985
Vintage gelatin silver prints,

18 × 24 cm (each)
Archives Pierre de Fenoÿl, Paris
© Pierre de Fenoÿl

———

Alain Fleischer
Born in 1944 in Paris, France
Lives between Paris and Rome, Italy
Pages 278 and 279
Maranello, sortie de la chaîne carrosserie
de la Ferrari 599 Fiorano, 2007
Gelatin silver print, 30 × 40 cm
Ferrari 599 GTB Fiorano, forme
d'emboutissage pour le passage de roue
avant gauche, 2007
Dye destruction print, 60 × 40 cm
Collection of the artist
© Alain Fleischer

———

Robert Frank
Born in 1924 in Zurich, Switzerland
Lives in New York, United States
Pages 259, 262, and 263
Assembly Plant, Ford, Detroit, 1955
Ford River Rouge Plant, 1955
Untitled, 1955
Gelatin silver prints,
35.5 × 28 cm or 33.5 × 22 cm
Detroit Institute of Arts, Founders Society
Purchase, Coville Photographic Fund
(pages 259 and 262)
Detroit Institute of Arts, Gift of Arthur
Stephen Penn and Paul Katz (page 263)
© Robert Frank
Pages 260 and 261, 403
Assembly Line, Detroit, 1955
Mary, Pablo and Andrea, U.S. 90, Texas, 1955
From *The Americans* series
Gelatin silver prints,
28 × 35.5 cm/50 × 38 cm
Detroit Institute of Arts, Founders Society
Purchase, Coville Photographic Fund
(pages 260 and 261)
© Robert Frank, from *The Americans*

———

Lee Friedlander
Born in 1934 in Aberdeen, United States
Lives in New York, United States
Pages 201 to 207
Montana, 2008
New York City, 2002
California, 2008
New York State, 2005
California, 2008
Colorado, 2007
Nebraska, 1999
From *America by Car* series
Gelatin silver prints, 37.5 × 37.5 cm (each)
Courtesy Fraenkel Gallery, San Francisco
© Lee Friedlander, courtesy Fraenkel
Gallery, San Francisco

———

Bernhard Fuchs
Born in 1971 in Haslach an der Mühl, Austria
Lives in Düsseldorf, Germany

Pages 33 to 37
Roter Ford-Bus, bei Freistadt, 1994
Grüner Fiat, Helfenberg, 1996
Blauer Opel, Bad Leonfelden-Traberg, 1994
Rotes kleines Auto, Helfenberg-Haslach, 2003
Blauer Passat, Herzogsdorf, 2004
From *AUTOS* series
C-prints, 36 × 48 cm/34.5 × 48 cm/
33 × 48 cm/35.5 × 48 cm/36 × 48 cm
Collection of the artist
© Bernhard Fuchs

———

Paolo Gasparini
Born in 1934 in Gorizia, Italy
Lives in Caracas, Venezuela
Page 213
*Viaje a la Ciudad Satélite, Estado
de México*, 1994
Gelatin silver prints, triptych,
121.5 × 60.5 cm
Collection Leticia and Stanislas
Poniatowski
© Paolo Gasparini
Shooting of the original works:
Patrick Goetelen

———

Óscar Fernando Gómez
Born in 1970 in Monterrey, Mexico
Lives in León de los Aldamas, Mexico
Page 215
Windows series, 2009
Slide show
Courtesy of the artist/Martin Parr Studio,
London
© Óscar Fernando Gómez

———

Jeff Guess
Born in 1965 in Seattle, United States
Lives in Paris, France
Page 381
Fonce Alphonse, 1993
Gelatin silver print, 20 × 30 cm
Collection of the artist
© Jeff Guess

———

Andreas Gursky
Born in 1955 in Leipzig, Germany
Lives in Düsseldorf, Germany
Pages 144 and 145
Cairo (diptych), 1992
Inkjet prints, 43 × 49.5 cm (each)
Courtesy of the artist/Sprüth Magers
© Andreas Gursky/ADAGP, Paris 2017/
courtesy Sprüth Magers

———

Fernando Gutiérrez
Born in 1963 in London, United Kingdom
Lives in London
Pages 369 to 373
Secuelas series, 2000–03
Inkjet prints, 30 × 45 cm (each)
Collection of the artist
© Fernando Gutiérrez

Jacqueline Hassink
Born in 1966 in Enschede, The Netherlands
Lives in New York, United States
Pages 357 to 361
Car girl hair color: blond
Car girl city: Shanghai
Car brand: Ferrari
From *Car Girls*, 2002–08
Video installation, 190 × 1360 cm
Collection of the artist
© Jacqueline Hassink

———

Anthony Hernandez
Born in 1947 in Los Angeles, United States
Lives in Los Angeles
Pages 117 to 119
Pico blvd. & Cochran ave., 1978
Denver ave. & Slauson blvd.
Looking West, 1978
1520 Adams rd. & Juliet st., 1979
From *Automotive Landscapes* series
Inkjet prints, 56 × 65.5 cm (each)
Courtesy Galerie Thomas Zander, Cologne
© Anthony Hernandez, courtesy Galerie
Thomas Zander, Cologne

———

Yasuhiro Ishimoto
Born in 1921 in San Francisco,
United States
Died in 2012 in Tokyo, Japan
Pages 13 to 17
Chicago, Snow and Car, 1948–52
Chicago, Snow and Car, 1948–52
Chicago, Snow and Car, 1948–52
Chicago, Snow and Car, 1948–52
Chicago, Snow and Car, 1948–52
Gelatin silver prints, 20.5 × 20.5 cm (each)
Collection of the Museum of Art, Kochi
© Kochi Prefecture, Ishimoto Yasuhiro
Photo Center

———

Peter Keetman
Born in 1916 in Elberfeld, Germany
Died in 2005 in Marquartstein, Germany
Pages 268 to 273
Stoßstangen, 1953
Vordere Abschlussbleche, 1953
*Hinterachskegelräder für das
Differential*, 1953
Vordere Abschlussbleche, 1953
Hintere Kotflügel, 1953
Türen für den Käfer, 1953
From *Eine Woche im Volkswagenwerk* series
Gelatin silver prints, 27 × 25 cm/
26 × 26 cm/27 × 26 cm/26 × 24.5 cm/
27 × 24.5 cm/27 × 26 cm
Nachlass Peter Keetman/Stiftung F.C.
Gundlach, Hamburg
© Nachlass Peter Keetman/Stiftung F.C.
Gundlach, Hamburg

———

Seydou Keïta
Born in 1921 in Bamako, Mali
Died in 2001 in Paris, France

Pages 66 to 67
Untitled, 1952–55
Untitled, 1952–55
Untitled, 1952–55
Gelatin silver prints, 50.5 × 60.5 cm/
50 × 60 cm/60.5 × 50.5 cm
CAAC – The Pigozzi Collection, Geneva
© SKPEAC (The Seydou Keïta Photography
Estate Advisor Corporation)

———

Germaine Krull
Born in 1897 in Poznań, Germany
(now Poland)
Died in 1985 in Wetzlar, Germany
Page 141
*Place de l'Étoile, avenue de la Grande-
Armée, avenue du Bois-de-Boulogne*, 1926
Vintage gelatin silver print, 14.5 × 22 cm
Centre Pompidou, Paris
Musée national d'art moderne/Centre
de création industrielle
Purchased at public sale, 1991
© Estate Germaine Krull, Museum
Folkwang, Essen
Photo © Centre Pompidou, MNAM-CCI,
Dist. RMN-Grand Palais/Jacques Faujour
Pages 142 and 143
Untitled, undated
Untitled, undated
Vintage gelatin silver prints,
19 × 15 cm/21 × 14 cm
Amsab-Institut d'histoire sociale, Ghent
© Estate Germaine Krull, Museum
Folkwang, Essen, courtesy Amsab-Institut
d'Histoire Sociale, Ghent

———

Seiji Kurata
Born in 1945 in Tokyo, Japan
Lives in Tokyo
Pages 132 and 133
Toshi no Zokei, 2008
Toshi no Zokei, 2008
Inkjet prints, 139 × 109 cm (each)
Courtesy of the artist/Taka Ishii Gallery,
Tokyo
© Seiji Kurata, courtesy of Taka Ishii
Gallery, Tokyo

———

Justine Kurland
Born in 1969 in Warsaw, United States
Lives in New York, United States
Pages 393 to 395
Heart Throb, 2014
280 Coup, 2012
Rebuilt Engine, 2013
Inkjet prints, 48 × 61 cm/47 × 61 cm/
51 × 63.5 cm
Courtesy of the artist/Mitchell-Innes &
Nash, New York
© Justine Kurland

———

Jacques Henri Lartigue
Born in 1894 in Courbevoie, France
Died in 1986 in Nice, France

Pages 310 and 311
*Grand Prix de l'Automobile Club de France
circuit de Dieppe, June 26, 1912. Excerpts
from the 1912 original album
Victor Rigal sur Sunbeam – Georges Boillo
sur Peugeot – Léon Duray sur Alcyon –
Richard Wyse sur Arrol-Johnston –
Georges Boillot sur Peugeot –
Paul Bablot sur Lorraine-Dietrich*
Gelatin silver prints, excerpts from one of
the artist's original albums, 37 × 52 cm
Donation Jacques Henri Lartigue,
Charenton-le-Pont
Photographie Jacques Henri Lartigue
© Ministère de la Culture – France/AAJHL
Page 312
*Une Delage au Grand Prix de l'Automobile
Club de France, circuit de Dieppe,
June 26, 1912*
Gelatin silver print, 30 × 40 cm
Donation Jacques Henri Lartigue,
Charenton-le-Pont
Photographie Jacques Henri Lartigue
© Ministère de la Culture – France/AAJHL

———

O. Winston Link
Born in 1914 in New York, United States
Died in 2001 in Katonah, United States
Page 79
Hot Shot Eastbound, 1956
Gelatin silver print, 40 × 60 cm
Collection Mathé Perrin, Brussels
© O. Winston Link

———

Peter Lippmann
Born in 1956 in New York, United States
Lives in Paris, France
Pages 336 to 339
Peugeot 201, 2012
Citroën Traction 7, 2012
From *Paradise Parking* series
C-prints, 75 × 100 cm (each)
Collection of the artist
© Peter Lippmann

———

Marcos López
Born in 1958 in Santa Fe, Argentina
Lives in Buenos Aires, Argentina
Page 27
Tristes Trópicos series, 2003–12
Dye destruction print, 39.5 × 39.5 cm
Collection Fondation Cartier pour l'art
contemporain, Paris
© Marcos López

———

Alex MacLean
Born in 1947 in Seattle, United States
Lives in Lincoln, United States
Pages 103 to 105
*Desert Overlay, Meadview, Kingman North
Arizona, USA*, 2009
*Housing Patch on Desert Floor, Escapees
North Ranch, Congress, Arizona, USA*, 2005
Desert Roads and Scattered Hills, County

Road 15, Mohave County, Arizona, USA, 2005
Inkjet prints, 101.5 × 152.5 cm (each)
Courtesy Dominique Carré, Paris
© Alex MacLean/Landslides Aerial
Photography

Ella Maillart
Born in 1903 in Geneva, Switzerland
Died in 1997 in Chandolin, Switzerland
Pages 235 to 237
*Entre Tabriz et Mâkou, Azerbaïdjan
occidental*, 1937
*Notre Ford traversant la mer Noire dans
une barque, Turquie*, 1939
*Notre Ford s'apprêtant à traverser la mer
Noire, Turquie*, 1939
*Une « Utchako » japonaise sur une route en
construction, Mandchukuo japonais*, 1934
*Entre Tabriz et Mâkou, Azerbaïdjan
occidental*, 1937
Vintage gelatin silver bromide prints
mounted on paperboard, 16 × 22 cm (each)
Musée de l'Élysée, Lausanne
© Fonds Ella Maillart/Musée de l'Élysée,
Lausanne

Man Ray
Born in 1890 in Philadelphia, United States
Died in 1976 in Paris, France
Page 313
*À Francis Picabia en grande vitesse,
Cannes*, 1924
Vintage gelatin silver print, 12.5 × 17.5 cm
The Bluff Collection
© Man Ray Trust/ADAGP, Paris 2017
Shooting of the original work: Ben Blackwell

Mary Ellen Mark
Born in 1940 in Philadelphia, United States
Died in 2015 in New York, United States
Page 409
The Damm Family, Los Angeles, 1987
Gelatin silver print, 51 × 40.5 cm
Courtesy Howard Greenberg Gallery, New York
© Mary Ellen Mark, courtesy Howard
Greenberg Gallery, New York

Arwed Messmer
Born in 1964 in Schopfheim, Germany
Lives in Berlin, Germany
Pages 374 to 379
Reenactment MfS, Car #15, 2017
Reenactment MfS, Car #13, 2017
Reenactment MfS, Car #16, 2017
Reenactment MfS, Car #04, 2017
Reenactment MfS, Car #10, 2017
Reenactment MfS, Car #06, 2017
Inkjet prints, 42 × 59.5 cm (each)
Collection of the artist
© Arwed Messmer, using information,
negatives, and prints from the files of the
Federal Commissioner for the Records of
the State Security Service of the former
German Democratic Republic (BStU)

Ray K. Metzker
Born in 1931 in Milwaukee, United States
Died in 2014 in Philadelphia, United States
Pages 157 to 159
Philadelphia, 1963
Philadelphia, 1963
Washington, DC, 1964
Gelatin silver prints, 18 × 23 cm/
20 × 25.5 cm/20 × 25.5 cm
Courtesy Les Douches la Galerie, Paris/
Laurence Miller Gallery, New York
© Estate Ray K. Metzker, courtesy Les
Douches la Galerie, Paris/Laurence Miller
Gallery, New York

Sylvie Meunier
Born in 1973 in Fontenay-sous-Bois, France
Lives in Fontenay-sous-Bois
Patrick Tournebœuf
Born in 1966 in Paris, France
Lives in Fontenay-sous-Bois, France
Pages 58 to 61
American Dream series, 2017
Installation of 196 vintage prints,
180 × 180 cm
Courtesy of the artists
© Sylvie Meunier and Patrick Tournebœuf

Joel Meyerowitz
Born in 1938 in New York, United States
Lives in New York
Pages 182 to 185
Upstate New York, 1977
California, 1970
From the Car, Taos Drive-in, 1971
Texas, 1971
Inkjet prints, 70 × 100 cm/40 × 60 cm/
40 × 60 cm/40 × 60 cm
Collection Joel Meyerowitz Photography,
New York
© Joel Meyerowitz, courtesy Polka Galerie,
Paris

Kay Michalak
Born in 1967 in Bremen, Germany
Lives between Bremen and Berlin,
Germany
Sven Völker
Born in 1974 in Coesfeld, Germany
Lives in Berlin, Germany
Pages 285 to 287
*Auto Reverse #13, Mercedes-Benz 230 CE,
Model 1984, 232 896 km*, 2011–15
*Auto Reverse #11, Volvo 940, Model 1993,
256 271 km*, 2011–15
*Auto Reverse #2, Jaguar E-Type,
Model 1970, 98 450 km*, 2011–15
Fine art prints, 158 × 100 cm (each)
Collection of the artists
© Kay Michalak and Sven Völker

Óscar Monzón
Born in 1981 in Málaga, Spain
Lives in Madrid, Spain

Pages 362 and 363
Karma, 2009–13
Installation of 7 C-prints and 5 inkjet
prints, 280 × 500 cm
Collection of the artist
© Óscar Monzón

Basile Mookherjee
Born in 1987 in Paris, France
Lives in Paris
Pages 364 and 365
Fully Fueled series, 2012–14
Installation of 10 inkjet prints,
219 × 300 cm
Collection of the artist
© Basile Mookherjee

Daido Moriyama
Born in 1938 in Ikeda, Japan
Lives in Tokyo, Japan
Pages 187 to 191
Nagano, 1978
Okinawa, 1975
On the Road, 1969
Okinawa, 1975
On the Road, 1969
Gelatin silver prints, 66 × 98 cm (each)
Akio Nagasawa collection, Tokyo
© Daido Moriyama Photo Foundation

Patrick Nagatani
Born in 1945 in Chicago, United States
Lives in Albuquerque, United States
Pages 345 to 347
*Mercedes, Grand Canyon, Arizona,
USA*, 1994
*Lincoln Continental, Ukok Plateau,
Siberian Altai, Russia*, 1995
*Infiniti, Jemez Pueblo, New Mexico,
USA*, 1996
*Cadillac Eldorado, Sandy Point Site,
Albuquerque International Sunport,
New Mexico, USA*, 1996
*Jeep Cherokee, Shahr-I Sokhta, Seistan,
Iran*, 1990
Aston Martin, Hazor, Israel, 1990
From *Excavations* series
Gelatin silver prints, 15 × 20 cm (each)
Collection of the artist, Albuquerque
© Patrick Nagatani

Arnold Odermatt
Born in 1925 in Oberdorf,
Switzerland
Lives in Oberdorf
Pages 323 to 325
Oberdorf, 1973, 1973
Oberdorf, 1964, 1964
Stansstad, 1969, 1969
From *Karambolage* series
Gelatin silver prints, 30 × 40 cm
Courtesy Galerie Springer Berlin
© Urs Odermatt, Windisch/
ADAGP, Paris 2017

Catherine Opie
Born in 1961 in Sandusky, United States
Lives in Los Angeles, United States
Page 125
Untitled #23, 1994
Untitled #26, 1994
Untitled #36, 1994
Untitled #38, 1994
Freeway series
Platinum prints, 5.5 × 17 cm (each)
Courtesy of the artist/Regen Projects,
Los Angeles
© Catherine Opie

Trent Parke
Born in 1971 in Newcastle, Australia
Lives in Adelaide, Australia
Page 80 and 81
Coober Pedy, South Australia, 2003
Gelatin silver print, 40 × 60 cm
Collection of the artist
© Trent Parke/Magnum Photos

Martin Parr
Born in 1952 in Epsom,
United Kingdom
Lives in Bristol, United Kingdom
Pages 161 to 165
Istra, Russia, 2002
Toronto, Canada, 2002
La Paz, Mexico, 2003
London, England, 2002
Amsterdam, Holland, 2002
Newcastle, England, 2002
Ljubljana, Slovenia, 2002
Beirut, Lebanon, 2002
Dublin, Ireland, 2002
New York, USA, 2002
From *Parking Spaces* series
C-prints, 25.5 × 35.5 cm (each)
Collection of the artist
© Martin Parr/Magnum Photos/
Kamel Mennour
Pages 220 and 221, 389 to 391
From A to B. Tales of Modern Motoring
series, 1994
C-prints, 51 × 61 cm (each)
Collection of the artist
© Martin Parr/Magnum Photos/
Kamel Mennour

Mateo Pérez Correa
Born in 1973 in Medellín, Colombia
Lives in Bogotá, Colombia
Pages 328 and 329
Siniestros series, 2015
Inkjet prints, 56.5 × 70 cm
Private collection, Bogotá
© Mateo Pérez Correa

Jean Pigozzi
Born in 1952 in Paris, France
Lives between Paris and New York,
United States

Pages 414 and 415
Muhammad Ali, New York, 1974
Liv Tyler, Paris, 2006
Jack Nicholson and Michael Douglas,
Summer Olympics, Barcelona, 1992
Keith Richards, Annie Leibovitz and
Patti Hansen, New York, 1978
Gelatin silver prints and inkjet prints,
28 × 35.5 cm/30 × 40 cm/
28 × 35.5 cm/30 × 40 cm
Collection of the artist
© Jean Pigozzi

Bernard Plossu
Born in 1945 in Đà Lạt, Vietnam
Lives in La Ciotat, France
Pages 193 to 199
Chiapas, Mexique, 1966
Mexique, 1966
Sur la route d'Acapulco, Mexique, 1966
Juan et Roger, Mexique, 1966
Linda et Georges, route d'Acapulco,
Mexique, 1966
Sur la route de San Miguel, Mexique, 1966
Chiapas, Mexique, 1966
From *Le Voyage mexicain* series
Gelatin silver print, 18 × 27 cm (each)
Courtesy of the artist/Galerie Camera
Obscura, Paris
© Bernard Plossu

Matthew Porter
Born in 1975 in State College, United States
Lives in New York, United States
Page 93
Borough Prime, 2015
Inkjet print, 63.5 × 78 cm
Courtesy of the artist/M+B Gallery, Los Angeles
© Matthew Porter

Edward Quinn
Born in 1920 in Dublin, Ireland
Died in 1997 in Altendorf, Switzerland
Pages 74 and 75
Françoise Sagan in a Jaguar XK120 at
a dealer's showroom in Cannes, 1954
Jane Fonda and Alain Delon in a Ferrari
250 GT SWB Spyder California, on the set
of "Joy House," Antibes, 1964
Gelatin silver prints, 36 × 36 cm/45 × 51 cm
Courtesy ArteF Galerie Zurich
© edwardquinn.com/courtesy ArteF
Galerie Zurich

Bill Rauhauser
Born in 1918 in Detroit, United States
Lives in Detroit
Pages 354 and 355
Detroit Auto Show series, c. 1975
Gelatin silver prints, 40.5 × 50.5 cm (each)
Detroit Institute of Arts, gift of the artist
in memory of Doris Rauhauser
© 2007 Rauhauser Photographic Trust.
All Rights Reserved

Rosângela Rennó
Born in 1962 in Belo Horizonte, Brazil
Lives in Rio de Janeiro, Brazil
Pages 382 to 385
Cerimônia do Adeus series, 1997–2003
C-prints face-mounted on Plexiglas,
50 × 68 cm (each)
Courtesy of the artist/Cristina Guerra
Contemporary Art, Lisbon
© Rosângela Rennó

Luciano Rigolini
Born in 1950 in Tesserete, Switzerland
Lives between Paris, France, and Lugano,
Switzerland
Pages 39 to 41
1963 American Cars, 2016
60 vintage gelatin silver prints, triptych,
128 × 110 cm (each)
Collection of the artist
© Luciano Rigolini (appropriation)
Page 43
Tribute to Giorgio de Chirico, 2017
Duratrans in lightbox, 124 × 154 cm
Collection of the artist
© Luciano Rigolini (appropriation –
unknown photographer, 1958)
Pages 113 to 115
Pure, 2013
9 vintage gelatin silver prints,
33 × 43 cm (each)
Collection of the artist
© Luciano Rigolini (appropriation)

Miguel Rio Branco
Born in 1946 in Las Palmas de Gran
Canaria, Spain
Lives in Rio de Janeiro, Brazil
Pages 300 and 301
2-1 Perdió, Mexico, 1985
Talons aiguilles en papier, Mexico, 1985
C-prints, 60 × 90 cm (each)
Collection of the artist
© Miguel Rio Branco

Ed Ruscha
Born in 1937 in Omaha, United States
Lives in Los Angeles, United States
Pages 151 to 155
Unidentified Lot, Reseda, 1967
Century City, 1800 Avenue of the Stars, 1967
May Company, 6150 Laurel Canyon, North
Hollywood, 1967
7133 Kester, Van Nuys, 1967
Zurich-American Insurance, 4465 Wilshire
Blvd, 1967
Fashion Square, Sherman Oaks, 1967
May Company, 6067 Wilshire Blvd, 1967
Pierce College, Woodland Hills, 1967
Rocketdyne, Canoga Park, 1967
5000 W. Carling Way, 1967
Good Year Tires, 6610 Laurel Canyon,
North Hollywood, 1967
Sears Roebuck & Co, Bellingham & Hamlin,
North Hollywood, 1967

Gilmore Drive-in Theatre, 6201 W. 3rd St, 1967
Litton Industries, 5500 Canoga,
Woodland Hills, 1967
5600-5700 Blocks of Wilshire Blvd, 1967
Dodgers Stadium, 1000 Elysian Park Ave, 1967
7101 Sepulveda Blvd, Van Nuys, 1967
State Dept. of Employment, 14400
Sherman Way, Van Nuys, 1967
Eileen Feather Salon, 14425 Sherman Way,
Van Nuys, 1967
Federal, County and Police Building Lots, 1967
From *Thirtyfour Parking Lots* series
Gelatin silver prints, 39.5 × 39.5 cm (each)
Chipmunk Collection
© Ed Ruscha, courtesy Gagosian Gallery

Sory Sanlé
Born in 1948 in Nianiagara, Upper Volta
(now Burkina Faso)
Lives in Bobo-Dioulasso, Burkina Faso
Pages 68 and 69
La Balade en ville, 1970–80
« Deux Chevaux » bricolée, 1970–80
Gelatin silver prints, 30 × 24 cm (each)
Courtesy Florent Mazzoleni/Galerie 127,
Marrakech
© Sory Sanlé

Hans-Christian Schink
Born in 1961 in Erfurt, Germany
Lives in Leipzig, Germany
Page 121
A 71, bei Traßdorf, 1999
From *Verkehrsprojekte Deutsche Einheit* series
C-print, 178 × 211 cm
Courtesy Kicken Berlin Gallery, Berlin
© Hans-Christian Schink

Antoine Schneck
Born in 1963 in Suresnes, France
Lives in Paris, France
Pages 318 and 319
F1, 2007
Pigment print under acrylic glass,
105 × 240 cm
Collection of the artist/Galerie Berthet-
Aittouarès, Paris
© Antoine Schneck

Stephen Shore
Born in 1947 in New York, United States
Lives in New York
Page 45
4-Part Variation, 1969
32 gelatin silver prints, 12.5 × 18 cm (each)
Courtesy of the artist/303 Gallery,
New York/Sprüth Magers
© Stephen Shore, courtesy 303 Gallery,
New York/Sprüth Magers

Malick Sidibé
Born in 1936 in Soloba, Mali
Died in 2016 in Bamako, Mali

Pages 64 and 65
Une déesse sur DS, 1974
Taximan avec voiture, 1970
Gelatin silver prints, 40 × 30 cm (each)
Courtesy Galerie Magnin-A, Paris
© Malick Sidibé

Guido Sigriste
Born in 1864 in Aarau, Switzerland
Died in 1915 in Pau, France
Pages 308 and 309
Gasteaux sur Mercedes 60 HP, 1903
Farman sur Panhard & Levassor, 1903
Turr sur Panhard & Levassor 40 HP, 1903
Koechlin sur Gobron Brillié 110 HP, 1903
De Brou sur De Dietrich 45 HP, 1903
Marcel Renault sur Renault Frères 30 HP,
1903
Aristotypes, 10.5 × 12.5 cm (each)
Collection Isabelle and Hervé Poulain, Paris
© Guido Sigriste

Raghubir Singh
Born in 1942 in Jaipur, India
Died in 1999 in New York, United States
Pages 28 and 29
Pilgrim and Ambassador Car, Prayag,
Uttar Pradesh, 1977
C-print, 60 × 80 cm
Succession Raghubir Singh
© 2017 Succession Raghubir Singh

Melle Smets
Born in 1975 in Rotterdam, The Netherlands
Lives in Rotterdam

Joost van Onna
Born in 1976 in Cologne, Germany
Lives in Rotterdam, The Netherlands
Pages 288 to 293
Turtle 1. Building a Car in Africa, 2016
Installation, variable dimensions
Courtesy of the artists/Paradox, Edam
© Melle Smets and Joost van Onna

Jules Spinatsch
Born in 1964 in Davos, Switzerland
Lives in Zurich, Switzerland
Pages 410 and 411
Sleep no. 6, 1998–2009
Sleep no. 4, 1998–2009
Gelatin silver prints, 90 × 120 cm (each)
Courtesy of the artist/Christophe Guye
Galerie, Zurich
© Jules Spinatsch

Dennis Stock
Born in 1928 in New York, United States
Died in 2010 in Sarasota, United States
Pages 82 to 86
On the Set of "American Graffiti," Filmed in
and Around the Bay Area, California, 1972
James Dean, the Race Car Scene in "Rebel
Without a Cause," 1955

James Dean, the Race Car Scene in
"Rebel Without a Cause," 1955
Montgomery Clift, Shooting of
"The Misfits," Nevada, 1960
Gelatin silver prints, 40 × 60 cm/
24 × 30 cm/24 × 30 cm/24 × 30 cm
Collection of the artist
© Dennis Stock/Magnum Photos

Hiroshi Sugimoto
Born in 1948 in Tokyo, Japan
Lives in New York, United States
Pages 341 to 343
On the Beach 011, 1990
On the Beach 007, 1990
On the Beach 001, 1990
Platinum and palladium prints,
96.5 × 66 cm (each)
Private collection
© Hiroshi Sugimoto

Juergen Teller
Born in 1964 in Erlangen, Germany
Lives in London, United Kingdom
Pages 216 and 217
OJ Simpson no. 5, Miami, 2000
Siegerflieger no. 98, Nurnberg, 2014
Giclee prints, 51 × 61 cm (each)
Collection of the artist
© Juergen Teller, 2017

Tendance Floue (Pascal Aimar,
Thierry Ardouin, Denis Bourges,
Gilles Coulon, Olivier Culmann, Mat Jacob,
Caty Jan, Philippe Lopparelli, Meyer,
Patrick Tournebœuf)
Artist collective founded in 1991
Pages 223 to 227
Nationale Zéro, Bornes, Europe, 2003
Video creation, 2017
Collection of the artists
© Tendance Floue

Thierry Vernet
Born in 1927 au Grand-Saconnex,
Switzerland
Died in 1993 in Paris, France
Page 243
Nicolas Bouvier sur la dépanneuse,
route de Shiraz, Iran, 1954
Gelatin silver print, 25 × 37.5 cm
Musée de l'Élysée, Lausanne
© Musée de l'Élysée, Lausanne

Weegee
Born in 1899 in Zolochiv, Austria
(now Ukraine)
Died in 1968 in New York, United States
Pages 326 and 327
Car Crash, c. 1940
Car Crash, c. 1940
Gelatin silver prints, 16.5 × 22 cm/
17 × 21.5 cm

Bequest of Wilma Wilcox, 1993,
courtesy International Center of
Photography, New York
© Weegee/International Center of
Photography, New York/Getty Images

Henry Wessel
Born in 1942 in Teaneck, United States
Lives in Point Richmond, United States
Pages 110 and 111
Pennsylvania, 1968
Southwest, 1982
Gelatin silver prints, 41 × 51 cm (each)
Courtesy Galerie Thomas Zander, Cologne
© Henry Wessel, courtesy Galerie Thomas
Zander, Cologne

Alain Willaume
Born in 1956 in Saverne, France
Lives in Paris, France
Pages 247 to 249
#5069, 2012
#5331, 2012
#4994, 2012
From Échos de la poussière et de la
fracturation series
Inkjet prints, 26 × 39.5 cm (each)
Collection of the artist
© Alain Willaume (Tendance Floue)

Unknown
Pages 71 to 73
Studio portraits, China, c. 1950,
collected by Thomas Sauvin
Retouched vintage gelatin silver prints,
variable dimensions
Collection Beijing Silvermine/Thomas
Sauvin, Paris
Photos all rights reserved

Pages 229 to 233
Michelin photographic survey of world
roads, c. 1930
Stereoscopic plates, 4.5 × 10.5 cm (each)
Collection Michelin, Clermont-Ferrand
© Michelin

Pages 238 to 241
The "Croisière Noire" or "Citroën Central
Africa Expedition," 1924–25
The "Croisière Jaune" or "Citroën Central
Asia Expedition," 1931–32
Inkjet prints, 12 × 17 cm (each)
L'Aventure Peugeot Citroën DS
© Citroën Communication/All rights
reserved

Sheltered from the Wind
and Rain
Pages 423 to 425
© Alain Bublex/ADAGP, Paris 2017
(images 1 to 9)
Pages 426 and 427
Photo © Renault Communication/DR
(image 1); photo © Mercedes-Benz Classic
(image 2); photo © National Automotive
History Collection, Detroit Public Library
(image 3); photo © From the Collections of
The Henry Ford (image 4); photo
© Deutsches Museum (image 5); photo
© akg-images (image 6)

Pages 428 and 429
Photo © FLC/ADAGP, Paris 2017 (image 1);
photo © akg-images/Universal Images
Group/Underwood Archives (image 2);
photo © Archives of the National Technical
Museum (image 3); photo © Citroën
Communication/Pierre Louÿs/DR (image 4);
photo © SZ Photo/Knorr & Hirth/
Bridgeman Images (image 5); photo
© Citroën Communication/Georges Guyot/
DR (image 6)

Pages 430 and 431
Photo © DLR – German Aerospace
Center (image 1); photo © Paul Meunier
(image 2); photo © akg-images (image 3);
photo © Citroën Communication/DR
(image 4); photo © British Motor Industry
Heritage Trust (image 5); photo © Renault
Communication/DR (image 6)

Pages 432 and 433
Photo © B. Meyers, 1964/Meyers Manx
Inc., 2017 (image 1); photo © akg-images/
picture-alliance/dpa (image 2); photo
© National Motor Museum/Heritage
Images/Getty Images (image 3) ;
© Mario Bellini photo © Castelli
(copyright unknown). The Museum of
Modern Art Exhibition Records, 1004.146.
The Museum of Modern Art Archives,
New York. Cat. no.: MA1187. © 2017. Digital
image, The Museum of Modern Art,
New York/Scala, Florence (image 4); photo
© ANP (image 5); © Chris Burden, photo:
Neil Golstein. Magasin III Museum &
Foundation for Contemporary Art,
Stockholm (image 6)

Pages 434 and 435
Photo © Renault Communication/DR
(image 1); photo © courtesy of Nissan
Motor Corporation (image 2); photo © John
B. Carnett/Bonnier Corp. via Getty Images
(image 3); photo © Reuters/Vincent
Kessler (image 4); photo © Getty Images/
AFP (image 5); photo © Kim Kulish/Corbis
via Getty Images (image 6)

Auto/Photo: Parallel Histories
Page 439
Photos © PVDE/Bridgeman Images
(images 1 and 2); photo © National Media
Museum/Science & Society Picture Library
(image 3); photo © Michelin (image 4)
Page 441
Photo © Tallandier/Bridgeman Images
(image 1); photos © From the Collections
of The Henry Ford (images 2 and 3); photo
© Retrograph/Mary Evans Picture Library
(image 4); photo © Keystone-France/
Gamma-Rapho (image 5)

Page 442
Photo © AGIP/Bridgeman Images (image 1);
photo © Bettmann/Getty Images (image 2);
photo © James Whitmore/Getty Images
(image 3); photo © Popperfoto/Getty
Images (image 4); photo © François
Lochon/Gamma-Rapho (image 5)

Page 445
Photo © akg-images/Interfoto/Friedrich
(image 1); photo © Raphael Gaillarde/
Gamma-Rapho via Getty Images (image 2);
photo © Mario Ruiz/The LIFE Images
Collection/Getty Images (image 3); photo
© Marc Aubry/Collection Maoby (image 4)

Page 446
Photo © akg-images/ullstein bild (image 1);
photo © Glenn Koenig/Los Angeles
Times via Getty Images (image 2); photo
© Philippe Huguen/AFP (image 3); photo
NASA/JPL-Caltech/MSSS (image 4); photo
© Philippe Huguen/AFP (image 5)

Quotes in order of appearance:

Langdon Clay, *Cars: New York City, 1974–1976* (Göttingen: Steidl, 2016);

Alex MacLean, *Over: The American Landscape at the Tipping Point* (New York: Abrams, 2008);

Robert Adams, *Along Some Rivers: Photographs and Conversations* (New York: Aperture, 2006);

Hans-Christian Schink, *Traffic Projects German Unity* (Ostfildern: Hatje Cantz, 2004);

Joel Meyerowitz, *Glimpse* (Kamakura: Super Labo, 2014);

Daido Moriyama, *Memories of a Dog* (Tucson, AZ: Nazraeli Press, 2004);

Bernard Plossu, *Le Voyage mexicain, 1965-1966* (Paris: Contrejour, 1990);

Lee Friedlander, *The New Cars 1964* (San Francisco, CA: Fraenkel Gallery, 2011);

David Bradford, *Drive-By Shootings* (Cologne: Könemann, 2000);

Andrew Bush, *Drive* (New Haven, CT: Yale University Press, 2008);

Ella Maillart, *The Crual Way: Switzerland to Afghanistan in a Ford* (Boston, MA: Beacon Press, 1987);

Nicolas Bouvier, *The Scorpion-Fish* (Oxford: Carcanet, 1987);

Alain Willaume, *Transition, paysages d'une société* (Paris: Xavier Barral, 2013);

Alain Fleischer, *599* (Rome: Agarttha Arte, 2007);

Melle Smets and Joost van Onna, *Turtle 1: Building a Car in Africa* (Edam: Paradox/Dortmund: Verlag Kettler, 2016);

Hiroshi Sugimoto, *On the Beach* (Tokyo: Amana, 2014);

Jacqueline Hassink, *Car Girls* (New York: Aperture, 2009);

Mary Ellen Mark, *Mary Ellen Mark, On the Portrait and the Moment* (New York: Aperture, 2015).

Cover:
William Eggleston, *Chromes* series, 1971–74

Printed and bound in March 2017 by Grammlich, Pliezhausen, Germany.

A catalog record is available from the Bibliothèque Nationale de France:
2nd trimestre 2017

ISBN 978-2-86925-131-1

Fondation Cartier pour l'art contemporain
261, boulevard Raspail, 75014 Paris
fondation.cartier.com

Éditions Xavier Barral
42, rue Sedaine, 75011 Paris
www.exb.fr